# A TEMPLE TREASURY

*The Judaica Collection of Congregation Emanu-El of the City of New York*

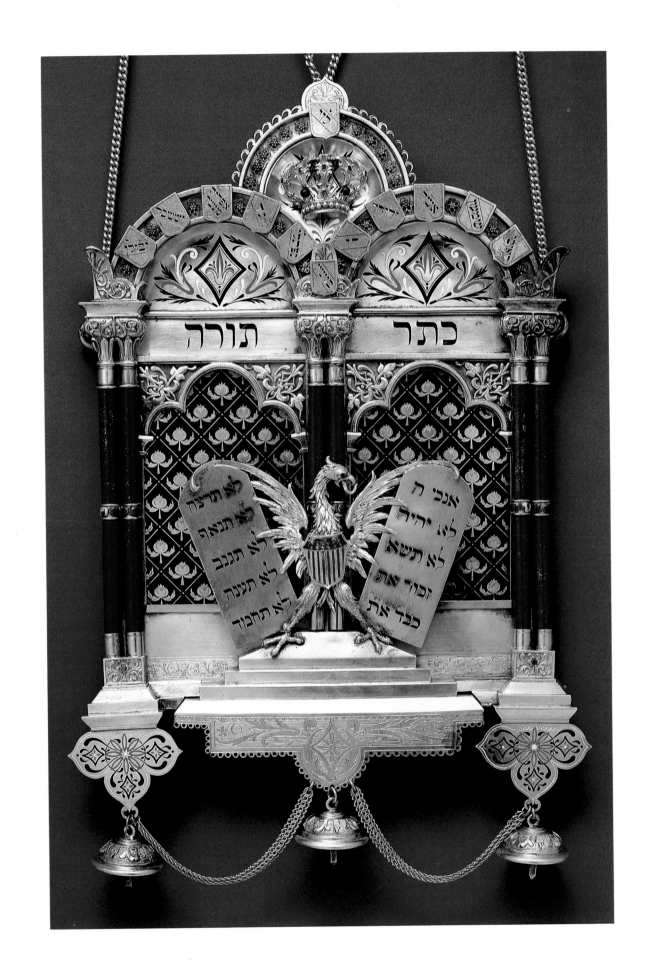

# A TEMPLE TREASURY

*The Judaica Collection of Congregation Emanu-El*
*of the City of New York*

*by*

CISSY GROSSMAN

*with essays by*
RONALD B. SOBEL
REVA GODLOVE KIRSCHBERG

HUDSON HILLS PRESS · *New York*
*in Association with Congregation Emanu-El of the City of New York*

FIRST EDITION

©1989 by Congregation Emanu-El of the City of New York
and Cissy Grossman

Published in the United States by Hudson Hills Press, Inc.,
Suite 1308, 230 Fifth Avenue, New York, New York 10001–7704

Distributed in the United States, its territories and possessions,
Canada, Mexico, and Central and South America by Rizzoli International Publications, Inc.
Distributed in the United Kingdom, Eire, Europe, Israel, and the
Middle East by Phaidon Press Limited.
Distributed in Japan by Yohan (Western Publications Distribution Agency).

Editor and Publisher: Paul Anbinder

For Congregation Emanu-El
Editor: Irene Gordon
Designer: Leon Auerbach

Composition: Unbekant Typographers, Inc., New York City
Hebrew Composition: Star Composition Service, New York City
Manufactured in Japan by Toppan Printing Company

Library of Congress Cataloging-in-Publication Data
Temple Emanu-El (New York, N.Y.)
A Temple treasury : the Judaica collection of Congregation
Emanu-El of the City of New York/Cissy Grossman : with essays
by Ronald B. Sobel, Reva Godlove Kirschberg. — 1st ed.
      p.    cm.
   Bibliography: p.
   Includes index.
   ISBN 1–55595–036–1 (alk. paper)
   1. Judaism—Liturgical objects—Catalogs.   2. Temple
Emanu-El (New York, N.Y.)—Museums—Catalogs.   3. Temple
Emanu-El (New York, N.Y.)—History.   I. Grossman, Cissy.
II. Sobel, Ronald B.   III. Kirschberg, Reva Godlove.
IV. Title.
BM657.A1T47   1989   87–73301
296.4—dc20                     CIP

*Jacket and frontispiece illustration*
Schiff Torah Shield (cat. no. 4)

# Contents

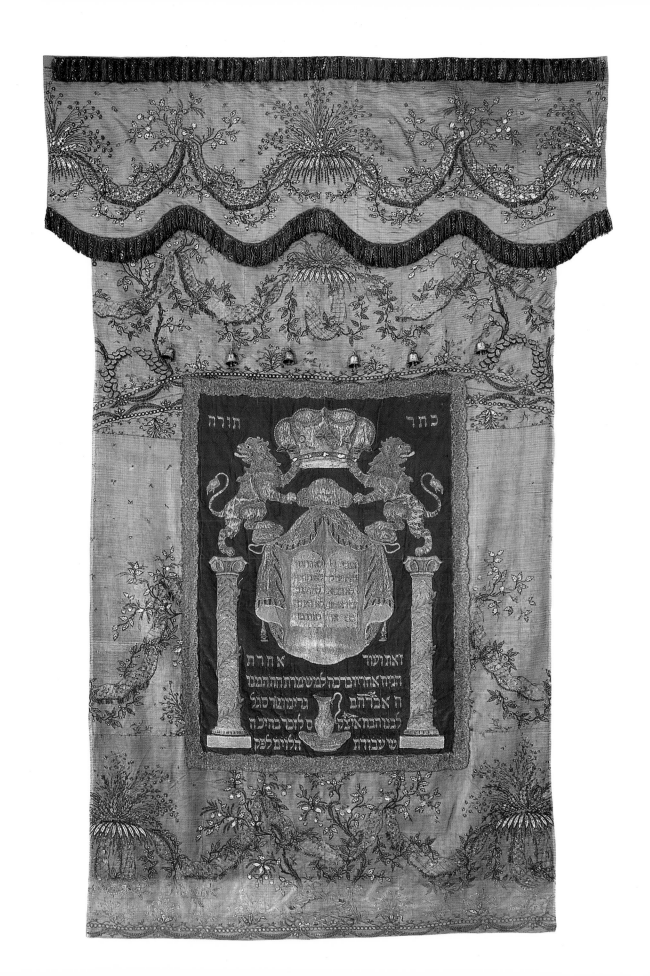

# Preface

This book came into being as a natural progression of events, as the flowering of a tree in early spring. And, like the invisible process that transforms buds to blossoms, this volume is the product of gradual and at times complex growth. The project was set in motion when I came to consult the collection of Temple Emanu-El in search of old Jewish textiles. After seven years as assistant curator of Judaica at the Jewish Museum in New York, I was planning to pursue new interests. This course was deflected when Reva Kirschberg asked me to document the Emanu-El Collection.

This American collection is unique for the tangible evidence it offers of the life of the Congregation and the way in which it illuminates and locates this particular Congregation in time and place. Many of the objects were commissioned especially to fulfill community obligations—of worship, of recognition, of enrichment of a heritage. It is probably symbolic that this great Reform Congregation has among its treasures many objects that originated in traditional Jewish communities, the sad result of the many dislocations suffered by European Jewry over centuries.

Reva Kirschberg became keeper of the Collection in addition to the many responsibilities she has undertaken over the years for the Congregation. As Museum Director she has applied extraordinary managerial skills, intelligence, and sensitivity to the many issues concerned with the care, history, conservation, and exhibition of these fine objects. She has inspired the Board of Trustees, the Rabbis, the Congregation, and the members of the staff to support the work of caring for an important Judaica collection.

The task of assembling, numbering, photographing, and recording each object, as well as centralizing and improving the storage, occupied more than four years. The record photography benefited from the talents of Alan Kirschberg, who provided excellent photographs for the accession files. Henry Fruhauf was an early supporter and caretaker of the collection, and his long history as Temple Administrator has been an ever-reliable source of recollection of particular objects and donors. Dr. Mark W. Weisstuch, present Temple Admin-

istrator, has carried forward the tradition of generous care. Gerald Davis, Building Manager, and his predecessor, Ezekiel Reiskin, safeguarded the objects before they were gathered into one central secured location. Members of the Congregation Harriet and Ruben Shohet, Ruth Silverman, Bernice Buchbinder, Elaine Dinerman, Caroline Schwartzman, and Gene Ullman also assisted us, as did Temple Librarian, Salome Cory.

In the course of our research we have had the whole-hearted assistance of many colleagues. First among these has been Senior Rabbi Dr. Ronald B. Sobel. Rabbis David M. Posner and Richard S. Chapin have offered scholarly critiques and constructive advice.

Some of the Hebrew inscriptions were translated fifty years ago by Rabbi I. S. Meyer for Judge Irving Lehman. Others have been translated by Zalman Alpert, scholar and librarian, to whom we also owe the complex Hebrew and Yiddish translation of the Avraham Rosenberger Torah Binder (cat. no. 41). For this volume, all the inscriptions have been examined and retranslated by Dr. Philip Miller, Librarian, Klau Library, Hebrew Union College–Jewish Institute of Religion, New York. Dr. Miller also provided sources of quotations, graciously responded to bibliographical queries, and participated with Rabbi Posner and the author in determining the approach to translation that is set forth in the Translator's Note. Shalom Sabar, Hebrew University, Jerusalem, was of immense help in translating the names of Italian Jews.

Bezalel Narkiss, Department of Jewish Art, Hebrew University in Jerusalem, has read critically several problematic entries. We extend our gratitude to this outstanding expert on Jewish art for making time for this project. Many others have been generous with their help and time: Rachel Wischnitzer, beloved doyenne of Jewish art studies, Professor Emeritus of Yeshiva University, New York; Rochelle Weinstein, Associate Professor of Art History, Borough of Manhattan Community College, City University of New York; Joseph Gutmann, Professor of Art History, Wayne State University, Detroit; Rose-Carol Washton Long, Chair, Art History Department, The Graduate Center, City University of New

Figure 1. Torah Curtain and Valance (cat. no. 38).

York; Chaya Benjamin, Curator, Judaica Department, The Israel Museum, Jerusalem; Dalia Tawil, former Curator, Yeshiva Museum, New York; Bezalel specialist Gideon Ofrat, Jerusalem; David J. Gilner, Deputy Librarian, Klau Library, Hebrew Union College–Jewish Institute of Religion, Cincinnati; Lubav Coolynetz, Curator, Ethnographic Collection, Ukrainian Museum, New York City; Aviva Müller-Lancet, former Curator of Ethnography, The Israel Museum; L. B. Gans, Amsterdam, whose late father was Moses Gans, the well-known Dutch dealer and Judaica collector; Victor Klagsbald, whose catalog of the Judaica Collection of the Musée de Cluny in Paris has been a model.

We thank our photographers Malcolm Varon, of New York, for the color photography produced with an unerring eye for the essential character of each object, and Will Brown, of Philadelphia, for the enormous effort expended to maintain the consistently high quality of his black-and-white photography.

Our editor, Irene Gordon, herself an art historian and member of the faculty of John Jay College of Criminal Justice, City University of New York, has been a vital support in her professionalism and enthusiasm for this publication. Leon Auerbach has been the ultimate designer in the intelligence and taste he has brought to every aspect in the development of this book. We are grateful as well to our publisher, Paul Anbinder, for his personal interest in this project and for the high standards that distinguish all his undertakings.

The possibility of publishing the information and discoveries that emerged during the documentation of this splendid collection and of sharing this knowledge with the Congregation and with Judaica collectors and scholars the world over has been made possible by the extraordinary gift of Felix Marx, a longtime member of the Congregation, whose confidence in our effort has been an inspiration.

Finally, we return to Dr. Ronald B. Sobel, spiritual leader of Congregation Emanu-El. His support, trust, and willingness to offer specific guidance when it was asked of him have been helpful beyond measure. He has inspired us all with his own spirituality and his personal loving-kindness.

CISSY GROSSMAN
New York City

# Introductory Notes

**EDITOR'S NOTE**

Although some of the objects shown in this volume have appeared in small displays in the Community House Lobby and others have been seen in loan exhibitions, for most of the work presented here, this book serves as a public debut. With this sense of discovery in mind, the structure of the catalog entries has been formulated to provide the descriptive data and discursive commentary that will interest both the amateur and the professional.

Each entry opens with factual information: master, maker, or designer; place of origin; date. Materials and technique are cited; dimensions are given in inches and centimeters, with height preceding width preceding depth. Masters' marks are noted, with indications of reference books in which they are found.

Inscriptions are recorded in the original languages, followed by English translations. The Hebrew system of citing a date by the use of characters that have established numerical equivalents, and by an abbreviated form that leaves the millennium understood, is rendered into English by the use of brackets, which indicate the absent digit, and parentheses, which interpolate the Common Era equivalent: [5]749 (1988/89). English inscriptions are given in italics, with original spelling and punctuation intact.

A descriptive paragraph cites the essential visual elements: form, materials, techniques, and, where relevant, condition and losses. Commentaries touch upon the function the object served, its craftsmanship, its relation to similar pieces, its iconographic details, its place in its own ethnographic history, as well as its relation to the comprehensive history of similar objects.

Bibliographic indications are separated into References, which point to similar objects or to comparisons noted in the commentary, and Literature, which refer to publications of the object under discussion. Writings are cited in abbreviated form in the entries; complete citations are given in the Bibliography.

IRENE GORDON
New York City

**TRANSLATOR'S NOTE**

In the translation of Hebrew inscriptions, care has been taken to assure that the English rendering reflect the Hebrew idiom as much as possible. For the translation of biblical verses, both the Tanakh, the new translation of the Holy Scriptures published by the Jewish Publication Society of America in 1985, as well as the Society's earlier translation (1917) have been consulted. At times, however, other translations have been used, especially in the case of verses that are well known and almost fixed in the popular imagination. This has been especially true where such verses have a liturgical use, and for such examples the Union Prayer Book (1940 edition) has been used.

The transcription of Hebrew words into the Latin alphabet reflects the Israeli (Sephardic) pronunciation, which has become an international standard. For words that have passed into English usage (e.g., bar mitzvah, Hanukkah), Webster's Third New International Dictionary Unabridged has been consulted; where a variant spelling reflected modern Hebrew pronunciation, that form has been selected. Words that do not appear in Webster are given in italics, as for example, in the case of yad and *yadaim*

Proper names in Hebrew presented a special problem. Instead of maintaining the forms found in English translations of the Bible (e.g., Abraham, Moses, Samuel), Hebrew variants have been used (Avraham, Moshe, Shmuel), because these are closer to the actual vernacular pronunciation than the English. The problems of phonological and dialectal variation (Moisheh versus Mawsheh) and the veracity of form are not addressed.

PHILIP MILLER
Klau Library
Hebrew Union College–Jewish Institute of Religion
New York City

# The Essays

**DR. LEO MERZBACHER**
1845–56
*(portrait unavailable)*

**DR. SAMUEL ADLER**
1857–91

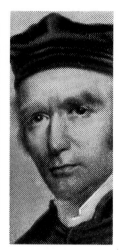

**DR. DAVID EINHORN**
1866–78
*Congregation Adas Jeshurun/Temple Beth-El*

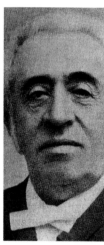

**DR. GUSTAV GOTTHEIL**
1873–1903

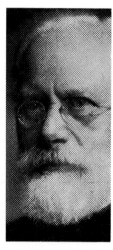

**DR. KAUFMANN KOHLER**
1879–1903
*Temple Beth-El*

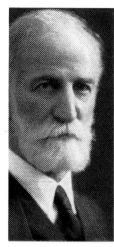

**DR. JOSEPH SILVERMAN**
1888–1930

**DR. SAMUEL SCHULMAN**
1898–1955
*Temple Beth-El/Congregation Emanu-El*

**DR. JUDAH LEON MAGNES**
1906–10

**DR. HYMAN G. ENELOW**
1912–34

**DR. NATHAN KRASS**
1923–49

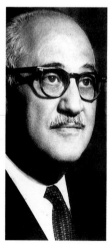

**DR. NATHAN A. PERILMAN**
1932–present

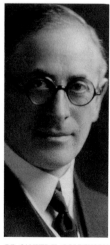

**DR. SAMUEL H. GOLDENSON**
1934–62

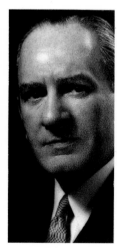

**DR. JULIUS MARK**
1948–77

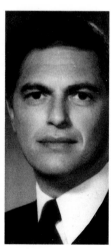

**DR. RONALD B. SOBEL**
1962–present

# The Congregation

*A Historical Perspective*

DR. RONALD B. SOBEL
Senior Rabbi

The Jewish historical experience is inextricably inter-woven with the history of Western civilization. It is the story of a minority interacting reciprocally with large complex societies and cultures. Therefore, unlike the history of any other people or civilization, the histori-cal experience of the Jewish people cannot be viewed or analyzed in isolation. In this respect there are no historical analogs.

From the dawn of civilization in the ancient Near East to the post-industrial, technological era of our own time, Jews have been a part of and remained apart from each circumstance encountered in history. They have created responsive forms appropriate to the cultures and societies in which they have lived throughout the globe for almost four thousand years. The Jewish people became experts in creative adaptation.

However, there was and remains a single constant amid the bewildering responses to changing historical circumstances. The constant is a concept of unity, the affirmation that God is One and omnipotent. Commit-ment to this idea of oneness in nature and human nature did not breed repetitive conformity century after cen-tury, but rather produced creative diversity generation after generation. The concept of God's unity allowed the Jewish people to live, survive, and create amid changing historical realities; the concept of unity allowed for the diversity necessary for survival. It was and remains the mortar with which the Jewish people have built their many houses among many peoples.

The process of Jewish adaptation to the society and culture of the United States has been defined within the broader phenomenon known as "Americanization." It was a complex process and the many methodologies employed reflect the diversities of Jewish life. The Jews who came to the United States as immigrants defined their destiny as inseparably bound to the well-being of all Americans. They became passionate advocates of the American experiment in democracy.

Though the first Jews to arrive on these shores came as early as 1654, it was not until the mid-nineteenth century that sufficient numbers of Jewish immigrants were present to allow the forms and shapes of Americanization to emerge. It was during that time that Temple Emanu-El was founded. The Jews who established Emanu-El, and those who joined their ranks during the first decades of the Congregation's existence, were immigrants from Germany who sought to reorient themselves by adapting their individual lives and col-lective institutions to the new environment of Ameri-can civilization. The congregation they created and the lifestyles they fashioned were only the most recent chapter in a long history of creative adaptation; what they accomplished was nothing new in the Jewish historical experience.

From the very beginning the United States pro-vided a polity in which the freest Jewish community the world has ever known was able to develop and grow. It was, and remains, within this unique experi-ment in democracy that Temple Emanu-El originated and subsequently flowered to world prominence.

It is useful to understand the nature of Western European immigration to the United States in the nine-teenth century in general, and German Jewish immigra-tion in particular, to grasp fully the origins of Temple Emanu-El. The conservative reactions that dominated Europe following the final defeat of Napoleon created a climate wherein many of the dreams set in motion by the Emancipation and the French Revolution were considerably constrained. The climate of rigid conser-vatism inhibited liberal growth in religion, in politics, and in the social sphere. After unsuccessful attempts to change that conservative trend, many liberals, find-ing no future in Europe, turned to America. They came to these shores with the hope and dream that in this land the preciousness of personality would be cherished and the dignity of individuality honored. Among those who came from Western Europe in the late 1830s were the men and women who would soon found Temple Emanu-El.

In September 1844, a "cultus verein" (cultural society) was established on New York's Lower East Side, and it was out of that cultural society that Emanu-El had its origins. In April 1845, thirty-three members of the society decided to establish a Reform congregation.

Figure 2. Rabbis of Temple Emanu-El and dates of their association.

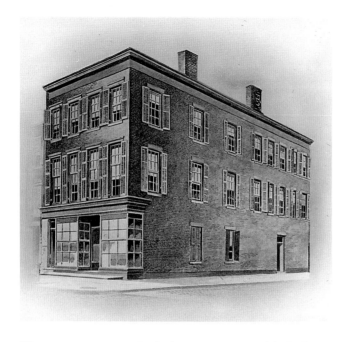

They were not particularly conversant with Reform Judaism and were only vaguely aware of its origins in their native Germany. Seeking advice, they wrote first to Congregation Beth Elohim in Charleston, South Carolina, which in 1824 was the first Reform congregation established in the United States; they also wrote to the leaders of the Har Sinai Congregation in Baltimore, Reform Judaism's second congregation in America, which was founded in 1843. They received some responses and proceeded to establish their own congregation, which they called Temple Emanu-El.

When they banded together as a religious community it was simultaneously the first in New York to be established as a Reform congregation and the third such Liberal congregation in America. It is of some interest to note that the use of the word "Emanu-El" as the name of a congregation is the first time in history that we know of that a Jewish congregation adopted this word as a designation. By choosing "Emanu-El," which means "God is with us," the founders were no doubt reflecting their hopes that God would be with them as they came to this new land, and as they put down their roots here.

Their spiritual hopes knew no bounds, but their material resources were limited. Thus the first place of worship was a rented room on the second floor of a private dwelling at the corner of Grand and Clinton streets (figure 3). The records indicate that at the organizing meeting in 1845, the men present contributed a total of less than thirty dollars, and with that modest sum began the Congregation. The founders quickly outgrew that rented room, and in 1848 they moved to Chrystie Street, a few blocks west of their original location. The Congregation was still limited by its financial resources and did not possess the means to erect its own synagogue. By necessity, therefore, they purchased an existant building, which had previously been used as a Methodist church, and with some changes transformed it for Jewish worship and communal meetings (figure 4).

In the first few years, Temple Emanu-El's growth, though not dramatic, was steady, and the members remained modest of means. Yet there was sufficient development that by 1854 the Congregation felt the need to move again, this time northwest to Twelfth Street near Fourth Avenue. As the general population in Manhattan was moving uptown so too was the Jewish population, and thus inevitably the members of Emanu-El as well. Again unable to build on their own, they bought a structure that had been a Baptist church and refurbished it as a synagogue (figure 5). However, their dreams of building a great temple were neither to be denied nor postponed to some distant future. In 1868, three years after the conclusion of the Civil War and twenty-three years after the final meeting of the "cultus verein," the members of Congregation Emanu-El were in a position to erect an imposing sanctuary at the northeast corner of Fifth Avenue and Forty-third Street (figure 6), which a critic of the time described as "the finest example of Moorish architecture in the Western world." That religious home was to remain the Congregation's place of worship until the latter part of 1927, when construction of the present edifice began.

It is remarkable that within a span shorter than twenty-five years the Congregation that had begun with so few in number and so little in material means was able to erect a building that was judged an architectural

Figure 3. Private dwelling, corner of Grand and Clinton streets, the first place of worship of Congregation Emanu-El (1845–48).

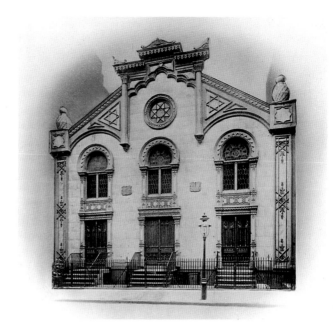

Figure 4. Temple Emanu-El, 56 Chrystie Street, the second place of worship of Congregation Emanu-El (1848–54). Formerly a Methodist church, the building was refurbished for its new congregation by Leopold Eidlitz.

wonder not only by the Jewish world but also by the people of the city of New York. The first quarter century of the Congregation's history may be viewed as a microcosm of the success of the Western European immigrant in general, and of the German Jewish immigrant in particular.

The first rabbi to serve Temple Emanu-El was Dr. Leo Merzbacher. Little is known about him, but it seems probable that he was the first ordained rabbi to serve a congregation in New York. Dr. Merzbacher led the Congregation in its earliest encounters with Reform Jewish philosophy and practice and authored one of the first Reform prayer books in America. Following his death in 1856, he was succeeded by Dr. Samuel Adler (figure 2), who by that time had already achieved a reputation as one of the great philosophical and theological leaders of the Reform movement in Germany. The first three decades of the Congregation's history were thus marked by significant radical reforms in liturgy, theology, and practice. But after 1875, having achieved great eminence, the Congregation tended to become somewhat more conservative. Innovations, ritual changes, and prayer book adaptations thereafter came slowly. Dr. Adler preached in German, as had Dr. Merzbacher before him, and that language adequately served the needs of the first generation of Temple Emanu-El's members. However, it did not serve the needs of the founders' children, whose principal language was English, and thus it was inevitable that this second generation expressed a desire for an English-speaking preacher. That need was satisfied with the election of Emanu-El's third rabbi, Dr. Gustav Gottheil (figure 2). Although born in Germany, Dr. Gottheil was fluent in English, having served a Liberal congregation in Manchester, England.

It is not without significance that Emanu-El's first three rabbis were trained in Europe, a circumstance necessitated by the fact that the American Jewish community had not yet been able to establish a successful rabbinic seminary. (However, it was not long thereafter that the need for such an institution was satisfied; two years following Gottheil's arrival in New York,

Isaac Mayer Wise created the Hebrew Union College in Cincinnati.) Dr. Gottheil served the Congregation until 1900 and advanced the cause of Reform Jewish life in several important ways: he was an innovator in liturgy, particularly by his authorship of a hymnbook, and he was one of the earliest rabbis in the United States to consciously reach out to the Christian community, and his rabbinate witnessed the beginnings of the interfaith movement. Better understanding between Christians and Jews has been an important element in the experience of the American Jewish community, and it significantly began at Temple Emanu-El. Dr. Joseph Silverman (figure 2), who joined the rabbinic staff in 1888 as Dr. Gottheil's assistant, was the first American-born rabbi to serve in New York and was a member of the second graduating class of Hebrew Union College.

In 1895, amid great joy and elaborate ceremony, the Congregation celebrated the fiftieth anniversary of its founding. On that occasion the city's most prominent rabbis, Christian clergymen, educators, and political figures were present. Their participation and the wide press coverage reporting the Golden Jubilee celebration reflected the enormous growth of Temple Emanu-El. A congregation that had begun so humbly on the Lower East Side was now, a half century later,

being recognized as among the most important religious institutions in the city.

Gottheil's successor was Dr. Judah Leon Magnes (figure 2), who was also American born and a graduate of Hebrew Union College. Magnes was an active member of the nascent Zionist movement and also played an important role in bridging the cultural diversities that separated the Jewish community of German origin from those who had emigrated from Eastern Europe. Magnes remained at Emanu-El only a few years and later became the first president of Hebrew University in Jerusalem. In 1912, the Congregation called the scholarly Dr. Hyman G. Enelow to the pulpit (figure 2). His contributions to higher Jewish learning were profound, and his writings are still studied by scholars all over the world.

When Temple Emanu-El was founded in 1845 there were approximately fifteen thousand Jews in the United States. Thirty-five years later that number had grown to a quarter of a million. In 1881, following the assassination of Czar Alexander II, dread pogroms were unleashed throughout most of Eastern Europe, and with them a great wave of immigration to America began as Jews fled from physical persecution, political oppression, and economic hardship. During the next forty years the Jewish population in the United States increased by an additional two-and-a-half-million men, women, and children.

Recognizing their responsibilities by remaining receptive to a centuries-old Jewish tradition that held that one must "aid the poor, care for the sick, teach the ignorant, and extend a helping hand to those who have lost their way in the world," the members and leaders of Temple Emanu-El responded generously and creatively to the profound poverty of their Jewish brethren who had emigrated to New York from Eastern Europe during this forty-year period. The wealth and talent of the uptown German Jews who worshiped at Emanu-El were generously bestowed upon the newly arrived Russian Jews. (However, even prior to this period of massive immigration, the Congregation had established its own tradition of philanthropic largesse.)

Figure 5. Temple Emanu-El, 110 East Twelfth Street, the third place of worship of Congregation Emanu-El (1854–68). The Gothic Revival building had originally been a Baptist church.

Although the members of Temple Emanu-El may have felt a sense of noblesse oblige in the performance of their charitable activities, and perhaps their efforts were largely directed toward Americanizing their "poor cousins" in order to reinforce their own standing in society, nevertheless what they and other German Jews in America did was nothing short of creating private institutions of philanthropy and education such as no com-

munity, Jewish or non-Jewish, had ever done before in history. The Temple and its leaders set an example to a world willing to learn about caring, and that caring including concern for non-Jews as well as Jews.

In 1920, the Congregation celebrated its seventy-fifth anniversary, again with great joy, but this time combined with a thanksgiving celebrating the recent American victory at the end of World War I. The fact that the United States had been at war with Germany caused somewhat of an identity crisis for many Americans of German origin, including some members of Temple Emanu-El. (There were also ambivalent feelings compounded by the fact that Russia, which had been our ally in the war, was the country that, during the previous four decades, was responsible for inflicting such horrible brutality upon the Jewish people.) However, the war was over, the Allies were victorious, and Emanu-El celebrated its anniversary in an exaltation of freedom.

By the beginning of the third decade of the twentieth century those Jews who had more recently arrived from Eastern Europe were beginning to settle into American life, to define themselves, and to make their own place in their new land of freedom. Less and less were they in need of the kind of assistance they had received for so long from the German Jews. And thus Emanu-El and its membership were now able to begin to address their own inner needs. In the 1920s a call for spiritual renewal went forth from the pulpit, and what followed was the establishment of many of the auxiliary organizations and activities that continue to this day to give so much vitality and meaning to the Congregation's programs and activities. It is also of interest to note that by the early 1920s some Eastern Europeans were beginning to join the Temple. A generation later, by the conclusion of World War II, the majority of the Congregation's members were men and women who traced their ancestry to either parents or grandparents of Eastern European rather than Western European origin.

In 1868, when the Congregation dedicated its Temple, Forty-third Street and Fifth Avenue was at the center of the most elegant residential section of the city.

However, by the mid-1920s that part of Fifth Avenue and its surrounding streets had undergone a radical transformation. What had been for so long quietly residential had now become noisily commercial, so much so that on Saturday mornings worshipers found it difficult to pray over the cacophony coming from the adjacent streets. Furthermore, until the early 1900s the majority of the Congregation's members lived in the immediate vicinity of the Temple, but by the 1920s the overwhelming majority were residing much farther north, on the Upper West Side as well as the Upper East Side. While the old building at Forty-third Street remained architecturally beautiful, it had serious functional problems. The student body in the Religious School was growing in size, and the classrooms were inadequate. There were insufficient meeting rooms to house the expanding programs of the Temple. Following several years of debate and consideration, the Congregation, upon the recommendation of its respected president, Louis Marshall, purchased property on the northeast corner of Fifth Avenue and Sixty-fifth Street. A better location could not have been chosen. The assumption was then, and the reality today remains, that so long as there is a Central Park, this part of Fifth Avenue would be exclusively residential in character.

It was also in the late twenties that the second most influential Reform congregation in New York, Temple Beth-El (House of God) consolidated with Emanu-El. Possessor of its own distinguished history, Temple Beth-El had been established in 1874 through the amalgamation of two earlier congregations, Anshe Chesed (Men of Mercy) and Adas Jeshurun (Congregation of Israel). Its first rabbi was Dr. David Einhorn (figure 2), one of the most important architects of nineteenth-century Reform Jewish thought. He was succeeded by the equally brilliant theologian Dr. Kaufmann Kohler (figure 2), who left the pulpit of Beth-El in 1903 to become president of Hebrew Union College in Cincinnati.

The newly merged congregations combined rabbinic resources as well as lay brilliance into one new great Congregation. The people of Emanu-El left Forty-third Street in 1927, and during the years that it took

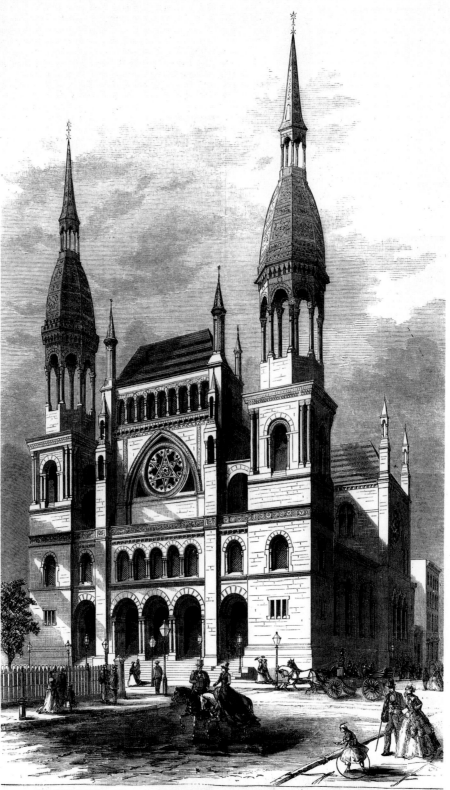

THE HEBREW TEMPLE EMANU-EL, CORNER OF FIFTH AVENUE AND FORTY-THIRD STREET, NEW YORK CITY.
[PHOTOGRAPHED BY ROCKWOOD.]

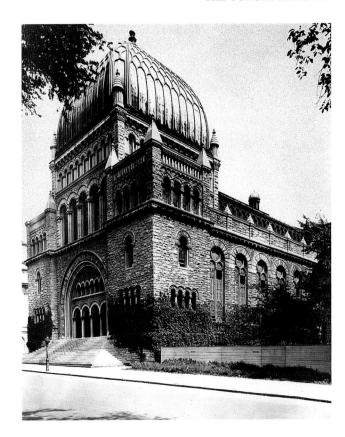

Figure 6. Temple Emanu-El, Fifth Avenue and Forty-third Street, 1868. Leopold Eidlitz and Henry Fernbach, architects. Engraving in *Harper's Weekly* of November 14, 1868, accompanying a report of the dedication of the Temple on September 11.

Figure 7. Temple Beth-El, Fifth Avenue and Seventy-sixth Street, 1891. Arnold W. Brunner, architect. (Demolished 1947.) After the consolidation of Emanu-El and Beth-El, the merged congregations worshiped here until the completion of Temple Emanu-El on Fifth Avenue and Sixty-fifth Street in 1929. Photo courtesy Photographic Department, The New York Edison Company.

to erect the new building, they worshiped at the handsome Temple Beth-El, which stood at Fifth Avenue and Seventy-sixth Street (figure 7).

The first religious service at the new Temple at Fifth Avenue and Sixty-fifth Street (figure 14) was conducted in September 1929; sadly, that gathering was occasioned by the death of Louis Marshall, the man who perhaps more than any other was responsible for the building of the great new Temple. A few weeks later, services for Rosh Hashanah and Yom Kippur were conducted. How fortuitous it was that the members of the Congregation decided to build and create this magnificent Temple when they did, for had they delayed, for whatever reason, in all probability this gloriously magnificent edifice that now stands as Temple Emanu-El would probably never have been built. In the latter part of October 1929 the stock market crashed, and the Great Depression began.

The Temple was formally dedicated in January 1930 in a ceremony presided over by the rabbis of the Congregation: the great orator Dr. Nathan Krass (figure 2), who had come to Temple Emanu-El in 1923; Dr. Hyman G. Enelow, the gentle scholar who had been with the Congregation since 1912; and the equally brilliant scholar Dr. Samuel Schulman (figure 2), who had been Senior Rabbi of Temple Beth-El. The newly elected President of the Congregation was the Honorable Irving Lehman, Judge of the New York State Court of Appeals (and Chief Judge from 1940 onward), whose family had been affiliated with the Congregation since the 1870s.

Sharply contrasting moods characterized the decade and a half that rounded out Temple Emanu-El's first hundred years. On April 4, 1945, the Congregation entered the majestic Sanctuary for a Service of Rededication, climaxing seven months of Centenary Celebration. It was a decade and a half that began with hope and ended with promise, while the interval was filled with crisis and horror, sorrow and tragedy, such as the human family had never before endured. The Jewish people, schooled in centuries of persecution, were made the victims of an ancient hatred welded to

modern technology, and by the time Nazism was finally destroyed by the Allied victory, the virtual annihilation of European Jewry had come to pass. The fortunate few who escaped to America were welcomed to Temple Emanu-El with the same attention and devotion shown by an earlier generation to those who had fled the tyranny of Czarist Russia.

As a result of the economic catastrophe precipitated by the Depression, the membership of the Congregation was significantly diminished. However, to the credit of the Board and the congregants of Emanu-El, in the face of burdensome debt they wholeheartedly assumed social responsibility for those beyond the precincts of the Temple. Both to the needs of the refugees from Hitlerism and the call for patriotic service during the war, Temple Emanu-El's men and women responded generously and willingly. In both areas they established and maintained programs of excellence.

During 1934 Rabbis Enelow, Krass, and Schulman retired, and Dr. Samuel H. Goldenson (figure 2) was selected as their successor. A gentle man, and a champion of Classical Reform, Dr. Goldenson brought to the rabbinate of Emanu-El a spirit of saintliness. Two years previously, in 1932, the ministry of Dr. Nathan A. Perilman had begun; he came to the Congregation with the

expectation of staying only six months, but remained for forty-one-and-a-half years, making his rabbinate the longest active service in the Congregation's history. Upon the retirement of Dr. Goldenson in 1948, Dr. Julius Mark (figure 2) was elected the Temple's Senior Rabbi. Dr. Mark had won wide recognition for the important role that he played as a Navy chaplain during World War II. At the time of Dr. Mark's election, Dr. Perilman was made Rabbi of the Congregation.

The years following World War II saw an enormous growth in the Temple's membership. The 1950s were characterized by an age of significant revival in religious institutions, and the Congregation grew wondrously as America was able again to settle down to a peacetime environment. New programs were introduced, old programs were revitalized, and adult-education offerings were significantly expanded. After twenty distinguished years, Dr. Mark retired in 1968 and was succeeded as Senior Rabbi by Dr. Perilman (figure 2), who remained with the Congregation for an additional five-and-a-half years, retiring at the end of 1973.

Dr. Perilman was then succeeded by Dr. Ronald B. Sobel, who had come to Temple Emanu-El as Assistant Rabbi immediately following his ordination at Hebrew Union College in 1962. When elected Senior Rabbi at the end of 1973, Dr. Sobel was the youngest spiritual leader ever elected by the Congregation. Today (figure 8) he is assisted by two longtime associates, Rabbi David M. Posner and Rabbi Richard S. Chapin.

The 1970s and the 1980s have continued to witness further growth in the Congregation, so much so that today Temple Emanu-El is world Jewry's most prominent house of worship. Physically it is the largest Jewish synagogue in the world, and the size of its membership also makes it the largest Reform congregation in the world. Innovative programs continue to be introduced and older programs are expanded as the members of the Congregation reach out more and more to the Jewish world in New York and beyond and to the other communities of which we are a part.

The past is always prelude to the present, the present forever a preparation for the future. In 1995 the

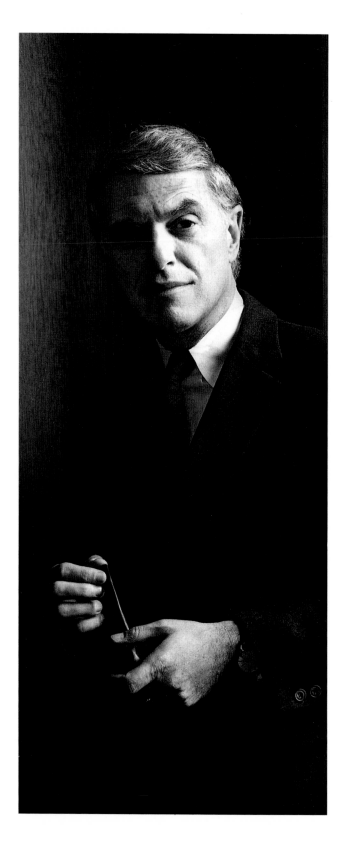

Figure 8. Dr. Ronald B. Sobel, Senior Rabbi of Temple Emanu-El. Photo by Kasia Gruda.

Congregation will celebrate its one hundred fiftieth anniversary. We have every expectation and hope that Emanu-El will continue to be a beacon and a pride to world Jewry.

Although much has changed in the near century and a half since the Congregation was founded at Grand and Clinton streets, the members of Temple Emanu-El continue to be fundamentally committed to a faith that proclaims:

**1.** Instead of one fixed and changeless revelation from God to Moses at Sinai, the Jewish people have been heir to a progressive revelation, which continues throughout history in the discoveries of science and in the insights of wise, sensitive human souls. The Bible and Talmud are valuable permanent records of earlier and decisive stages in this process. But, since revelation comes from God through human beings, all the documents of revelation are a mixture of the divine and the human, the eternally valid as well as the temporary and transient. Judaism is a living, growing way of life, evolving gradually from earlier and more primitive forms to the full flowering of its universal spiritual message.

**2.** Central and changeless is the belief in the one and holy God, who is to be served through righteousness and mercy. God's law is basically ethical. Ritual and ceremony, as the prophets declared long ago, are not the essence of religion. Moreover, historical study reveals that ceremonial practice has been constantly subject to change. Indeed, ritual is not without value: it is a means of making religious truth more vivid and inspiring to the worshiper. But the forms are not sacrosanct. If they fail to instruct and uplift those who practice them, they may be modified or discarded.

**3.** The universal ethical aspect of Judaism must forever remain primary in the consciousness of the Jewish people. Therefore, the members of Temple Emanu-El do not hope for the coming of a personal Messiah to usher in a period of national restoration, but rather look forward with anticipation to a universal messianic era for all humanity. Neither the establishment of a nation-state in the ancient homeland, nor the restoration of the Jerusalem Temple, nor the reinstitution of the sacrificial cult are necessary prerequisites for the realization of the messianic dream. Thus, we believe that Jews are, and should remain, citizens of the various nations in which they live.

**4.** The survival of the Jewish people as a religious group is a sacred and urgent obligation. The Jewish people have a mission to humankind, a mission ordained of God and proclaimed by the prophets of ancient Israel. This mission requires that the people born in, or adopted into, the Covenant of Abraham must persuade humankind through teaching and example that the One and Only God can be worshiped in holiness only as His children serve each other in love. To acknowledge God's unity requires obedience to, and reverence for, His ethical mandates and moral imperatives. The mission of Israel will not have been fulfilled until righteousness and peace prevail everywhere for everyone. Until that great messianic fulfillment, the Jewish people must survive as a "kingdom of priests" dedicated to the service of God and humanity.

These were the principles of faith proclaimed by the founders of Congregation Emanu-El in 1845; they remain the principles to which this generation of Temple Emanu-El constantly rededicates itself.

The story of Temple Emanu-El is the history of successful Americanization. From 1845 to the present the members of the Congregation have authored a new chapter in the chronicle of Jewish creative adaptation. Their lives have served as an enviable model of what the Jew could strive to become, and continue to be, in the United States.

References

LEVY, BERYL H.
*Reform Judaism in America: A Study in Religious Adaptation.* New York: Bloch, 1933.

PHILIPSON, DAVID.
*The Reform Movement in Judaism.* Rev. ed. New York: Macmillan, 1931.

RIVKIN, ELLIS.
*The Shaping of Jewish History: A Radical New Interpretation.* Lyceum Editions. New York: Scribner's, 1971.

SOBEL, RONALD B.
"A History of New York's Temple Emanu-El: The Second Half Century." Ph.D. diss., New York University, 1980.

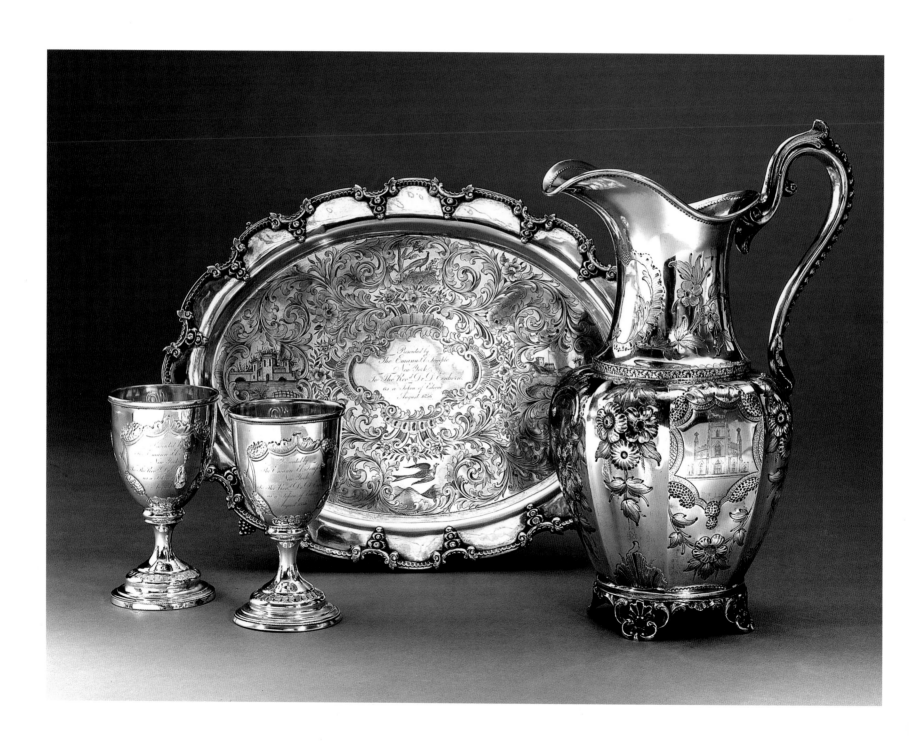

# The Collection

## *Early Patrons*

REVA GODLOVE KIRSCHBERG
Museum Director

Objects of Judaica made to enhance and enrich Jewish ceremonial life have been created over the years for the congregations Emanu-El (God is with us) and Beth-El (House of God), which merged in 1927, as well as for the two congregations, Anshe Chesed (Men of Mercy, formed in 1828) and Adas Jeshurun (Congregation of Israel, formed in 1866), whose amalgamation in 1874 formed Temple Beth-El. We are fortunate that the caretakers of the past have always had great regard for their Judaica objects, and they have come to us as part of our Congregation's history. In addition, objects that were in private collections and given as gifts to the Congregation, which were not necessarily used by Reform Jews, nonetheless incorporate a precious heritage to us all and provide a vivid sense of the collective history of the Jewish people.

For example, in 1856 Dr. David Einhorn, then rabbi of Har Sinai Congregation in Baltimore and later of Temple Beth-El in New York, was invited to lecture at the eleven-year-old Congregation Emanu-El. After his sermon, the Board of Trustees presented him with a resolution stating that he was "an able advocate of the true principles of Judaism" and also gave him a beautiful matched silver set consisting of a tray, pitcher, and two wine cups. The pitcher is engraved with a depiction of Temple Emanu-El on East Twelfth Street. After Dr. Einhorn's death the cups were separated from the pitcher and tray, but in 1956, one hundred years later, both cups were returned as gifts to the Congregation. The complete set (figure 9) is now in the Collection.

Some years later, in 1888, the Congregation honored Lewis May, its president of twenty-five years, and presented him with a magnificent silver vase commissioned from Tiffany & Co. This was decorated with an engraving of the Temple Emanu-El of its day at Fifth Avenue and Forty-third Street, as well as other Jewish motifs and a laudatory Hebrew inscription in relief (cat. no. 64). In 1931, Winston Lewis May, son of Lewis May, presented the vase to the Congregation, and it now is a gem of the Collection.

In 1890 a splendid gift presented to the Congregation by the great philanthropist and financier Jacob H. Schiff and his wife, Therese, on the occasion of the confirmation of their daughter, Frieda, contributes to our understanding of the elegance of the Temple's worship service. It is a set of Torah ornaments purchased from Posen Silberwaaren, a firm of silversmiths in Frankfurt on the Main and Berlin (frontispiece and cat. no. 4). The set was used on one of the Torah scrolls in the Ark of the Temple for many years. Eventually it became too fragile for use, and today is simply admired for its beauty and history.

All of these works were made as functional objects that were a part of the life of the community. The idea of a museum collection came much later in the history of the Congregation when, in 1928, Henry M. Toch, Trustee and Treasurer of Temple Emanu-El (figure 10), and his wife, Dora, offered a group of thirty ceremonial objects to be conserved in a "Musee Judicae" (*sic*) for the new synagogue then under construction. In his personal catalog (figure 11) Toch recorded that these objects had been owned by his family for more than eighty years, and that they were formerly used in a private synagogue in his father's home at 155 Forsyth Street, on New York's Lower East Side. This family synagogue was open for worship to the people of the neighborhood. Among the ceremonial objects Toch donated to the Congregation is a pair of Torah finials (cat. no. 19) made in Amsterdam in the early eighteenth century which bear the crests and monograms of the Da Fonseca and Mendez families.

The largest and most important gift of Judaica to Congregation Emanu-El was the bequest of the Honorable Irving Lehman, Judge of the New York State Court of Appeals, which was received in 1945. Judge Lehman collected Judaica over many years, listing each acquisition in a small notebook in which he set down details relating to some of the objects (figure 12). Among others, he mentions two Sabbath plates that had belonged to his mother and grandmother (cat. nos. 94 and 95); works from the Bezalel School of Arts and Crafts brought to him from Jerusalem by his father-in-law, Nathan Straus (cat. no. 29); and a silver Sabbath lamp bought at auction in an undifferentiated lot (cat.

Figure 9. Emanu-El Tray, Pitcher, and Goblets (cat. no. 60).

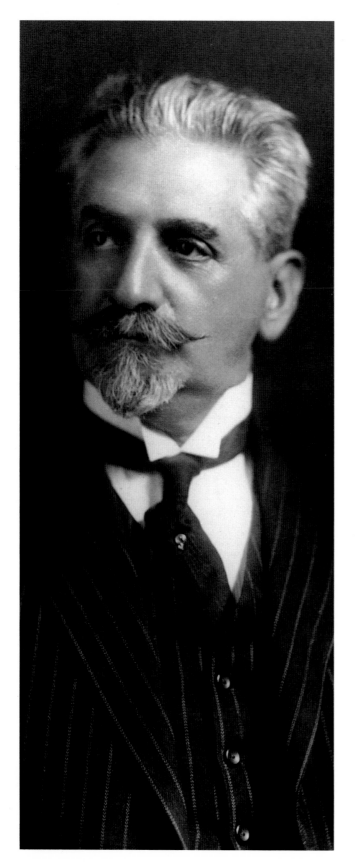

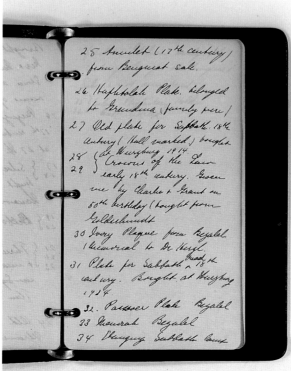

Figure 10. Henry M. Toch, 1922. Member of the Board of Trustees and the Building Committee of Temple Emanu-El at Fifth Avenue and Sixty-fifth Street.

Figure 11. Henry Toch's leather-covered loose-leaf notebook in which he recorded his Judaica collection and his family history.

Figure 12. Notebook in which Judge Irving Lehman listed the items in his collection, noting such personal indications as "belonged to Grandma" (number 26).

Figure 13. The Mayer Lehman family, Tarrytown, New York, circa 1888. *Reading from left to right, first row:* sons Herbert H. and Irving. *Second row:* daughter Hattie (Mrs. Philip J. Goodhart) with daughter, Helen [Mrs. Frank Altschul]; Mayer Lehman with grandson Howard L. Goodhart; wife, Babette Newgass Lehman, with grandson Allan Lehman; daughter Setti (Mrs. Morris Fatman) with daughter, Margaret [Mrs. Werner Josten]; son Arthur. *Back row:* son-in-law Philip J. Goodhart; daughter-in-law, Harriet (Mrs. Sigmund M. Lehman); son Sigmund M. Lehman; daughter Clara [Mrs. Richard Limburg]; son-in-law Morris Fatman. Photo courtesy Herbert H. Lehman Papers, Rare Book and Manuscript Library, Columbia University, New York.

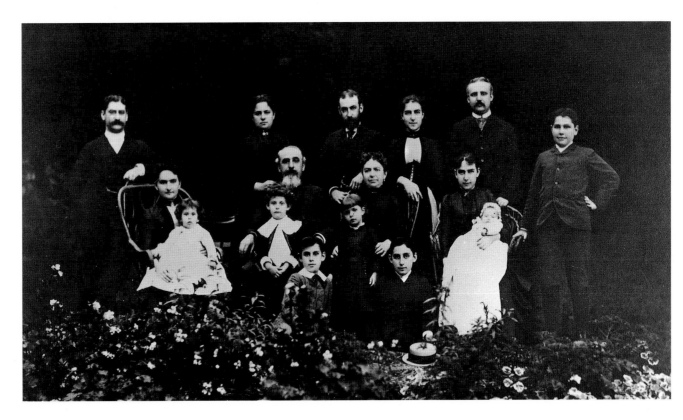

no. 86). In 1932, Judge Lehman had a more formal catalog of his collection prepared by Rabbi I. S. Meyer, who also translated the Hebrew inscriptions. The Lehman collection continued to be augmented by purchases and gifts he received, and by the time it was bequeathed to the Congregation it included one hundred and fifty pieces, among which were such famous objects as the Figdor Hanukkah lamp, which now, fifty-seven years later, is referred to as the Lehman/Figdor lamp (cat. no. 152). Extant Jewish medieval bronzes, such as this lamp, are extremely rare. That Congregation Emanu-El possesses such special objects is largely due to the vision of Irving Lehman (figure 13), who not only loved and enjoyed his Jewish heritage, but also bequeathed his cherished collection to this Congregation so that both his fellow congregants and fellow New Yorkers might share his vision.

Over the years there have been many other gifts from generous members of Congregation Emanu-El and from other friends noted in the catalog. The collection now numbers over four hundred objects and it continues to grow. It includes unique objects, precious objects and more humble ones, all infused with a value of their own as examples of ritual objects, household objects, and memorabilia. Each incorporates a component of Jewish history.

References

CONGREGATION EMANU-EL.
Trustees Minutes, August 3, 1856.

LEHMAN, IRVING.
List of one hundred eleven objects. Circa 1928.

MEYER, RABBI I. S.
"Catalogue of the Jewish Art Objects in the Collection of Judge Irving Lehman." April 18, 1932.

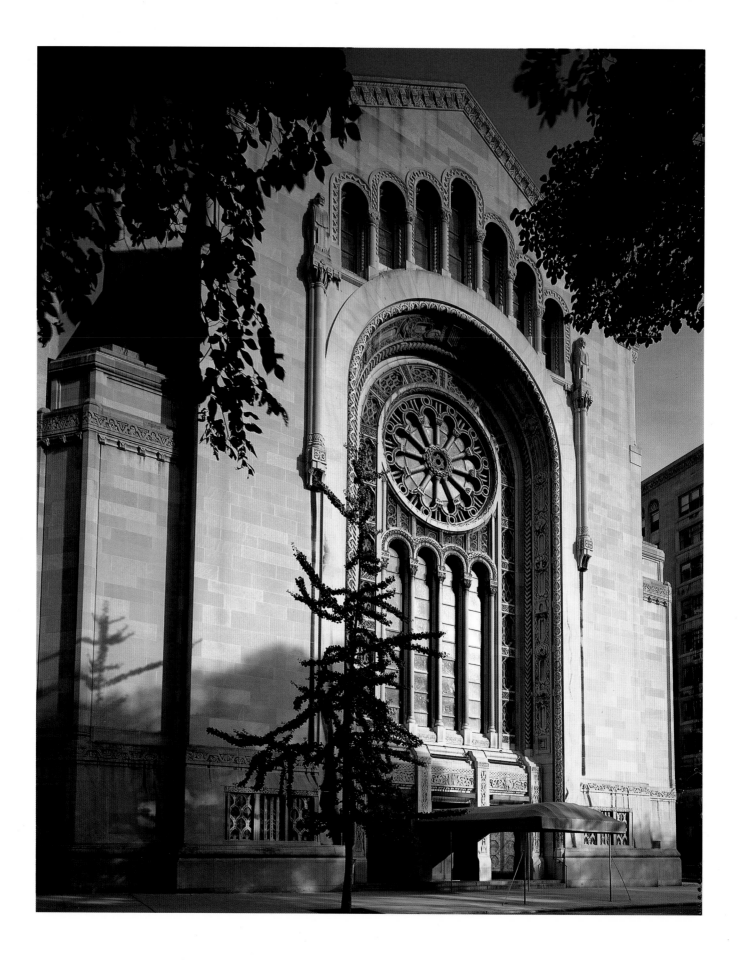

# Temple Emanu-El

## *The Building*

CISSY GROSSMAN
Consulting Curator

Temple Emanu-El stands on the northeast corner of Fifth Avenue and Sixty-fifth Street, its impressive smooth limestone façade pierced by a great archway, sunlight seeking out its exotic carving, its setbacks, its great, round stained-glass window (figure 14). One perceives the building in terms of grandeur, of complexity of ornamentation disciplined by an overall simplicity of form. Completed in 1929, it speaks of the historicity of style: the terms Romanesque, Byzantine, Moorish, Gothic have all been used to describe its architectural character. While it is true that architectural styles of the past were appropriated in the nineteenth century, as in the periods known as the Greek or Gothic Revival, none were used without meaning. In the case of Temple Emanu-El, the stylistic elements were most carefully chosen. They resonate with remembrances of the history of the Jewish people; of their ancient synagogues in the Galilee; of synagogues in Islamic and Christian Spain; of the great twelfth- and thirteenth-century synagogues in Worms and in Prague, which were still in use at the time Temple Emanu-El was designed. To make the allusions quite clear, small stained-glass windows within the Sanctuary depict these architectural forerunners, as well as the earlier synagogue built by the Congregation on Fifth Avenue and Forty-third Street.

But while it remembers its past, the complex of buildings speaks directly of its own time, of its architects, its designers, and its artisans, and most of all, it speaks of its patrons: their ritual requirements; whom they chose as architects; their notions of beauty; their specific spatial needs; their sense of kehillah (community); their perception of self and the image they wished to project—all are germane to the building of a Jewish house of worship. And it is not only the desires of the builders but also the receptivity of the larger community to the physical presence of the synagogue that limits, tolerates, or encourages the creation of such a building.

The Board of Trustees that met in 1925 and 1926 to plan the new structure had Louis Marshall as its president. Marshall was a constitutional and corporate lawyer and a prodigious civic leader. He was active in labor issues and reform legislation concerned with human rights. He was president of the American Jewish Committee, chairman of the Board of the Jewish Theological Seminary of America (which educates rabbis for the Conservative movement), and director of the Educational Alliance, whose mission it was to assist the thousands of East European Jews who arrived in New York as destitute refugees.

Marshall's fellow trustees at Emanu-El included Daniel Guggenheim, industrialist and philanthropist who advanced the study of aeronautics; Irving Lehman, Judge of the New York State Court of Appeals; Adolf S. Ochs, president and publisher of the *New York Times*; and Samuel M. Newburger, investment banker. In the report of the Building Committee to a special meeting of the Board of Trustees on February 7, 1926, the mandate of the Committee, and the process of finding an architect for the proposed building, was clearly spelled out: "This investigation was confined...to the Jewish architects of the City of New York, it being the wish of your Committee, if possible, to employ none but Jewish architects in the designing of the Temple." Fifteen architects and their firms are listed, each of which is discussed in detail with regard to their experience in designing religious buildings. The firm of Arnold W. Brunner Associates receives high praise. But Brunner himself, who had designed Temple Beth-El at Fifth Avenue and Seventy-sixth Street in 1891 (figure 7) and Shearith Israel, the Spanish and Portuguese Synagogue on Central Park West and Seventieth Street in 1897, had died in 1925.

The Committee also believed that "it would be a great mistake to go outside the City of New York to select an associate architect...because a local architect of proper standing is very much more familiar with the general character of this city's architecture than an outside architect could possibly be." The Committee's final recommendation was the firm of Robert D. Kohn, Charles Butler, and Clarence S. Stein, with Bertram G. Goodhue Associates as their consultants (who were later replaced by Francis L. Mayers, Oscar H. Murray,

Figure 14. Façade of Temple Emanu-El, Fifth Avenue and Sixty-fifth Street, 1929. Robert D. Kohn, Charles Butler, and Clarence S. Stein, architects.

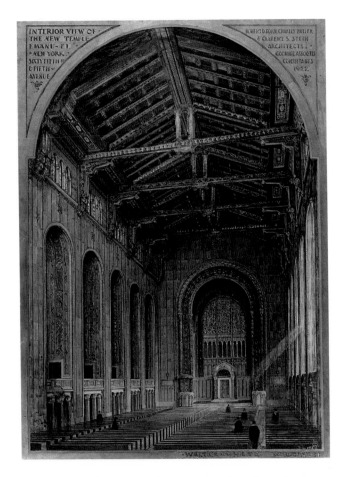

Figure 15. Walter K. Hase. "Interior View of the New Temple Emanu-El New York Sixty-fifth St. & Fifth Avenue. Robert D. Kohn, Charles Butler & Clarence S. Stein Architects. Goodhue Associates Consultants 1927." Tempera on paper, 22½ x 16¼ in. Collection Congregation Emanu-El, Gift of Mr. and Mrs. David E. Marrus. Study for the interior, subsequently changed.

and Hardie Phillip). At the time the Goodhue firm was design consultant for the Church of the Heavenly Rest at Ninety-second Street and Fifth Avenue, and earlier Goodhue himself had designed Saint Bartholomew's Church at Park Avenue and Fiftieth Street.

The Board had wanted a Jewish architect who would be empathic to the spiritual needs of their Jewish community, and they achieved this in their choice of Clarence Stein. They also needed the architectural expertise that could successfully create unobstructed seating for over two thousand persons within a modern religious edifice that would be an adornment for the city. In the Goodhue firm they had that expertise. The Building Committee's conclusion was that it had "endeavored to select the very best that could be had irrespective of faith."

The Temple sits squarely on its site, fitting in and coordinating with the wall of apartment houses on upper Fifth Avenue. The smaller building, named the Beth-El Chapel for the congregation that had merged with Emanu-El in 1927, is set back from the façade of the Temple to create a harmonious transition to the adjacent apartment house. The majestic vertical plane of the façade is deeply indented by the great Romanesque arch and pierced by seven narrow, arched windows framed by Art Deco guardian lions that sit atop elongated engaged columns. Light and shadow play within the recesses and on the carved decorations, the ornamental circular window, and the three decorated bronze entrance doors. The ornamentation is contained within these elements, providing a modern contrast with the smooth unadorned stone walls. The two low stair-towers that flank the central vertical mass provide a balance that visually contains the structure and prevents the sheer sides from soaring unrestrained from the street.

The Sanctuary rises behind the gabled façade and continues along Sixty-fifth Street as a procession of small high buttresses concealing the structural steel beams that create the great open vaulted space within. The Community House makes its presence felt with a tower that echoes the inset windows of the façade and marks the back of the Sanctuary.

The entrance to the great Sanctuary is on Fifth Avenue. A wide stone vestibule with low wood-paneled ceiling is fitted with angular Art Deco fixtures whose subdued light provides a transition from the daylight. On the walls are cast bronze plaques bearing the names of congregants who fought and died for their country. It is in this vestibule that one first perceives the consummate craftsmanship that subtly imparts a sense of warmth and richness to the whole complex of buildings. The details of ceiling molding, the small metal flowerlike ornaments set at the stone joints in the walls, the matched marble floors are all expressions of the close relationship of architect to artisan. The geome-

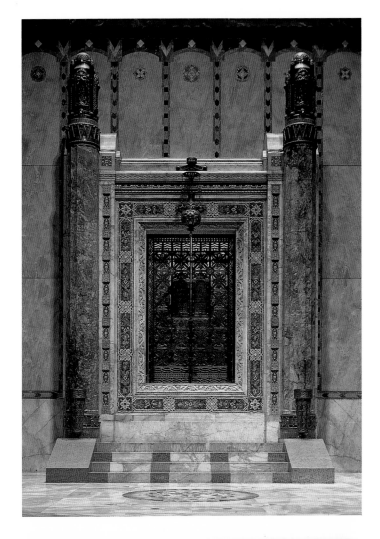

Figure 16. Portion of the eastern wall of the Sanctuary, with the Ark on the bimah. Interior of Temple Emanu-El, Fifth Avenue and Sixty-fifth Street, 1929. Robert D. Kohn, Charles Butler, and Clarence S. Stein, architects.

Figure 17. Mosaic work on the bimah. Designed by Hildreth Meiere, executed by the Ravenna Mosaic Company, Berlin.

try of the architectural elements create the Art Deco atmosphere of the vestibule. There has been careful concern throughout the complex to create decorative programs in glass, bronze, and tile replete with Biblical and Talmudic symbolism.

One is never fully prepared for the great volume of open unobstructed space of the Sanctuary, the focus of which is the wall of the sacred Ark set within a great arch that echoes the arch of the entrance (figure 15). The richness of colored light flowing from the stained-glass windows on three sides, the soft tonality of the acoustic tile walls, the high light from the simulated timbered roof, the sparkling color and gold reflected off the variegated mosaic tiles around the arch combine to fill the huge volume with majesty and wonder. This is the largest Jewish house of worship in the world. Over twenty-five hundred people can be seated with comfort in the Sanctuary.

The rectangular Ark with its bronze doors is flanked by tall fluted marble columns crowned by great abstract, Jugendstil finials. Decorative colored-tile ornament and bands of carving (figure 16) frame the Ark, much like the carpet page of a medieval Hebrew manuscript. The Ark itself (figure 16), set into the back wall of the bimah—the raised reader's platform—is, in the tradition of the Ashkenazic synagogue, located on its eastern wall, made possible and comfortable by both the shape of the site and the location of the entrance on Fifth Avenue.

The Ark, choir loft, and organ screen are set within the great arch that fills the whole eastern wall. The frame of the arch is articulated by alternate round and flat molding covered with mosaics of gold and colored-glass (figure 17). The gold and the vibrant color are not so much references to Byzantine church decoration as they are to the palette of the Viennese painter Gustave Klimt. The richly decorative arts-and-crafts designs of the architects of the Vienna Secession were known and appreciated by many of the well-traveled congregants with Austro-Germanic roots.

The sides of the Sanctuary are opened with five massive, recessed arches lit by colored-glass windows

and set with low balconies. The huge, round stained-glass window of the facade which rises above the vestibule associates Temple Emanu-El with the great medieval Gothic cathedrals. Emanu-El is not the first synagogue to use stained glass in its Sanctuary, and yet it is this circular window and the profusion of colored glass that possibly suggest a "churchlike" atmosphere to some visitors.

Many Ashkenazic synagogues, even those built in early-nineteenth-century America, such as the Lloyd Street Synagogue of 1845 in Baltimore, employed stained-glass windows. These not only provided privacy from the street, but also created an ethereal colored light that is most sympathetic to a house of worship. Berlin's Reform Oranienburgerstrasse Temple, completed in 1866 (and at that time the largest synagogue in the world), also used colored glass in its windows; it was no doubt known and admired by many Emanu-El congregants.

One might note here that while the form of the rose window is best known from its grandeur in European medieval cathedrals, the motif itself also has Jewish origins. The spokes in the wheel-like rose window at Emanu-El relate to the form of the Zodiac circle in mosaic synagogue pavements discovered in the Holy Land, which date from the fourth to the sixth century of the Common Era. The depictions of the Twelve Tribes in Emanu-El's windows make that didactic connection as well, since the twelve months of the Zodiac and the Twelve Tribes are often a numerically interchangeable symbol. The six-pointed star at the center of the round window at Temple Emanu-El also relates to early maps, which rendered the world as a flat circle with Jerusalem at its center.

Although Emanu-El's colored windows and immense inner space have been compared to the medieval cathedral, the essential space is totally dissimilar. The planners were clear in this notion. Just as the Jews of Prague six hundred years ago built the Altneuschul in the prevailing Gothic style in order to achieve great inner height, but carefully placed an additional rib in the vaulting in order to avoid any appearance of a cross

on the ceilings of the bays, so were the planners of Temple Emanu-El determined to avoid a cruciform groundplan. The interior space is clearly a rectangle. The former building at Fifth Avenue and Forty-third Street, completed in 1868, had been a Moorish-inspired fantasy, designed by Leopold Eidlitz and Henry Fernbach (figure 6). There were many problems with that building. The transept, the lateral arms of a cruciform plan, intended to provide more space before the bimah had been criticized as inappropriate to a synagogue (figure 18). In addition, the sight lines were not all good, and the acoustics were impossible.

As they built the new building, the architects learned from the mistakes of the past, but they also saved what was beautiful. The smaller and very lovely Beth-El Chapel that adjoins the main Sanctuary incorporates above its Ark the delicate stained-glass Tiffany window that was salvaged from the earlier Temple at Forty-third Street.

It is when filled with congregants that the Sanctuary is most inspiring. Men, women, and children seated together experience their wholeness as a great body of worshipers. In a moment of liturgical exaltation the great Ark is opened to reveal the Torah scrolls covered with fabric mantles and topped by large handsome crowns. The Torah is carried to the reader's desk, the scroll opened, and the Scriptural lesson read. The sermon follows the Torah reading. Throughout the worship service the great organ fills the space with sacred music as the cantor and choir sing out and chant the liturgy. The congregation responds with contemporary translation of ancient Hebrew prayer.

A synagogue has three names in Hebrew: *bet ha-tefillah* (House of Prayer); *bet ha-midrash* (House of Study); *bet ha-knesset* (House of Assembly). These designations define synagogue functions. Thus the adjoining Community House that forms the eastern boundary of the building provides space for the activities that have traditionally been essential to a Jewish community. Classrooms, rabbinic study rooms, a library, music rooms, meeting rooms, plus the office space that a modern institution requires to make it work

Figure 18. Interior of Temple Emanu-El, Fifth Avenue and Forty-third Street, 1868. Leopold Eidlitz and Henry Fernbach, architects (Demolished 1927.) Engraving in *Harper's Weekly* of November 14, 1868, accompanying a report of the dedication of the Temple on September 11.

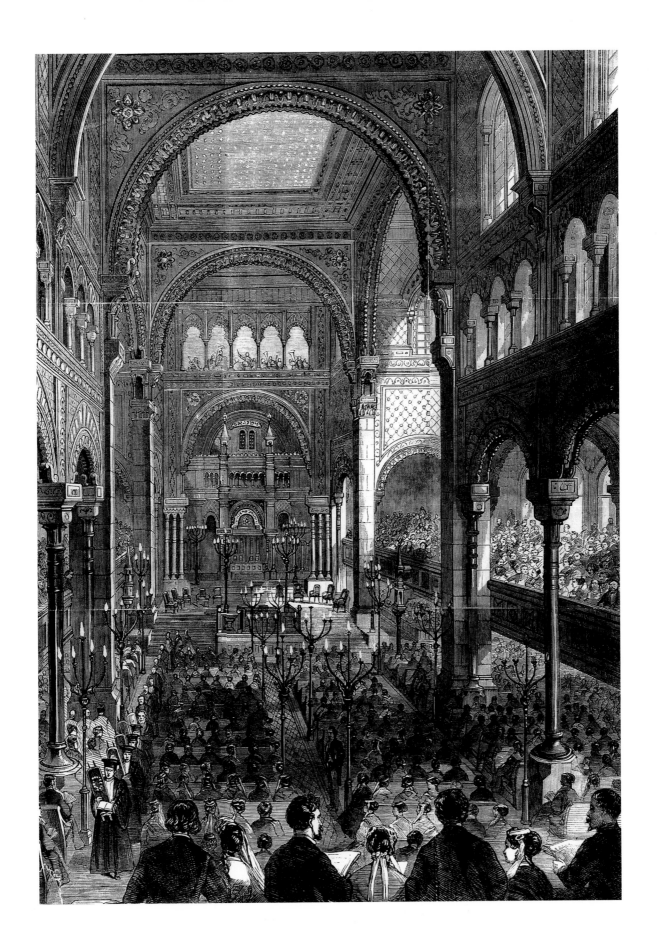

are located here. Since 1964 the complex also includes the Goldsmith Religious School Building, which fronts on East Sixty-sixth Street and joins the Community House on the inside. It provides an additional large Auditorium/Sanctuary, a brightly lit nursery school, and many more classrooms for religious instruction.

In Europe before the modern period, constraints were placed on the building of synagogues. They had to be erected in the Jewish section of town; sometimes they were required to be on the edge of the town to serve as a fortress in time of invasion. Synagogues could only attain a prescribed height; oftentimes they were hidden behind other buildings so as not to invite destruction or desecration. Not so in this Golden Land. This great Reform Jewish community, with confidence in itself and its neighbors, was able and felt empowered to build a great synagogue building. Its contemporary style, which is clearly a restrained and formal Art Deco design, utilized the latest steel construction of its day to achieve a strong, dignified, and majestic house of worship. It shares its importance to the larger Jewish community with other great synagogues of the city: Central Synagogue designed by Fernbach in 1872; Shearith Israel designed by Brunner in 1897; and Park Avenue Synagogue, of 1926, with Deutsch and Schneider as architects. Emanu-El also shares in fellowship with Saint Patrick's, the great Catholic cathedral designed by James Renwick; Saint Bartholomew's by Goodhue; and the Cathedral of Saint John the Divine whose original structure was designed by Heins & LaFarge and revised by Ralph Adams Cram. Temple Emanu-El is what its planners hoped it would be, a living monument to faith in God and to faith in American democracy.

References

BUTLER, CHARLES.
"The Temple Emanu-El, New York," *Architectural Forum*, vol. 52, no. 2 (February 1930), pp. 150–54.

CONGREGATION EMANU-EL.
Trustees Minutes, February 1, 1926–December 15, 1930.

KRINSKY, CAROL HERSELLE.
*Synagogues of Europe: Architecture, History, Meaning.* An Architectural History Foundation Book. Cambridge: MIT Press, 1985.

*The Universal Jewish Encyclopedia.* 10 vols. New York: 1939–43.

*Who's Who in American Jewry, 1928.* 2d ed. New York: Jewish Biographical Bureau, 1928.

WISCHNITZER, RACHEL.
*Synagogue Architecture in the United States: History and Interpretation.* Philadelphia: Jewish Publication Society of America, 5716–1955.

# The Collection

# Objects Used in the Sacred Service

A lampstand hammered of pure gold; fine linens in blue, purple, and scarlet; furnishings carved of acacia wood overlaid with pure gold and set with precious stones—all are set out in the biblical descriptions of the ornaments of the tabernacle (Exod. 25–28). Songs of rhythm and imaginative splendor sung to the strumming of a harp, tinkling bells on the garments of the priests, and aromatic burning incense heightened the aura of the worship service in the ancient Temple of Jerusalem.

When the Temple and the holy city of Jerusalem were leveled by the Romans in the year 70 of the Common Era the national and political base of the Jews was destroyed. The form of ritual was recast, but Judaism retained its spiritual and ethical beliefs. Instead of Temple pilgrimages and worship through priestly intermediaries, Jews now worshiped anywhere in the world in groups of at least ten persons with one among them as leader. Prayer and hope for redemption replaced animal sacrifice and service in the Temple. The synagogue service symbolically continues the Temple ritual and alludes to Jerusalem and the Holy Temple. Today the prayer service remains a feast of the senses, creating an atmosphere of beauty and exaltation in which a congregation finds in the liturgy and ritual a means to approach God.

The objects that cover, decorate, and store the Torah scroll all participate symbolically or metaphorically in the development of the liturgy and in the history of the Jews in the Holy Land and in the Diaspora. They establish existential continuity between past and present.

The Torah (Pentateuch) is composed of the first five books of the Bible. The Torah scroll read in the synagogue by the congregation's leader is handwritten in Hebrew on kosher animal skin by a devout scribe using special ink. The vellum or parchment sections are sewn together and rolled on two wooden staves called *atzei hayyim* (Trees of Life); the ornaments placed atop them are called *rimmonim* (pomegranates), the fruit of the Tree of Life.

The person reading the Torah to the congregation from the reader's desk uses a pointer, a yad (hand), to follow the text. One does not put one's finger on the Holy Writ. When not in use, the Torah scroll may be placed in its own box *(tik)* or covered with a fabric mantle, embellished with finials or crown, hung with ornamental shield and pointer, and placed in the Holy Ark *(aron kodesh)*, a decorated cabinet usually on the eastern wall of the synagogue. The name "Holy Ark" refers to the ark described in the Bible in which the Ten Commandments were carried in the desert and later enshrined in Solomon's Temple (1 Kings 6:14–19). The curtain *(parokhet)* that hangs either before or inside the synagogue ark refers to the veil that shielded the biblical ark.

The religious act (mitzvah) of beautifying Jewish worship is demonstrated by the two-thousand-year-old practice of building beautiful houses of worship. The visual evidence on mosaic floors found in the ruins of synagogues dating from the second to the sixth century of the Common Era, and the actual ruins themselves, indicate that ancient synagogue buildings had elaborately designed mosaic floors, splendid arks for the Law, fine curtains that hung before the arks, decorated screens, and painted walls.

The endurance of Jewish iconography, largely bibilical in origin, is evidence of the abiding self-awareness of Jewish communities, which sought to maintain a Jewish way of life within diverse ethnic and religious environments. Jewish motifs often relate objects to the ancient Temple by such visual references as the architecture of the Temple façade, the seven-branched lampstand, freestanding columns (which stood at the entrance to the Temple), the Ten Commandments inscribed on two tablets, guardian animals and birds, and the Lion of Judah. Crowns are a favorite motif. They represent the authority of Jewish law and symbolize the "royalty" of the Holy Writ, the writings that recall the Kingdom of Israel. It is this "kingship" of the law

that allows Jews to experience themselves as a holy people in whatever community they may live.

Jerusalem continues as a central symbol although its meaning and signification change over the centuries in response to the Jewish historical experience. After the destruction of the city by the Romans, there was hope that Jerusalem would emerge again as the capital of a Jewish nation. Over time two ideas prevailed, the reality of Jerusalem as a pilgrimage city and the belief in a spiritual or mystical Jerusalem that would be rebuilt in a messianic time. In the modern period the reestablishment of the State of Israel, the rebuilding of the old city, even the archaeological efforts to rediscover its material past, exist side-by-side with the sense of a mystical Jerusalem.

The style and technique of an object is, like all art, indigenous to its time and place. Carved and painted wooden arks, wooden Torah pointers, dreidels (toy tops used during Hanukkah) were carved and painted by local folk artists in small European towns where the forests were plentiful but wealth was not. In the spirit of the golden vessels fashioned for the Temple, the preferred materials for Torah ornaments have been gold and silver. Polish artisans created handsome brass objects that were lovingly polished to a golden hue. Pewter, once a much cherished material for functional objects, has been used for pitchers, lavers, and water tanks for handwashing. Pewter plates, made only by Christian guild members in large cities, were purchased as blanks, then decorated and personalized in the towns by Jewish artisans who often used book illustrations as models.

Silversmithing in Europe was also largely controlled by Christian guilds, and in Germany well-to-do Jewish clients ordered their Torah ornaments from great Christian workshops. There were, however, Jewish silversmiths in Italy and in Eastern Europe. Objects of great quality and originality of design bearing no official marks are the products of East European Jewish silversmiths who had no legal status. Ceramic ritual objects were also made. In the Middle East and North Africa, Jews made jewelry, as well as silver and gold ritual objects. In Yemen, Jewish silversmiths were famous for their fine filigree work. In America, ritual silver has a long history that begins with Dutch, British, and Colonial silversmithing. Through the ages, Jews were also involved in the weaving and printing of cloth and its decoration. In modern Israel the revival of all handcrafts began in the late nineteenth century and they flourish today.

Congregation Emanu-El continues the age-old tradition of supporting an uplifting environment for religious worship and the gathering of its community. It continues the tradition of creating objects for the beautificiation of its worship service. It has dedicated itself to conserving and preserving objects from its own history and from Jewish communities that were destroyed or dislocated. We approach them with renewed wonder and respect.

1

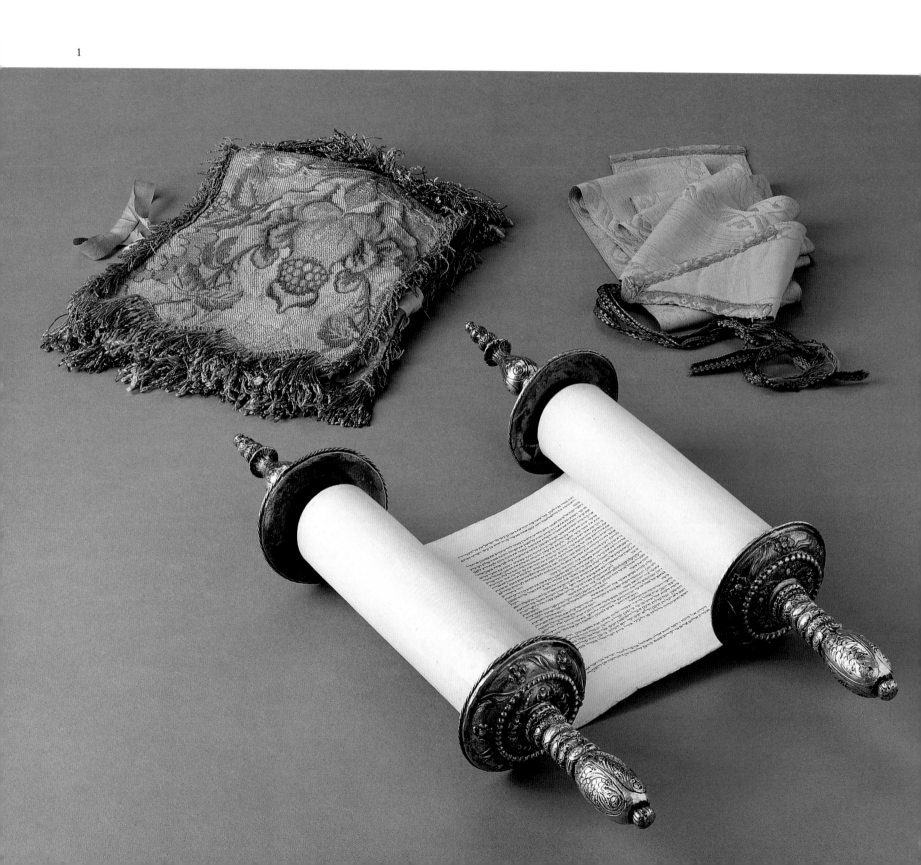

# 1

## Miniature Torah Scroll with Silk Brocade Mantle and Ribbon Binder

**Scroll**
Italy, probably 18th century
Vellum; handwritten
Height 6⅜ in. (16.2 cm)
Text columns 4¾ x 2¾ in. (12.1 x 7 cm), 42 lines each
HANDLES AND FINIALS
Cast silver, traces of gilding
Height 14½ in. (36.5 cm)

**Mantle (*Me'il*)**
Italy, about 1700
Silk, weave patterned
9½ x 6½ in. (24.2 x 16.5 cm)

Two panels with scalloped bottom, of weave-patterned silk brocaded with silk threads of green, apricot, rose, and citron yellow and threads wrapped in silver and gilded silver. Edged on all sides with gilded-silver fringe; lining of undyed silk. Bound all around and tied at sides with citron-yellow ribbons. One ribbon is a replacement.

**Binder (*Mappah*)**
France or Italy, probably 18th century
Silk ribbon
Length 45⅛ in. (114.7 cm), width 3¼ in. (8.4 cm)

Pink (faded) and undyed silk with edge in reverse-weave pattern; in center, faint remnant of floral print. Pink-and-brown ribbon tie.

Such a small handwritten scroll, which includes the first five books of the Bible (the Pentateuch), might be used at home and during travels, or it might simply be an object of beauty displayed in the home. This set was purchased by Judge Irving Lehman in New York, who noted in 1932, "I bought this scroll from Goldschmidt who acquired it from Siegfried Wagner who in turn received it from Richard Wagner. At least so runs the tale."

The precious silk remnant used in the mantle has a central figure pattern of a pomegranate with its seeds, which made it an apt choice for the design of a Torah cover since the multiseeded fruit is a common meta-phor for the wisdom of the Torah. The color combination reveals an Italian preference, as well as appreciation, for fine brocaded fabrics seen in other Italian silk mantles and binders (Grossman 1980).

Literature
Rabbi I. S. Meyer, "Catalogue of the Jewish Art Objects in the Collection of Judge Irving Lehman," 1932, cat. no. 20, marginal note; C. Grossman, *Days of Awe*, 1986.

BEQUEST OF JUDGE IRVING LEHMAN, 1945
(CEE 45–20A/B/C)

# 2

## Miniature Torah Scroll with Two Mantles

**Scroll**
Moravia (?), late 17th century
Vellum; handwritten
Height 4¹⁄₁₆ in. (10.2 cm)
Text columns 3½ x 2⅛ in. (9 x 5.3 cm), 42 lines each
HANDLES AND FINIALS
East European, probably Ukraine, late 19th century
Silver, embossed and engraved
Height 9¼ in. (23.5 cm)
MARK: *12*

**Mantle (*Me'il*)**
Probably Italy, 17/18th century
Silk net
5½ x 6⅛ in. (14 x 15.5 cm)

INSCRIBED
On lining
כ ת
C[rown of] T[orah]

Black silk net sewn into a cylinder, reembroidered with silk threads of salmon pink, green, turquoise blue, and citron yellow and silver-wrapped threads; bordered with silk and silver braid. White silk lining, embroidered with inscription and six-pointed star in citron-yellow silk thread. One-inch-wide green moiré silk ribbon sewn to top for hanging on scroll. The colors are faded and the silver is tarnished.

## Mantle (*Me'il*) and Matching Box

Probably Eastern Europe, 1885
MANTLE
Velvet
5⅜ x 5⅜ in. (13.3 x 13.3 cm)
Box
Wood, velvet covered; brass fittings
4¼ x 11⅞ x 6¾ in. (10.7 x 30.4 x 17.2 cm)

INSCRIBED
On front of mantle

כתר תורה / ת'ר'מ'ה' / כתר כהונה / כתר

Crown of Torah / [5]645 (1884/85) / Crown of priesthood /
Crown [of royalty]

Purple and green velvet sewn into a cylinder embroidered with gold-wrapped thread and gold sequins. Scalloped embroidered valance bordered by draped curtains frame embroidered Hebrew inscription embellished with images of Torah scroll with double staves, Oriental-style crown, and hands raised in blessing flanked by two wheels. Band of green velvet sewn to top for hanging on scroll. A large section of the lowest band of embroidery is lost.

In the view of Dr. Philip Miller, Librarian at the Klau Library, Hebrew Union College–Jewish Institute of Religion, New York, the miniature scroll appears to date from the late seventeenth century (verbal communication), which places it in the same time frame as the Italian silk net mantle. The late-nineteenth-century silver handles and finials, purple and green velvet mantle, and purple velvet box with brass fittings are all contributions of an owner who nevertheless preserved the original Italian cover. Both the earlier and later mantles are in the Ashkenazic style, which prefers simple, soft enclosures. This same owner may be responsible for replacing the original rollers, probably made of wood, with the present silver rollers.

The images of the crowns embroidered on the velvet mantle are taken from Pirke Avot (The Ethics of the Fathers) 4:13, where Rabbi Simon teaches, "There are three crowns: the crown of Torah, the crown of priesthood, and the crown of royalty; but the crown of a good name is the greatest of all." The two wheels flanking the hands are perhaps symbols of eternity, representing the crown of a good name. The method

and style of the gold embroidery of these motifs indicate that it is the work of a professional embroiderer.

Of the scroll and its mantles Judge Irving Lehman noted, "Brought back from Russia by Dr. Bogen [?] who purchased it from the leading rabbi of Ukraine. Said to have been in rabbi's family about 200 years."

Restored by the Textile Conservation Workshop, South Salem, New York, 1981.

Literature

Rabbi I. S. Meyer, "Catalogue of the Jewish Art Objects in the Collection of Judge Irving Lehman," 1932, cat. no. 21, marginal note.

BEQUEST OF JUDGE IRVING LEHMAN, 1945
(CEE 45–257A/B/C/D)

## 3

# Miniature Torah Scroll with Ornamented Top

Probably Italy, 18th century
Vellum; handwritten
Height 9⅛ in. (23.3 cm)
Text columns 7¼ x 2¾ in. (18.5 x 7 cm), 56 lines each
HANDLES AND FINIALS
Gilded silver, embossed, mounted on wood; appliquéd filigree, red stones
Height 15¾ in. (40 cm)

Wooden rollers with slim cylindrical handles terminate in a rounded silver support with wooden core. The rounded silver finials also over wood, appliquéd with filigree flower forms with red stones in centers. The small shafts at the top have lost their ornamentation.

The finials of this damaged but still elegant Torah scroll at one time probably had coral beads as an amuletic adornment atop the finials. The detail of a finial (cat. no. 3–A) reveals the luxury of the embellishment.

Such a small Torah was probably used in a private synagogue in a home. When not in use it would have been covered by a beautiful mantle and stored in a small ark or cabinet.

(CEE 29–51)

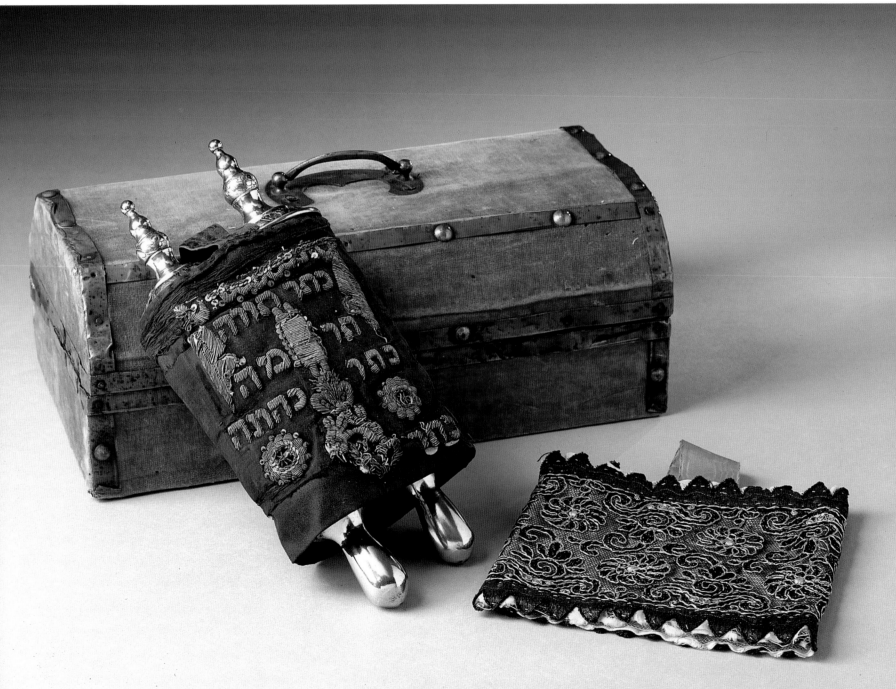

<u>4</u>

# Schiff Set of Torah Ornaments

SILVERSMITH: Posen
Frankfurt, 1890

### Torah Shield (*Tas*)
Gilded silver, embossed and chased; castings, enameling, lapis, semiprecious stones, niello
15¾ x 11⅜ in. (40 x 29 cm)
MARK: Date (Rosenberg, no. 3)
*Cover and frontispiece*

INSCRIBED
On arches

לוי

ראובן שמעון אשר יהודה דן
בנימין
נפתלי גד אפרים יששכר מנשה זבולון

Levi / Reuben Simeon Asher Judah Dan / Benjamin / Naphtali Gad Ephraim Issachar Manasseh Zebulun (Gen. 48, 49)

On lintel
כתר תורה
Crown of Torah
On Tablets of the Law

אנכי ה / לא יהי / לא תשא / זכור את / כבד את
לא תרצח / לא תנאף / לא תגנב / לא תענה / לא תחמד

I am the L[ord] (your God) / You shall have no (other gods beside Me) / You shall not swear (falsely) / Remember (the Sabbath) / Honor (your father and your mother)
You shall not murder / You shall not commit adultery / You shall not steal / You shall not bear (false witness) / You shall not covet (Exod. 20:2–14)

Coupled lapis columns support a trio of three-dimensional round arches lined with blue, white, and black enameling. Within the central arch, a three-dimensional crown set with rubies, lapis beads, and sapphires; centered on the rim a shield inscribed with "Levi"; frames of the two lower arches set with eleven shields, each bearing the name of the remaining tribes of Israel. Across the lintel beneath these arches, "Crown of Torah" enameled in Hebrew. Enameled panels below decorated with chased pomegranates and framed by trefoil arches in high relief. On a projecting stepped base, a cast eagle with an enameled American shield on its breast and engraved Tablets of the Law within its outstretched wings. Chased base decorated with a central medallion and enameled trefoils at each side; three bells suspended from each, festooned with chains. The shield has been repaired several times; some of the lapis is lost.

### Torah Finials (*Rimmonim*)
Gilded silver, embossed and chased; castings, lapis, semiprecious stones, enameling, niello
18 x 10½ in. (45.8 x 26.7 cm)
MARKS: Place and date (Rosenberg, nos. 3, 2071)

Columnar staves carry a platform with bells attached to the lower edges and rampant lions set in the corners above. In the center, a slender column supports a three-dimensional, belled ogee arch surmounted by a spire that displays a lion medallion. At each side double-domed towers terminate in spires ornamented with bells.

### Torah Pointer (Yad)
Gilded silver, embossed and chased; castings, lapis, ivory, enameling, niello
Length 12 in. (30.5 cm)

Double shaft ornamented with chased designs; two cutout bulbous forms, one in center and one as finial, reveal pieces of ivory within. Lower form decorated with twelve lapis stones in graduated sizes terminates with realistically rendered pointing hand topped by a green and white enameled cuff.

This magnificent set of ornaments for the Torah scroll was presented to Temple Emanu-El by Jacob H. and Therese Schiff in commemoration of the confirmation of their daughter, Frieda, on Shavuot, May 25, 1890. They were used originally in the Temple Emanu-El synagogue on Fifth Avenue and Forty-third Street, and subsequently in the present building on Fifth Avenue and Sixty-fifth Street. Schiff was an outstanding financier and philanthropist; his daughter continued the tradition of good works as the wife of Felix Warburg.

The architectural form of the heavy Torah shield, with its trio of arches and coupled columns, is a metaphor for the Temple. It seems probable that the enameled American shield was added to the piece to particularize it for its American purchasers. The rampant lions, bells, enameled ornaments, deeply chased and nielloed surfaces, and colored stones of the *rimmonim* add to the variety of texture and visual drama.

Repaired by Isaac Kheit & Associates, New York, 1984.

GIFT OF JACOB H. AND THERESE SCHIFF, 1890
(CEE 29–27/28/29)

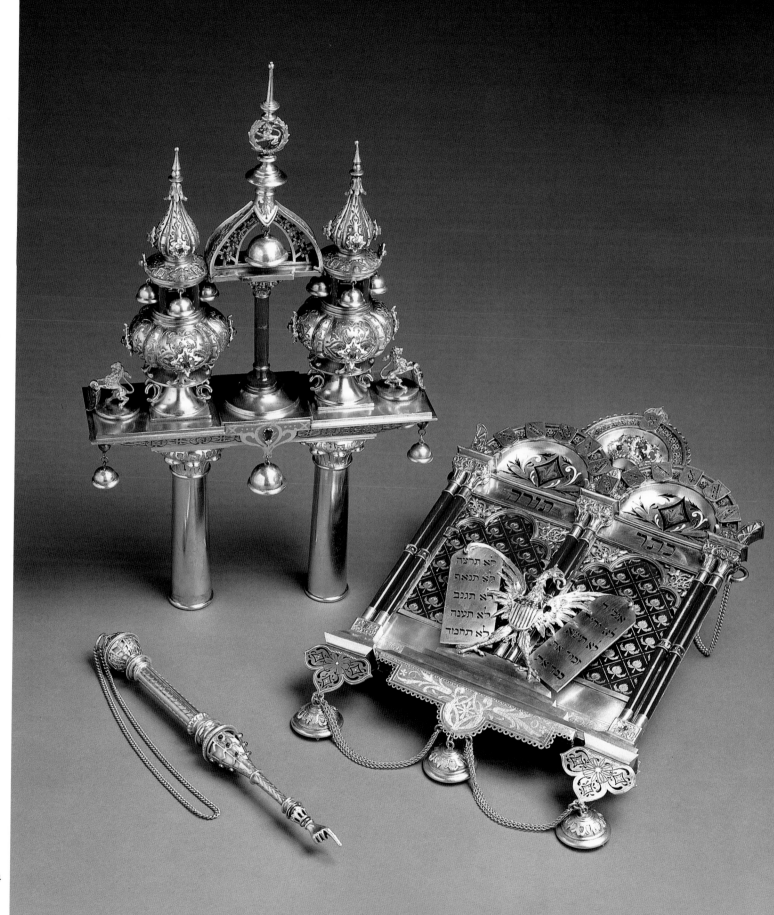

5

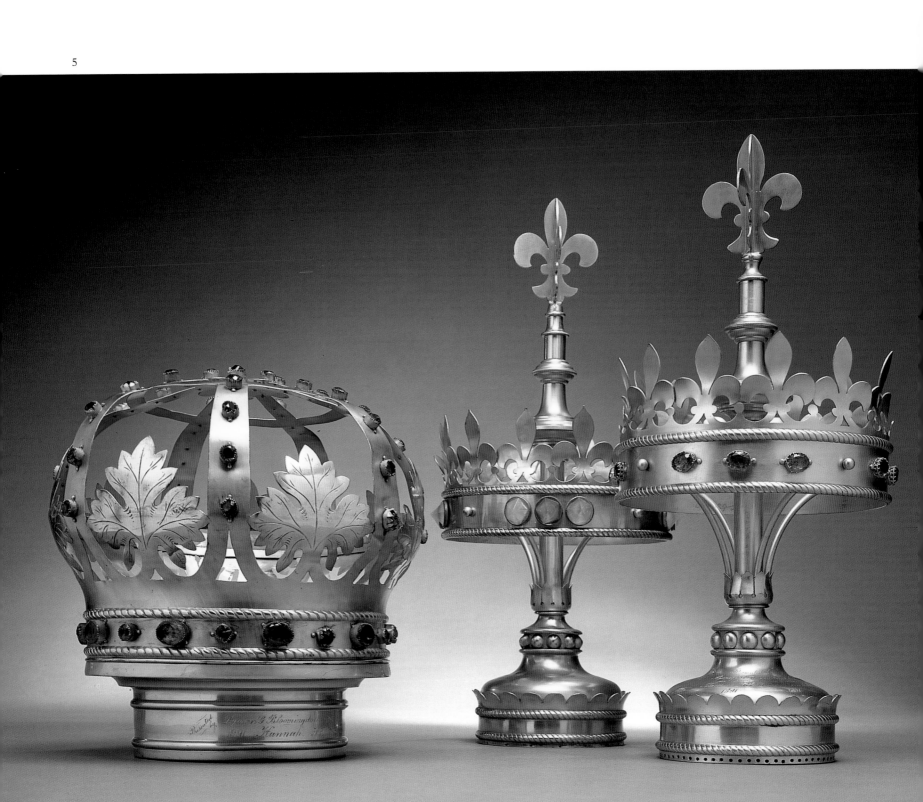

# 5

## Bloomingdale Torah Crowns

New York, 1891
Gilded brass; cutout work, appliqué, colored stones
Height 12 in. (30.5 cm), 21 in. (53.3 cm), 20½ in. (52 cm)

INSCRIBED
Round crown, on base
*Presented by Lyman G. Bloomingdale in memory of his*
*daughter Hannah 1891 5651*

Open crown, on base
*Presented by Lyman G. Bloomingdale in memory of his*
*Mother 1891 5651*

Open crown, on base
*Presented by Lyman G. Bloomingdale in memory of his*
*brother Samuel E. Bloomingdale 1891 5651*

Round crown (*keter*) decorated with variegated colored stones
and seven oak leaves which allude to the Torah as a Tree of Life.
The finial (probably matching the fleur-de-lis form of the open
crowns) is lost. One open crown (*attarah*) set with stones of
blue milk glass; the other, with purple and amber stones (one
purple stone is a replacement). Both decorated with fleur-de-
lis cutouts and finials of flat intersecting fleur-de-lis forms.

The crowns were presented to Temple Beth-El, which
merged with Emanu-El in 1927. The donor, Lyman G.
Bloomingdale, was a prominent New Yorker and art col-
lector, who served at one time as treasurer of Temple
Beth-El and also as treasurer of the Montefiore Hospi-
tal. Born in 1841 in New York, he began working with
his father as a traveling merchant in the western states.
At the outbreak of the Civil War he enlisted in the
Kansas Volunteers. After the war he worked with his
father in the hoopskirt business; in 1872, he opened
a drygoods store which developed into the present-day
Bloomingdale's. He owned important examples of
American paintings and was a Fellow in Perpetuity of
the Metropolitan Museum of Art.

The crowns are regularly used to decorate three
Torah scrolls in the Sanctuary of Temple Emanu-El.

References
"Bloomingdale, Lyman (Obituary)," *New York Times,* Oct. 14, 1905,
p. 9, col. 6; idem, *Universal Jewish Encyclopedia,* vol. 2, p. 414.

GIFT OF LYMAN G. BLOOMINGDALE, 1891
(CEE 29–53A/B/C)

# 6/7

## De Benedetti Set of Torah Ornaments

### 6

**Torah Shield (*Tas*)**
MASTER: Jacob Raffael Levi di Carmagnola
Asti, Italy, 1810
Silver, partial gilt, embossed and chased
11 x 8¾ in. (28 x 22.2 cm)
MARKS: Lozenge shape, wheel, and letters *IL* (*Ebrei a*
*Torino,* p. 140); Besançon silver marks (Rosenberg, nos.
5857, 5870B, 5871)

INSCRIBED
Front, medallion
כתר / תורה
Crown / of Torah

Front, upper rim
נדבת טודרוס לב״ב ביום הכנסנו למצות שנת ה'ת'ק'ע'
The presentation of Todros of the H[ouse of] B[aruch] on his
entrance into Commandments (the day of his becoming Bar
Mitzvah) in the year 5570 (1810)

Front verso
עטרה של אהרן חיים לב״ב שהגיעה לגורלו בחלקו עם אחיו
יהושע בועז
Crown of Aharon Ḥayim of the H[ouse of] B[aruch] which came
to his lot as his portion with his brother Joshua Boaz

Back
כתר / תורה
Crown / of Torah

Front section of three-part silver shield bears embossed oval
medallion with chased scale pattern and gilded applied inscrip-
tion. Embossed winglike sections on both sides with garlands
in high relief continue draped central flowered swags embel-
lishing open support of central crown. Rounded foliate crown
with Hebrew presentation inscription in relief supports gilded
Tablets of the Law that bear first words of the Ten Command-
ments. Above, a smaller three-dimensional crown with relief
decorations and foliate rim attached with screws. Top section
of shield has open ribbons, braid, leaves, and tassel ornamen-
tation. At the bottom, a small foliate border, flower in relief, and
bells hanging from scrolls. Small back section echoes front
medallion in form and chasing and carries same gilded Hebrew
inscription in relief in smaller size. Originally triple strands of
chain connected the three parts of the shield, and bells hung
only from the bottoms of the front medallion and back plaque.
Small side ornaments are lost; the piece has old repairs.

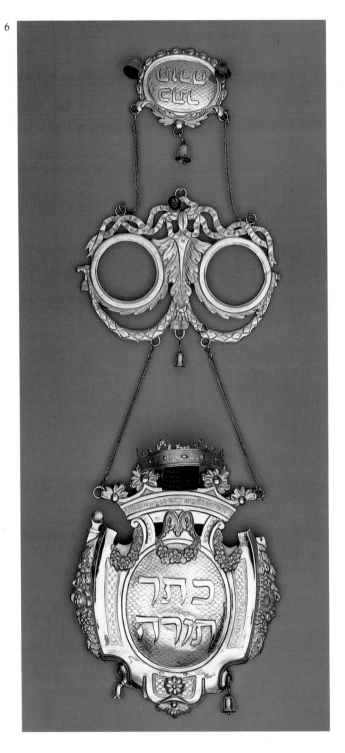

6

7

## 7
### Torah Crowns (*Ketarim/Attarot*)

MASTER: Pacifico (Shalom ?) Levi
Turin, Italy, 1835
Silver, partial gilt, embossed and chased
Height 8⅝ in. (22 cm), diameter of base 5 ½ in. (14 cm)
MARKS: Round with hand holding pitcher and hand hold-
ing laver, letters *PL* (Bargoni, L–61, pp. 160, 286); Turin
marks (Rosenberg, nos. 7471, 7476B)

INSCRIBED
Lower section of both crowns

נדבת אהרן חיים לב״ב / בר יצחק אשר / ביום הזכרון
הת״קצו

The presentation of Aharon Ḥayim of the H[ouse of] B[aruch] /
son of Isaac Asher / on the Day of Remembrance 5596 (Rosh
Hashanah, 1835)

Tall open crowns (*attarot*) with embossed inscriptions on base
framed by twisted cord with intersecting arches above. Six car-
touches on a diapered ground interspersed with scrolling
leaves, braids, and tassels; upper edges conform to the scroll
and leaf pattern. Gilded castings affixed to the cartouches by
screws are motifs relating to worship in the Temple: hands of
blessing, flower-filled urn, pitcher and laver, Tablets of the Law,
headdress of the priest, robe of the priest, altar with wings, altar
with fire, seven-branched lampstand, table of showbread, hang-
ing lamp, covered urn.

This three-part shield and pair of crowns made twenty-
five years apart are joined by their inscriptions. Both
were gifts to a synagogue in Asti from Aharon Ḥayim
(Vitale?) De Benedetti. The embossed inscription on
the upper rim of the front of the shield indicates that
it was originally commissioned for Todros De Benedetti
in 1810. On the reverse the name of Aharon Ḥayim of
the House of Baruch (De Benedetti) is engraved as the
new donor, with the information that the piece was
inherited by him and his brother. Shalom Sabar's sug-
gestion that *lamed bet bet* is an abbreviation for the
House of Baruch or the De Benedetti, a family well
known in the Piedmont area, is confirmed by a pho-
tograph of the De Benedetti of Asti (*Ebrei a Torino*, p.
39), as well as a note in the same publication (p. 140)
indicating that the silversmith Jacob Raffael Levi di
Carmagnola worked in that city.

In 1835, the same Aharon Ḥayim commissioned

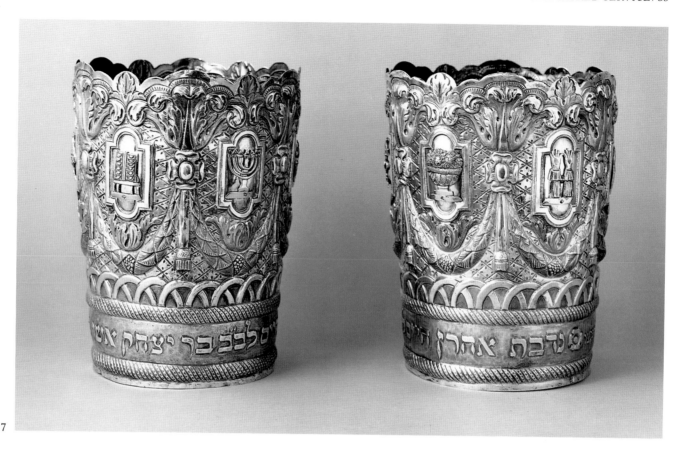

7

the pair of crowns (and no doubt finials as well, since such open crowns are accompanied by tall belled finials). From their original Lehman catalog numbers, it would appear that they were purchased by Judge Lehman sometime between 1928 and 1932.

The style of the three-part shield with its bold cutout baroque silhouette was apparently a Piedmontese invention. Another example, also dating from the first half of the nineteenth century, is in the collection of the Communità Israelitica of Turin (*Ebrei a Torino*, p. 142); an unpublished shield is in the Italian Jewish Museum in Jerusalem; and one is in the Musée Historique Lorrain, Nancy, France (Wigoder, p. 85, incorrectly cited as French). Later examples lose the open exuberance and become more compact in form. The style of tall crowns with embossed inscriptions on their lower borders also appears about this time; earlier Italian crowns generally are stockier and do not carry inscriptions. The decorative gilded castings depicting motifs relating to the worship in the Temple also appear on Italian finials.

When in use, the Torah shield would be put on over the mantle-covered Torah scroll with the top sec-tion placed over the staves. The large shield hanging from its chains would be seen on the front, and the small plaque would hang down the back. An open crown, or in this case double crowns, would be placed atop the mantle. Tall Torah finials (*rimmonim*) with bells on long chains were then placed on the wooden staves within the crowns.

Italian Torah scrolls were generally tall, the mantles made of vibrantly colored silk brocades often with silver and gold threads. A tall, richly dressed Torah, the bells of the *rimmonim* striking the crowns, carried, as was the Italian tradition, from the ark at one end of the synagogue to the reader's desk at the other, no doubt created a magnificent spectacle.

References

For similar shields, see *Ebrei a Torino*, 1984, pp. 128, 135, 141, 143; G. Wigoder, *Jewish Art and Civilization*, 1972, p. 85. For crowns by the same master, inscribed 1832, see *Ebrei a Torino*, p. 145, Communità Israelitica of Turin, inv. no. c30a/b. For similar crowns, see S. Kayser and G. Schoenberger, *Jewish Ceremonial Art*, 1955, cat. no. 36, pl. xx, and *Ebrei a Torino*, pp. 136, 137, 141.

BEQUEST OF JUDGE IRVING LEHMAN, 1945
(CEE 45–110) (CEE 45–103A/B)

# 8

# Beth-El Torah Ornaments

MASTER: I. Perlman
Warsaw, late 19th century
Silver, partial gilt; embossed, filigree, castings
MARKS: Master; city and date (Lileyko, p. 100);
*STERLING*

**Torah Shield (*Tas*)**
16 x 10½ in. (40.6 x 26.7 cm)

INSCRIBED
On Tablets of the Law

אנכי י"י׳ / לא יה / לא תשא / זכור / כבד
לא תרצח / לא תנאף / לא תגנב / לא תענה / לא תחמד

I am the Lord (your God) / You shall have no (other gods beside
Me) / You shall not swear (falsely) / Remember (the Sabbath) /
Honor (your father and your mother)
You shall not murder / You shall not commit adultery / You shall
not steal / You shall not bear (false witness) / You shall not covet
(Exod. 20:2–14)

On back
*PRESENTED BY THE WOMENS GUILD OF TEMPLE BETH EL
COMMEMORATING THE GOLDEN JUBILEE FEBRUARY 1924*

An elongated arch shape with a wide border of appliquéd fili-
gree elements with raised flower forms set with gilded
flowerettes. In the center, a raised filigree ark with a functional
door opening to reveal a gilded Torah scroll. On either side, fil-
igree columns sprout gilded flowers. Below, a filigree frame for
the interchangeable plaques (here indicating Yom Kippur).
Above the ark, Tablets of the Law tilted forward. Above the
Tablets, an openwork crown of filigree ribs encloses a gilded
bell; three gilded bells suspended from leaves surround the ribs.
At the top, a cast bird finial with outspread wings perches on
an inverted-bell shape amid flowers and leaves.

**Torah Finials (*Rimmonim*)**
Height 19 in. (48.3 cm), diameter of base 4 in. (10.2 cm)

INSCRIBED
*PRESENTED BY THE WOMENS GUILD OF TEMPLE BETH EL
COMMEMORATING THE GOLDEN JUBILEE FEBRUARY 1924*

Hexagonal finials with filigree elements of flowers, circlets, and
scrolling patterns on squat shafts with stepped bases. Double
globular shape of lower tier with gilded flowerettes and gilded
bells hung on cast brackets of scrolling animals. Uppermost tier
in form of a double crown set with gilded flowerettes. Finial
of gilded cast bird with outspread wings set on a small globe
atop a double layer of gilded leaves hung with gilded bells.

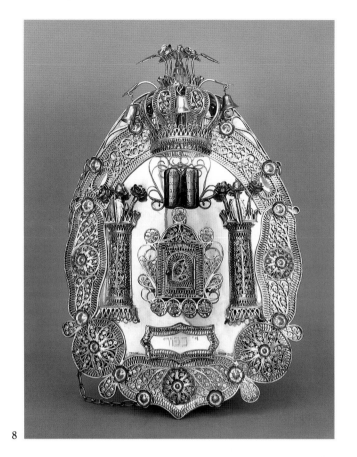

8

The ornate design of these pieces conveys the eclec-
tic air of a busy Jewish workshop in late-nineteenth-
century Warsaw, which no doubt had a clientele that
included hundreds of synagogues. Nevertheless, there
are elements that echo earlier Polish motifs created by
the finest Jewish craftsmen who made unmarked silver
objects before the era in which Jewish silversmiths in
Poland had legal status. The sturdy flowers and leaves
seen here sprouting from the columns and top of the
shield are found in more fragile versions of spice
containers, Torah crowns, and finials made in
eighteenth-century Poland (Kayser and Schoenberger,
cat. no. 23, and Grossman, cat. no. 47).

This set of ornaments became part of the collec-
tion in 1927, when Temple Beth-El and Congregation
Emanu-El merged. They have been used for many years
in the Leon Lowenstein Sanctuary during the High Holy
Days.

References

S. Kayser and G. Schoenberger, *Jewish Ceremonial Art*, 1955,
cat. no. 23; C. Grossman, *Fragments of Greatness Rediscovered*, 1981,
cat. no. 47.

GIFT OF THE WOMENS GUILD TO TEMPLE BETH-EL
(CEE 29–34A/B)

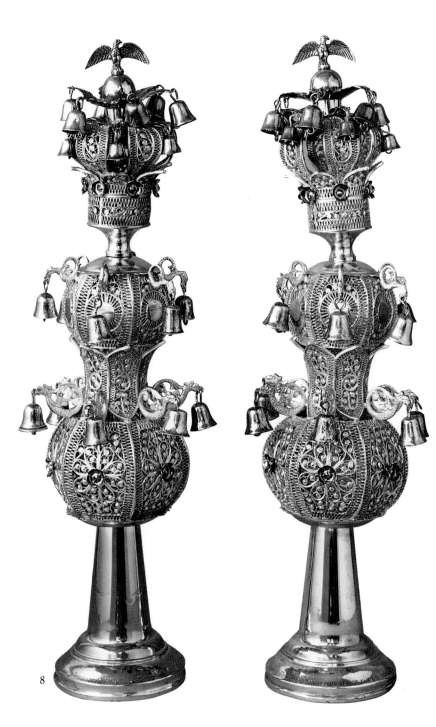

8

## 9

# Set of Torah Ornaments

Probably United States, mid 19th century
Silver, partial gilt; embossed, engraved, castings

**Torah Shield (*Tas*)**
16 x 11 in. (40.8 x 28 cm)

INSCRIBED
On Tablets of the Law

אנכי ה / לא יהי׳ / לא תשא / זכור את / כבד את

לא תרצח / לא תנאף / לא תגנב / לא תענה / לא תחמד

I am the L[ord] (your God) / You shall have no (other gods beside
Me) / You shall not swear (falsely) / Remember (the Sabbath) /
Honor (your father and your mother)
You shall not murder / You shall not commit adultery / You shall
not steal / You shall not bear (false witness) / You shall not covet
(Exod. 20:2–14)

On plaque

שייך להה״ק צבי בר משה הלוי מאזעס / ואשתו א״ח מ׳
מרים בת ר׳ שמואל גאלדמאן / משוויינסטהויפטען / וזאת
התו׳ר׳ה אשר שם משה׳ לפני ב׳ני ישרא׳ל

Belonging to the h[umble] Tzvi son of Moses ha-Levi Moses /
and his wife the w[oman of] v[alor] M[istress] Miriam daugh-
ter of R[eb] Shmuel Goldman / from Schweinsthauften / This
is the Torah which Moses placed before the Children of Israel
(Deut. 4:44)

Rectangular shield with large gilded three-dimensional open-
ribbed crown at top carried by cast gilded rampant lions stand-
ing on three-dimensional gilded columns. Chased central panel
with affixed gilded shining sun and gilded Tablets of the Law
framed by stylized cloud formations and lightning bolts. Below,
the cutout frame for interchangeable plaques (here indicating
Pesach) and an applied oval plaque bearing inscription of the
original patrons. On the lower frame, scallops decorated with
a leaf design interspersed with four suspended bells. At each
side near the lions' heads, two flamelike forms hold the chains.
All the applied elements are held by screws.

**Torah Finials (*Rimmonim*)**
Height 18½ in. (47 cm)

Hexagonal two-storied towers of superposed arches stand on
smooth shafts with domed bases. Gilded bells hang in the arch-
ways and from brackets at the lowest level. Cast gilded columns
frame the archways and cast scroll elements frame each of the
facets. Chased leaves in relief decorate bottom tier and tentlike
upper tier. At the top, a tall open-rib crown surmounted by a
finial formed of a cast bird with outspread wings

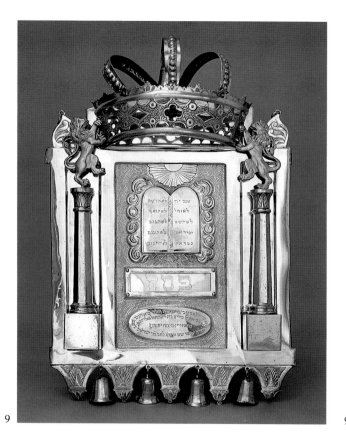

9

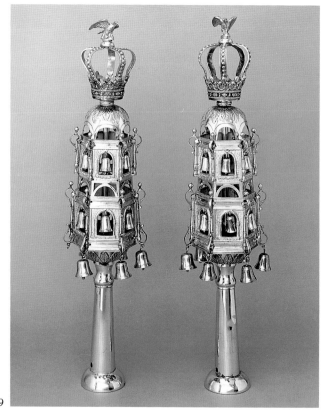

9

The Biblical verse with which the inscription ends is a chronogram in which the sum of the indicated letters gives the year, in this case [5]608, which is 1847/48. Dr. Philip E. Miller, Librarian, Klau Library, Hebrew Union College–Jewish Institute of Religion, has suggested that the place-name that appears as *Schweinsthaupten* in the inscription may be a (deliberate?) misspelling of the town *Schweinhaupten*, in northern Bavaria, creating an ironic play on words, suggesting the idea of "pig's baptism."

The symbolism of the shield probably comes from book illustrations and refers to the façade of the Temple. The freestanding columns refer to the columns Jachin and Boaz (1 Kings 7:21) which stood before the Temple. The sun, clouds, and lightning around the Tablets refer to the Giving of the Law on Mount Sinai, the Law that was later enshrined in the Holy of Holies within the Temple. The lions of Judah upholding the crown of Torah refer to the cherubim who guarded the Holy Ark.

Davis Brown, a collector of Judaica who was a member of the Board of Trustees, gave this set of Torah ornaments to Temple Emanu-El in 1929. At the same time he donated an almost identical set with similar iconography but slightly different dimensions. The inscription on the plaque of the Torah shield of this second set (CEE 29–50A/B) reads:

שייך לכה ר׳ יצחק בר אשר דב / אבערמייאר ולאשתו מרת / טריינלא בת ר׳ דוד ולבתו / פראדל שרה בשנת ת׳ר׳י׳ג׳ ל׳פ׳ק׳

Belonging to the h[onorable] R[abbi] Isaac son of Asher Dov / Obermayer his wife Mistress / Treinele daughter of R[eb] / David and to his daughter / Fradl Sarah in the year [5]613 (1852/53)

Both sets of ornaments are used on Torah scrolls in the Ark on all the Festivals and High Holy Days.

GIFT OF DAVIS BROWN, 1929
(CEE 29–49A/B/C)

## 10

# Perlman Set of Torah Ornaments

Warsaw, 1882
Silver, pressed, engraved; castings

**Torah Crown (*Keter*)**
Height 21 in. (53.3 cm)
MARK: Date (similar to Lileyko, p. 100); *84*

INSCRIBED
In cartouche on front
*IN LOVING MEMORY / OF / OUR PARENTS / MOLLIE &
SAMUEL PERLMAN / 1884–1958*

In cartouche on back
ז"נ חברה ק' מאגודת א'/א' סטאלין

T[his is] a p[resentation] of the H[oly] Society (Burial Society)
of the Association of M[en of] / T[ruth] Stolin

Large lower crown with wide band of scrolling openwork and
wide swelling ribs interspersed with flower medallions hung
with bells. Circlets of flower petals with cast centers decorate
the base of each rib and ring the cap of the crown, from which
rises a small open-ribbed crown. Bells suspended from brackets
ring the base of the crown; at the cap, small bells alternate with
the wide ribs. Above, mounted on a globe, a finial of a cast bird
with outspread wings.

**Torah Shield (*Tas*)**
14½ x 10½ in. (37 x 26.8 cm)
MARK: Date (similar to Lileyko, p. 100); *84*

INSCRIBED
Center, above and below Tablets of the Law
*IN LOVING MEMORY OF / OUR PARENTS / MOLLIE &
SAMUEL PERLMAN / 1884–1958*

On Tablets of the Law
אנכי ה / לא יהוה / לא תשא / זכור את / כבד את
לא תרצח / לא תנאף / לא תגנב / לא תענה / לא תחמד

I am the L[ord] (your God) / You shall have no (other gods beside
Me) / You shall not swear (falsely) / Remember (the Sabbath) /
Honor (your father and your mother)
You shall not murder / You shall not commit adultery / You shall
not steal / You shall not bear (false witness) / You shall not covet
(Exod. 2–14)

In medallion
ז"נ / חברה ק' מאגודת א' / א' סטאלין

T[his is a] p[resentation] / of the H[oly] Society (Burial Society) /
of the Association of M[en of] / T[ruth] Stolin

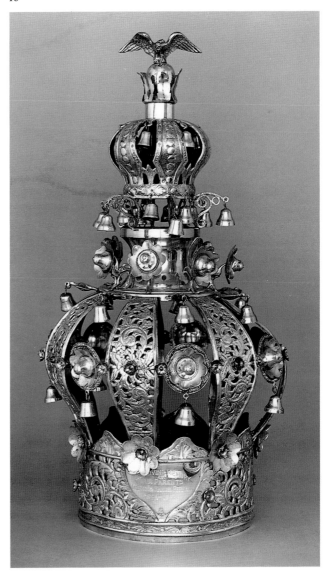

10

Rectangular shield with trilobed upper rim framed by scroll-
and-leaf designs. Tablets of the Law, columns with bells, cutout
frame for interchangeable plaques (here indicating Yom
Kippur), and medallion for donor inscription fill mid and lower
center. In upper center, lions atop the columns support a three-
dimensional crown with cast bird finial.

10

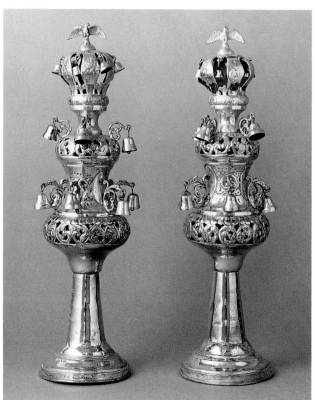

10

**Torah Finials (*Rimmonim*)**
MAKER: AG
Height 16¾ in. (42.5 cm)
MARK: *84*

INSCRIBED
On rim of base (at left)

ז"נ ה' טויבה שיימאהן וכלתה רבקה

T[his is] a p[resentation of M[istress] Toibe Scheimohn and her daughter-in-law Rivka

On rim of base (at right)

לבהכ"נ של החברה א' א' א' סטאלין בשנת ת'ר'פ'א'

For the H[ouse of] A[ssembly] (Synagogue) of the (Burial) Society of the A[ssociation] of M[en of] T[ruth] Stolin in the year [5]681 (1920/21)

On both shafts
*IN LOVING / MEMORY / OF OUR / PARENTS / MOLLIE & SAMUEL / PERLMAN / 1884–1958*

Vase-shaped finials on stocky shafts with stepped feet. Two lower tiers with openwork scroll pattern and cast scrolling bell holders are surmounted by a third tier of an open-ribbed crown topped by a cast open-winged bird finial.

This group of Torah ornaments was probably purchased in Warsaw, where inexpensive pressed-silver objects for synagogues and homes were made by Jewish silversmiths who flourished in the late nineteenth and early twentieth centuries. A small shul in the shtetl of Stolin in Pinsk was the original owner of these ornaments; the set was brought to an Orthodox synagogue in Williamsburgh, Brooklyn, by a former resident of Stolin. In 1961, on liquidation of the Brooklyn synagogue, the ornaments were purchased by William M. Perlman and donated to Temple Emanu-El, where the shield and finials are used in the Leon Lowenstein Sanctuary during the High Holy Days.

Reference

On nineteenth-century Warsaw silversmiths, see H. Lileyko, *Srebra Warszawskie* (Warsaw Silver), 1979.

GIFT OF MR. AND MRS. WILLIAM M. PERLMAN AND HIS SISTERS, MRS. LEE HOLTZMAN, MRS. ANNE ROBIN, MRS. SOPHIE WEINTRAUB, 1961

(CEE 61–3) (CEE 61–1) (CEE 61–2A/B)

## 11

# Swan Torah Crown (*Keter*)

Probably Eastern Europe, late 19th century
Silver, partial gilt; pressed, engraved
Height 26 in. (66 cm)

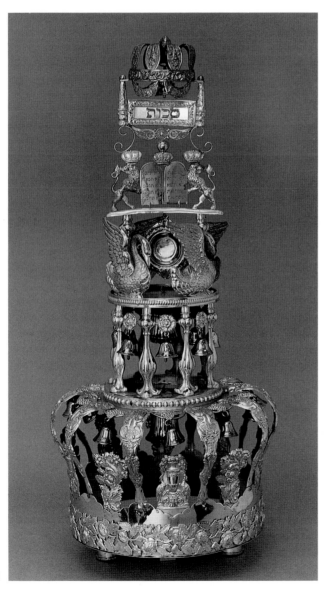

11

INSCRIBED
On Tablets of the Law

אנכי ה׳ / לא יהיה / לא תשא / זכור את / כבד את

לא תרצח / לא תנאף / לא תגנב / לא תענה / לא תחמד

I am the L[ord] (your God) / You shall have no (other gods beside
Me) / You shall not swear (falsely) / Remember (the Sabbath) /
Honor (your father and your mother)
You shall not murder / You shall not commit adultery / You shall
not steal / You shall not bear (false witness) / You shall not covet
(Exod. 20:2–14)

Lowest tier an open-ribbed crown with pressed floral motifs
and ten gilded bells hanging from grape clusters and large bell
hanging within. Second tier an open rotunda with eight gilded
bells suspended from floral medallions. On third tier, four
pressed swans with wings unfurled appear to swim; two
columns support an upper lintel from which a large gilded
medallion hangs. On the lintel, crowned Tablets of the Law held
by crowned rampant lions. Supported by the three crowns a
superstructure of wheel, wings, frame for interchangeable
plaques (here indicating Sukkot), columns, and an open-ribbed
crown with wreaths and bell.

The grand contrivance of towering crowns was
undoubtedly of Polish origin. The so-called Lemberg
Crown at the Jewish Museum in New York City is a fine
example of such a model (Kleeblatt/Mann, pp. 102–3).
The community that purchased this crown obviously
did not have the financial resources to purchase a hand-
hammered object. The making of pressed silver objects
is best known from the Warsaw manufacture of Sab-
bath candlesticks, which were made of pressed-brass
halves soldered together and silver plated.

This four-tiered crown of pressed silver pieces sol-
dered and screwed together with adjustable holders
beneath, to place it atop the staves of the Torah scroll,
is a sharp-edged, unwieldy, and fragile object. Consider-
ing its good condition, one can assume that it was prob-
ably used only on special holidays. The inventive
fantasy of its conception makes it endearing.

Reference

N. Kleeblatt and V. Mann, *Treasures of the Jewish Museum*, 1986, pp.
102–3.

BEQUEST OF JUDGE IRVING LEHMAN, 1945

(CEE 45–143)

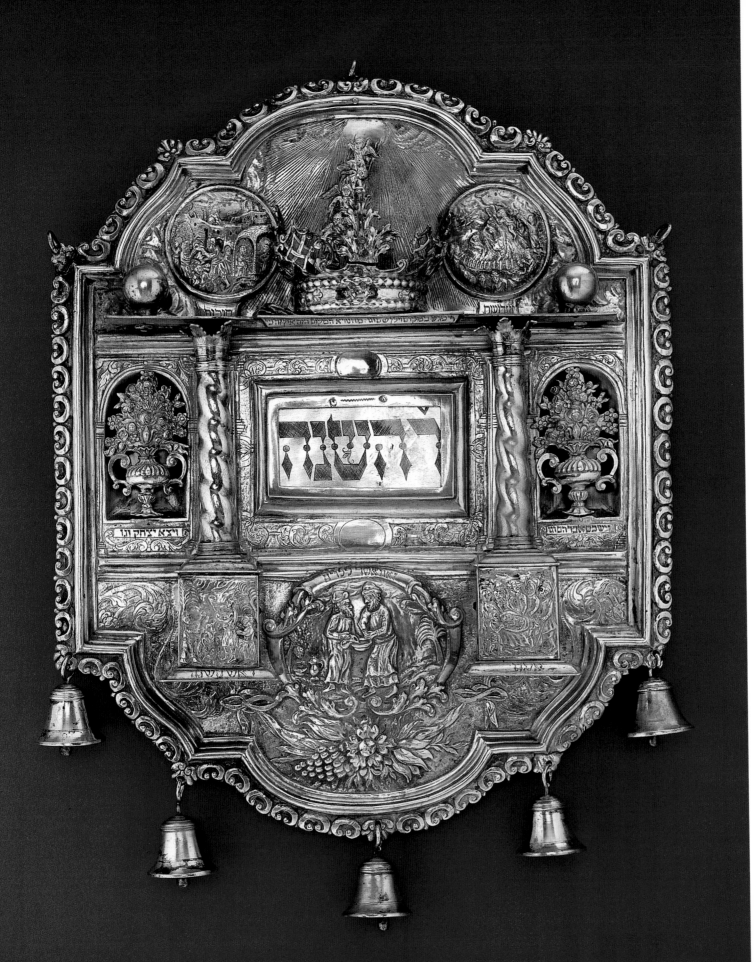

**12**

# Jacob ha-Levi Torah Shield (*Tas*)

MAKER: Hahn (?)
Nuremberg, after 1717
Silver gilt, embossed, engraved; cutout ornaments
14½ x 12½ in. (36.9 x 31.8 cm)
MARKS: Master (rooster in circle); place and date
(Rosenberg, no. 3762)

INSCRIBED
Beneath right upper roundel
**שבועות**
Shavuot

Beneath left upper roundel
**סכות**
Sukkot

On and under ledge
**ויפגע במקום וילן שם וגו': מה נורא המקום הזה אין זה כי / אם בית אלהים וזה שער**
He (Jacob) came upon a certain place and stopped there for the night etc. How full of awe is this place! This is none other / than the house of God and this is the gate (Gen. 28:11, 17).

Beneath right niche
**וישכם אברהם וגו'**
Abraham hurried etc. (Gen. 19:27)

Beneath left niche
**ויצא יצחק וגו'**
And Isaac went out etc. (Gen. 24:63)

On upper frame of lower cartouche
**זאת אשר ללוים**
This is what pertains to the Levites (Num. 8:24)

On base of right column pedestal
**פסח**
Pesach

On base of left column pedestal
**ראש השנה**
Rosh Hashanah

Symmetrical shield with straight sides and curved top and bottom framed by relief molding and scrollwork. A gridlike field formed by three-dimensional molding that divides the area into three horizontal sections; three-dimensional twisted and crowned columns on pedestals create three vertical sections. Ball finials at either end of three-dimensional ledge supported by columns flank three-dimensional crown in center. In midsection, frame for interchangeable plaques (here indicating Rosh Hashanah). Niches at either side contain cast, flower-filled

Frontispiece to Isaiah ha-Levi, *Gates of Heaven* [in Hebrew]. Amsterdam, 1717. (Courtesy Hebrew Union College–Jewish Institute of Religion Library, Cincinnati.)

12–A

urns. In the bottom section, a central cartouche with embossed scene; on either side, pedestals have embossed plaques with scenes. Bells hang from scrollwork at bottom.

An elaborate program depicts the three Pilgrimage Festivals, Shavuot, Sukkot, and Pesach, as well as Rosh Hashanah. The reliefs in the upper roundels on either side of the crown (cat. no. 12–B) depict on the right, Moses and the Burning Bush and Moses Receiving the Tablets of the Law on Mount Sinai, with a fence at the base of the mountain (Shavuot), and on the left, booths in courtyards and on tops of houses in the process of being made or already occupied (Sukkot). The scene on the pedestal at right shows five men and a child with the Paschal Lamb on a plate (Pesach). On the pedestal at the left, Rosh Hashanah—blowing of horns (shofrot) in the Holy Land (cat. no. 12–C).

Above the crown in the center of the upper panel winged angels in relief are shown descending a ladder (cat. no. 12–D). On the ledge is a three-dimensional rock (Jacob's pillow) and markings suggesting earth. The inscriptions on and under the ledge refer to Jacob. The scene in the center of the lower panel depicts two priests, the Levites of the Temple, performing the rite of handwashing with laver and pitcher.

Holes behind the ledge make it clear that the present crown is a replacement, for what was probably a three-dimensional figure of Jacob asleep on the ledge, his head resting on the rock. The cast urns that fit so uncomfortably within the niches are replacements as well, for figures of Abraham and Isaac according to the inscriptions beneath each niche.

The centrality and importance of the Jacob references as well as the depiction of the Levites below is

12–B

12–C

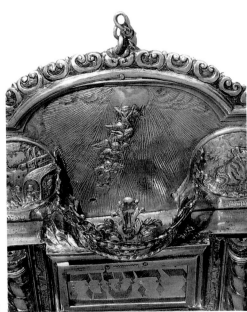

12–D

convincing evidence that we have in this object an encoded message: this Torah shield was commissioned by the person, or the family of, Jacob ha-Levi (perhaps with an additional surname as well).

The complete iconographical model for this shield is to be found in the frontispiece of *Gates of Heaven* (cat. no. 12–A), a prayerbook written by Isaiah ha-Levi Horowitz (1555–1630), edited by his great-grandson Abraham Isaiah Horowitz as a daily prayerbook in the Ashkenazic rite, and printed in Amsterdam in 1717.

The presence of the three patriarchs recalls the rabbinic tradition in which each of the three times of prayer is related to a Patriarch: the morning prayer to Abraham, the afternoon prayer to Isaac, and the evening prayer to Jacob. The format with its emphasis on Jacob and its reference to the Levites would certainly appeal to our presumptive patron.

This Torah shield offers rare insight into the close relationship of the Jewish patron and the Christian workshop. A printed prayerbook in the Ashkenazic rite distributed in Germany catches the eye of a patron who takes it as a model to the silversmith. The artisan then completes a three-dimensional work using the techniques and skills of his craft to produce an object rich in Jewish meaning. This shield was apparently designed for a patron with a liberal attitude toward figurative art. The removal of the three-dimensional figure of Jacob asleep on the ledge and its replacement with a crown, as well as the substitution of the urns for figures of Abraham and Isaac indicate a subsequent change of attitude.

References

Compare I. Shachar, *Jewish Tradition in Art*, 1981, cat. no. 173 and colorplate; for a similar shape, S. Kayser and G. Schoenberger, *Jewish Ceremonial Art*, 1955, cat. no. 54. See also, C. Benjamin, *The Stieglitz Collection*, 1987, cat. no. 249.11, pp. 376–77; "Horowitz, Isaiah," *Jewish Encyclopedia*, vol. 6, 1904, pp. 465–66.

Literature

S. Kayser and G. Schoenberger, *Jewish Ceremonial Art*, 1955, no. 52.

BEQUEST OF JUDGE IRVING LEHMAN, 1945

(CEE 45–217)

**13**

# Heart-Shaped Torah Shield (*Tas*)

Probably Augsburg, early 18th century
Silver, embossed, chased; cutout work
10⅞ x 11½ in. (27.6 x 29.2 cm)

Modified heart-shaped shield with scrolling edges bordered on two sides with graduated beading. Modeled high-relief scrolling leaf decoration and fine "sharkskin" chasing on the background create rich textural contrasts. "Twisted" columns with flowered capitals and sawtoothed bases flank large central frame for interchangeable plaques (here indicating the Torah reading for Passover). Below, center designed with a shell motif flanked by framed fields. The holes in which the bells hang are additions; at one time these were accompanied by two more, which hung from the framed fields. The cast crown is an apparent replacement for the original which sat on the raised lintel and probably filled the undecorated area behind. There are many losses along the edges and breakage at the center top and bottom, and there are no longer any hallmarks, which were probably along the edges and on the original crown.

The Temple Sanctuary is symbolized by the columns and lintel, which create a sacred space. The crown symbolizes the majesty of the Law, in this case represented by the Torah reading designated by the interchangeable plaque.

The strong floral ornamentation on both sides emphasizes the origin of this style of Augsburg Torah shield. As discussed by Richard Cohen, the style of these shields originated in silver wall calendars with framed interchangeable plaques that provided the date. The Jewish iconography struggles to find its space in the total design.

Reference

Y. (Richard) Cohen, "Torah Breastplates from Augsburg in the Israel Museum," 1978, pp. 74–85.

BEQUEST OF JUDGE IRVING LEHMAN, 1945
(CEE 45–23)

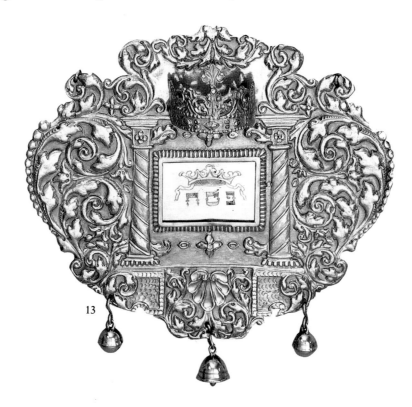

13

**14**

# Paris-Style Torah Shield (*Tas*)

Paris, 1770/71
Silver, embossed and chased; cast ornaments
7⅜ x 6 in. (18.8 x 15.1 cm)
MARKS: Place and date (Rosenberg, no. 6427, later German mark, no. 3)

Heavy silver shield in clear rectangular form with scroll-and-leaf upper frame. In center section, confronting rampant lions holding the Tablets of the Law with the Ten Commandments designated by Roman numerals beginning on lefthand tablet and continuing to the right. Behind the Tablets, the seven-branched lampstand (menorah) framed by draperies and leaves and surmounted by a three-dimensional crown. Beneath the lions, a three-dimensional framed box for interchangeable plaques (now missing) that designate the reading. A decorative border fills the space below. Within framed panels at the sides, fluted columnar altars contain slender flames whose tips pierce the upper frame and hold the rings for the hanging chain. In lower border, intersecting Gothic arches flanked by festooned pedestals. Hanging from rings below, three scroll-framed cast hearts (meant for dedications but blank).

This rigidly compartmented design maintains its angularity even within the customarily curved motifs of drapery and menorah. In an unusual depiction, the straight branches of the menorah create a stepped silhouette. The motifs of curtains, menorah, Commandments, and guardian lions refer to the inner sanctuary of the Temple, which was shielded from the populace by curtains. The secular motifs of garlands and intersecting pointed arches on the bottom of the shield and the odd admixture of flaming altars and elaborate columns at the sides are highlighted by the alignment of the Ten Commandments, which does not follow the Hebrew order but moves from left to right instead. This Torah shield is in fact unusual in that it carries no Hebrew inscription on its face.

The emphasis on drapery perhaps reflects the French interest in theater. The piece has a decidedly French flavor which, while early, foreshadows the style of the Bezalel School of Arts and Crafts founded in Jerusalem in 1903.

BEQUEST OF JUDGE IRVING LEHMAN, 1945
(CEE 45–25)

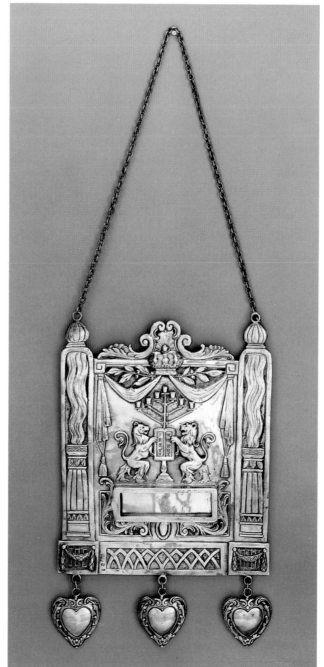

14

**15**

# Ark-Door Torah Shield (*Tas*)

MASTER: I S
Poland, 1828
Silver, traces of gilt; embossed, engraved, cutout work;
carved and engraved mother-of-pearl
9 x 6⅞ in. (23 x 17.5 cm)
MARK: Place and date (Tardy, p. 329)

INSCRIBED
On crown
כתר תורה
Crown of Torah

On door
וזאת / התורה / אשר / שם / משה / לפני בני / ישראל
This is / the Torah / that / Moses / set / before the children / of
Israel (Deut. 4:44)

Fanciful arch-shaped, bead-framed shield bears representation
of the façade of the Temple in Jerusalem. Twisted columns deco-
rated with flowering vines support the embossed roof of the
Temple rendered in perspective. Rampant guardian lions stand
at pedestals similarly embossed as three-dimensional objects.
Flowering vines and grape clusters fill the sides; at the bottom,
a formal central cartouche. The silver-rimmed door of the ark
filled with a freely carved mother-of-pearl panel on which an
appropriate Hebrew inscripton is engraved. In the ark behind
the door, in high relief, two dressed Torah scrolls ornamented
with arch-shaped Toral shields. Openwork crown above the
door (affixed with screws) mounted over a basket of flowers
flanked by eagles. A single chain hangs from attached side rings.

The imagery of flowers and crown may suggest an
underlying allusion to the flowering of the Torah and
the wings extending from the crown may refer to the
biblical reference "I bore you on eagles' wings" (Exod.
19:4).

The master carving of the mother-of-pearl door,
which differs from the naïve quality of the silverwork,
in addition to the horizontality of its design lead one
to believe that it was made originally for another object
and has been reused in this piece. Many old repairs
reveal the esteem in which this silver shield was held
over the years. It has been included annually in the past
in a small Shavuot exhibition shown in the Commu-
nity House Lobby of Temple Emanu-El. With its bibli-
cal quotation and its charming depiction of the Law

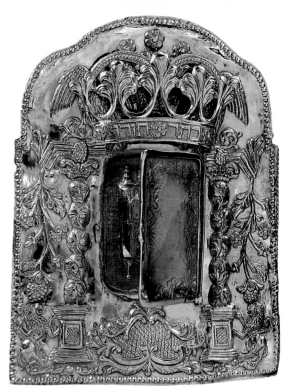

15

behind the ark door, it is eminently appropriate for the
holiday celebrating the giving of the Law.

Literature

C. Grossman. *Shavuos…the Giving of the Law*, 1986.

BEQUEST OF JUDGE IRVING LEHMAN, 1945
(CEE 45–27)

**16**

# Sabbath Torah Shield
# (*Shabes Tas*)

Eastern Europe, 19th century
Silver, embossed, chased, engraved
8¾ x 6¾ in. (22.2 x 17.2 cm)

INSCRIBED
On Tablets of the Law
א / ה אל / ל יה / ל ת / זכור / כבד
לא / תרצח / ל ת / ל ת / ל ת / ל ת
I [am] / the Lord y[our God] / Y[ou shall have] n[o] (other gods
beside Me) / Y[ou shall] n[ot swear] (falsely) / Remember (the
Sabbath) / Honor (your father and your mother)
You shall not / murder / Y[ou shall] n[ot commit adultery] /
Y[ou shall] n[ot steal] / Y[ou shall] n[ot bear] (false witness) / Y[ou
shall] n[ot covet] (Exod. 20:2–14)

Lower center
שבת
Sabbath

Curved shield in rectangular shape with arched top, framed by a double border with fluted edge. In the center, Tablets of the Law repeat the outline of the shield, flanked by embossed tassels and rampant lions gazing outward. Below, a scrolling frame enclosing the Hebrew designation, bordered on two sides by vaselike columns and scrolling flowers and leaves. Two slits at the base of the arched top indicate the loss of a three-dimensional crown. Bells once hung from the five holes at the bottom edge. Two large rings soldered to the back held a chain by which the shield hung on the dressed Torah scroll.

The high relief of the stylized lions and the Tablets of the Law soldered onto a raised back has the tactile sense of sculpture. Instead of being a flat plane to which raised elements have been added, this curved shield achieves a three-dimensional quality by the roundness of the forms in high relief and the irregular, rough quality of the background chasing.

The fluted edge and lack of identical symmetry of the design is in the best tradition of Jewish folk art of Eastern Europe. While the main theme of the shield is a symbolic representation of the Temple Sanctuary (the large tassels on either side of the Tablets suggest the curtain that hung before the Holy of Holies), a secondary design motif appears in the fleur-de-lis that is represented in the center of the floral motif at the top. Below, the frame that outlines the word "Sabbath" includes a base and crowned finial in the fleur-de-lis form. The small columns on either side of the frame have fleur-de-lis capitals, and the motif is repeated in the scrolling flower and vine forms. Even the footpads of the stylized lions are in a trefoil design. The presence of the lily-flower motif may refer to the original donor's name, probably Frankel, Franco, or Tsarfati, common names for Jews of French origin. However, the fleur-de-lis has a long design history in the Middle East and appears on ancient coins used in the Holy Land.

Reference
*Treasures of the Holy Land*, 1986, p. 185 and fig. 68.

GIFT OF MR. AND MRS. HENRY M. TOCH, 1928
(CEE 29–21)

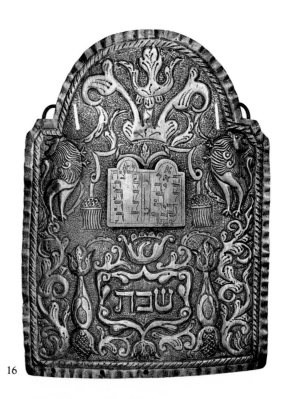

16

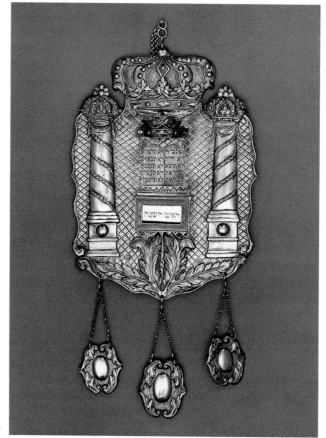

17

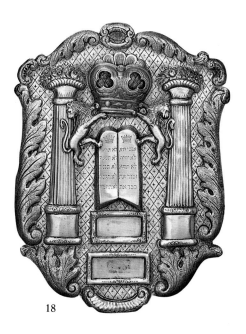

18

## 17

# Four-Crown Torah Shield (*Tas*)

MASTER: A S
Hamburg, early 19th century
Silver, partial gilt; embossed, chased
9 x 6⅝ in. (23 x 16.8 cm)
MARK: Place and date (Rosenberg, no. 2372)

INSCRIBED
On Tablets of the Law

אנכי ה' / לא יהיה / לא תשא / זכור את / כבד את

לא תרצח / לא תנאף / לא תגנב / לא תענה / לא תחמד

I am the Lord (your God) / You shall have no (other gods beside
Me) / You shall not swear (falsely) / Remember (the Sabbath) /
Honor (your father and your mother)
You shall not murder / You shall not commit adultery / You shall
not steal / You shall not bear (false witness) / You shall not covet
(Exod. 20:2–14)

On a diapered ground, crowned columns in high relief en-
twined with leafy garlands. Between them at top center a large
silhouetted crown below which is a small, three-dimensional
crown set above the Tablets of the Law placed at an angle resem-
bling an open book. At the bottom a large central leaf ornament
completes the composition. Three blank framed medallions
hang from the lower edge. Crowns, leaves, raised rim, plaque
frame, and Tablets are all gilded. The interchangeable plaque
designates the reading for Rosh Hashanah.

The symbols of the columns and the Tablets of the Law
relate the object to an enduring message of Judaism:
remembrance of the ancient Temple in Jerusalem. The
biblical reference is combined with the Talmudic met-
aphor that becomes a personal moral reference, that
is, the four crowns mentioned in Pirke Avot, "the crown
of Torah, the crown of priesthood, and the crown
of royalty, but the crown of a good name surpasses
them all" (4:13).

The glittering gilding on the columns, crowns, and
scrolling edge of this small shield creates a pleasant con-
trast to the silver background.

Reference

For a similar design, see L. Franzheim, *Judaica*, 1980, cat. no. 42, pp.
122–23.

GIFT OF MR. AND MRS. HENRY M. TOCH, 1928
(CEE 29–20)

## 18

# Torah Shield (*Tas*)

Probably United States, 19th century
Silver, partial gilt; embossed, chased, engraved
10⅞ x 8 in. (27 x 20.3 cm)

INSCRIBED
On Tablets of the Law

אנכי הא / לא יהיה / לא תשא / זכור את / כבד את

לא תרצח / לא תנאף / לא תגנב / לא תענה / לא תחמד

I am the Lord (your God) / You shall have no (other gods beside
Me) / You shall not swear (falsely) / Remember (the Sabbath) /
Honor (your father and your mother)
You shall not murder / You shall not commit adultery / You shall
not steal / You shall not bear (false witness) / You shall not covet
(Exod. 20:2–14)

Edges of shield framed by leaves and scrolls. On a diaper-pattern
background, fluted columns, Tablets of the Law, and lions
upholding a crown relate to the façade of the Temple. Three
rings soldered to the back hold the chains to hang the piece
on the Torah.

The lions and the crown appear to be replacements,
since they do not fit their spaces. The two frames are
empty of donor or designation. Unusual elements here
are the flower-filled urns atop the columns.

The absence of hallmarks leads to the conclusion
that the manufacture was American although the design
is based on European models.

GIFT OF MR. AND MRS. HENRY M. TOCH, 1928
(CEE 29–19)

## 19

# Mendez da Fonseca Bells (*Rimmonim*)

MASTER: Willem Rosier (?)
Amsterdam, 1717
Silver, partial gilt; cast, embossed, chased
Height 18 ¼ in. (46.4 cm)
MARKS: Master, lozenge (Voet, no. 200); city and date; year mark *G*

INSCRIBED
On base of middle tier of each bell
כתר תורה
Crown of Torah

Three-tiered hexagonal tower-form composed of open, cast elements carried on a plain shaft rising from a circular stepped base and ending with a gilded, striated, compressed knop. The lowest tier, a bulbous openwork vegetal form with pomegranate-shaped openings supported by shell elements and accented by bud finials. Gilded bells fill each pomegranate shape and hang from the intervening ribs. Above, a hexagonal arcaded turret with a golden bell hanging in each archway; the columns in between topped by bud finials. On the turret base, the family crests and cutout Hebrew inscription. Turret roof decorated with shell ornaments carries a hexagonal beaded, ribbed bud form hung with golden bells. Above, a ribbed crown surmounted by a cast bud finial. A warm gray patina covers the surface. Each *rimmon* carries the crest and monogram of one of the original donor families. The shafts bear the hallmarks.

This rare pair of Dutch ornaments for the Torah scroll bear the crests and the cutout monograms of the Da Fonseca and Mendez families (cat. nos. 19–A and 19–B). This would seem to indicate that they were a gift to the synagogue by these two well-known Sephardic families, probably at the time they were united in marriage. Such an event is documented by a ketubah in the Municipal Archives in Amsterdam which records the marriage of David de Abraham Dias da Fonseca and Ester de Jacob Israel Mendez on October 16, 1716 (14 Tishri 5477). The complete gift might have been a new Torah scroll, its embroidered silk mantle, a silver Torah pointer, and these silver bells, as the *rimmonim* are called in the Sephardic tradition. The shell motif that is a striking element on these objects is probably a reference to the Spanish heritage of these Dutch Jews, since the shell was the emblem of Saint James (Santiago), the patron saint of Spain.

This shape, which combines the bulbous pomegranate form in the lower tier with the tower and spire of the upper tiers, relates to other Dutch bells made in the early eighteenth century (Barnett, plate LX, no. 111). The hallmark of the maker could be that of Willem Rosier. Voet lists five marks used by Willem Rosier (nos. 195–200), the last of which is a lozenge with what appears to be a flower within. However, Citroen (p. 175) gives Rosier's birthdate as 1707, which would make him too young to have produced these finials in the year 1717. The years 1717 and 1766 are among the years for which the year mark *G* was used. The mark could also denote Johannes Schouten, who was active from 1763 to 1791 (Citroen, p. 234) and is known to have made synagogue silver. However, the style suggests the earlier date, which is supported by the ketubah as well as the Dutch bells dated by Barnett to 1714, which may indicate that the Rosier family of silversmiths was already active in Amsterdam early in the century.

The tower form for Torah finials is known from the fifteenth century, but the landscape of Amsterdam with its synagogues and guild halls adorned with steeples could well have inspired the popularity of the form in that city. Certainly the landscape of Jerusalem with its David's tower was well known to Dutch Jews. Engraved maps with views of Jerusalem by seventeenth-century Dutch cartographers always depicted the tower, as well as the towers on the gates of the city. The watchtower is a worthy symbol for a Torah finial, for the notion of watching, or guarding, the Law is a continuing concept in Jewish life.

According to Henry Toch, in 1860 his father and brothers established a family synagogue in their home at 232 East Tenth Street, New York City, which they maintained for some thirty years. These Torah finials were probably used there to decorate the Torah scroll.

19–A

19–B

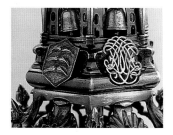

References

For similar style, see R. D. Barnett, *Catalogue of the Jewish Museum, London*, 1974, pl. LX, no. 111; for architectural style, idem, pl. LIV, no. 125. For a Mendez monogram, see *Treasures of a London Temple*, 1951,

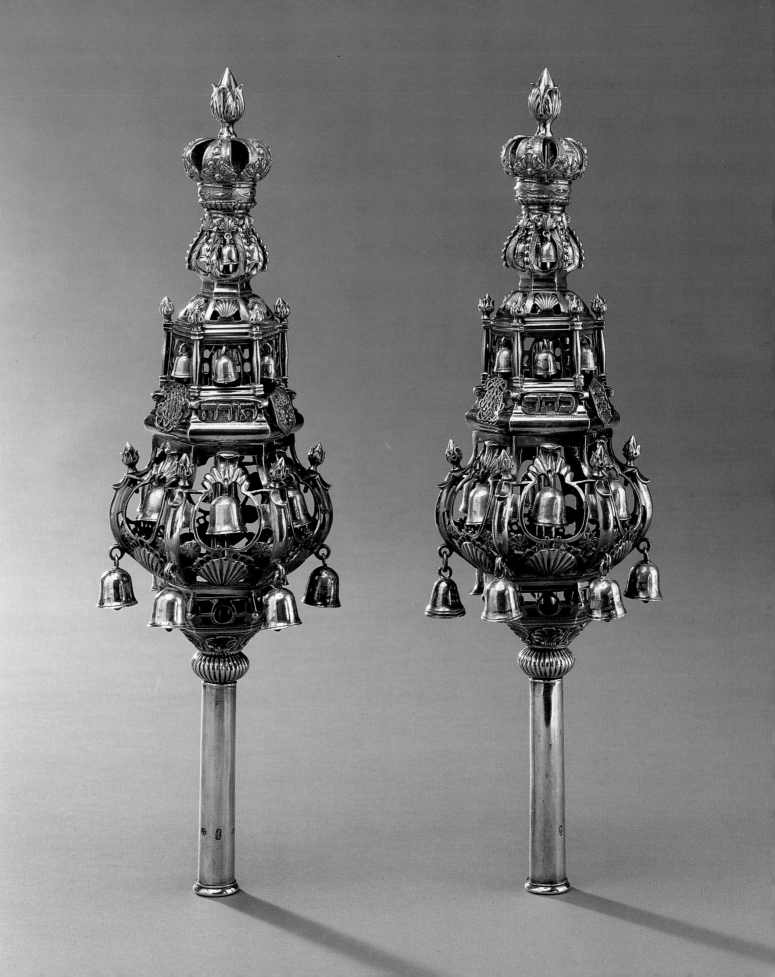

19

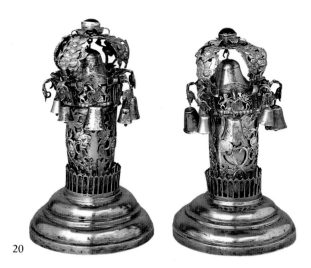

20

pl. V, p. 58. For the family crests, see J. B. Rietstap, *General Illustrated Armorial*, 1950, vol. 2, pl. CCCXXXVIII (Fonseca) and vol. 4, pl. CLXXXV (Mendez). For a discussion of English and Dutch silver, see A. G. Grimwade, "Anglo-Jewish Silver," 1958, pp. 113–17. Publication of the banns and ketubah of David Dias da Fonseca and Ester Israel of Amsterdam courtesy W. Chr. Pieterse, Director of the Municipal Archives, Amsterdam.

Literature

H. M. Toch, "Jewish Ceremonial Objects Presented by Mr. and Mrs. Henry M. Toch to Temple Emanu-el, 1929," p. 2.

GIFT OF MR. AND MRS. HENRY M. TOCH, 1928
(CEE 29–9A/B)

## 20

# Lemberg-style Torah Finials (*Rimmonim*)

Polish, 18th century
Silver, partial gilt; embossed, engraved, cutout work;
green stones, castings
Height 7 in. (17.8 cm), diameter of base 4½ in. (11.5 cm)

Short columnar form set on a wide stepped gilded base. Center silver shaft of cutout sections engraved with scrolling leaf forms, bunches of grapes and flowers set on a gilded inner shaft encircled at the base by an arcaded fence. At the top, narrow gilded beading and four scalloped edges decorated with cutout rampant lions and eight alternating gold and silver bells hanging from cast grape leaves amid vines and gilded ribbons. Above, open bands of cast and chased flowers form a crown within which a large gilded bell hangs. A single green stone set on leaves tops each finial. One flower band on each finial is a finely embossed old replacement.

The exquisite silverwork on these unmarked finials relates them to other objects said to originate in Lemberg. A pair of finials from that city now in the Jewish Museum (Kayser and Schoenberger, cat. no. 23) are also shafts on wide bases decorated with a bouquet of leaves, flowers, and nuts. The freshness and exuberance of the cutout work are reminiscent of the cut-paper *mizrakh* decorations made by Jewish folk artists (Kayser and Schoenberger, cat. no. 176). (*Mizrakh*, meaning

east, is a name given to objects put on the wall to denote the direction of Jerusalem. These were often amuletic.)

The fence appears often on Polish brass Hanukkah lamps, and on silver objects as well, as a visualization of the Talmudic injunction, "Make a fence around the Law" (Pirke Avot 1:1), that is, be careful to make all the observances, lest we transgress. We see in the imaginative use of symbols and the freshness of workmanship an expression of the religious zeal and originality that was characteristic of Jewish life in the shtetl.

Reference

S. Kayser and G. Schoenberger, *Jewish Ceremonial Art*, 1955, cat. nos. 23, 176.

BEQUEST OF JUDGE IRVING LEHMAN, 1945
(CEE 45–105A/B)

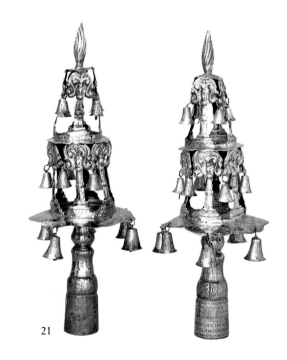

21

## 21

# Date-Palm Torah Finials (*Rimmonim*)

Eastern Europe, 19th century
Silver, pressed, embossed, engraved
Height 13¾ in. (35 cm)

INSCRIBED
On shaft
משה ב״ר יוסף
Moshe s[on of] R[eb] Yoseph

On shaft
מלכה בת יחיאל
Malkah daughter of Jehiel

On plaques affixed to shafts
*PRESENTED TO / TEMPLE EMANUEL / BY J. W. RIGLANDER /
TO / PERPETUATE THE NAME / OF RIGLANDER FAMILY*

Two-tiered finials made of pressed silver sections in which flat collars support six lower and four upper columns fashioned as palm trees. Between them, bells decorated with tooled engraving hang from rings. Above, the finial fashioned in the form of a flame. Shaped handle and lower collar chased with leaves and flowers.

The simple workmanship of pressed and engraved silver, the use of rolling tool marks, and bells reminiscent of sewing thimbles indicate an unsophisticated taste. But the imaginative design of colonnades of palm trees symbolizing the Holy Land and the flame finial as a symbol of light of Torah give these *rimmonim* a special charm. Unfortunately, the thin sheets of pressed silver are easily bent out of shape in the frequent handling of the Torah scroll.

One wonders whether Moses M. Riglander, congregant of Temple Emanu-El and son of Jacob W. who presented the finials to the Temple, was the grandson of the original donor, Moshe, son of Reb Yoseph.

The affixed plaques are the work of McCarty Silversmith, New York.

GIFT OF JACOB W. RIGLANDER WHOSE WIFE WAS MATILDA (NÉE STRAUSS) AND WHOSE SON WAS MOSES M. RIGLANDER MARRIED TO S. MARGARET (NÉE MEIER)
(CEE 29–48A/B)

## 22

# Bird-Beak Torah Pointer (Yad)

Germany, 17th century (?)
Silver, embossed, cast
Length 8 in. (20.3 cm)

INSCRIBED
On shaft
שייך להקצין הר״ר מאיר הנובר
Belonging to the leader [our] r[abbi] R[abbi] Meir Hanover

Right-handed pointer with round tapered shaft made in two sections defined by rings at each end and one in center. Index finger of exaggerated thickness in the form of a bird's beak (cat. no. 22–A). Little finger wears a ring; all fingernails incised, except for index finger. Two-part globe decorated with feathered triangles separates hand from shaft; at other end, finial formed by similar globe, with two holes, and a small attached ring from which hangs a large ring and chain.

The use of the bird's beak as a motif is a clear reference to the famous thirteenth-century "Birds' Heads" manuscripts of South Germany, in which the human figures are provided with the heads of birds in order to avoid depicting humans in liturgical works. In this region the use of bird or animal heads was a special feature and apparently appealed to Jewish patrons of prayer books because it coincided with their avoidance of depicting the human figure. The intent in this rare pointer is not one of substitution but may instead reveal a proud association with prized zoomorphic medieval Hebrew manuscripts. The Jewish Museum in New York City owns an unpublished pointer of similar style with the index finger in the form of a bird's beak (F3636), which Guido Schoenberger catalogued as seventeenth-century Germany.

The upper globe with the two holes may have held colored stones to indicate the eyes of a bird, which would make yet another reference to the bird-beak form of the pointing hand.

References

B. Narkiss, *Hebrew Illuminated Manuscripts*, 1969, pp. 90–97, pls. 25–28; idem, "On the Zoocephalic Phenomenon in Mediaeval Ashkenazic Manuscripts," 1983, pp. 49–62.

BEQUEST OF JUDGE IRVING LEHMAN, 1945
(CEE 45–13)

## 23

# Amsterdam Torah Pointer (Yad)

MASTER: Pieter von Hoven
Amsterdam, 1694
Silver, partial gilt; embossed, cast
Length 9 in. (22.9 cm)
MARKS: Master, *VH* (Citroen, no. 879); city and date; year mark *H*; control mark

Slim silver shaft of right-handed pointer divided by gilded molding into two unequal sections. Shorter upper section is hexagonal. Lower round section of slightly bulbous form tapers at bottom as in a forearm. Cast gilded pointing hand has relaxed index finger and four clenched fingers, all with incised fingernails; short full continuation of the wrist suggests a gauntlet. Cast gilded finial in the form of a small globe set on molding, small ring above holds a larger ring. The chain is missing.

The hexagonal upper section appears to be cast, giving the piece a pleasant weight in the hand. One of the sides bears all the hallmarks denoting master, date, silver quality, city, and state (cat. no. 23–A).

BEQUEST OF JUDGE IRVING LEHMAN, 1945
(CEE 45–239)

23–A

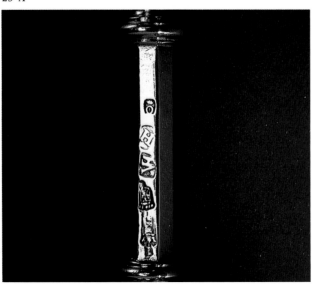

## 24

# Gorham Gold Torah Pointer (Yad)

MASTER: William C. Codman
Providence, Rhode Island, ca. 1910
Gold, cast; set with pearls
Length 14¾ in. (37.4 cm)
MARKS: Master, lion on anchor (Rainwater, p. 60); *14K*

Long slender tapered handle of right-handed pointer made in three sections. Pointing hand and all three sections marked off by bands of beading and leaves. Shaft decorated with a relief design of intersecting Gothic arches and fleur-de-lis. Center section and open-leaf finial set with pearls. A gold chain is threaded through the open finial.

The hand is shaped in a naturalistic, almost lifelike manner with an indication of knuckles and wrist and a suggestion of skin surface, (cat. no. 24–A). The fingers, all showing fingernails, are elegantly feminine, the index finger gracefully extended. The Gothic elements and the Art Nouveau style are characteristic of the designs of William C. Codman, one of the outstanding designers in the Ecclesiastical Department of the Gorham Company, where he worked during the years 1891 to 1914 (Carpenter, pp. 203–4).

This pointer is used in the Main Sanctuary of Temple Emanu-El during the High Holy Day services.

References

Gorham Company Records; C. Carpenter, *Gorham Silver 1831–1981*, 1982, pp. 203–4.

(CEE 63–1)

24–A

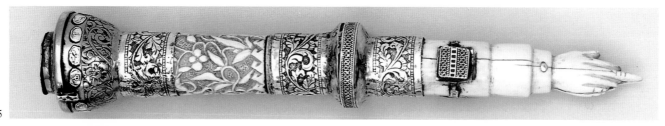

25

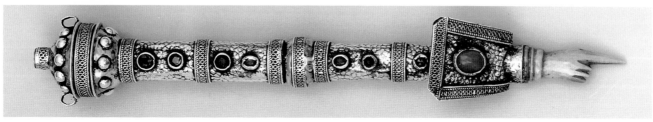

26

## 25/26

# Smilovici Torah Pointers (*Yadaim*)

MASTER: Moshe Smilovici
Tel Aviv, 1950s

### 25
**Torah Pointer (Yad)**

Reused stippled silver; bands of filigree ornament, set stones
Length 11¾ in. (29.8 cm)

Right-handed pointer made of sheets of stippled silver wrapped on a core of bone or wood. Bone hand carved in stylized manner with index finger as sharply tapered point. Bands of filigree ornament cuff, shaft, and beaded, urnlike spice container at the top. Colored stones set in silver applied in a row down the length of the piece.

### 26
**Torah Pointer (Yad)**

Reused chased silver bands; silver filigree, silver-washed copper, carved ivory
Length 11⅞ in. (30.2 cm)

Bottom section of carved ivory in the form of two apposed

hands with projecting middle fingers and sleeves banded with phyllactery-like boxes. Shaft made of bands of reused silver-work and filigree. Urnlike top of silver-washed copper spice container set with small oval medallions bearing symbols of the Twelve Tribes; holes in the cover permit emission of the aroma of spices.

Moshe Smilovici (1912–1962) was born in Bucharest, from where he emigrated to Israel with his wife, Lucica Koffler Smilovici, in 1950. In the brief decade that followed, the former jeweler and antiques dealer created a vast quantity of Judaica objects. He fashioned these out of old pieces of silver, which he treated as collage elements and to which he added his own ivory and bone carvings and colored stones (conversation with Lucica Smilovici, October 1986, who identified these pieces). The freedom of his fantasy combined with a rich spiritual feeling for Judaica have created a unique corpus of work, of which the best examples might well be classified as Israeli folk art.

Reference
See cat. no. 181, case for the Scroll of Esther.

GIFT OF ARTHUR DIAMOND IN MEMORY OF HIS WIFE, ESTELLE, 1978
(CEE 78–1) (CEE 78–2)

## 27/28

# Torah Pointers (*Yadaim*)

### 27

**Torah Pointer with Gilded Cuff (Yad)**
Western Europe (Hungary?), 19th century
Silver, partial gilt; embossed, chased, engraved, castings
Length 12 ½ in. (31.7 cm)

INSCRIBED
On upper shaft
*I. Obermeir*

Undecorated, round, tapering two-part shaft divided by a knob decorated with roses and leaves in relief. Gilded, cuffed right hand with long pointing index finger curved downward. Fluted finial has small attached ring that holds the chain. The owner's name is engraved in a large fine script.

### 28

**Torah Pointer with Arm (Yad)**
Danzig (?), 18th century (?)
Silver, traces of gilt; embossed, engraved, castings
Length 11 ½ in. (29.2 cm)

Two sections separated by beaded molding. Upper section designed as a spiral with alternating engraved bands. Lower round section decorated with stepped bands of engraving. Right hand with naturalistic forearm terminates in pointing index finger bent back. Ball finial surmounted by finely cast lion's head, mouth holds rings of the chain (cat. no. 28–A); attached to the other end of the chain, a ringed ball.

The conjecture that this pointer may have been made in Danzig is based on Danzig pointers in which a dolphin head holds an additional arm with pointing finger (Jewish Museum, New York, D37). However, it is possible that here the forearm/hand section is a replacement. Whether the index finger was bent under by design or use is unclear.

Both pointers were used for many years in the arks in the Temple sanctuaries.

References

S. Kayser and G. Schoenberger, *Jewish Ceremonial Art,* 1955, cat. no. 63; *Danzig 1939,* 1980, cat. no. 92.

(CEE 72–23)
(CEE 72–4)

27 / 28

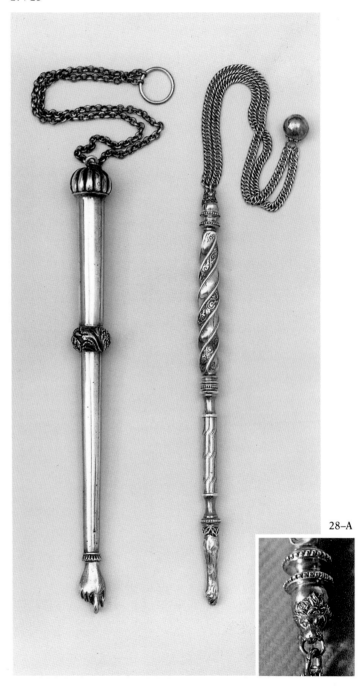

28–A

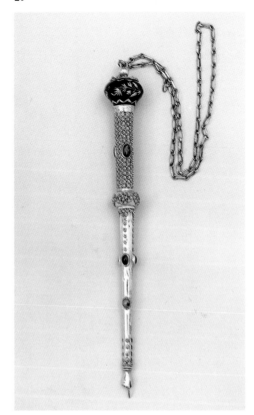

## 29

# Bezalel School Torah Pointer (Yad)

Jerusalem, about 1912
Bezalel School of Arts and Crafts
Silver, filigree, embossed, cast; set stones and gold inlay on oxidized metal
Length 11¾ in. (29.5 cm)

INSCRIBED
On rim below finial
בצלאל ירושלם
Bezalel Jerusalem

Two-part pointer with tapered shaft. Upper section encrusted with filigree roundels set with three dark oval stones; separated from lower section by a globular knob decorated with similar filigree elements. Lower section ornamented with four stones and filigree elements imitates an embroidered sleeve. A small cast right hand with delicate, curved index finger. Globular finial of black oxidized metal inset with gold leaf sprigs and zigzag lines. Filigree and small ball top screws the piece together.

Judge Irving Lehman wrote about this piece in his notebook, "Brought from Jerusalem by Mr. and Mrs. Straus in 1912. Stones are ancient from ruins of Samaria." According to an Israel Museum catalog (*"Bezalel" of Schatz*) concerning a related pointer, the filigree is of Yemenite workmanship.

Reference
*"Bezalel" of Schatz,* 1983, cat. no. 700, p. 61.

Literature
I. Lehman, List of one hundred eleven objects, circa 1928, no. 15.

BEQUEST OF JUDGE IRVING LEHMAN, 1945
(CEE 45–18)

## 30/31/32

# Torah Pointers (*Yadaim*)

### 30
**Torah Pointer with Hand Finial (Yad)**
German (?), 19th century
Silver, partial gilt; filigree, stamped, soldered
Length 11½ in. (29.2 cm)

30 / 31 / 32

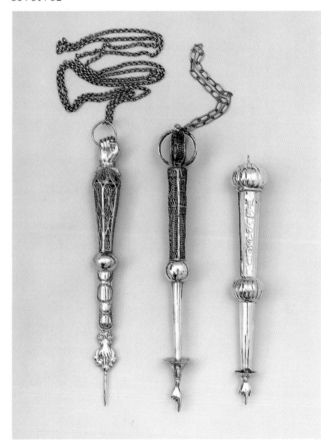

Two tapered filigree sections joined by a gilded, stamped knob. At one end, a gilded hand stamped on a floral background from which a long, cast pointer extends; at the opposite end, a larger gilded hand with jester sleeve holds a ring finial. The filigree work has been partially melted by repairs, and the hand and finial appear to be replacements. The lower section has sustained a loss in its center and has been reassembled with an obvious discontinuity. The repairs may have been carried out in Hungary during the 1920/30s.

### 31

**Torah Pointer with Filigree Top (Yad)**
SILVERSMITH: J. Berg
United States, 1930s (?)
Silver, filigree, embossed; cast
Length 11½ in. (29.2 cm)
MARKS: Master; *STERLING*

Two-part tapered pointer with lower section composed of cast pointing right hand and separate rolled flaring cuff and plain shaft terminating with smooth knob. Upper section composed of filigree elements. Finial composed of four bands of filigree creating an open globe with upper ring holding a chain.

### 32

**Torah Pointer with Engraved Top (Yad)**
SILVERSMITH: J.V.(?) T.V.(?)
Probably Central Europe, early 20th century
Silver, embossed, engraved; cast
Length 10 in. (25.4 cm)

Tapered shaft in two sections, alternately engraved octagonal sides above and a smooth rounded tapered shape below. Fluted knob divides the sections and another serves as a finial. Small pointing cast right hand has a simple flared cuff.

Pointers are a favored personal ritual object. Broken pointers are often repaired with new parts, or are sometimes assembled from unrelated parts.

Literature

C. Grossman, *Days of Awe*, 1986.

BEQUEST OF JUDGE IRVING LEHMAN, 1945
(CEE 45–17)
DONOR UNKNOWN
(CEE 29–35)
BEQUEST OF JUDGE IRVING LEHMAN, 1945
(CEE 45–238)

### 33

# Torah Pointer (Yad)

Eastern Europe, 18th century (?)
Silver, embossed, filigree; cast
Length 12¼ in. (31.2 cm)

INSCRIBED
On upper shaft
Graffiti initials *D F*

Large right-handed pointer with slightly tapered, smooth shaft made in two sections separated by a swelling filigree rim. Similar, more globular filigree form serves as cuff for large stylized cast hand with large, slightly bent pointing index finger. Globular finial with slight traces of gilt has upper section ornamented with beaded filigree roundels. A small attached ring holds the chain. The pointer shows evidence of extensive repairs and melting, as well as loss of filigree elements.

From the indentations on the cast hand one can see that the piece at one time included a slim shaft, probably a scroll, held in three clenched fingers.

GIFT OF MR. AND MRS. HENRY M. TOCH, 1928
(CEE 29–26)

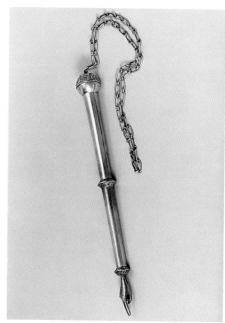

33

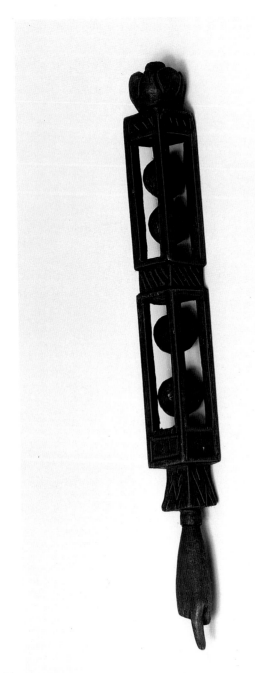

## 34

# Wooden Torah Pointer (Yad)

Eastern Europe, 1838
Wood, carved, stained
Length 8¾ in. (22.2 cm)

INSCRIBED
ת / ק / צ / ח
1837/38

Pointer carved of a single piece of wood designed as two open rectangular frames within each of which two balls move freely. Below the shaft a flaring cuff holds simplified pointing right hand with short fingers. Flower finial above has a small hole which held a ring or cord. Carved Hebrew letters, one on each side, serve as numerical abbreviations for the year [5]598 (1837/38).

Skillfully carved of one piece of wood with moving beads within, this pointer combines the folk charm of toy-making with a mystical religious tradition that incorporates noisemaking. This pointer supposedly came from a synagogue in the Carpathian Mountains.

Reference

For a similar pointer, described as South German, nineteenth century, see N. Rosenan, *L'Année juive*, 1976, cat. no. 60, pp. 53, 60.

GIFT OF JULIUS CARLEBACH, THROUGH RABBI NATHAN A. PERILMAN, 1939
(CEE 39–1)

## 35/36

# Rabinowitz Torah Pointers (*Yadaim*)

### 35
**Torah Pointer (Yad)**
MASTER: Harold Rabinowitz
New York City, 1987
Sterling silver; 14K gold
Length 12⅜ in. (31.4 cm)
MARKS: *RABINOWITZ; STERLING; TOBE PASCHER WORKSHOP, THE JEWISH MUSEUM*

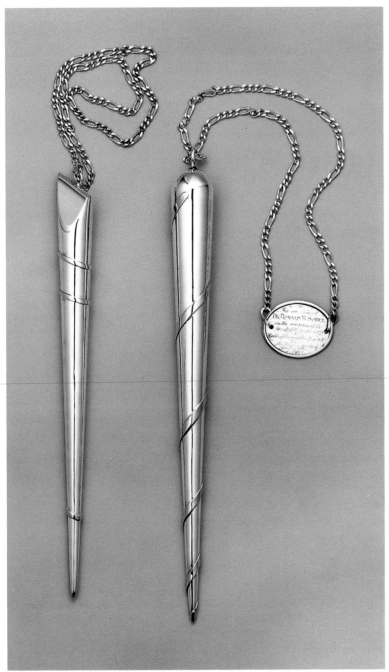

Rounded one-piece tapered silver shaft ornamented with three gold bands and a small gold tip. Sharply indented top suggests the top of a cantorial headdress. A small ring soldered to the top holds the chain.

The pointer without a realistic hand has predecessors in eighteenth-century Dutch and later North African types. This pointer, kept in the ark of Temple Emanu-El, is used during the reading of the Torah.

## 36

**Torah Pointer (Yad)**
MASTER: Harold Rabinowitz
New York City, 1987
Sterling silver; 14K gold
Length 13 ¾ in. (35 cm)
MARKS: *RABINOWITZ; STERLING; TOBE PASCHER WORKSHOP, THE JEWISH MUSEUM*

INSCRIBED
On plaque
*For our beloved / DR. RONALD B. SOBEL / on the occasion of his / Twenty-fifth Anniversary / as / Rabbi of Congregation Emanu-El / from / The Women's Auxiliary / New York City / 1987*

Simple rounded one-piece silver pointer with a full round top tapering to a point. Applied gold band spiraling entire length of shaft forms part of the point. Silver ring soldered to the top holds chain that carries a gold-rimmed oval plaque bearing the engraved inscription.

The pointers, honoring Dr. Ronald B. Sobel and Alan Kirschberg, were commissioned from Harold Rabinowitz (born 1939), a New York silversmith who is a fellow of the Tobe Pascher workshop in the Jewish Museum. The workshop, originally under the guidance of the late Ludwig Wolpert, was founded by the Abram Kanof family to encourage the production of contemporary Jewish ritual objects.

GIFT OF REVA G. KIRSCHBERG IN HONOR OF HER HUSBAND ALAN'S 80TH BIRTHDAY, APRIL 11, 1987
(CEE 87–27)
PROMISED GIFT OF DR. RONALD B. SOBEL
(CEE 87–L1)

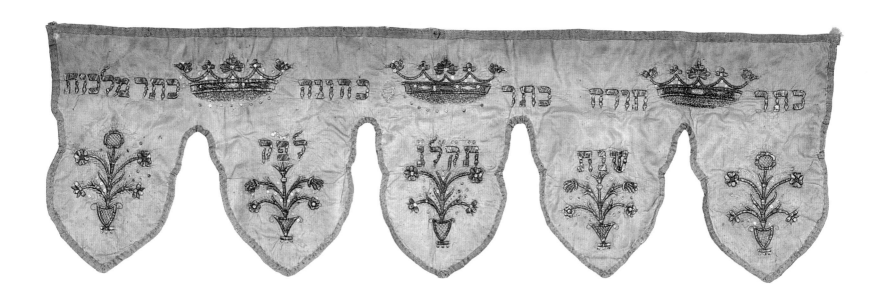

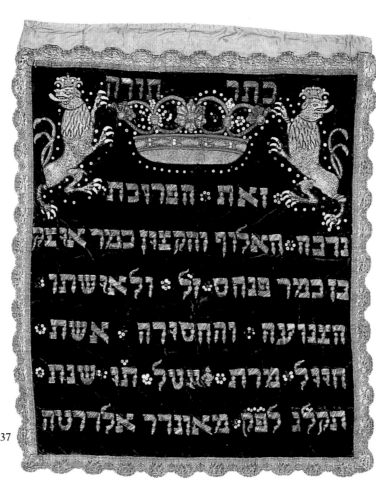

כתר תורה

ואת הפרוכת

37

## 37

# Torah Curtain Panel (fragment) and Valance

Central Europe, 1773

**Panel**
Green velvet; appliqué embroidery in silver thread, gold-covered thread, rose and green silk thread, metallic sequins
27½ x 21⅝ in. (70 x 55 cm)

**Valance**
Rose-colored silk; embroidered with silver thread, gold-covered thread, rose and green silk thread, metallic sequins; green silk ribbon
13½ x 47 in. (34.3 x 119.4 cm)

INSCRIBED
Embroidered at top of panel

כתר תורה
Crown of Torah

Embroidered on body of panel

זאת הפרוכת / נדבה האלוף והקצין כמ׳ר איצק /
בן כמ׳ר פנחס ז״ל ולאשתו / הצנועה החסידה אשת
חייל ייטל ת״ו שנת / תקל״ג לפ״ק מאונדר אלדטה

This ark curtain / was presented by the leader and chief [our] h[onored] t[eacher and] r[abbi] Itzik / the son of [our] h[onored] t[eacher] and r[abbi] Pinḥas [may his] m[emory be a] b[lessing] and his humble and pious wife / a woman of valor Yeitl [may] she [live] and [flourish] in the year / [5]533 (1772/73) from Onder Eldatah (?)

Embroidered across top of valance

כתר תורה כתר כהונה כתר מלכות / שנת ת׳ק׳ל׳ג׳ לפ׳ק
Crown of Torah crown of priesthood crown of royalty (Pirke Avot 4:13) / In the year [5]533 (1772/73)

Embroidered green velvet panel bordered by scalloped silver metallic braid. Above, animated, double-tailed, bearded rampant lions support a large open crown, embroidered in rose and green silk threads and gold-covered threads, all appliquéd to the ground. The appliquéd inscription embroidered in silver thread fills the remainder of the panel. Valance with five deep scallops of rose-colored silk banded by green silk ribbon. Three open crowns, Hebrew inscriptions, five vases with flowers, and the date in Hebrew embroidered in rose and green silk threads and gold and silver metallic threads, all appliquéd. Sequins enliven the surface.

The fragment of a Torah curtain resides in this center panel, or "mirror," whose folded-back edges reveal that the curtain was originally rose-colored silk, as was the valance. The style of a densely embroidered mirror panel often on a green velvet ground edged with metallic braid or lace and set on plain or weave-patterned dress silk is seen in other curtains of mid-eighteenth-century Europe. The embroidery was done by professional embroiderers, but it often has a vitality close to folk art, as can be seen in these lions, looking backward, with prominent almost birdlike paws, and by the use of sequins, which is unconventional and folkish.

The center panel was called a "mirror" probably because of its reflective quality. Made usually of metallic fabrics or metallic embroidered inscriptions which no doubt shone, the "mirror" can be compared to the glitter of the gold leaf in manuscripts, which has earned them their designation as illuminations. The use of mirror relates as well to its mystic properties, which, like the sound of bells, can repel evil spirits (evil eye).

The Hebrew inscription, which follows the usual highly embellished form, gives the name of the donor and his wife, in this case, Itzik and Yeitl Pinhas. It is replete with honorifics, includes the mention of his late father and the fervent hope for the long life of his wife, who was apparently an admirable woman.

The salvage of the center panel when the rest of the curtain was beyond repair was a common occurrence. Had the piece remained within its own community it might well have been reused in a new curtain with the remnants of the valance incorporated into it.

The place-name Onder Eldatah, probably Dutch, has not been identified.

Restored by the Textile Conservation Workshop, South Salem, New York, 1980.

Reference

For a similar curtain, see B. Kirshenblatt-Gimblett and C. Grossman, *Fabric of Jewish Life*, 1977, cat. no. 23, p. 20.

BEQUEST OF JUDGE IRVING LEHMAN, 1945
(CEE 45–236A/B)

## 38

# Torah Curtain (*Parokhet*) and Valance

Bratislava, 1832/33
Yellow silk; embroidered with gold and silver metallic
thread, and silk thread, appliquéd with colored silver foils,
sequins, studs, shell; hung with silver bells
CURTAIN: 93 x 58 in. (236.2 x 147.4 cm)
VALANCE: 26 x 69½ in. (66 x 176.6 cm)
MARKS (on bells): Place (Rosenberg, no. 9341); date for
1821 (Rosenberg, no. 9361)
*Figure 1*

INSCRIBED
Embroidered on upper corners of center panel

כתר תורה

Crown of Torah

Embroidered on Tablets of the Law

אנכי יי׳ / לא יהיה לך / לא תשא / זכור את יום / כבד את
לא תרצח / לא תנאף / לא תגנב / לא תענה / לא תחמד

I am the Lord (your God) / You shall have no (other gods beside
Me) / You shall not swear (falsely) / Remember (the Sabbath)
Day / Honor (your father and mother)
You shall not murder / You shall not commit adultery / You shall
not steal / You shall not bear (false witness) / You shall not covet
(Exod. 20:2–14)

Embroidered on lower section of center panel

זאת ועוד אחרת / הניח אחריו ברכה למשמרת ה׳ה׳
המנו׳ / ה׳ אברהם גרינוולד סג׳ל לבנו הבח׳ איצק
ס׳ לזכר׳ בהיכ׳ה׳ / ש׳ ע׳ב׳ו׳ד׳ת׳ ה׳ל׳ו׳י׳ם׳ לפ״ק

This and more (was) left / as a remembrance of th[is] w[orld] /
(by) the l[ate] Abraham Gruenwald Segal (the Levite) / for
his son the y[oung man] Itzik as a s[ign] in [his] memory
BHYḰH (?) / [in the] y[ear] service of the Levites (chronogram
for the year [5]593, i.e., 1832/33)

Side panels and upper central portion of curtain each formed
of three pieces of yellow silk sewn together. Fabric woven with
metallic stripes, embroidered with floral designs and appliquéd
with colored silver foils, sequins, studs, and pieces of shell. Six
silver bells hang above center panel of red velvet edged with
gold braid. On center panel, motifs of appliquéd raised silver
embroidered with metallic and blue and red silk thread relate
to the Temple: Tablets of the Law framed by draped curtains
set between columns on which rampant lions support central
cartouche and crown above. Valance made of a single panel of
embroidered yellow silk edged with scallops trimmed with
metallic fringe (cat. no. 38–A).

38–A

The reuse of beautiful fabrics was common in Europe.
In this case, the fragile but glittering curtain was pieced
together from what was once a fabulous silk ball gown.
The curtain originally hung before a Torah ark; it was
enlarged at Temple Emanu-El with additional yellow
fabric in order to serve as a lining for the Ark in the main
Sanctuary. It has since been removed from the Ark.

The cartouche surmounted with a crown on the
red velvet center panel is very similar to designs on
silver Torah shields made at the turn of the nineteenth
century. In both instances the curtains are shown drawn
up in exaggerated poufs, creating a characteristic
baroque silhouette framing the Tablets of the Law
within. The Hebrew inscription on this panel is embroi-
dered with a pitcher and laver, referring to the Levites,
who performed the ritual hand washing in the ancient
Temple. It is set within the lower inscription in which
the donor is noted as being a Levite.

The undeciphered "BHYḰH" may be an abbrevi-
ation for "BYHK"—*Be-Yom Ha-Kippurim*—in which
case this curtain may have been dedicated on the Day
of Atonement in the year 1812.

Valance restored by the Textile Conservation Workshop, South Salem,
New York, 1984.

References

For an example of a similar Torah shield, see N. Rosenan, *L'Année juive*,
1976, cat. no. 36, p. 34. For examples of Torah curtains fashioned of
reused silks, see B. Kirshenblatt-Gimblett and C. Grossman, *Fabric of
Jewish Life*, 1977, nos. 49, 23, 25, 30, 31, 45, 46.

GIFT OF LUDWIG VOGELSTEIN, 1929
(CEE 29–56A/B)

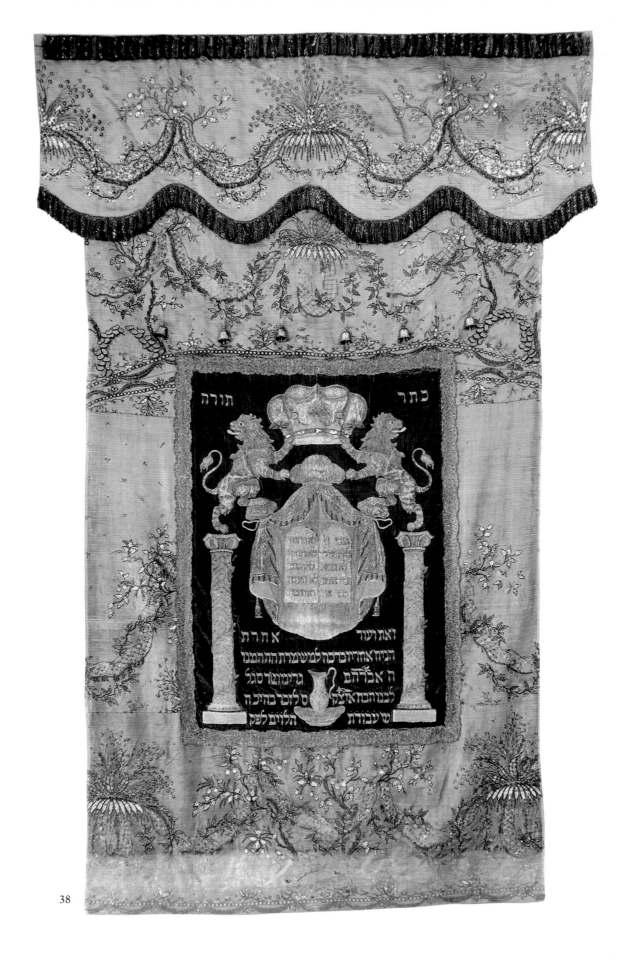

38

# Torah Binders

Binders hold the Torah scroll in place for a particular reading. The scroll is then covered with a mantle and further adorned with a Torah shield, crown, or finials, and stored in the Holy Ark of the synagogue.

The binder is often merely a length of braid, a piece of ribbon, or strip of fabric, but in south Germany centuries ago it became elaborated into a folk art form fashioned from the linen or cotton cloth that held the male infant during the rite of circumcision. The cloth was divided into strips, sewn together lengthwise, and painted or embroidered with an inscription derived from the blessing recited during the circumcision ceremony, "May he grow up to Torah, to huppah, and to good deeds, Amen." The formula was embellished with the name of the child, his father's name, his birthday,

and his zodiac sign. Often representations of the marriage canopy or depictions of the boy holding the scroll at his becoming bar mitzvah were added. The Hebrew letters of the inscription were decorated with flowers, foliage, and animals, much like the ornament of Ashkenazic Hebrew illuminated manuscripts.

In Italy, a related custom arose, centered around the hopes and prayers of women. Jewish women created binders for the Torah scroll using beautiful silk brocades, linens, and fine needlework. The prayers inscribed on these long binders relate the desire for children, thanksgiving on a marriage, or hope for the long life of a dear husband or father. The Italian embroideries are often dated and give the name of the maker. "Made by my hand" is often part of the inscription.

## 39

## Torah Binder (*Wimpel*)

Germany, 1761
Silk embroidery on linen
Height 6 in. (15.2 cm), length 152 in. (386.1 cm)

Four linen panels (one 37 inches, another 38½ inches, and two of 38¼ inches each) connected selvage-to-selvage with interlocking buttonhole stitch. Edges turned under and embroidered with varicolored threads. Letters of the inscription embroidered in chain stitch in silk thread of rose, blue, green, gold, and beige.

MAIN TEXT

משה בר יעקב שליט' נולד במ' ביום ה ה ניסן תצא ל' השם
יגדל" בתורה ולחופה ולמעשים טובים אמן סלה

Moshe, son of Yaakov, may [he live] l[ong and] h[appy] d[ays, amen]. Born under a g[ood] s[ign] on the fifth day [of the week] 5 Nisan [5]521 according to [the short counting] (1761). May God raise him in Torah, and to huppah, and to good deeds. Amen. Selah.

Above pencil drawing of ram and small embroidery of ram

מזל טוב

Mazal tov

39–A

Within embroidery of Torah scroll

עץ חיים היא למחזיקי'

It is a tree of life to those that hold it fast (Prov. 3:18)

The penciled and embroidered ram is Moshe's zodiac sign, *Taleh* (Aries). The Hebrew calendar corresponds to the Persian calendar and is based on the twenty-eight-day month with an additional month (second Adar) in some years. The words *mazal tov* mean "a good sign," so that in wishing a person good luck one wishes that the occasion is propitious. Shown in the detail (cat. no.

39–A) is an embroidered huppah (marriage canopy).

This binder was formerly in the collection of Sigmund S. Harrison.

GIFT OF MR. AND MRS. DONALD E. NEWHOUSE, 1982
(CEE 82–2)

## 40

# Nathan Straus Torah Binder (*Wimpel*)

Otterberg, Germany, 1848
Ink and paint on linen; silk embroidered edge
Height 6½ in. (16.5 cm), length 136 in. (345.4 cm)

Four pieces of linen (each 34¼ inches) attached at the selvages by fagoting. The long edges turned under and embroidered with buttonhole stitch in various colors of silk thread. Inscription outlined in ink and filled in with wavy brush strokes in red, yellow, and green.

MAIN TEXT

נתן בר אלעזר הלוי נולד במז"ט ביום ב' כ"ו שבט תרח לפק
ה יגדלו לתורה ולחופה ולמעשים טובים אמן סלה

Natan, son of Elazar Halevi, was born under a g[ood] s[ign] on the second day [of the week] 26 Shevat [5]608 according to the sh[ort] c[ounting] (1848). May God raise him to Torah, and to huppah, and to good deeds. Amen. Selah.

Below the word *Natan*

המכונה נטע

Known as Noteh

Above the pitcher

וזאת אשר ללוים

And this is what pertains to the Levites (Num. 8:24)

Above Hebrew date
*1848*

Some abbreviation marks are painted in the form of carnations. One lamed ascender is decorated with the head of a pheasant, and a pitcher is depicted for the sign of the Levites (cat. no. 40–A).

This was the binder of Nathan Straus, the father-

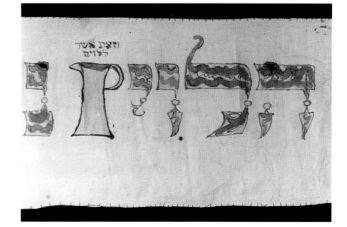

40–A

in-law of Irving Lehman. Rabbi I. S. Meyer noted that according to Judge Lehman, the binder was "presented in the year 1849 by the parents of the late Nathan Straus when he was one year old and was brought to the community synagogue for the first time."

The presence of the Yiddish name under the Hebrew name indicates that Jews often gave their children Yiddish names in addition to the name a boy was required to have that was acceptable to the rabbis for ritual occasions, such as being called to the Torah. This binder reveals that within the family circle Natan was known as Noteh.

Literature

Rabbi I. S. Meyer, "Catalogue of the Jewish Art Objects in the Collection of Judge Irving Lehman," 1932, p. 32.

BEQUEST OF JUDGE IRVING LEHMAN, 1945
(CEE 45–102)

## 41

# Avraham Rosenberger Torah Binder (*Wimpel*)

Bavaria, 1855
Paint and ink on linen
Height 7 in. (17.7 cm), length 116 in. (294.7 cm)

Four natural linen sections (29¾ inches, 28¾ inches, 29¼ inches, 28¼ inches) joined together by fagoting. Painted in red, blue, yellow, green, and tan. Fleur-de-lis, crown, fruit, flowers, the huppah, musical instruments, the six-pointed star, wheel of fortune, Tablets of the Law, and the Temple façade are the major motifs and symbols. Sayings in Hebrew and Yiddish fill the letters, with translations and explanations above and below the major text.

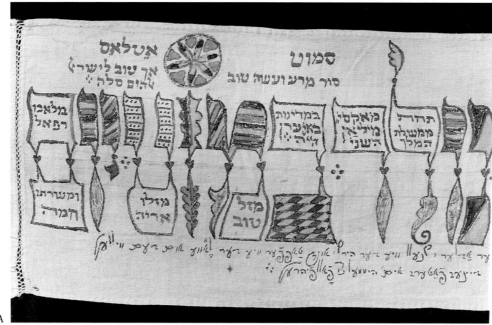

41–A

## MAIN TEXT

אברהם בר שלמה נולד במז״ט יום א' ז' אב תרט״ו לפ״ק
הקב״ה ית״ש יזכהו לגדלו לתורה ולחופה ולמעשים טובים
אמן סלה

Avraham, son of Shlomo, born under a g[ood] s[ign] on the first
day of the week 7 Av [5]615 to the sh[ort] c[ounting] (1855). May
the H[oly One], let H[is] N[ame be blessed], grant that he be
raised to Torah, and to huppah, and to good deeds. Amen Selah.

Within letters of main text, in Hebrew
May his Rock and Redeemer watch over him. May he live long
and happy days, Amen. Honor thy father and thy mother.

Known as Zalman Rosenberger, who was born from Blimele,
the daughter of Manes Neimeyer from the Holy Congregation
of Ederheim

Under the reign of King Maximilian II in the State of Bavaria
[may his Majesty be exalted].

In the first day toward the Sabbath.

His angel was Raphael and His helper is the Sun.

Seven days.

The sign of the lion. The 22d of July. The Lion ascending in the
sphere (?).

In the year five thousand six hundred and fifteen.

In Yiddish
5615 since the creation of the world.

In Hebrew
The Holy One. He was, He is, and He will be. The Holy One.
May He be blessed.

In Yiddish
The Holy One may He be praised.

In Hebrew
May His Name be exalted for eternity.

Love your neighbor as yourself (Lev. 19:18). Our Father our King.
May the Messiah come speedily and in our time. (Followed by
Yiddish translation of same.)

God our King the exalted One.

Forgive all the sins and raise up all the fallen.

Inside the bet of *Avraham*
AR
Inside the lamed of *Shlomo*
SBR

Over the words *under a good sign*
Samvet Atlas (amuletic phrase) / Shun evil and do good (Ps.
34:15). Only good to Israel. Selah. Mazal tov, his sign is the lion.

After the words *to Torah* over a depiction of a Torah stretching
behind Tablets of the Law.
Crown of Torah
Let Torah be my faith and God my Help
And I will dwell among the people Israel (Ezek. 43:7)

Within depiction of the Torah
This is the Torah that Moses set before the children of Israel
(Deut. 4:44). (Followed by Yiddish paraphrase of same.) It is a
tree of life to those that hold it fast; and the supporters thereof
are happy (Prov. 3:18). Followed by Yiddish paraphrase of same.)

Within Tablets of the Law
(First two words of each commandment)

Within depiction of curtained huppah and musical instruments
after words *to huppah*
Mazal tov. The voice of joy and the voice of gladness, the voice
of the bridegroom and the voice of the bride (Jer. 33:11). May

God rejoice over you as a bridegroom rejoices over a bride. Rejoicing and jubilation have met, and grief and sadness have fled. Be thou consecrated unto me with this ring, according to the faith of Moses and Israel (from the wedding ceremony). (Followed by Yiddish translation of previous sentence.)

And God blessed them and God said to them, "Be fertile and increase, fill the earth and master it" (Gen. 1:28). (Followed by Yiddish translation of same.)

In Yiddish
Be fruitful and multiply like chickens.

In Hebrew
Below major text
Be strong as the leopard, light as the eagle, fleet as a hart, and mighty as the lion, to do the will of thy Father, Who is in Heaven (Pirke Avot 5:20). (Followed by Yiddish translation of same.)

The day is short, and the task is great, and the laborers are sluggish, and the recompense is ample, and the Master of the house urgent (Pirke Avot 2:15). (Followed by Yiddish translation of same.)

Know what is above thee—a seeing eye, and a hearing ear, and all thy deeds recorded in a book (Pirke Avot 2:1). (Followed by Yiddish translation of same.)

Be among men a deaf man who hears, a blind man who sees, and a mute man who speaks. (Followed by Yiddish translation of same.)

Over the words *with mazal tov* in the main text is a hex sign—a flower within a circle (cat. no. 41–A)—even though the text says that Avraham's sign is the lion. Amuletic phrases and signs are meant to ward off evil spirits and protect the life of the infant boy.

Avraham Rosenberger was apparently of an illustrious family; the mention of his mother, Blimele, her father's name, and her origin in Ederheim is unusual in German Torah binders. Hebrew quotations indicate biblical scholarship, revered by Jews, but the use of Yiddish paraphrasing, Yiddish proverbs, and Yiddish names reveals a love of expressive language and make this binder an important folk art object.

GIFT OF MRS. MAX KAHN IN MEMORY OF HER BROTHER, LEON S. ALTMAYER, 1948
(CEE 48–2)

**42**

# Torah Binder (*Wimpel*)

Probably German, 1840
Paint and pencil on glazed cotton
Height 7⅞ in. (20 cm), length 144 in. (365.8 cm)

Four cotton strips (each 35 ¾ inches long) attached with fagoting and hemmed on the edges. Letters painted in many bright colors and filled with various designs.

MAIN TEXT

יוסף בר נפתלי שליט׳ נולד במז״ט יום ב׳ ט״ז תמוז ת״ר
לפ״ק השם יזכהו לגדלו לתורה ולחופה ולמעשים טובים א״ס

Yosef, son of Naftali, may [he live] l[ong and] h[appy] d[ays, amen], was born under a g[ood] s[ign] on the second day [of the week] 17 Tammuz [5]600 according to the sh[ort] c[ounting] (1840). May God grant that he be raised to Torah, and to huppah, and to good deeds. A[men]. S[elah].

In the drawing of the crowned Torah scroll following the words *to Torah*

כתר תורה
Crown of Torah

Written on the scroll

וזאת התורה / אשר שם משה / לפני בני ישראל
And this is the Torah / that Moses set / before the children of Israel (Deut. 4:44)

Within the first letter of *huppah*

מזל טוב
Mazal tov

42–A

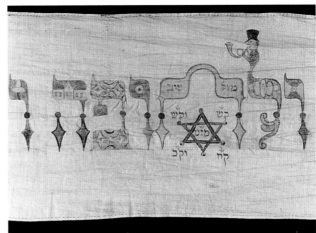

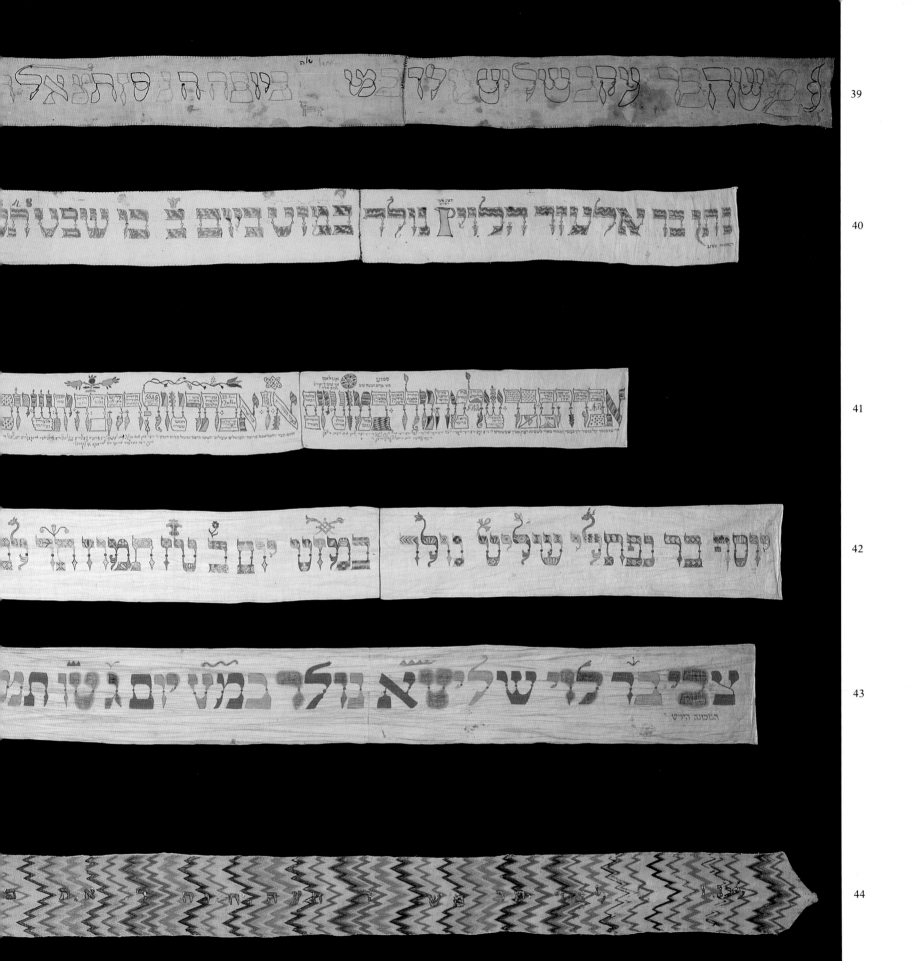

Within and around the six-pointed star

מז״ט / ק״ש / וק״ש / ק״ח / וק״כ

Maz[al] t[ov] / The v[oice of] j[oy], / and the v[oice of] g[ladness], / the v[oice of the] b[ridegroom], / and the v[oice of the] b[ride] (Jer. 33:11)

The ascenders of the letters are ornamented with flower forms and animal heads. The word *Torah* is decorated with a Torah scroll; the initial letter of *huppah* forms a marriage canopy; nearby a musician with a tall hat is the horn player "on the roof" (cat. no. 42–A).

(CEE 29–38)

## 43

# Torah Binder (*Wimpel*)

Probably German, 1857
Paint and pencil on glazed cotton
Height 8½ in. (21.7 cm), length 138½ in. (351.8 cm)

Four strips (each 34⅝ inches long) of glazed cotton joined by double seams, hemmed on all sides except for the first two lower edges, which are selvages. Text painted in glossy solid-color letters in red, blue, green, and yellow, with red dots at the articulation points of the Ashkenazic script.

MAIN TEXT

צבי ב״ר לוי שליט״א נולד במ״ט יום ג׳ ט״ו תמוז תרי״ז
לפ״ק השם יגדלהו לתורה ולחופה ולמעש״ט א״ס

Tzvi, son of R[eb] Levi, may [he live] l[ong and] h[appy days], a[men] was born under a g[ood] s[ign] on the third day [of the week] 15 Tammuz [5]617 according to the sh[ort] c[ounting] (1857). May God raise him to Torah, and to huppah, and to g[ood] d[eeds]. A[men], S[elah].

Below the name Tzvi

המכונה הירש

Known as Hirsch

Within drawing of Torah scroll after the words *to Torah*

כ״ ת״ / וזאת / התורה

C[rown of] T[orah] / and this is / the Torah

The heavy blocky letters drawn freehand emphasize the weight of the text. The only playfulness appears in

the gay little abbreviation marks over the appropriate letters. *Tzvi* means deer or hart in Hebrew and is a symbol of the land of Israel. *Hirsch*, which appears under that word here (cat. no. 43–A), is the Yiddish equivalent. In such cases the boy might be called by both names, *Tzvi Hirsch*.

(CEE 29–37)

## 44

# Torah Binder (*Mappah*)

Italy, about 1660–1700
Silk embroidery on linen with appliquéd silver inscription; linen lining
Height about 7¼ in. (18.5 cm), length 145½ in. (369.5) cm)

Two pieces of linen fabric lined with three pieces of undyed linen. Ground embroidered in silk threads of natural, light browns, greens, blues, grays, and pink. Letters embroidered in silver-wrapped thread over paper and appliquéd onto the embroidered ground. In ink on back, written by hand, *1671*. The green tie affixed to the pointed tongue at one end is probably a replacement. One band of color is lost through complete deterioration of the dye, and many of the appliquéd letters are now missing.

TEXT
Reconstruction from remaining letters

לכבוד יוי ולכבוד התורה מעשה ידי ] [ בשנת הללו ה
הללו אל בקדשו

To honor the Lord and to honor the Torah / the work of my hands [    ] in the year Hallelujah. Praise God in His sanctuary (Ps. 150:1) 448 (?) (1688)

44–A

This remarkable binder is made entirely in Bargello-type embroidery, an allover flame-stitch pattern that required great skill and patience (cat. no. 44–A). The silver work was prepared separately and then appliquéd because the metal, had it been embroidered through the flame-stitched silk ground, would have cut the threads. Even so, the silver has been abraded by its use on the Torah, and the many losses preclude an accurate dating and a complete reading of the text. The conclusion of the text contains a chronogram for the year date, which would appear to be 1688. The embroiderer has inserted an extra letter in the quotation (the tet, which equals 400) in order to achieve the numbers required to complete the date. The lost color may have been of a darker pigment, such as black or dark blue.

This binder was formerly in the collection of Sigmund E. Harrison.

References

For similar workmanship on a Torah mantle, see S. Bondoni and G. Busi, *Cultura ebraica in Emilia-Romagna*, 1987, p. 273, colorplate p. 626; C. Grossman, ''Italian Torah Binders,'' 1980, pp. 35–43.

GIFT OF MR. AND MRS. DONALD E. NEWHOUSE, 1982
(CEE 82–3)

## 45

# Torah Binder (*Wimpel*)

United States, 1855
Multicolor paint on glazed cotton
Height 8½ in. (21.6 cm), length 144 in. (366 cm)

Four strips of glazed cotton (each 36 inches long) sewn selvage to selvage, hemmed top and bottom in a fine hand. Letters painted in bright multicolor pigments and filled with colored designs and pictures. Among them, a painted eagle wearing a shield and carrying olive branches serves as an abbreviation sign over the zayin in *mazal tov* (cat. no. 45, detail).

MAIN TEXT
שלמה בר אהרן ש״י נולד במז״ט יום ש״ק כ״ג טבת תרט״ו
לפ״ק השם יזכנו לגדלו לתורה ולחופה ולמעשים טובים. א״ס

Shlomo, son of Aharon, may he [live], was born under a g[ood] s[ign] on [the] h[oly] S[abbath] day 23 Tevet [5]615 according to the sh[ort] c[ounting] (1855). May God grant that he be raised to Torah, and to huppah, and to good deeds. A[men] S[elah].

Under the word *Shlomo*
המכונה זאלאמאן בערלין
Known as Solomon Berlin

Within Torah scroll
וזאת התורה / אשר שם משה / לפני בני ישראל
And this is the Torah / that Moses set / before the children of Israel (Deut. 4:44).

Within six-pointed star under huppah
מז״ט
Maz[al] t[ov]

(CEE 85–10)

## 46

# Torah Binder (*Wimpel*)

United States, 1858
Dark blue and red colors on linen
Height 6 in. (15.3 cm), length 138⅞ in. (352.7 cm)

Four strips (34½ inches, 34¾ inches, 34⅞ inches, 35 inches) sewn selvage to selvage, hemmed on upper and lower edges. Dark blue and red colors outline the letters and fill them with linear designs. Flags and snakes embellish the ascenders. The family name, May, is written within a small structure, thus visualizing the house of May (cat. no. 46, detail).

MAIN TEXT

אלעזר ב״ר אליהו נולד במז״ט יום ג' ר״ח ניסן תרי״ח לפ״ק
השם יזכהו לגדלו לתורה ולחופה ולמעשים טובים. אמן

Elazar s[on of] R[eb] Eliyahu was born under a g[ood] s[ign] on the third day [of the week] the fi[rst of] Nisan [5]618 according to the sh[ort] c[ounting] (1858). May God grant that he be raised to Torah, and to huppah, and to good deeds. Amen.

Within a house under the name *Eliyahu*

מאי

May

Within rendering of a huppah above the word *huppah*

קול ששון / קול שמחה

The voice of joy / the voice of gladness (Jer. 33:11)

The fabric is marked: ALL PURE LINEN, Manufactured and bleached by Hugh Wallace Glengormly Belfast 4/4 wide.

(CEE 85–11)

## 47

# Torah Binder (*Wimpel*)

United States, 1852
Multicolored paint on linen
Height 8¾ in. (22.3 cm), length 138 in. (350.8 cm)

Four strips (each measuring 34½ inches) sewn selvage to selvage and hemmed top and bottom. Drawn stylized Ashkenazic letters colored in a feathery pattern that suggests embroidery. An unusual depiction of the huppah as two columns arched by flowers and leaves (cat. no. 47, detail).

MAIN TEXT

צבי בר שמואל נולד במז״ט יום ה' י״ז אייר תר״יב לפ״ק
השם יגדליהו לתורה ולחופה ולמעשים טובים אמן סלה

Tzvi, son of Shmuel, was born under a g[ood] s[ign] on the fifth day [of the week] 17 Iyyar [5]612 according to the sh[ort] c[ounting] (1852). May God raise him to Torah, and to huppah, and to good deeds. Amen. Selah.

Under the name *Tzvi*

המכונה הירש

Known as Hirsch

In Torah scroll after words *to Torah*

וזאת התורה אשר / שם משה לפני בני / ישראל עץ חיים
היא למחזיקים בה / תורת י״י תמימה משיב' / טוב תורת
פיך / מאלפי זהב וכסף

And this is the Torah that / Moses set before the children / of Israel (Deut. 4:44). It is a tree of life to those that hold it fast (Prov. 3:18). / The Torah of the L[ord] is perfect, restoring the soul (Ps. 19.8). / The Torah of Thy mouth is better than / thousands of gold and silver (based on Ps. 119:72).

Within depiction of a huppah after words *and to huppah*

קול ששון וקול / שמחה קול / חתן וקול כלה

The voice of joy, and the voice / of gladness, the voice / of the bridegroom, and the voice of the bride (Jer. 33:11)

Under these Hebrew words
*Rev. D. Frank*

On the back, written in faded ink
in a cursive Ashkenazic hand

צבי בר שמואל מת ה' כ״ז אייר תריב 1852

Tzvi, son of Shmuel, died on the fifth day [of the week] 27 Iyyar [5]612 1852

(CEE 85–12)

## 48

# Torah Binder (*Wimpel*)

United States, 1860
Multicolored paint on fine glazed linen
Height 9¼ in. (23.7 cm), length 139½ in. (354.3 cm)

Four strips of linen (each 34½ inches) sewn selvage to selvage and hemmed in undyed thread. Painted over penciled guide lines in blue, green, yellow, and red. A serpent, flags, and a coachman mark the ascenders; houses appear in some of the letters; the letter yod appears in the shape of a fish (cat. no. 48, detail).

MAIN TEXT

מנחם בר שמעון ש״י נולד במז״ט יום ג' ר״ח חשון תרכ״א
לפ״ק השם יזכהו לגדלו לתורה ולחופה ולמעשים טובים א״ס

Menahem, son of Shimon, may he [prosper], was born under a g[ood] s[ign] on the third day [of the week] the f[irst day of] Heshvan [5]621 according to the sh[ort] c[ounting] (1860). May God grant that he be raised to Torah, and to huppah, and to good deeds. A[men]. S[elah].

Under words *Menahem, son of Shimon*

המכונה מאניס פראנק

Known as Mannes Frank

45

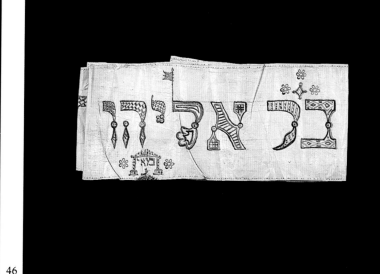

46

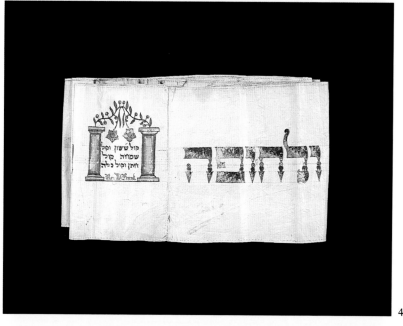

47

48

49

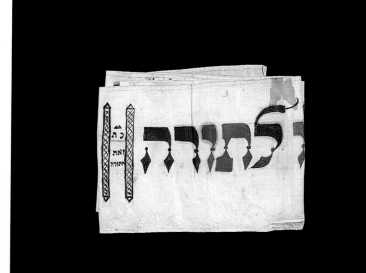

50

Beneath the word *Torah*

וזאת התורה / אשר שם משה / לפני בני ישראל

And this is the Torah / that Moses set / before the children of Israel (Deut. 4:44)

Within words *to the huppah* in a six-pointed star

מז"ט

Maz[al] t[ov]

(CEE 85–13)

## 49

# Torah Binder (*Wimpel*)

United States, 1844
Multicolored paint on linen
Height 8½ in. (21.6 cm), length 134½ in. (341.6 cm)

Four strips (each 34 inches long) joined at the selvages by an embroidery stitch. Painted in flat areas of blue, green, yellow, and red within penciled guidelines. Portions of some letter outlines and paint go over the seams, indicating that the pieces were sewn together first and then painted. The marriage canopy is freely painted, depicted as a green cloth supported by poles to which it is tied by blue ribbons (cat. no. 49, detail).

MAIN TEXT

שמעון ב"ר יחיאל נולד ב'מ'ז'ט' יום ה' כ"ג אדר תר"ד
לפ"ק ה' יגדלהו לתורה ולחופה ולמ"ט

Shimon, the s[on of] R[eb] Yehiel, was born under a g[ood] s[ign] the fifth day [of the week] 23 Adar [5]604 according to the sh[ort] c[ounting] (1844). May G[od] raise him to Torah, and to huppah, and to g[ood] d[eeds].

Under the name *Shimon*

שמעון טהאלמאן

Simon Thalman

In Torah scroll after the words *to Torah*

וזאת התורה אשר / שם משה לפני בני / ישראל עץ חיים
היא / למחזיקים וכל / דרכיה מאשר דרכי נעם / וכל
נתיבותיה שלום.

And this is the Torah that / Moses set before the children / of Israel (Deut. 4:44). It is a tree of life / to those that hold it fast, and the / supporters thereof are happy. / Its ways are ways of pleasantness / and all its paths are peace (based on Prov. 3:18, 3:17).

(CEE 85–14)

## 50

# Torah Binder (*Wimpel*)

United States, 1859
Multicolor paint on fine glazed linen
Height 8 in. (20.3 cm), length 142½ in. (362 cm)

Four strips (35⅜ inches, 36 inches, 35½ inches, 35⅝ inches) sewn together selvage to selvage and hemmed top and bottom. Simply painted in flat, dark colors of brick red, dark blue, and medium and dark greens. The Torah scroll is naively depicted as two poles with a single sheet stretched between them (cat. no. 50, detail). The oil base paint has seeped into the fabric, creating a brown aura on many letters.

MAIN TEXT

מאיר ב"ר לוי שליט"א נולד במז"ט במי"כ על יום א' י"א
תשרי תר"כ ל' השם יגדלו לתורה ולחופה ולמעשים טובי'
אמן סלה.

Meir, s[on of] R[eb] Levi, may [he live] l[ong and] h[appy days] a[men], was born under a g[ood] s[ign] on the e[ve following] Y[om] K[ippur] on the first day [of the week] 11 Tishri [5]620 according to the [short counting] (1859). May God raise him to Torah, and to huppah, and to g[ood] deeds. Amen. Selah.

Under word *Meir*

המכונה מאקס

Known as Max

Within Torah scroll after words *to Torah*

כ"ת / זאת / התורה

C[rown of] T[orah] / This is / the Torah (Deut. 4:44)

Within a huppah after words *to huppah*

במז"ט

With maz[al] t[ov]

(CEE 85–15)

## 51

# Natan Shames Pitcher and Laver

MASTER: Meyer
ENGRAVER: Natan Shames
Berlin, 1800
Silver, embossed, engraved

PITCHER
Height 10 in. (25.4 cm)

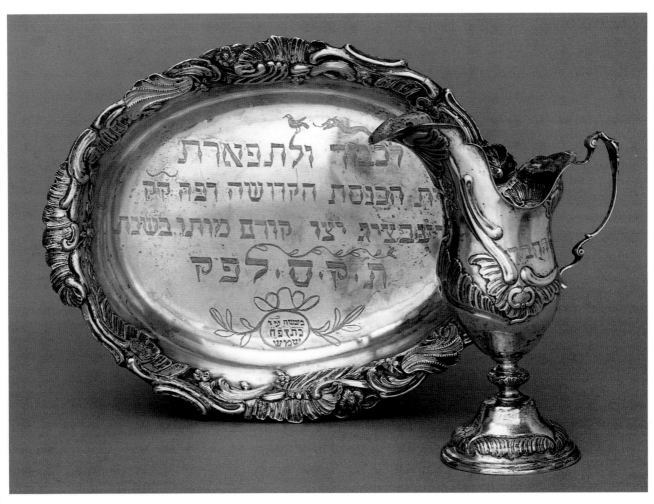

51

**LAVER**
Length 15 in., width 11½ in., depth 2 in. (38.2 x 29.2 x 5.1 cm)
MARK: Master; place and date (similar to Rosenberg, no. 1155)

INSCRIBED
On pitcher

ז" נ המנוח החבר ר' יהודה בן החבר שלמה הכהן

Th[is] is the presentation of the late member R[eb] Judah, son of the member Solomon ha-Kohen

On laver

לכבוד ולתפארת / בית הכנסת הקדושה דפה ק"ק / גרעבצייג
יצ"ו קודם ומותו בשנת / ת'ק'ס לפ"ק

For the honor and glory of the holy synagogue of this place, the H[oly] C[ongregation] of Grebtzig. May [its] R[ock protect] and [give it life]! Before his death in the year [5]560 (1799/1800).

In cartouche on laver

נעשה ע"י / נתן פ"ה / שמש

Made by the h[and of] Natan, f[unctionary of] the [community], Shames.

Flaring pitcher on an oval stepped base with scrolling handle embossed with scroll and wave patterning. Hands of the priests (*kohanim*) wheel-engraved above the name of the donor, Shlomo ha-Kohen, whose surname means "priest" in Hebrew.

The ascender of the lamed decorated with the head of a serpent. Shallow oval basin similarly embossed with scroll and wave patterning, the edge freely conforming to the design. Engraved on one of the ascenders, a snake with outstretched tongue; on another, a bird perches. A leaf and vine design outlines the cartouche within which is the name of the engraver.

This set is an example of the practice of purchasing stock objects from a Christian workshop in a big city and taking them back to a small town where they were personalized by Jewish craftsmen. In this case the mention of the synagogue indicates that the set was specifically intended for the ritual washing of the hands. The Jewish engraver, Natan Shames, proudly declares that it was made by his hand. This Jewish folk artist uses the inscription creatively by altering the size and thickness of the individual letters and adding animals and linear detail as further embellishments.

Grebtzig, the place named in the inscription, has yet to be identified.

BEQUEST OF JUDGE IRVING LEHMAN, 1945
(CEE 45–123/124)

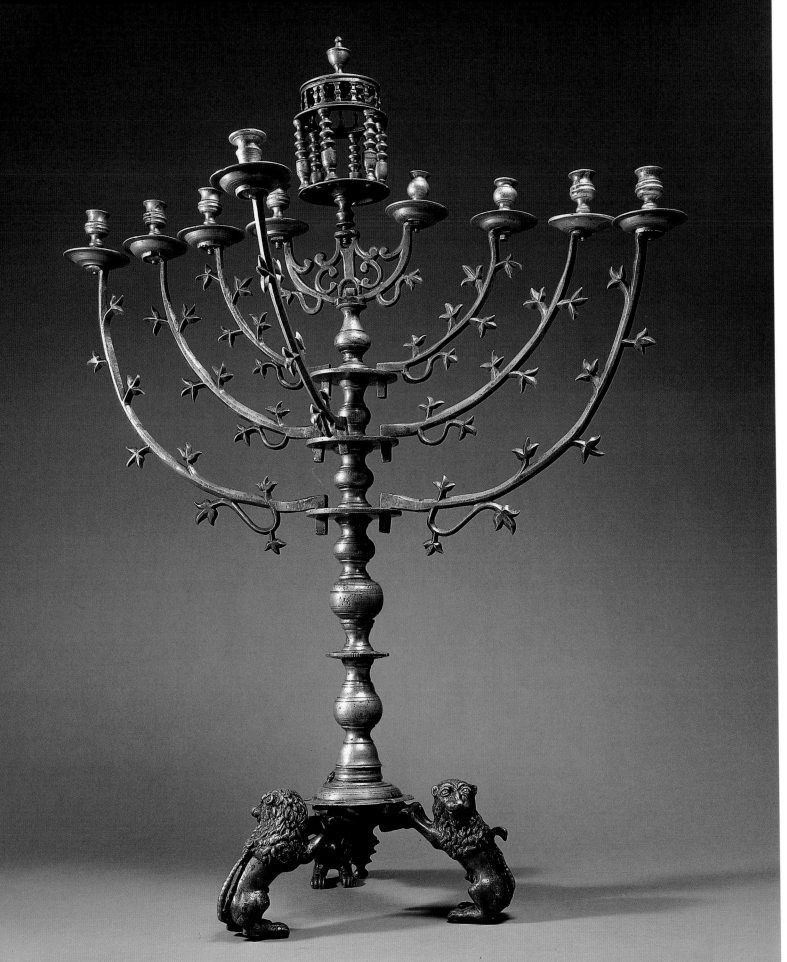

**52**

# Emanu-El Sanctuary Standing Hanukkah Menorah

Poland, probably 17th century
Cast brass
51½ x 40 in. (131 x 102 cm)

Eight curved branches with lily flower attachments on the stems fit horizontally into knobbed central shaft. The six lower, removable branches fit into rectangular openings on protruding rims of the shaft; the two uppermost branches formed as one piece with scrolled center that holds an elaborate rotunda with urn-shaped finial. The servant light (shammash) stretching forward on a tall branch matches the other branches. Three muscular rampant lions facing left with full manes and long tails folded back on their spines support the base. Large brass fitting that holds the piece together protrudes from below the base. Six round holes on both the lower rim of the shaft and rim of the base reveal the loss of twelve ornaments that originally encircled this lower section. These ornaments were probably brass flowers and buds, carrying out the metaphor of the menorah as a flowering tree.

The branches of this menorah are worn and no longer even; the tips of the tails of two of the supporting lions are broken off; only two of the candle holders are original; and the elaborate rotunda finial may not be original to the piece, although there is a similar top on an unpublished lamp at the Israel Museum in Jerusalem (No. 118/603).

The oldest extant Hanukkah lamps, which date from the thirteenth and fourteenth centuries, were small objects used in the doorways of homes (see cat. no. 152). When Hanukkah lamps were lit in synagogues a large standing lampstand was developed which could be seen by the congregation. The seven-branched menorah described in the Bible (Exod. 25:31–37) was modified for Hanukkah by the simple expedient of adding another double branch. The servant light was not placed over the shaft but was made as an additional protruding branch.

The seven-branched lamp was generally not used in the synagogue, although the image of the menorah appeared as a flat decorative element. The Babylonian Talmud forbade making anything—house, porch, court-

**53**

yard, table, candlestick—after the design that object had had in the Temple. One might, however, make a candlestick "with five, six, or eight [branches], but with seven he may not make one" (Menaḥoth, 28b). There were exceptions to this proscription, however, and in some synagogues in Italy and France the seven-branched menorah decorated the bimah. Nowadays it is often used in Reform synagogues.

References

Compare N. Kleeblatt and V. Mann, *Treasures of the Jewish Museum*, 1986, pp. 76–77. See also M. Narkiss, *The Hanukkah Lamp*, 1939, cat. no. 180; B. Narkiss, "The Feast of Lights," 1986, pp. 103–24; J. Gutmann, *The Jewish Sanctuary*, 1983, p. 20.

**53**

# Synagogue Hanukkah Lamp for Oil

Poland, probably 17th century
Cast brass
32 x 35 in. (81.2 x 88.8 cm), diameter of base 15 in. (38.2 cm)

Heavy shaft formed of acorn- or vase-shaped knobs in diminishing size. Double, open scrollwork arms carry a bar supporting eight oil beakers with protruding spouts for wicks. An opening in the center of the bar reveals where the branch for the servant light (shammash), now missing, had been attached.

The flat rimmed base has two prominent holes through which large screws must have attached this lamp to a pedestal. One can imagine that a pedestal would restore the piece to a less squat and more amiable proportion. The large oil beakers must have enabled the lamp to cast a goodly light for a long period on the evenings they were lit. This lamp shows some evidence of having been converted at one time to a gaslight. There are several old repairs.

## 54

# Covered Wine Goblets for Kiddush

DESIGNER: William Myers, Sheffield Company
Brooklyn, N.Y., 1950
Silver, embossed, appliqué, castings; gilt interior
Height, each 8 in. (20.3 cm), diameter of base, each 4¼ in.
(10.9 cm)
MARKS: Left, *HANDMADE STERLING*; right, *STERLING*;
master; *HANDMADE*

INSCRIBED
On both bases

ברוך אתה י"י אלהינו מלך העולם בורא פרי הגפן

Blessed is the Lord our God, Ruler of the universe, Creator of
the fruit of the vine (Kiddush, Blessing over wine).

Inside both bases
*PRODUCED BY / JOINT COMMITTEE ON CEREMONIES /
U.A.H.C. AND C.C.A.R. / A PROJECT OF THE / UNION OF
AMERICAN HEBREW CONGREGATIONS*

On rims
Left
*IN GRATITUDE FOR / THE NEIGHBORLY GENEROSITY / OF
TEMPLE EMANU-EL / OF THE CITY OF NEW YORK / UNION
OF AMERICAN HEBREW CONGREGATIONS*

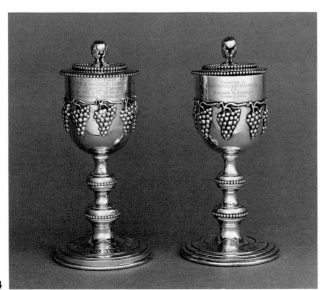

54

Right
*PRESENTED TO / CONGREGATION EMANU-EL / BY /
STEPHEN M. DRYFOOS / MARCH 6, 1950*

Each goblet set on stepped base; stem with double globular
knobs accented with silver beading. Bowl of cup encircled by
applied relief of continuous vine and grape clusters. Each cover
circled by two bands of beading, topped by round finial upheld
by four leaf forms. Inscription on base of cup on left is cutout
work; inscription on right cup is engraved.

According to Myron Schoen of the Department of Syn-
agogue Relations of the Union of American Hebrew
Congregations, this cup used for Kiddush was designed
under the patronage of the Union of American Hebrew
Congregations and was made from 1950 until 1957.
 The inscription on the base of each cup repeats
the blessing over the wine. Both cups are used regu-
larly in the Sanctuary for the Kiddush.

GIFT OF UNION OF AMERICAN HEBREW CONGREGATIONS,
1950
(CEE 50–3)
GIFT OF STEPHEN M. DRYFOOS, 1950
(CEE 50–2)

## 55

# Beth-El Wine Goblet for Kiddush

SILVERSMITH: R. & W. Wilson
United States, before 1927
Silver, embossed, chased, engraved
Height 7⅞ in. (19.4 cm), diameter of upper rim 3¾ in. (9.6 cm)
MARK: Master (Ensko, p. 230)

INSCRIBED
*Presented / to / TEMPLE BETH EL / by Myer Whitehead / & /
Louisa Whitehead*

Plain cup with engraved inscription set on a slim stem that flares
into its base. Base decorated with an embossed shell-and-scroll
motif on a flowered background.

This cup was used in Temple Beth-El prior to the merger

55

with Emanu-El in 1927. In recent years it has been used at the Passover Seder meal of Congregation Emanu-El.

GIFT OF MYER AND LOUISA WHITEHEAD

(CEE 29–41)

57

## 56

# Wolpert Sabbath Candlesticks

MASTER: Ludwig Yehuda Wolpert
New York, 1960s
Silver, embossed; applied letters
Height 11½ in. (28.2 cm), diameter of base 3½ in. (8.9 cm)
MARKS: Master; *STERLING SILVER*

INSCRIBED
Right candlestick

התעוררי התעוררי

Awake, awake

Left candlestick

כי בא אורך קומי אורי

Your light has come! Arise, shine ("Lecha Dodi")

Tall shaft shaped like a tree trunk with flaring base on which Hebrew inscription is affixed. Separate round candleholder fits into neck of shaft.

The rich hand-hammered surface, organic form, and stylized Hebrew letters attached to each other at a high horizontal are characteristic of a group of works in silver made by the silversmith and sculptor Ludwig Yehuda Wolpert (see cat. no. 169). Although the work done by Wolpert in Germany in the thirties is in the aesthetic of the Bauhaus, his later work in silver, such as these candlesticks, is expressionistic. His oeuvre consists mainly of Jewish ceremonial objects.

Reference
*Ludwig Yehuda Wolpert,* 1976.

GIFT TO THE CONGREGATION BY HIS COLLEAGUES AND THE STAFF IN HONOR OF HENRY FRUHAUF ON THE OCCASION OF HIS RETIREMENT AFTER THIRTY-EIGHT YEARS AS ADMINISTRATIVE VICE PRESIDENT OF TEMPLE EMANU-EL, 1988

(CEE 88–1)

## 57

# Set of Synagogue Honors Tablets (*Aliyah* Cards)

New York (?), early 20th century
Silver; cut out of sheet silver and engraved
Each 1½ x 1⅞ in. (3.9 x 4.7 cm)

INSCRIBED
On face of each tablet

כהן. לוי. שלישי. רביעי. חמישי. ששי. שביעי. הוספה / א.
הוספה / ב. אחרון. מפטיר. הגבה. גלילה. הוצאה / והכנסה

Kohen [First honor]. Levi [Second honor]. Third [honor]. Fourth [honor]. Fifth [honor]. Sixth [honor]. Seventh [honor]. F[irst] / additional [honor]. S[econd] / additional [honor]. Last [regular honor]. [Honor after] conclusion of Torah reading (Prophetic portion). Raising the Torah [honor]. Dressing the Torah [honor]. Taking out / and returning [the Torah] (Ark honor)

Fourteen tablets made of flat sheet silver, decorated with free-hand tool engraving of flowers, leaves, scrolls, baskets.

These tablets were kept in a small commercial calling-card case, from which the original owner's initials have been removed. They were distributed before the service by the rabbi or his assistant. When the number of the honor was called from the bimah (reader's desk), the person holding the corresponding tablet would go up to assist in the service. Such honors are generally given to congregants who serve the congregation.

GIFT OF DR. JACOB BIRNBAUM IN MEMORY OF HIS SISTER, HENRIETTA LEAH BIRNBAUM, 1987, THROUGH CANTOR HOWARD NEVISON

(CEE 87–40)

56

# Commemoratives

To honor persons for achievement and for good works it is customary for congregations to bestow an engraved medallion or gift in such forms as cups, pitchers, trays. In many instances outstanding students are rewarded with medals purchased by the school from the stock of companies which then personalize them with engraved names and dates. Occasionally special medals are commissioned, and these often bear distinctive motifs. In the case of Congregation Emanu-El and its earlier congregations, gifts to rabbis, cantors, and congregation members were often returned as gifts or bequests at later times. These contribute to the history of the congregation, not only memorializing specific persons who participated in the work of the congregation, but also preserving a sense of the taste of the time.

While some of these objects are grand, especially commissioned works, most are ordinary stock objects. In every case, however, they make permanent a moment of honor, and each recalls a specific individual for whom the Jewish community was a special part of life.

## 58

## Merzbacher Wine Goblet for Kiddush

MASTER: T. Dicker
Stuttgart, 1st half of 19th century
Silver
Height 5 ½ in. (13.9 cm)
MARKS: Master; place and date (Rosenberg, no. 4635)

INSCRIBED
*Presented / to / Rev. Dr. Merzbacher / by the School Committee of the / Congregation Anschi Cheset [sic] / New York / April 26th 1849*

Simple rounded cup set on a vase-shaped fluted stem rising from a round base embossed with scalloped rim.

The large plain surface of this cup makes it an excellent presentation piece, providing a large dedication space whose elegant engraving is balanced by the detail below.

The Reverend Dr. Leo Merzbacher (d. 1856) was rabbi of Congregation Anshe Chesed before he became rabbi of Congregation Emanu-El in 1845. According to the minutes of Anshe Chesed for May 6, 1849, "A bill of $9.80 for a silver cup and engraving thereon by David Goldsmith was sent in by Mr. Goodstein as one of the Schoolcommittee [*sic*] who bought the Same as a present to Dr. Merzbacher for his Services at 2 Examinations...."

Reference
M. Stern, *The Rise and Progress of Reform Judaism*, 1895, passim.

Literature
Trustees Minutes, Congregation Anshe Chesed, May 6, 1849.

GIFT OF DR. LEO MERZBACHER
(CEE 29–42)

58          59

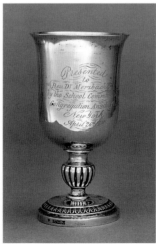 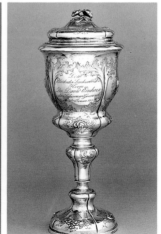

# 59

## Einhorn Covered Goblet

MASTER: P
Berlin, mid 19th century
Silver, embossed, chased, engraved
Height 15¼ in. (38.5 cm)
MARKS: Master; date (Scheffler, *Berliner*, p. XXI, no. 20); city (Rosenberg, no. 1161)

INSCRIBED
Front
*Dem / scheidenden Landesrabbinen / Herrn / Dr. David Ein-horn / die Schweriner Gemeinde / am 5ten Januar 1852*
To the / departing chief rabbi / the honorable / Dr. David Ein-horn / from the Schwerin congregation / January 5, 1852
Rear
*Samuel II 20, 42. / Ziehe hin in Frieden! / Was wir Beide uns geschworen / Gott sei zwischen mir und dir / das bleibt in Ewigkeit.*
Go in peace / forasmuch as we have sworn both of us (. . .): The Lord shall be between me and thee / (. . .) forever (1 Sam. 20:42).

Vase-shaped cup on inverted pear-shaped stem set on rounded flaring base divided vertically into four sections by deeply incised lines. Each section ornamented with embossed and engraved flower, leaf, and scroll forms. Front and back sections of bowl of cup filled with inscriptions. Cap-shaped cover continues sectioned, embossed, and engraved pattern. Two roses with leaves on a stem serve as a finial screwed to top.

In 1852 David Einhorn left the territory of Mecklen-burg-Schwerin in Germany for a Reform congregation in Budapest. The Austrian government, opposed to the Reform movement, soon closed the synagogue, and Dr. Einhorn came to the United States. In 1855 he became rabbi of Har Sinai Congregation in Baltimore. His denunciation of slavery forced him to leave Balti-more in 1861. He became rabbi of Congregation Keneseth Israel in Philadelphia, and in 1866 he moved to New York as rabbi of Adas Jeshurun.

Although the inscription cites the Biblical quota-tion as from the second book of Samuel, it is actually in the first book.

Reference
"Einhorn, David," *Encyclopaedia Judaica*, vol. 6, 1971, cols. 531–32.

GIFT OF DR. DAVID EINHORN
(CEE 29–44)

# 60

## Emanu-El Tray, Pitcher, Goblets

SILVERSMITH: Wood & Hughes
New York City, 1856
Silver, embossed, chased, engraved; castings
TRAY
Length 15¾ in. (39.9 cm), width 12 in. (30.3 cm)
PITCHER
Height 13¾ in. (35 cm), width at top 10 in. (25.4 cm)
GOBLETS
Each 5¾ in. (14.6 cm)
MARK: Master and place (Ensko, p. 249)
*Figure 9*

INSCRIBED
In cartouches on all four objects
*Presented by / The Emanu-El Temple / New York, / To the Revd. Dr. D. Einhorn / as a Token of Esteem / August 1856.*

On goblet bequeathed by Dr. Samuel Schulman
*Presented to / Rev. Dr. Samuel Schulman / By the Einhorn Family / as a Token of Appreciation / May 1909 Bequeathed to / Congregation Emanu-El / by / Rev. Dr. Samuel / Schulman / 1956*

Shallow oval tray with indented border of modernized scroll-work in high relief set on four cast feet in form of grape clusters. Tray surface has center cartouche with inscription, landscape scenes, birds, flowers, and scrolling leaves. Pitcher with flar-ing neck and spout, squat faceted body set on cast, openwork footed base. Decorated with embossed and engraved flowers, leaves, and cartouches on each side, one engraved with the façade of Temple Emanu-El on Twelfth Street, other with dedicatory inscription. High flaring handle with scale back and fishtail at top, feathered eagle head at bottom. Matching goblets with narrow stems on stepped bases; embossed cartouches with inscriptions framed by flower and scroll forms. Narrow chased beading at rim, upper portion of stem, and lower base.

The pitcher with flaring spout and biomorphic handle together with a tray was a favored presentation set of the mid-nineteenth century. Congregation Mikveh Israel of Philadelphia owns a somewhat similar set, dated 1851, inscribed to the Reverend Isaac Leeser.

Dr. David Einhorn (1809–1879) became rabbi of Adas Jeshurun in 1866. When that congregation merged with Anshe Chesed to form Congregation Beth-El he continued as rabbi. In 1879 he was succeeded by his son-in-law Dr. Kaufmann Kohler. Dr. Kohler (1843–1926)

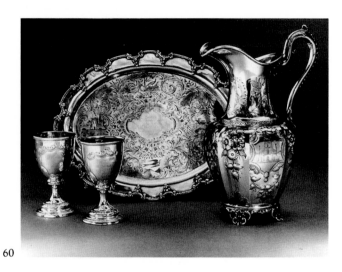

60

left Beth-El in 1903 to become president of Hebrew Union College. Dr. Samuel Schulman (1864–1955) succeeded him and became rabbi of Emanu-El when the congregations merged in 1927.

The presentation of this silver service was made by the Board of Trustees for a visiting sermon Dr. Einhorn delivered on June 21, 1855, when he was rabbi of Har Sinai Congregation in Baltimore, and for his development and strong advocacy of the principles of Reform Judaism.

### References

See C. Grossman, *A Philadelphia Sampler*, 1981, cat. no. 26. "Einhorn, David," *Encyclopaedia Judaica*, vol. 6, 1971, cols. 531–32; "Kohler, Kaufmann," *Universal Jewish Encyclopedia*, vol. 6, 1942, pp. 428–30; "Schulman, Samuel," ibid., vol. 9, 1943, pp. 428–30.

### Literature

Trustees Minutes, Temple Emanu-El, August 3, 1856; C. Grossman, *Remembrances of Times Past*, 1986.

GIFT OF DR. DAVID EINHORN
(CEE 29–43A/B)
BEQUEST OF DR. SAMUEL SCHULMAN, 1956
(CEE 56–1)
GIFT OF MISS LILI KOHLER, 1956
(CEE 56–2)

## 61

# Michelbacher Crystal Kiddush Goblet

Probably New York City, 1859
Crystal, cut and engraved
Height 6¾ in. (17 cm)

INSCRIBED
On back of goblet

וייי ב׳ר׳ך א׳ת׳ א׳ב׳רה׳ם ב׳כל לפ״ק

And the Lord had blessed Abraham in all things (Gen. 24:1) a[ccording to the] sh[ort] c[ounting] (1859)

Cut-crystal goblet with seven facets on base of cup which continue onto the stem. An engraving on the front depicts the Temple Emanu-El synagogue on Twelfth Street; on the reverse an etching of an anchor on a leafy branch, above which is the Hebrew inscription.

The sum of the letters indicated in the Hebrew verse from Genesis is 619, yielding a chronogram for the year 5619, or 1858/59. The inscription is also a play on the name of the original owner, Abraham Michelbacher (whose son donated this gift to the Collection). In 1853 Mr. Michelbacher became the first elected president of the Congregation, a post he occupied until 1864. Since the inscription is laudatory, and because the cup also pictures the synagogue on Twelfth Street (figure 5), we

61                                          62

63

## Adler Presentation Trowel

United States, 1866
Silver; ivory handle
Length 11 in. (27.7 cm), width of blade 3 in. (7.4 cm)

INSCRIBED
Obverse
*PRESENTED / to / Rev. Dr. Adler / at the / Laying of the Corner Stone / of the / TEMPLE EMANU EL" / by the / BUILDING COMMITTEE. / A. L. Langer, Sec. M. Dittman, Chairman. / M. Schloss, Wm. Seligman, / J. Stettheimer, Jacob Goldsmith, / J. Bernheimer, S. Schiffer, / New York, Oct. 30th 1866.*

Reverse
Within wreath
עמנו אל
Emanu-El

According to Trustees Minutes dated April 4, 1898, this small decorative replica of an industrial trowel was received "from the family of the late Dr. Adler and used by him in laying the corner stone of the Temple." This was the building at Fifth Avenue and Forty-third Street completed in 1868 (figure 6).

Dr. Samuel Adler (1809–1891) was born in Worms, Germany, and his first rabbinical appointment was in that city. In the early part of 1857, a few months after the death of Dr. Leo Merzbacher, he was invited to serve as rabbi of Temple Emanu-El, where he remained until 1874, when he became rabbi emeritus. Dr. Adler was a scholar and a man of action. In his native land he campaigned vigorously to remove civil inequities directed toward Jews and worked strenuously to achieve equality of the sexes in the sphere of religion. Throughout his life he contributed articles to scholarly publications and at his death left an extensive library of rabbinica, which was later given to Hebrew Union College.

Reference

"Adler, Samuel," *Jewish Encyclopedia*, vol. 1, p. 199.

Literature

Trustees Minutes, Temple Emanu-El, April 4, 1898.

GIFT OF THE FAMILY OF DR. SAMUEL ADLER, 1898
(CEE 85–17)

can presume this was a gift to Mr. Michelbacher from the Congregation. One can only wonder at the use of the anchor. Perhaps Michelbacher was an amateur yachtsman, or a boat builder.

Literature

C. Grossman, *Remembrances of Times Past*, 1986.

GIFT OF ARCHIE H. MICHELBACHER, 1940
(CEE 40–1)

62

## Silver Anniversary Kiddush Goblet

SILVERSMITH: R. & W. Wilson
Philadelphia, 1860s
Silver, embossed, engraved
Height 6⁵⁄₁₆ in. (16 cm)
MARKS: Master and place (Ensko, p. 230)

INSCRIBED
In cartouche
*May your / Silver turn / to Gold*

On base
*For the Silver Wedding of Mr. and Mrs. Michelbacher from Dr. David Einhorn Sept 25th 1864*

Hexagonal goblet set on a hexagonal vase-shaped stem and flaring double base. Decorated by engraved work that highlights the dedications.

Dr. David Einhorn (1809–1879) was rabbi of Keneseth Israel in Philadelphia when he gave this cup to his friends Janette and Abraham Michelbacher. Michelbacher, who had served as president of Emanu-El since 1853, retired in the same year that he and his wife celebrated their twenty-fifth wedding anniversary. The donor was a grandson of the Michelbachers.

Reference

"Einhorn, David," *Encyclopaedia Judaica*, vol. 6, 1971, cols. 531–32.

GIFT OF CLARENCE DOTTENHEIM, 1956
(CEE 56–3)

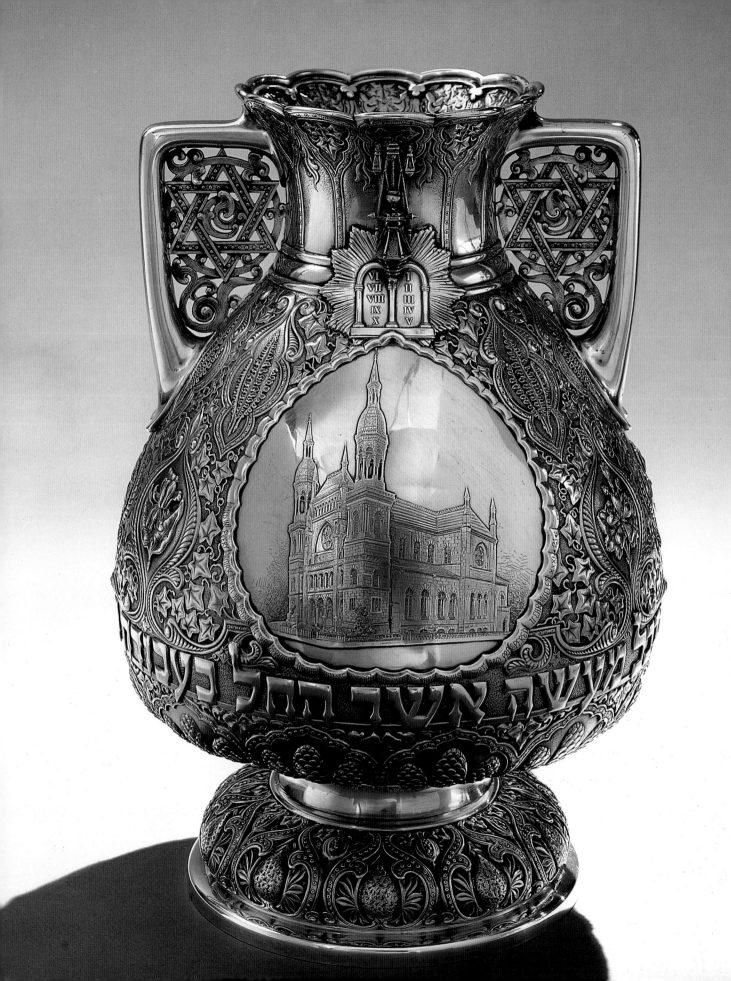

## 64

# Lewis May Presentation Vase

MASTER: Edward C. Moore, Tiffany & Co.
New York City, 1888
Silver, embossed, chased, engraved; cutout appliqué work
Height 19 in. (48.2 cm)
MARKS: Master (Carpenter, no. 20); *STERLING SILVER*

INSCRIBED
Front
On Tablets of the Law
(Roman numerals of the Ten Commandments)

Around lower body

ובכל מעשה אשר החל בעבודת בית האלהים בכל לבבו עשה
והצליח

Translation in frame of cartouche
*AND IN EVERY WORK THAT HE BEGAN IN THE SERVICE OF
THE HOUSE OF GOD HE DID IT WITH ALL HIS HEART, AND
PROSPERED II CHRONICLES XXXI:21.*

Back
On left shield
*DEUT*

On right shield
*VIII 8*

In cartouche
*Presented to / Mr. Lewis May / President of the Congregation /
Temple Emanu El / New York / In grateful recognition of his /
Twenty Five Years faithful and / devoted service as leader and /
administrator of the affairs of the / Congregation by a number /
of its members / May years of life and usefulness / be added
thereto; blessing and / peace be with him, his / beloved wife
and children.*

Above and in front of the Tablets of the Law, a three-dimensional
hanging lamp (ner tamid). Engraved in cartouche below, a view
of Temple Emanu-El at Fifth Avenue and Forty-third Street. On
the reverse, an identical cartouche contains the inscription;
above it, a shield with embossed reference to a verse in Deu-
teronomy. Entire surface outside the cartouches embellished
in high relief with decorative motifs of ivy leaves, a bee, sheaves
of wheat and barley. Bold and graceful six-pointed stars are set
within angular handles.

This large vase, impressive in size and decorative rich-
ness develops two themes in its ornamentation. The
first is the visualization of the synagogue, expressed in
the front cartouche by the engraving of the temple at
Fifth Avenue and Forty-third Street that had been com-
pleted in 1868 (figure 6). Lewis May, president of the

64–A

Congregation from May 4, 1865, to his death on July
22, 1897, had occupied that position when the syna-
gogue was commissioned and built. The inscription in
Hebrew and in English translation praises him for
twenty-five years of devotion to the synagogue.

On the reverse, shields above the cartouche are
engraved with the words "Deut VIII 8," which allude
to the second theme. The biblical quotation "A land of
wheat and barley, of vines, figs, and pomegranates, a
land of olive trees and honey" is the key that explains
the presence of ivy leaves (vines), beehive (honey),
sheaves of wheat and barley (cat. no. 64–A).

Lewis May was a devoted philanthropist. In addi-
tion to his service at Emanu-El, he was treasurer and
director of Mount Sinai Hospital in New York and an
organizer and first president of the Young Men's
Hebrew Association (*Universal Jewish Encyclopedia*,
vol. 7, p. 418). It is remarkable that Edward C. Moore
of Tiffany & Co. could so well integrate complex idea-
tional concepts to provide a presentation piece that
makes physical and real a man's devotion to his heri-
tage and his congregation.

According to Janet Zapata, Archivist for Tiffany &
Co., records list the vase as completed August 24, 1888,
weight 1679.05 Troy ounces, cost to make, $844. The
vase was presented to May at services on Thanksgiv-
ing Day, November 29, 1888.

Reference

C. Carpenter and M. Carpenter, *Tiffany Silver*, 1978, p. 251.

Literature

Trustees Minutes, Temple Emanu-El, November 5, 1888; D. Warren, K.
S. Howe, M. K. Brown, *Marks of Achievement*, 1987, cat. no. 127, p. 156.

GIFT OF WINSTON LEWIS MAY, 1931

(CEE 31–1)

## 65/66/67

# Ceremonial Keys

### 65

**Temple Beth-El Key**
New York City, 1891
Brass; formerly gold plated
Length 8¼ in. (21 cm)

INSCRIBED
*DEDICATON / OF / Temple Beth-El / Sept. 18th 1891*
*JACOB H. FLEISCH, President / DAVD MAYER, Chairman*
*Bldg. Committee*
*PRESENTED BY / BRUNNER & TRYON / ARCHITECTS*

### 66

**Temple Emanu-El Key**
New York City, 1930
White metal, silvered
Length 8¼ in. (21 cm)

INSCRIBED
On medallion
*TEMPLE EMANU-EL NEW • YORK • CITY • BUILT •*
*1927–1929*

On shaft
DEDICATION OF TEMPLE EMANU-EL AND BETH-EL CHAPEL /
JANUARY 10 • 1930 / IRVING LEHMAN, PRESIDENT /
SYDNEY H. HERMAN, VICE-PRESIDENT • WILLIAM I.
SPIEGELBERG, VICE-PRESIDENT / PRESENTED BY THE
BUILDING COMMITTEE BENJAMIN MORDECAI—
CHAIRMAN

A view in relief of the new temple is prominently depicted on this key, which is permanently displayed in the wall of the meeting room of the Board of Trustees in the Community House on Sixty-fifth Street.

### 67

**Goldsmith Religious School Key**
New York City, 1964
Brass, gold plated; enameling
Length 8⅜ in. (22 cm)

INSCRIBED
Front
*CONGREGATON EMANU-EL OF THE CITY OF NEW YORK /*
*RELIGIOUS SCHOOL / DEDICATION / 1964*

Back
*DEDICATION OF / NEW RELIGIOUS / SCHOOL / BUILDING /*
*4/19/64*

A blue-and-white enameled seal distinguishes this key, which also bears a depiction of the six-story Goldsmith Religious School building that fronts on East Sixty-sixth Street and joins the Community House on the inside.

(CEE 29–55)
(CEE 30–1)
(CEE 64–1)

## 68

# Beth-El Cup for Ritual Handwashing

SILVERSMITH: Mauser Manufacturing Company
New York City (?), 1903
Silver, embossed, engraved; weighted base
Height 6¼ in. (15.7 cm)
MARKS: Master (Rainwater, p. 103); *STERLING; 12082;*
*1½ PINT; 925/1000 FINE*

INSCRIBED
Front
*Presented / to / Dr. Kaufman [sic] Kohler / in / Loving Remembrance / by / The / Class of 1903*

Back
*Presented / to / Dr. Samuel Schulman / in / Grateful Appreciation / by / The Family of / Dr. Kaufman [sic] Kohler*

  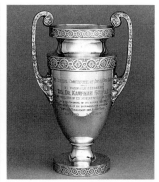

Smooth cup with three high, flaring handles on high rounded base. Inscriptions fill spaces between handles.

This simple three-handled cup, associated by its form to cups used to pour water over the hands as a benediction, has a rich history preserved in its inscriptions. It was given by the family of Dr. Kohler, presumably after his death, to Dr. Schulman, who succeeded Dr. Kohler as rabbi of Temple Beth-El. It is a physical representation of the passing on of love and responsibility. The donors are grandchildren of Dr. Schulman.

References

"Kohler, Kaufmann," *Universal Jewish Encyclopedia*, vol. 6, pp. 428–30; "Schulman, Samuel," ibid., vol. 9, pp. 428–30.

GIFT OF PEGGY MASBACH MAY AND EDWIN R. MASBACH, JR., 1985
(CEE 85–8)

## 69

# Schulman Presentation Cup

SILVERSMITH: Dieges & Clust
New York City, 1908
Silver, embossed; applied inscription
Height 11¼ in. (28.6 cm)
MARKS: Master; *23 JOHN ST. / N.Y. / STERLING; 249*

INSCRIBED
*CONGREGATION TEMPLE BETH EL / TO ITS RABBI / REV. DR. SAMUEL SCHULMAN / AS A TOKEN OF / AFFECTION AND APPRECIATION / ON THE / TENTH ANNIVERSARY OF HIS FAITHFUL / AND / EFFICIENT MINISTRY / JANUARY 1909*

Smooth vase-shaped cup on rounded base with two double-scroll handles; applied inscription within shield.

A handsome double-handled stock cup with the addition of applied lettering becomes a fitting presentation piece for ten years of rabbinic service. The early Reform title of Reverend Doctor is preserved in the inscription. The donors are grandchildren of Dr. Schulman.

Reference

"Schulman, Samuel," *Universal Jewish Encyclopedia*, vol. 9, pp. 428–30.

GIFT OF PEGGY MASBACH MAY AND EDWIN R. MASBACH, JR., 1985
(CEE 85–9)

## 70

# Kaufmann Kohler Birthday Cup

SILVERSMITH: Gorham Company
Providence, Rhode Island, 1912
Silver embossed; applied banding, cast handles
Height 10 in. (25.4 cm)
MARKS: Master and place; date (Carpenter, p. 285);
*STERLING; 1157A; 2½ PINTS*

INSCRIBED
*THE CENTRAL CONFERENCE OF AMERICAN RABBIS / TO / ITS HONORARY PRESIDENT / REV. DR. KAUFMAN [SIC] KOHLER / ON THE COMPLETION OF THE SEVENTIETH YEAR OF HIS LIFE / AS A TESTIMONIAL OF ITS ESTEEM AND ITS / APPRECIATION OF HIS DISTINGUISHED CAREER AS / SCHOLAR, THEOLOGIAN AND ACTIVE RABBI / MAY 10, 1913   3 IYAR 5673*

Two-handled vase decorated on handles, rim, body, and base with die-rolled applied bands in a style reminiscent of the Egyptian Revival.

A stock item produced by the Gorham Company, this cup nevertheless made a handsome birthday gift to an esteemed rabbi from his colleagues. Kaufmann Kohler was rabbi of Temple Beth-El from 1879 until 1903, when he became president of Hebrew Union College. He was a major innovator in Reform Judaism. The cup was given to the Collection by Dr. Kohler's daughter.

Reference

"Kohler, Kaufmann," *Universal Jewish Encyclopedia*, vol. 6, pp. 428–30.

GIFT OF MISS LILI KOHLER, 1956
(CEE 56–4)

## 71

# Saminsky Bowl

SILVERSMITH: Michael C. Fina Co.
New York City, about 1958
Silver, embossed, engraved
Height 4 ½ in. (11.4 cm), diameter 7 in. (17.8 cm)
MARKS: Master; *117; EXEMPLAR / Paul Revere / 1768*

INSCRIBED
Around upper body
*TO OUR BELOVED MAESTRO LAZARE SAMINSKY FROM THE TEMPLE EMANU-EL CHOIR NEW YORK CITY 1958*

Engraved signatures on body
*Betty Baisch, Robert Baker* (Organist), *Herman Berlinski, Dorothy Bergquist, Donald Bryan, William Gephart, Nancy Hall, William Hoffman, Martha Hoswell, Patricia J. Kavan, Lynn Meyers, Martha Reynolds, Melverne Rosen, Violet Serwin, Jerold Sienna, Clifford Snyder, Clifton Stein, Robert Strobel, James Wainner, Margaret Wilson, Arthur Wolfson* (Cantor), *Maxine Yeater.*

Smooth round bowl with slightly flaring lip set on stepped base. Inscription around rim; facsimiles of signatures distributed around body.

The "Revere" bowl has been a favorite presentation piece almost from the day Paul Revere designed and made the original. Although the bowl itself is a design cliché, the inscribed sentiments and signatures elevate it in this case to a historical document.

Lazare Saminsky (1882–1959) was Music Director at Emanu-El from 1924 to 1959. He was a well-known Russian-born composer who wrote symphonies and operas, as well as choral compositions and many works for the synagogue. His widow, Jennifer Grandower Saminsky, retired to Sandwich, England; when she was in her final illness, Elisabeth Vinaver, her old friend, found the bowl and sent it to Emanu-El.

Reference

"Saminsky, Lazare," *Encyclopaedia Judaica*, vol. 14, 1971, cols. 767–68.

GIFT OF JENNIFER GRANDOWER SAMINSKY THROUGH ELISABETH VINAVER, 1987
(CEE 87–22)

71

**72**

# Religious School Medals and Pin

Left to right
Top row
Obverse
*Mortimer Freund / MERIT*
Reverse
*Sabbath School, / Beth El*
Silver, 1¼ in. (3.2 cm)

(CEE 72–15A)

Obverse
*MORTIMER FREUND / IN / COMMEMORATION / OF / MRS. ROSIE WOLLSTEIN LICHTENFELS / LATE TEACHER / OF CLASS / VI*
Reverse
*SABBATH SCHOOL / TEMPLE BETH EL / 1895*
Gold, 1½ in. (3.8 cm)

(CEE 72–15B)

Middle row
Obverse
*EDWARD UNGER / MERIT / SABBATH SCHOOL / TEMPLE BETHEL / 1902*
Silver, 1⅜ in. (3.5 cm)

(CEE 72–13A)

Obverse
*EDWARD UNGER / SABBATH / SCHOOL / TEMPLE BETH-EL / 1903*
Silver, 1¼ in. (3.2 cm)

(CEE 72–13B)

Obverse
*EDWARD UNGER / SABBATH SCHOOL TEMPLE BETHEL / 1904*
Gold, 1½ in. (3.8 cm)
MARKS: *14K; DIEGES & CLUST / 25 JOHN ST. N.Y.*

(CEE 72–13C)

*Obverse*
*EDWARD UNGER / MERIT SABBATH SCHOOL TEMPLE BETHEL*
Sterling silver, 1½ in. (3.8 cm)
MARKS: *STERLING; DIEGES & CLUST / 25 JOHN ST. N.Y.*

(CEE 72–13D)

Bottom row
Obverse
*TEMPLE EMANUEL NEW YORK*
Reverse
*THE LEWIS MAY MEDAL / AWARDED / TO / MAURICE MENDEL / 5648 / 1888*
Gold, 1½ in. (3.8 cm)

(CEE 72–14)

Obverse
*TEMPLE EMANUEL NEW YORK*
Reverse
*THE GUSTAV GOTTHEIL MEDAL / AWARDED / TO / FRANK K. GREENWALD / 5670 / 1910*
Gold; enamel
1¼ in. (3.2 cm)

(CEE 85–1)

Obverse
*TEMPLE EMANUEL NEW YORK*
Reverse
*THE LEWIS MAY MEDAL / AWARDED / PHILIP WASSERMAN / 5671 / 1911*
Gold; enamel
1⅛ in. (2.9 cm)

(CEE 48–1)

Pin
*1917 / EMANUEL SISTERHOOD / RELIGIOUS SCHOOLS*
Metal, gilded; enamel
⅞ in. (2.2 cm)
MARK: *J. BALCO / N.Y.*

(CEE 85–3)

These medals were awarded to students of Temple Beth-El and Temple Emanu-El, which merged in 1927. They were obviously treasured by their recipients, who ultimately returned them to the Congregation. The Emanuel Sisterhood noted on the pin refers to a social service group that provided Sabbath and day schools for children of the Lower East Side.

## 73

# Nathan and Lina Straus Testimonial Scroll in Case

Jerusalem, 1928

**Scroll**
Vellum; handwritten
Height 2⅞ in. (7.3 cm)

**Megillah Case**
Ze'ev Raban (?)
Silver, embossed and engraved; filigree, semiprecious stones
Height 8¾ in. (22.2 cm)

INSCRIBED
פעולות / נתן ולינה / שטראוס
The good works of / Nathan and Lina Straus

Scroll inscribed with elegant Hebrew script sewn into cylindrical silver case decorated with three bands of filigree work composed of filigree roundels, beading, and lozenges. Rounded base and onion-domed top composed of similar filigree elements; top set with five blue stones. Short round handle below has matching filigree work in bands at bottom and top.

The text of the scroll, which is set into a type of case usually used to house a Purim scroll, records speeches

delivered in 1928 at the cornerstone ceremony of Straus House, the Medical Clinic of Hadassah Hospital. The Straus family later gave the case and scroll to their son-in-law, Irving Lehman, collector of Judaica.

Although the case is unmarked, it is in the style of Ze'ev Raban (1890–1970) of the Bezalel School of Arts and Crafts. The catalog of the exhibition *Raban Remembered*, held at Yeshiva University Museum in 1982, illustrates a similar case with scroll by Raban. In her accompanying text Batsheva Goldman mentions that Raban was commissioned to create commemorative gifts for public figures. The actual fabrication of the case was probably the work of different "departments" at Bezalel, such as those for filigree, the deep etching they called "batik," and gem-setting.

Nathan Straus (1848–1931) was a prominent New York merchant and philanthropist. With his brother Isidor he was owner (1888–96) of R. H. Macy & Co. He served as New York City's park commissioner, was president of the Board of Health, and during the last decade of the nineteenth century led the campaign for

73

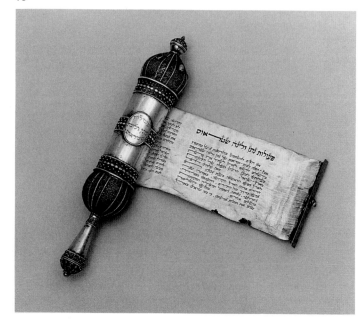

pasteurized milk. During these same years, and extending to the period after World War I, he supported lodgings and food depots for the city's unemployed, hungry, and homeless. He was also concerned with public health conditions in Palestine, especially the problems of malaria, trachoma, and the lack of sanitation. He aided war orphans in Palestine and was a major benefactor of the Jewish War Relief Fund.

In the speech contained in this scroll he speaks of the love and devotion both he and his wife, Lina, feel for the Land of Israel. In the last years of his life he devoted most of his fortune to good works in the Holy Land. This scroll and its case, then, are a modest tribute to a great humanitarian couple.

References

B. Goldman, "Raban—A Traditional Jewish Artist," 1982, pp. 57–58, fig. 4; "Straus, Nathan," *Universal Jewish Encyclopedia*, vol. 10, 1943, pp. 75–77.

Literature

*"Bezalel" of Schatz*, 1983, p. 63, no. 716.

BEQUEST OF JUDGE IRVING LEHMAN, 1945
(CEE 45–234)

## 74

# Herbert Lehman Testimonial Scroll in Case

**Scroll**
Vellum; handwritten, in Hebrew, English, and Greek
Height 5 ¼ in. (13.4 cm)

**Megillah Case**
Greece, 19th century
Height 14 in. (35.5 cm)
Silver, embossed, chased, engraved; castings

INSCRIBED
On rounded top
*To Herbert Lehman / From the Athens Jewish Community 20.7.1945*

74

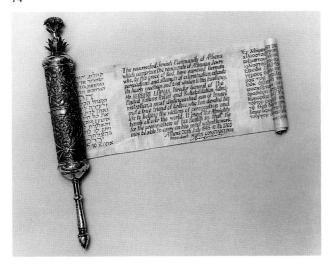

Long cylindrical silver shaft embossed with scrolls, flowers, and vines in high relief with chased background. Rounded top and bottom engraved with leaf-and-vine pattern. Finial in form of cast sunflowers in a vase surrounded by leaves screwed onto the stem; handle, a long knobbed stem with bud at bottom. Scroll sewn to a slim silver handle that fits into the shaft.

Herbert Lehman (1878–1963), member of a prominent banking family, devoted his life to philanthropy and public service. During World War I he was special adviser to the Secretary of War. From 1928 to 1932 he was lieutenant governor of New York State; at the end of that term he was elected governor and served in that capacity for ten years. From 1943 to 1946 he was director general of the United Nations Relief and Rehabilitation Administration. He culminated his career as United States senator, a position he held from 1950 to 1956. A brother of Judge Irving Lehman (1876–1945), he, like other members of the family, often gave Judaica objects to Irving, the family collector. This scroll and its silver case was such a gift.

Reference

A. Nevins, *Herbert H. Lehman and His Era*, 1963.

BEQUEST OF JUDGE IRVING LEHMAN, 1945
(CEE 45–235)

# Objects for the Home

The centrality of the home in Jewish religious observance can be likened to the centrality of the Temple in Jewish thought. The family table around which the members gather to welcome the Sabbath and partake of the Sabbath meal, to display the ritual foods of Passover and tell the story of the Exodus from Egypt can be compared with the altar of the Temple and the rituals of the Jewish priests. Even the modern voyage to rejoin the family at the Passover table can be compared with the return to Jerusalem on the pilgrimage festivals to which Jews brought offerings and came to be counted.

Special objects such as the seven-branched lampstand (menorah) and the table of showbread were originally created for the Tabernacle (Exod.

25:30–40), and the great bronze vessel held by twelve oxen was made for Solomon's Temple (2 Chron. 4). Following suit, Jews have made objects to be used at home on festivals, such as Sabbath lamps, spice containers, Hanukkah lamps, Esther scrolls, and plates for Purim and Passover. The Hanukkah lamp is a unique Jewish form, a lamp for eight lights with a differentiated ninth light.

Judaic objects that express the particular time and culture of their origin have been collected and treasured for centuries. Congregation Emanu-El has been particularly fortunate in having received as gifts and bequests the domestic objects discussed in this section, which generations of congregants have treasured.

---

## 75

## Sissie Lehman's Prayerbook in Silver Binding

BINDING
Bezalel School of Arts and Crafts
Jerusalem, 1925
Silver, embossed, engraved, chased; filigree, cast medallion
4 x 3¼ x ⅞ in. (10.2 x 8.2 x 2.2 cm)
MARKS: Bezalel Jerusalem (in Hebrew)

TEXT
Gate of Jerusalem
Hebrew Prayerbook according to the Sephardic Rite
Jerusalem, 1913
PUBLISHER: Levy and Partners
PRINTER: Naftali Dov Rabinovitch
Printed page 3¾ x 2⅝ in. (9.5 x 6.7 cm)

INSCRIBED
Front cover
כותל המערבי
The Western Wall

On Tablets
*SISIE LEHMAN / STRAUS / FROM / PAPA & MAMA*

On base of Tablets
בצלאל ירשלם
Bezalel Jerusalem

Spine
סדר / תפלת ישראל
Book / of Jewish Prayers

Front cover with upper section of filigree work and applied cast medallion showing people at prayer at the Western Wall; in lower section, in flat relief against deeply chased background ("batik" work), two eternal lights in a sea of stars flank the Tablets bearing dedication and name of the school. Raised bands of spine imitating a leather-bound book divide area in three sections; title engraved in cartouche in center panel, upper and lower panels decorated with filigree roundels. Back cover filled with flat relief elements of seven-branched lampstand (menorah) and cartouche encircled by an arabesque.

The disparate sections of the binding clearly reflect the organization of the various studios in the Bezalel School of Arts and Crafts. An object could be, and often was, made in various workshops that specialized in particular techniques and then assembled. While the techniques were well crafted, the cumulative effect could sometimes convey a sense of busyness that resulted from a lack of unity of design and workmanship.

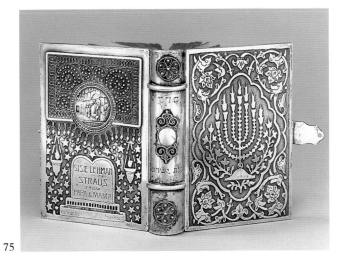

75

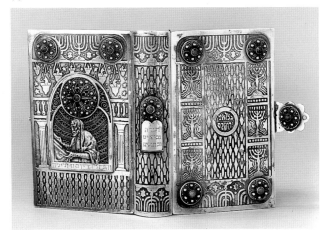

76

"Sisie" (Sissie) Straus was married to Judge Irving Lehman, a major donor to the Emanul-El Judaica collection. "Papa" was Nathan Straus, a patron of the Bezalel School of Arts and Crafts in Jerusalem, and "Mama" was Lina Gutherz Straus (see cat. no. 73).

Literature

C. Grossman, *Remembrances of Times Past*, 1986.

BEQUEST OF JUDGE IRVING LEHMAN, 1945

(CEE 45–8)

## 76

# Irving Lehman's Bible in Bezalel Binding

BINDING
Bezalel School of Arts and Crafts
Jerusalem, about 1922/23
Silver, chased; filigree, casting, malachite stones
5 ¼ x 3 ¾ x 1 ¼ in. (13.3 x 9.5 x 3.2 cm)

TEXT
Hebrew Bible
PRINTER: J. B. Peace, M.A.
at the University Press, Cambridge, 1919
4 ¾ x 2 ¾ in. (12.2 x 7 cm)

INSCRIBED
Front cover
והגית בו יומם ולילה
But recite it day and night (Josh. 1:8)

Spine
תורה / נביאים / וכתובים
The Five Books of Moses / The Prophets / The Writings

Back cover
בצלאל / ירושלם
Bezalel / Jerusalem

Inside clasp
*PRESENTED TO / IRVING LEHMAN / BY THE BOYS OF /
CAMP LEHMAN / 1923*

On front cover within a filigreed archway a praying man stands at a reader's desk under a large filigree roundel set with a malachite stone. Background of surrounding area deeply chased ("batik" work) with four registers of design elements: seven-branched lampstands, hanging lamps with stars, columns supporting a lintel, and an abstract linear design (perhaps representing stonework). Two small filigree roundels with malachite centers fill upper corners.

Spine with three registers of design elements. In center panel, against background of abstract design elements an arched plaque with tablets engraved with title of book surmounted by a filigree and malachite roundel. Upper register contains lampstand design similar to front; bottom register repeats the design upside down.

Back cover with wide border along all four sides repeats a lampstand motif; in the corners, the familiar filigree and malachite roundel. Deeply chased center panel repeats abstract design element of spine; in center, a roundel with "Bezalel/Jerusalem" (in Hebrew).

Clasp repeats motif of filigree and malachite roundel.

This small binding has a charming unity of design and a most appropriate theme, that of the devout scholar, which relates it to the study of the enclosed Bible, obviously a compliment to Irving Lehman.

In his catalog, written about 1928, Lehman noted: "Bible bound at Bezalel School. Presented by boys at Camp Lehman Y.M.H.A. & used when I was sworn in by Judge Cardozo as Judge of Court of Appeals—Duplicate of Bible presented to Lord Balfour by [?]."

Literature

I. Lehman, List of one hundred eleven objects, circa 1928, no. 7.

BEQUEST OF JUDGE IRVING LEHMAN, 1945

(CEE 45–7)

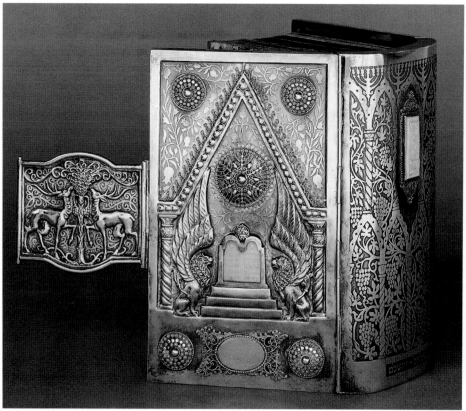
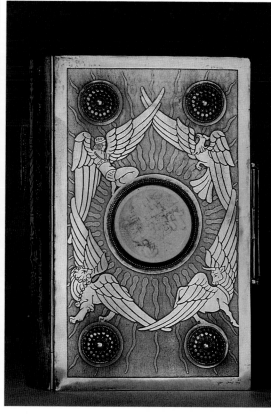

77

## 77

# Bible with Raban Jerusalem Binding

BINDING
MASTERS: Ze'ev Raban with Meir Gur-Aryeh
Bezalel School of Arts and Crafts
Jerusalem, after 1923
Silver, chased, embossed; appliquéd filigree, ivory/bone
plaques, stone settings
8¼ x 6 x 4 in. (20.9 x 15.2 10.2 cm)
MARKS: Masters (in Hebrew)

TEXT
Hebrew Bible
Frankfurt, 1677
PRINTER: Balthazar Christoph. Wust
EDITOR: David Clodius
8 x 4¾ in. (20.3 x 12 cm)

INSCRIBED
Front cover
On Tablets of the Law

אנכי ה' / לא יהיה / לא תשא / זכור את / כבד את
לא תרצח / לא תנאף / לא תגנב / לא תעמה / לא תחמד

I am the L[ord] (your God) / You shall have no (other gods beside
Me) / You shall not swear (falsely) / Remember (the Sabbath) /
Honor (your father and your mother)
(You shall) not murder / (You shall) not commit adultery / (You
shall) not steal / (You shall) not bear (false witness) / (You shall)
not covet (Exod. 20:2–14)

Spine
On ivory plaque

ת / ג / כ

P[entateuch] / P[rophets] / W[ritings]

Lower margin

בצלאל-ירושלם

Bezalel–Jerusalem

On the front cover, a tentlike structure with gabled roof edged
with beaded molding and a lacelike cresting supported by spiral
columns stands on an embossed base appliquéd with two raised
filigree roundels and a framed, blank ivory oval. Between the

columns, ivory Tablets of the Law with carved Hebrew letters on a stepped podium flanked by winged lions. Above the Tablets and in upper corners, raised filigree roundels set against a deeply chased ground ("batik" work) of pomegranates and leafy branches.

On the spine, a two-tiered arcade against a background deeply chased with vine-and-grape motif; the spandrels of the upper tier filled with seven-branched lampstands. Within the central arch of the upper tier, a filigree frame resembling a mezuzah encloses an ivory rectangle on which the book title is carved.

In the center of the back cover against a deeply chased ground, a carved medallion set in a beaded, silver frame depicts the Western Wall. Superimposed on flamelike rays emanating from the roundel, four winged creatures: an eagle, an ox, a lion, and a man. In the corners, raised roundels of beaded filigree.

On the clasp, against a chased scroll background, two deer in high relief flank a central tree on which they feed.

All the motifs on the binding refer to Jerusalem, the Temple Sanctuary and its furnishings: the Ark of the Covenant guarded by winged lions (the cherubim of the Bible) originally placed in the Tabernacle (tent) of the wilderness; the façade of the Temple (the spiral columns); the seven-branched lampstand (menorah); the Western Wall; and the figures representing the four creatures in Ezekiel's vision (Ezek. 1:1–28). According to tradition, the winged creatures and wheeled chariot rose to the heavens from the site of the Temple mount in Jerusalem, thus the depiction here of the Western Wall as a symbol of Jewish Jerusalem and the four creatures rising in emanations from its center.

Lions and creatures with outstretched wings were favored motifs of Ze'ev Raban (1890–1970). As emblem of God's presence, the wings are also an emblem of the otherworldliness of the Art Nouveau movement and its characteristic sinuous natural forms. According to Gideon Ofrat, Raban is "the artist who, more than anyone else, developed and perfected the so-called Bezalel style" (p. 19). That style incorporated motifs of the Bible and symbols of the Holy Land with the forms of Art Nouveau while utilizing and developing the craft techniques of the Jews of the Middle East.

The printed book within the silver binding is the first edition of a Bible edited by the Christian Hebraist David Clodius (1644–1684), which was later reprinted in 1692. It has both a Latin title page and an engraved Hebrew title page depicting an arcaded room.

References

*Bezalel 1906–1929*, 1983, p. 374; G. Ofrat, "The Art of Zeev Raban," 1982, pp. 19–38.

Literature

*Raban Remembered: Jerusalem's Forgotten Master,* 1982, cat. nos. 12 and 111, p. 73.

Bequest of Judge Irving Lehman, 1945
(CEE 45–136)

78

## 78

# Miniature Torah Pointer (Yad)

SILVERSMITH: Tiffany & Co.
Newark, New Jersey, about 1910
Silver, embossed, appliquéd, engraved; cast hand
Length 3⅞ in. (9.8 cm)
MARKS: Master (Carpenter and Carpenter, p. 252);
*STERLING; m*

Shaft in undulating form with rows of appliquéd, open flowers set within appliquéd elongated arches. Undulating narrow band rests atop narrow cuff of delicate cast hand with curved pointer finger and simplified fingers. Rounded top decorated with engraved diaper pattern on front side only. Attached ring holds short chain of narrow rectangular links.

79                              80

The style of this elegantly wrought pointer appears to be based on earlier Japanese motifs used in Tiffany ware. The background behind the flowers seems to be more mat finish than the flowers and arches, a technique that had been used by Tiffany & Co. in the 1870s and 1880s.

The master mark *m* on the piece refers to John C. Moore, president of Tiffany & Co. from 1907 to 1938.

GIFT OF DR. JACOB BIRNBAUM IN MEMORY OF HIS BROTHER, DR. ABRAHAM S. BIRNBAUM, 1987, THROUGH CANTOR HOWARD NEVISON
(CEE 87–34)

## 79/80

# Women's Velvet-Covered Prayerbooks

### 79
#### Sophie Rothschild's Prayerbook

TEXT
Edifying Prayers for Jewish Women on Various Occasions in Life [in German]
PUBLISHER: J. Kauffmann
Frankfurt, 1876

BINDING
Purple velvet; pressed brass corners, cast brass clasp, formerly gilded; engraved ivory plaque
6½ x 5 x 1½ in. (16.5 x 12.7 x 3.8 cm)

INSCRIBED
Cover
On ivory plaque
*SR*

Purple velvet binding with pressed brass corners simulating filigree work. Book opens from left to right on German title page and sixteen pages of special prayers. Remaining 604 numbered pages open right to left and contain Hebrew prayers translated into German on facing pages. The leather spine is a modern addition.

On the first page preceding the German text Sophie

Rothschild listed the names and birthdays of her four children. On the second page she recorded the death of her beloved husband, Henry Rothschild. These notes clearly reinforce the use of the book as a personal feminine possession.

Rebound by Herbert E. Weitz, New York, 1987.

### 80
#### Amalia Schloss's Book of Hymns and Prayers

TEXT
*The Order of Prayer for Divine Service.* Revised by Dr. L. Merzbacher and Dr. S. Adler [in Hebrew and English]
New York, 1864

BINDING
Velvet; pressed brass, formerly gilded; leather and cardboard slipcase
7½ x 4¾ in. (19 x 12 cm)

INSCRIBED
Cover
*Amalia Schloss*

Purple velvet binding with remains of trefoil ornamented clasp at one time gilded. Name embossed in gold on cover.

Newspaper clippings of funerals and weddings pasted and taped to the opening blank pages concern members of the family of Amalia Walter, who was married to Moses Schloss (1818–1897), at one time vice president of Congregation Emanu-El. The donors are the great-grandchildren of Amalia Schloss.

Rebound by Herbert E. Weitz, New York, 1987

GIFT OF MRS. ALFRED R. BACHRACH, GRANDDAUGHTER OF THE ORIGINAL OWNER, 1985
(CEE 85–5)

GIFT OF PROFESSOR RICHARD A. WEBSTER AND MRS. KATHERINE W. AIBEL, 1984
(CEE 84–9)

## 81

# Woman's Red Kiddush Glass

Possibly Bohemia, late 19th century
Red glass; painted and engraved
Height 5¼ in. (13.3 cm), diameter at rim 4⅞ in. (12.4 cm)

INSCRIBED

מרת / מ״ל / ד״לב

Mistress / M.L. / S[ufficient] f[or a] b[lessing]

Painted scroll pattern of cream-colored paint highlighted with gilt encircles center of vase-shaped glass. Freehand inscription is cut into the glass below the pattern.

While well-to-do Jews commissioned special objects for ritual use and for Jewish holidays, people of modest means often personalized humble objects. With such an inscribed glass the woman of the house expressed her status as well as her piety.

(CEE 72–11)

## 82

# Crested Kiddush Cup

Berlin, 2d half of 18th century
Silver, embossed, engraved, chased; traces of gilt
Height 3⅝ in. (9.2 cm), diameter at rim 3⅝ in. (9.2 cm)
MARK: Place and date (Rosenberg, no. 1148)

INSCRIBED

ה׳ רעי לא אחסר

The L[ord] is my shepherd; I shall not want (Ps. 23:1)

Slightly tapered cup on stepped spreading foot. Bordered above and below with engraved and chased strapwork decoration. Between the strapwork bands a family crest with a sun in a shield, a lamb at rest above a knight's helmet.

The presence of the verse inscribed on this kiddush cup is unusual and was probably chosen because the complete psalm refers to such an object, "My cup runneth over" (Ps. 23:5).

BEQUEST OF JUDGE IRVING LEHMAN, 1945
(CEE 45–65)

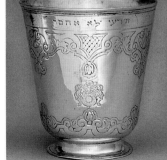

82

81

## 83

# Selverstone Family Kiddush Cups

**Kiddush Cup (*Becher*)**
MASTER: Israel A. Goldman
Warsaw, 1876–90
Silver, embossed and engraved
Height 2⅝ in. (6.7 cm), diameter at rim 2½ in. (6.4 cm)
MARKS: Master (Lileyko, no. 21); place (Lileyko, p. 100)

**Kiddush Cup (*Becher*)**
MASTER: M.K.
Moscow, 1871
Silver, embossed and engraved
Height 2⅜ in. (6 cm), diameter at rim 2 in. (5.1 cm)
MARKS: Master; place and date (Tardy, pp. 353, 354); *84*

**Kiddush Cup (*Becher*)**
MASTER: GSR
Moscow, 1873
Silver, embossed and engraved
Height 1⅝ in. (4.1 cm), diameter at rim 1½ in. (3.8 cm)
MARKS: Master (in Cyrillic); place and date (Tardy, pp. 353, 354); *84*

**Kiddush Cup (*Becher*)**
MASTER: GSR
Moscow, 1873
Silver, embossed and engraved
Height 1⅝ in. (4.1 cm), diameter at rim 1½ in. (3.8 cm)
MARKS: Master (in Cyrillic); place and date (Tardy, pp. 353, 354); *84*

**Kiddush Cup (*Becher*)**
MASTER: CJ (?)
Moscow, 1855
Silver, embossed and engraved; niello work
Height 2⅞ in. (7.3 cm), diameter at rim 2⁵⁄₁₆ in. (5.9 cm)
MARKS: Master; place and date (Tardy, pp. 353, 354); *84*

Four cups on the left decorated with tool engraving imitating embossed strapwork and flower designs of earlier German cups. Larger and heavier cup at right decorated with deeply engraved allover scroll-and-leaf design accented with niello work between plain upper and lower bands.

According to the donor, this family of cups and a spice container were brought to this country by his mother when she emigrated from the Russian Ukraine in 1889. His father had fled earlier, while his mother remained with their six children to run the family granary. Three years later they were reunited at Ellis Island.

Such beakers were used by Russians as vodka cups, but they were much prized by Jews as kiddush cups. They were often decorated by local Jewish crafts people, who sometimes added Jewish motifs and Hebrew names. Landscape scenes in cartouches as seen on the center cup are also common.

GIFT OF DR. JONAS SELVERSTONE, 1980
(CEE 80–2) (CEE 80–3) (CEE 80–4) (CEE 80–5) (CEE 80–1)

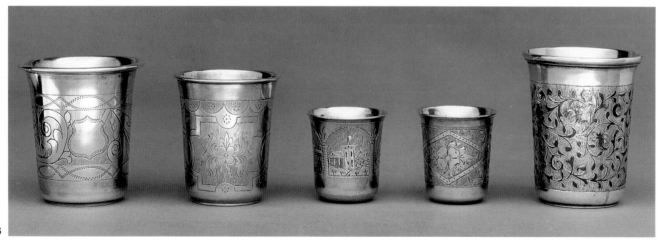

83

## 84

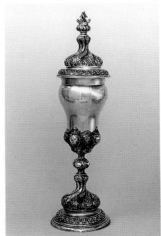

84

85

# Mordecai Rosenberg's Covered Kiddush Goblet

Probably Berlin, after 1887
Silver, embossed and engraved; gilt interior
Height 18 in. (45.7 cm), diameter of base 6⅛ in. (15.6 cm)
MARK: Place and date (Rosenberg, no. 5)

INSCRIBED

איש יהודי שמו מרדכי / ב״הרב מה״ורר גבריאל יצחק
ראזענבערג / גבאי ראשון דביה״מ פה ברלין / ליום מלאת
לו שבעים שנה ב׳ט׳ו׳ב׳ סיון בשנת כ׳ה׳ ת׳ב׳ר׳כ׳ו׳ / מתנה
מחברת ביה״מ

"A Jewish man . . . and his name was Mordecai" (Esther 2:5),
s[on of] the rabbi, our m[aster] and t[eacher] Gabriel Yitzhak
Rosenberg/chief Gabai of the Beit [Ha] M[idrash] here in Berlin/
on his seventieth birthday, the 19th [with happiness] of Sivan
in the year [5]653 (1893). / A gift from the Bei[t] Ha M[idrash]
Society.

Tall vase-shaped goblet screwed into embossed base decorated
with scrolls and shells in high relief. Matching cover a coun-
terpart of the base, topped with a cast finial in the form of four
dolphins supporting a ball.

This sumptuous cup is enriched by a dedication of
reverence and love. In the inscription, the birthday year
is given in the form of a chronogram that serves as a
blessing. The practice of including a biblical quotation
that refers to the name of the recipient is yet another
form of honor. The society of Beit Ha Midrash defines
itself as a House of Study, one of the Hebrew names
for a synagogue.

BEQUEST OF JUDGE IRVING LEHMAN, 1945
(CEE 45–77)

## 85

# Persian Covered Kiddush Cup

Persia, 19th century
Silver, embossed and engraved; cast finial
Height 4¼ in. (10.8 cm), diameter at rim 2⅜ in. (6 cm)

Crudely hammered cup, banded with scroll designs on top;
faceted bottom with ten arches decorated with fleur-de-lis.

Dome-shaped cover with tooled flat rim topped by a cast bird
finial.

Despite its simple craftsmanship this tactile cup has a
luminous surface in sharp contrast to the darkened
engraved designs. The motifs of the cup are architec-
tural. The arches recall arcaded courtyards and the
domed cover refers to palaces and mosques, as well as
to simple domed village houses made of white painted
stone or mud. The little bird has been referred to by
B. Goldman (pp. 58–60) as the mystical hoopoe.

Irving Lehman, in a marginal note in the 1932 cata-
log of his collection by Rabbi Meyer, wrote, "Very old
cup bought from Persian Jew in Jerusalem by Dr.
Magnes." He probably is referring here to Judah Magnes,
who had been rabbi of Emanu-El and was the first presi-
dent of the Hebrew University in Jerusalem. The cup
has been variously identified as an etrog container and
a spice container.

References

I. S. Meyer, "Catalogue of the Jewish Art Objects in the Collection of
Judge Irving Lehman," 1932, no. 99; B. Goldman, "Raban—A Traditional
Jewish Artist," 1982, pp. 57–69.

BEQUEST OF JUDGE IRVING LEHMAN, 1945
(CEE 45–72)

## 86

# Venetian Hanging Sabbath Lamp

MASTER: AP
Venice, early 1700s
Silver, embossed and chased; castings
Length 35 in. (88.9 cm), diameter of basin 14 in. (35.6 cm),
depth of basin 8 in. (20.3 cm)
MARKS: Place and date (Rosenberg, no. 7485); *AP*; *ARC*

86–A

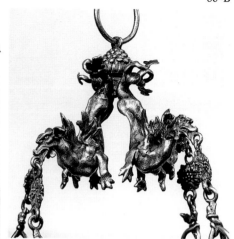

86–B

Eight-pointed, star-shaped embossed oil lamp with double-curved basin defined by eight graceful ribs within which chased backgrounds highlight leafy designs and embossed flowers. Rim and points of star embellished with fountain imagery of animals and figures in high relief (cat. no. 86–A) that terminate in three-dimensional forms: four nude mermen, each struggling with a serpent atop a wild horse with cloven front feet, alternate with four masks with animal headdress and cloven front feet which rise from edges of agitated waves. Four additional young nude mermen gazing downward perch at the rim, each with a raised left arm holding a single link to which four chains and the canopy are attached. At the bottom of the basin a pendant finial is held by lion-headed ribs, the lower portion of puffed rectangular form, chased and decorated with grapes and winged putti heads at the corners, terminates in a flower and leaf cluster.

Canopy (cat. no. 86–B) attached to hanging ring, composed of four cast sea monsters suspended from a pineapple form hold in their mouths cast links formed of cast rosettes that alternate with three entwined serpents.

With oil lit and tips aglow, mermen peering down over the sides, and anthropomorphic creatures silhouetted against the light, this Venetian hanging Sabbath lamp for oil was no doubt a magnificent spectacle. A tin or glass liner held the oil, the wicks extending from the eight points of the star.

The star-shaped lamp was so favored by German Jews that it earned the appelation *Judenstern*. It is probable, therefore, that the Italian use of the form comes from a union of cultures—the Ashkenaz (German-Jewish) and Italian. The Italians moreover were surely inspired by the Roman fountains of Gian Lorenzo Bernini and his contemporaries. The imagery of mermen and mythological sea beasts is that of the fountain (see cat. no. 87). Guido Schoenberger, late Research Fellow at the Jewish Museum in New York, explained the apt use of the fountain reference in his discussion of a

German Sabbath lamp where he quoted the prayer recited during the Sabbath welcome, which includes the passage, "For with Thee is the fountain of life, in Thy light do we see light" (Ps. 36:10).

This silver creation has the excitement, agitation, fantasy, and elegance of form found in the best Italian Baroque. The nudity and the use of Greek and Christologic images may seem out of Jewish context, but the cosmopolitan taste of the wealthy Jewish patron who commissioned the work must be kept in mind, as well as the fact that such a patron would recognize the imagery as representing "fountain." Indeed, anthropomorphic images and cherubim are found not only on Hanukkah lamps (see cat. no. 154) but also in medieval and Renaissance illuminated Hebrew manuscripts originating in Germany as well as in Italy. Unlike the condition in Germany, where Jews were not permitted to join the silver and goldsmithing guilds, in Italy there were legal Jewish silver workshops.

According to Judge Lehman's listing of circa 1928, this lamp was purchased as part of an unnumbered lot in a Benguiat sale.

References

G. Schoenberger, "A Silver Sabbath Lamp from Frankfort-on-the-Main," 1951, pp. 189–97. For an eighteenth-century Piedmontese silver Sabbath lamp, see S. Cusin, *Arte nella tradizione Ebraica*, 1963, colorplate and description, pp. 108–9. For examples of illuminated manuscripts, see B. Narkiss, *Hebrew Illuminated Manuscripts*, 1969, pl. 26, p. 92 and pl. 55, p. 150.

Literature

I. Lehman, List of one hundred eleven objects, circa 1928, no. 34.

BEQUEST OF JUDGE IRVING LEHMAN, 1945
(CEE 45–34)

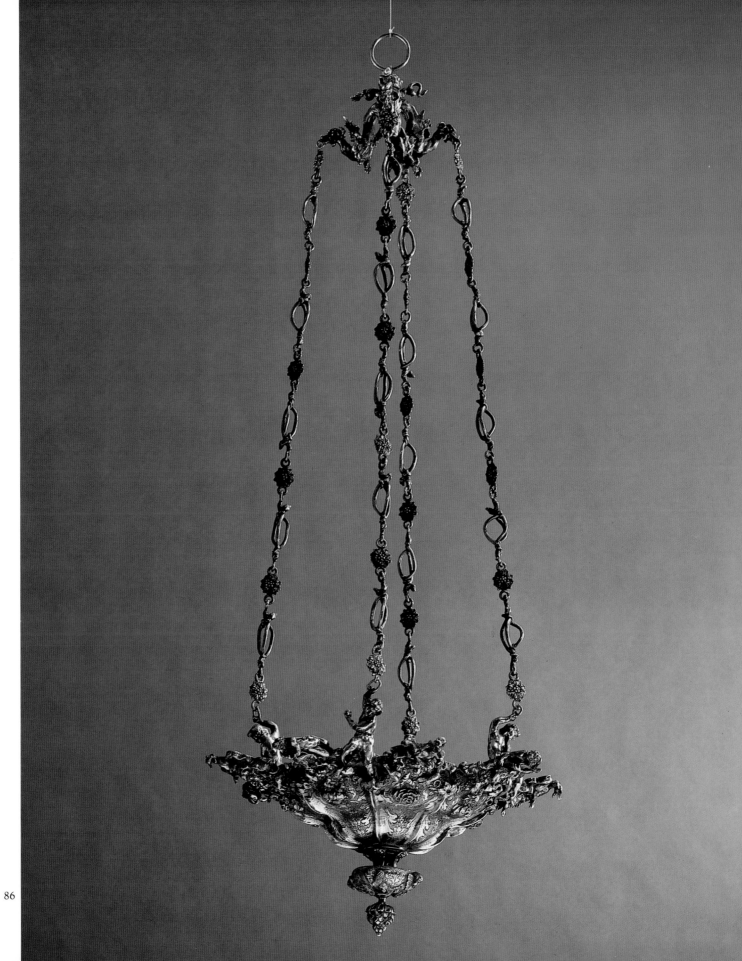

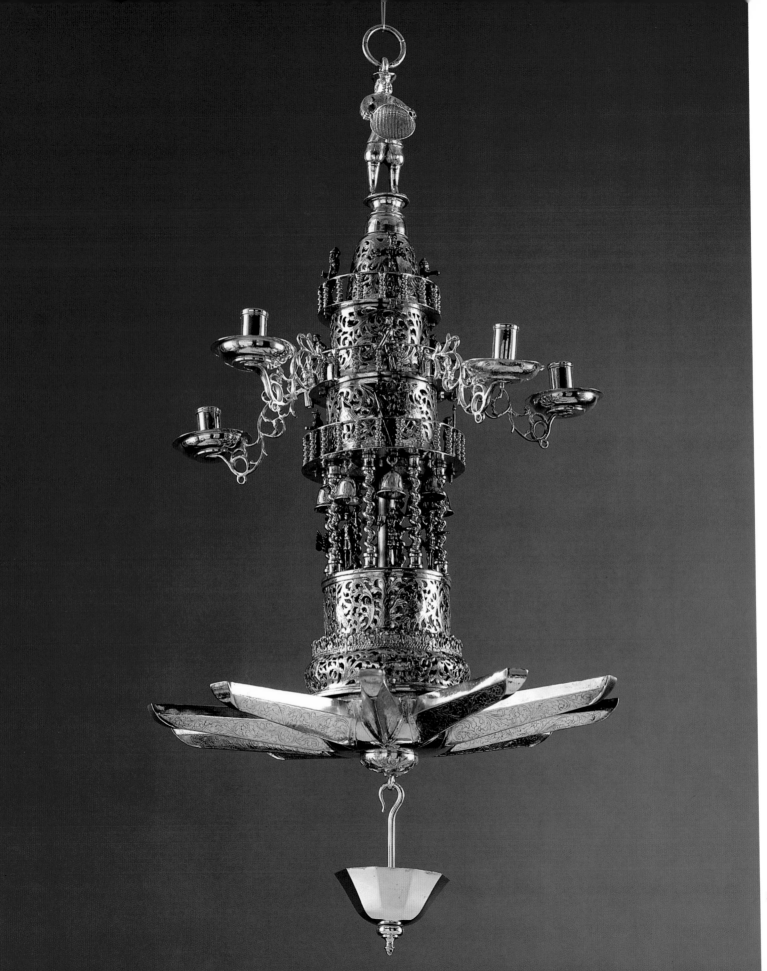

## 87

# Boller Sabbath and Festival Hanging Lamp

MASTER: Johann Adam Boller
Frankfurt, after 1706
Silver, embossed; cutout, chased, castings, traces of gilt
Length 31 in. (78.7 cm), diameter of basin 15½ in. (39.4 cm)
MARKS: Master (Scheffler, *Hessens,* no. 356:265); place and date (Rosenberg, no. 2004)

Five-tiered, tower-shaped hanging oil lamp with ten-pointed, star-shaped oil reservoir attached to base; hanging drip cup hooks onto lion mask at center bottom. Lowest tier in two cutout and chased sections separated by cast openwork frame depicts a hunt scene below and birds in branches above. Second tier, a columned rotunda hung with bells and eight cast figures set between eight spiral columns. Upper tiers, each with a railing carrying similar cutout and chased bird and leaf designs and four cast figures. At top, cast finial with attached ring in form of a knickered male figure holding a flat, empty basket before him. Five candleholders on brackets attached to middle railing. The original drip pan and channels for carrying the overflow of the expanding oil from the tip of the star to the drip pan are now lost; the present pan is a replacement.

Made in the famous Frankfurt workshop of Johann Adam Boller, who became a master silversmith in 1706, this lamp is a further development of an earlier form that more clearly represented a type of fountain found in a German village square. While the lower tiers of earlier lamps bore representations of the cannon mouths out of which water gushed in the actual fountains, in this five-tiered shaft Boller follows only the general form of the German fountain. Guido Schoenberger, late Research Fellow at the Jewish Museum in New York, clarified the fountain form first in an article and then in the catalog of an exhibition held at the Metropolitan Museum of Art (no. 70), in which earlier examples as well as this lamp were shown.

The cutout and chased hunting scene on the lowest tier with hunter, dogs, and two deer is perhaps based on the hunting scene that appears as a mnemonic in Passover haggadahs. The open rotunda with cast figures of the second tier is a characteristic feature of this whole group of Frankfurt lamps (Kayser and Schoenberger, nos. 70–72). However, this example and a Boller lamp sold at Christie's in 1981 suggest that the addition of the railing with twisted columns was a Boller innovation. Although Schoenberger believed that the bracketed candleholders were a later addition, one of the holders has a Boller hallmark; the remaining four are not of the same exemplary workmanship and are not hallmarked. If the candleholder brackets were an addition, they were added by Boller himself, which accounts for the graceful proportions that do not overpower the shaft on the star-shaped oil reservoir.

The cast-figure finial is not unknown. A fifteenth-century bronze chandelier, possibly Flemish, at the Cloisters of the Metropolitan Museum of Art has a cast kneeling angel at the top with a ring in its head to which the hanging chain is attached. Similar finials are found on sixteenth-century secular German cups, in which the figure is quite large in comparison with the entire object. A havdalah candleholder by Boller in the Israel Museum (no. 124/396) has a large figure of a man holding a book and a candle. The Emanu-El lamp finial is cast in the figure of a knickered man with a distinctive face and flattened Jewish hat who carries a large round basket in his extended arms. Is this a metaphor for the owner's name? Schoenberger suggested (p. 193) that the owner might have lived in a house with the shield "Zum Korb" (at the basket).

All the cast figures can be identified by their emblems. The figures of the topmost tier are wholly three-dimensional and slightly larger than the others. They are the leaders: David (with harp) and Moses (with Torah scroll) alternate with captains of the guard, whose lances are now broken. All the remaining figures are three-dimensional in front but hollow in back. The fourth tier carried four trumpeters, but one is now lost and is replaced by a watchman reproduction. The third tier has four watchmen with lances (three are modern reproductions). The eight figures of the second tier represent holidays and Sabbaths: one figure holds a Hanukkah menorah and pitcher; one holds a shofar and book, for Rosh Hashanah; one holds a scroll and rattle, for Purim; one with a matzah and matzah scorer, for Pass-

over; two Sabbath figures with spice box and book; another, the wake-up shammes, holds the *schulklopfer*, its other symbol broken off; and an original watchman that replaces a figure now lost.

This then clearly is a lamp for Sabbath and the festivals. Mordechai Breuer, writing in the *Encyclopaedia Judaica* on liturgical music in Frankfurt, mentions the controversial introduction at the beginning of the seventeenth century of the Sabbath hymn "Lecha Dodi," written in Safed about 1571, which contains the passage, "Come with me to meet Shabbat, forever a fountain of blessing." He points out that each festival has a melody of its own, sung by the cantor, as a kind of musical calendar. The iconography of this lamp corresponds to these ideas and advances the significance of the concept by being a representation of the fountain as it relates to the Sabbath hymn and by presenting the holidays through the depiction of all the Jewish festival occasions on which the lamp would be lit.

That this lamp was actually used in the Lehman household is indicated by a Jewish New Year's card sent by the Lehmans to their friends which bears an engraving of the Boller lamp hanging near a wall with candles in the candleholders and carries the message, "Mr. & Mrs. Irving Lehman wish you a Happy New Year, 119 East 71."

Restored by Isaac Kheit Associates, New York, 1984.
At the time of this restoration, the decision was made to replace all the lost figures with watchman reproductions in order to make clear which were the original figures.

References

S. Kayser and G. Schoenberger, *Jewish Ceremonial Art*, 1955, nos. 70 and 71; *Sale of Fine European Silver*, Christie's, Geneva, May 13, 1981, lot 191; V. B. Mann, "The Golden Age of Jewish Ceremonial Art, in Frankfurt," 1986, p. 403; J. Rorimer, *The Cloisters*, 1951, p. 140, fig. 80 (for a recent photograph, by Malcolm Varon, see *A Walk through the Cloisters*, 1979, p. 113); *Towers of Spice*, 1982, p. 47, XIX; M. Breuer, "Frankfort on the Main: Music," 1971, col. 92; A. Z. Idelsohn, *Jewish Liturgy*, 1932, pp. 128–30; *Gates of Prayer*, 1975, p. 124.

Literature

G. Schoenberger, "A Silver Sabbath Lamp from Frankfort-on-the-Main," 1951, p. 193 n. 12 and p. 197 n. 27; S. Kayser and G. Schoenberger, *Jewish Ceremonial Art*, 1955, no. 72; I. Winter, *Ingathering*, 1968, cat. no. 63;

I. S. Meyer, "Catalogue of the Jewish Art Objects in the Collection of Judge Irving Lehman," 1932, no. 139; Lehman Family New Year's Card, Jewish Theological Seminary of America, New York.

BEQUEST OF JUDGE IRVING LEHMAN, 1945
(CEE 45–139)

## 88/89/90

# *Judenstern* Hanging Lamps

### 88

Germany, 18th century
Brass, cast
Length with drip pan and ratchet 30⅝ in. (78 cm), length without ratchet 18½ in. (47 cm), diameter at burners, 8⅞ in. (22.5 cm)

Eight-pointed, star-shaped oil reservoir attached to tall vase-shaped column, two holes in the top hold ornate trefoil-shaped hanging ring. Ratchet hanger with bird-head stop. Eight oil slides hang on tips from star, drip pan hooks onto bottom of oil reservoir.

### 89

Germany, 18th century
Brass, cast
Length with drip pan and ratchet 39 in. (99 cm), length without ratchet 19½ in. (49.5 cm), diameter at burners 11 in. (27.9 cm)

Eight-pointed, star-shaped oil reservoir attached to columnar shaft with knobbed swellings at top and bottom. Cup-shaped top holds trefoil-shaped hanging ring suspended from bird-head ratchet holder. Drip pan hooks onto bottom.

### 90

Germany, 18th century
Brass, cast
Length with drip pan and ratchet 28 in. (71.1 cm), length without ratchet 16¾ in. (42.5 cm), diameter at burners 8¼ in. (21 cm)

Six-pointed, star-shaped oil reservoir attached to baluster shaft. Cup-shaped top with circular cutouts and scalloped edge holds arch-shaped hangar suspended from bird-head ratchet. The lamp has been electrified by the addition of a ceiling fixture

89

88

90

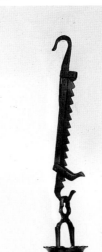

and shallow round cups soldered to the tip of each burner which support cardboard holders for flame-shaped electric light bulbs that simulate candles.

The star-shaped oil lamp was known as a *Judenstern* (Jewish star) lamp because of its wide use as a Sabbath oil lamp by German Jews and is so noted in record books of German silversmiths. Hebrew manuscripts dated to the fourteenth century show such lamps in use, and a four-pointed cast bronze Sabbath lamp dated to the fifteenth/sixteenth century is in the Kölnisches Stadt-museum. The star as a messianic symbol dates back at least to the millennium when Bar-Kochba (Son of the Star) was thought to be the messiah.

The hanging Sabbath lamp made of cast brass with a pointed, star-shaped oil reservoir hangs from varied baluster-type shafts. Wicks were set into the points of the star, and these brought the oil up from the center. As the oil on the wicks burned there was some over-flow of the heated oil, which was caught by thin brass channels that hung on the points of the star and car-ried it to a drip pan below. The lamp was filled with oil, cleaned, and supplied with wicks by lowering and raising it on the ratchet hanger. It often hung over the dinner table.

Oil was no doubt messy and in time was replaced by candles. Often this change was accomplished by the expedient of adding candleholder brackets to the old lamp (see Shachar, pl. Ic). Gas jets could be added and even electrification (cat. no. 90). The beauty of the oil lamp was nonetheless respected, and the electrified lamp still carries its oil drip pan.

References

For an example of a star-shaped oil lamp in a fifteenth-century manu-script, see B. Narkiss, *Hebrew Illuminated Manuscripts*, 1969, pl. 38, pp. 116, 117; for an early lamp, see L. Franzheim, *Judaica*, 1980, cat. no. 121, pp. 310, 311; for candle addition, see I. Shachar, *The Jewish Year*, 1975, pl. Ic.

BEQUEST OF JUDGE IRVING LEHMAN, 1945
(CEE 45–219) (CEE 45–220)
ANONYMOUS GIFT
(CEE 72–20)

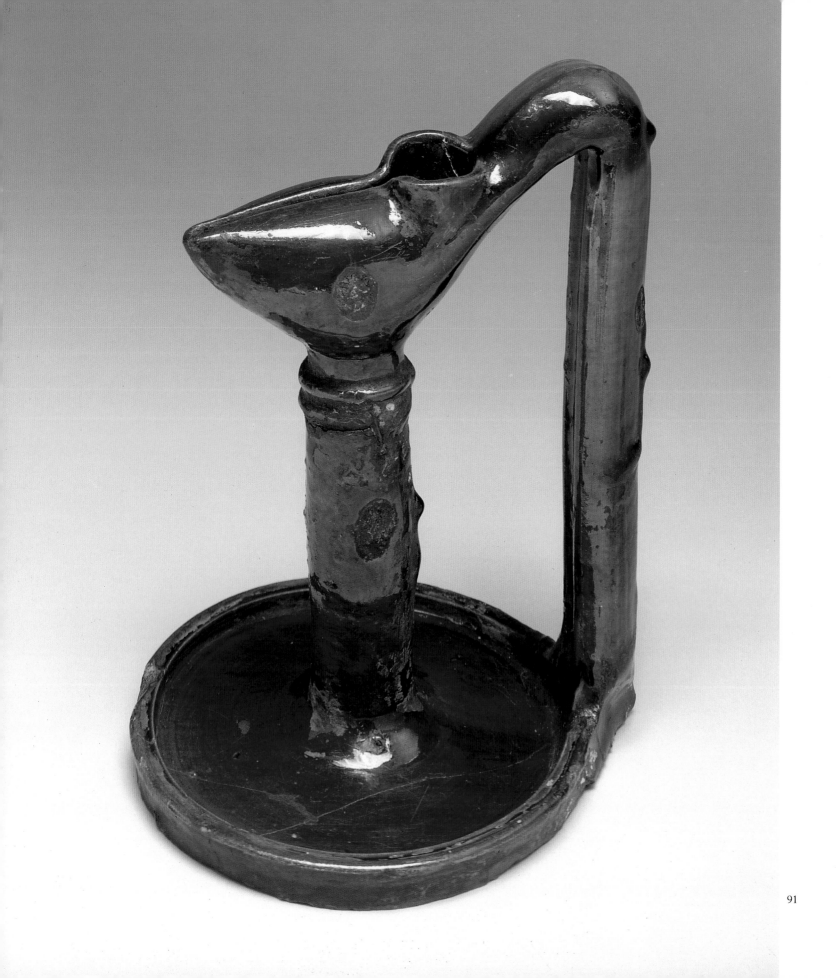

92

## 91

# Green-Glaze Sabbath Lamp

Fez, 18/19th century
Hand-shaped pottery, glazed
Height 9¾ in. (24.8 cm)

Bean-shaped oil container with slit for wick and round opening to receive oil leading to a long straight handle that parallels the tall columnar shaft and connects to a round flat base with narrow rim. The lamp was broken into four parts and repaired. Some breaks have been glued; the break on the upper shaft has been glued and wired. Several oval losses may indicate the original presence of applied ornaments, such as seals or jewels.

A fine example of the emerald-green glaze famous in southern Morocco, this lamp comes from the Rissani region according to Jaimé Cohen, a New York dealer and an expert on Moroccan ware. The form of the lamp—a tall columnar shaft set on a round dish with a handle that attaches the lamp to the dish—is seen in early Persian examples, such as the glazed pottery lamp for seven wicks, dated to the fourteenth century, in Cologne (*Synagoga*, no. A 35).

References
*Synagoga*, 1960, no. A 35. For a similar lamp, see *La Vie juive*, 1973, p. 86, no. 138.

CONGREGATION EMANU-EL MUSEUM PURCHASE FUND, 1986
(CEE 86–8)

## 92

# Pair of Sabbath Candelabra

Poland, late 19th century
Brass, cast
Height 13 in. (33 cm), width at top 9½ in. (24.1 cm)

Knobbed shaft on round base holds double scrolling branch that supports three candleholders.

Brass-making was a great Polish-Jewish craft. Single candleholders, as well as multi-branched candelabra, were the staple of Polish-Jewish homes. They were vigorously polished each week in order to welcome the Sabbath with candlesticks holding many lights and shining like the golden implements of the ancient Temple in Jerusalem.

(CEE 72–17A/B)

93

## 93

# Candlestick and Spicebox for Havdalah

MASTER: GLF
Nuremberg, 1650–1700
Silver, embossed and chased; engraved initials
Height 7½ in. (19.1 cm), diameter of base 3¼ in. (8.3 cm)
MARKS: Master (cloverleaf with star); place and date
(Rosenberg, no. 3762)

INSCRIBED
On box
*S.G.*

Flaring articulated base ornamented with strapwork design and chasing supports small box with drawer for spices divided into four compartments. Sliding candleholder attached to four posts that terminate in flaring handle cut out in center to accommodate candle.

The lights blessed on Saturday evening—a blessing that ends the Sabbath and separates it (Havdalah) from the ordinary days of the week—are in the form of a braided candle with several wicks. This unwieldly multi-wick

candle usually burns unevenly, and this ingenious device permits continued use of the candle, which may be extinguished, unlike Sabbath candles, which burn down completely. This form of special candleholder that also contains the spices was favored during the seventeenth and eighteenth centuries in the major silversmithing centers of Germany.

In his 1928 catalog Irving Lehman noted of this candleholder, "Given me by Helen Altschul, bought at well-known sale in Frankfort. Early 17th century."

Literature

I. Lehman, List of one hundred eleven objects, circa 1928, no. 70.

BEQUEST OF JUDGE IRVING LEHMAN, 1945
(CEE 45–43)

## 94

# Lehman Family Havdalah Plate

Augsburg, 1670s (?)
Silver, embossed, engraved, chased; cutout appliqué in center; traces of gilt
Diameter 8 in. (20.3 cm)
MARKS: Master (leaf in fan shape); place and date (Rosenberg, nos. 164, 278)

INSCRIBED
Around rim
מצות יי ברה מאירת עינים
The commandment of the L[ord] is pure, enlightening the eyes (Ps. 19:9)

In star, in Yiddish
גוט וואך / אונד / גוט יאהר
Good week / and / good year

Small plate with banded rim bearing embossed inscription and a grapevine with grape clusters in high relief. Fine engraved and chased background of center bears six-pointed star in high relief within which is an appliquéd inscription.

Such a plate may have been used to hold the wine cup for the blessing over the wine at the close of the Sab-

bath. The Havdalah service includes a blessing over lights, over wine, and over spices. The Yiddish expression in the center would be the exchanged wish among those present at the close of the blessings, "Have a good week," and the response, "And a good year."

There are three hallmarks on the plate: an unknown mark (leaf in fan shape) and two different Augsburg marks. One of the latter dates from the years 1670 to 1678 and the other from 1781 to 1783. The appliqué in the center may have been added later, since it rests on a similar embossed inscription.

Irving Lehman added a marginal note to the Meyer catalog of 1932, "Given to me by my grandmother in Wurzburg. Family piece."

Literature

I. Lehman, List of one hundred eleven objects, circa 1928, no. 26; I. S. Meyer, "Catalogue of the Jewish Art Objects in the Collection of Judge Irving Lehman," 1932, no. 26.

BEQUEST OF JUDGE IRVING LEHMAN, 1945
(CEE 45–26)

## 95

# Babette Lehman's Footed Havdalah Tray

Nuremberg, early 19th century
Silver, partial gilt; embossed, chased, castings
Height 2 in. (5.1 cm), diameter 9⅛ in. (23.2 cm)
MARKS: Master (wheel in circle; Rosenberg, no. 4316); place and date (Rosenberg, nos. 3801, 3794)

INSCRIBED
Around rim
מצות ה׳ ברה מאירת עינים
The commandment of the L[ord] is pure, enlightening the eyes (Ps. 19:9)

In star, in Yiddish
גוט וואך / אונד / גוט יאהר
Good week / and / good year

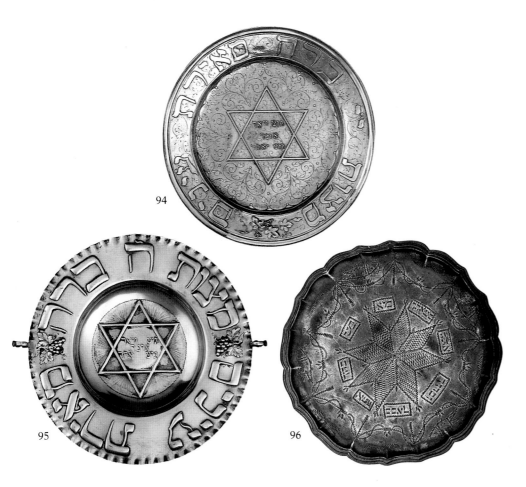

94

95

96

## 96

# Pewter Havdalah Plate

MASTER: Phyllipp Yacob Schott
ENGRAVER: Unknown
Freiburg, end 16th / early 17th century
Pewter, cast and rolled; later engraving
Diameter 10 in. (25.4 cm)
MARKS: Master, place, and date (Hintze, vol. 5, no. 897)

INSCRIBED
In center rectangles

ברוך / אתה / בבאך / וברוך / אתה / בצאתך / מא / סט

Blessed / shall you be / in your comings / and blessed / shall
you be / in your goings (Deut. 28:6) / M. A. / S. T.

Round, shallow plate with raised, scalloped triple-banded rim.
Center engraved with eight-pointed star and words of inscrip-
tion set in rectangles between the points. All bordered by
festoon decorations.

Pewter plates were favored in well-to-do European
homes from medieval times. Since Jews were not per-
mitted to enter pewter guilds, decorated pewter plates
for Jewish festivals were created by purchase of blank
plates in the big cities, which were then taken to the
smaller towns where Jewish folk engravers made them
appropriate by applying Hebrew inscriptions and
designs. The decorations were often based on illustra-
tions in Hebrew books related to such holidays as Pass-
over, when the Haggadah would be the natural source,
or to Purim, for which illustrated Esther scrolls would
provide inspiration.

The inscription here belongs to the conclusion of
the Sabbath service. The initials are probably those of
the owners. This dish would have held a kiddush cup
and perhaps a spice container to be used at the close
of the Sabbath. When not so employed, the plate no
doubt graced a cupboard or mantle.

The engraving on this plate was made with a rotary
tool. The central star imitates embroidery stitchery and
design, as do the swags, tassels, and fish that decorate
the outer edge. Embroidery, the folk art of women, was
a natural inspiration for folk art in another medium.

(CEE 29–46)

Small broad-rimmed tray with fluted edge on four cast, scroll-
ing feet. Border bears inscription in broad letters in high relief
punctuated with grape clusters and vine leaves framed by cast
handles. Rounded center carries embossed six-pointed star with
Yiddish inscription in relief. Raised surfaces, rounded inner sur-
face, handles, and feet are gilded or bear traces of gilt.

This popular type of German plate was widely copied
from earlier examples (see cat. no. 94), which was
produced in porcelain as well as silver. The folkloric
Yiddish inscription made it an appropriate family pos-
session. The plate probably held the kiddush goblet
during the prayer recitation on Saturday evening at the
close of the Sabbath. In Rabbi Meyer's catalog of 1932,
Irving Lehman's marginal note reads, "Belonged to
Mother [Babette Newgass Lehman]."

Reference

For similar plates, see I. Shachar, *Jewish Tradition in Art*, 1971, pp.
92–95, nos. 233 and 234.

Literature

I. S. Meyer, "Catalogue of the Jewish Art Objects in the Collection of
Judge Irving Lehman," 1932, no. 33.

BEQUEST OF JUDGE IRVING LEHMAN, 1945
(CEE 45–33)

## 97/98/99/100

# Berlin Round Towers

### 97

#### Spice Container (*B'samim* Box)

MASTER: Workshop of George Heinrich Steffin (?)
Berlin, 1821–41
Silver, filigree; embossed, chased, cutout
Height 11½ in. (29.2 cm), diameter of base 2⁵⁄₁₆ in. (5.8 cm)
MARKS: Master (Scheffler, *Berliner*, no. 1360:233?); place
and date (Scheffler, *Berliner*, nos. 14, 18)

Knobbed and striated footed base supports three-tiered tower
composed of three round filigree boxes in graduated sizes.
Largest box composed of four sections, one a hinged door, with
filigree half rounds and stylized flower in center. Sections of
second tier also composed of filigree half rounds. Filigree
sections composed along a diagonal decorate third tier, from
which a smooth spire rises, culminating in ball and cutout flag.

### 98

#### Spice Container (*B'samim* Box)

MASTER: August Friedrich Ferdinand Eisolt
Berlin, 1854–60
Silver, embossed and chased; filigree
Height 8¾ in. (22.2 cm), diameter of base 2⅜ in. (6 cm)
MARKS: Master (Scheffler, *Berliner*, no. 2029:415); place
and date (Scheffler, *Berliner*, nos. 15, 21)

Stepped base and smooth stem with chased bands support
round box with filigree sections composed along a diagonal,
one section a hinged door. Spire with lower section of
embossed leaf ornament and smooth upper section terminates
in globe. The flag is lost.

### 99

#### Spice Container (*B'samim* Box)

MASTER: Eduard Friedrich Wilhelm Reinick (?)
Berlin, 1845–60
Silver, embossed and chased; filigree
Height 7⅞ in. (20 cm), diameter of base 2¼ in. (5.7 cm)
MARKS: Master (Scheffler, *Berliner*, no. 2035:422a?); place
and date (Scheffler, *Berliner*, nos. 15, 21)

Stepped base and smooth stem with chased bands support
round box with filigree sections composed along a diagonal,
one section a hinged door. Spire embossed with leaf and feather
motifs within ovals and arches culminates in small globe and
undulated flag.

### 100

#### Spice Container (*B'samim* Box)

MASTER: August Friedrich Ferdinand Eisolt
Berlin, 1847–50
Silver, filigree; embossed, chased, cutout
Height 11½ in. (29.2 cm), diameter of base 2⅜ in. (6 cm)
MARKS: Master (Scheffler, *Berliner*, no. 2029:414); place
and date (Scheffler, *Berliner*, nos. 14, 20)

Stepped base and stem with decorative band support three-
tiered tower composed of round boxes in graduated sizes deco-
rated with filigree diagonal leaf motif. Largest box, with one
hinged section serving as door, bordered with bands of
embossed roses. Spire embossed with leaf and feather motifs
within ovals and arches culminates in globe and undulated flag.

Apparently one could go to the silversmith and pur-
chase a single- or multi-tiered tower according to one's
taste and pocketbook. The parts are interchangeable,
as one can see from similar spires (cat. nos. 99 and 100)
and similar boxes (cat. nos. 98 and 99). A filigree con-
tainer was especially suitable for holding spices, since
one could then readily smell the fragrance emanating

97 / 98 / 99 / 100

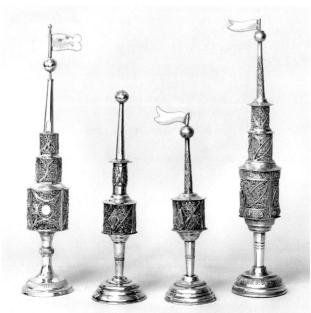

through the openwork patterning of the decoration.

Mr. Toch's notes of 1929 indicate, regarding catalog number 99, "Psom Box . . . used in the home of Mrs. Henry M. Toch."

Literature

H. M. Toch, "Jewish Ceremonial Objects Presented by Mr. and Mrs. Henry M. Toch to Temple Emanu-el, 1929," no. 6.

BEQUEST OF JUDGE IRVING LEHMAN, 1945
(CEE 45–41)

GIFT OF MILTON HALLER, 1970
(CEE 70–1)

GIFT OF MR. AND MRS. HENRY M. TOCH, 1928
(CEE 29–6) (CEE 29–12)

## 101/102/103/104

# Berlin Rectangular Towers

### 101

#### Spice Container (*B'samim* Box)

MASTER: August Friedrich Ferdinand Eisolt
Berlin, 1854–60
Silver, filigree; embossed, chased, cutout; traces of gilt
Height 11¼ in. (28.6 cm), diameter of base 2⅝ in. (6.7 cm)
MARKS: Master (Scheffler, *Berliner*, no. 2029:415); place and date (Scheffler, *Berliner*, nos. 14, 21)

Stepped base with embossed band and embossed stem support two-tiered tower. Lower tier a rectangle decorated with filigree half rounds, a small round door, and gilded, undulated flags at the corners. Smaller second filigree tier supports a double spire. Lower spire embossed with confronting, crowned lions holding the Tablets of the Law; upper spire embossed and chased. A globe and undulated gilded flag crown the spire.

### 102

#### Spice Container (*B'samim* Box)

Berlin (?), after 1888
Silver, filigree; embossed, chased, cutout; traces of gilt
Height 8 in. (20.3 cm), diameter of base 2⅛ in. (5.4 cm)
MARKS: Place and date (Rosenberg, no. 5); two unidentified marks

Stepped base and stem with chased bands support single square with sides decorated with filigree sections composed along a diagonal, one section opening as a door. Four gilded undulated flags at the corners. Banded spire terminates in fluted ornament.

### 103

#### Spice Container (*B'samim* Box)

Berlin, 19th century
Silver, filigree; embossed
Height 11 in. (27.9 cm), base 2⁹⁄₁₆ in. square (6.5 cm)

Straight stem rising from stepped round base on square pedestal supports two-tiered filigree tower. Lower tier decorated with filigree crescents and round flower-like centers; one panel contains lozenge-shaped door. Upper, round tier decorated with filigree sections composed along a diagonal. Smooth spire culminates in globe and large undulated flag.

### 104

#### Spice Container (*B'samim* Box)

Berlin (?), after 1888
Silver, embossed and chased; filigree, traces of gilt
Height 10 in. (25.4 cm), diameter of base 2⁷⁄₁₆ in. (6.2 cm)
MARKS: Place and date (Rosenberg, no. 5); unidentified mark

101 / 102 / 103 / 104

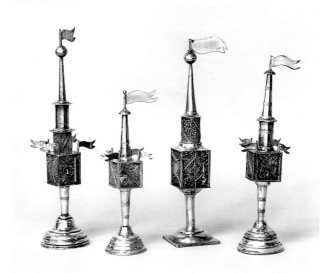

Stepped, banded base and banded stem support single square box decorated with filigree sections composed along a diagonal, one section serving as a door. Inside, a two-part removable drawer for spices. Gilded, undulated flags at corners. Double spire with chased bands culminates in fluted ornament and undulated gilded flag.

The filigree tower box in various sizes and stories was a favored spice container in Berlin. The Berlin style of strongly marked filigree sections was popular, with stems and spires often echoing each other above and below. The one spice container of this group that differs strongly in its base (cat. no. 103) appears to have lost its original stem and base; the replacement is unmarked.

BEQUEST OF JUDGE IRVING LEHMAN, 1945
(CEE 45–42)

GIFT OF MR. AND MRS. HENRY M. TOCH, 1928
(CEE 29–8)

BEQUEST OF JUDGE IRVING LEHMAN, 1945
(CEE 45–45) (CEE 45–40)

## 105

# Filigree Spice Tower (*B'samim* Box)

Probably Italy, 18th century
Silver, filigree; embossed and cutout work
Height 9 in. (22.9 cm), base 2⅛ in. square (5.4 cm)

Wide, double-flared base on balled feet supports tower form of lacy filigree wire. Twisted wire articulates edges; silver buttons centered on petaled flower forms on all sides and on base. Filigree globes at spire, animal-shaped flag at top.

This tower has been extensively repaired over the years and no longer opens. A long screw may have held all the parts together. The large silver buttons and ball feet may be part of the repairs.

In his notes, Henry Toch wrote, "Psom Box Filigree, Venice 1730."

Literature
H. M. Toch, "Jewish Ceremonial Objects Presented by Mr. and Mrs. Henry M. Toch to Temple Emanu-el, 1929," no. 11.

GIFT OF MR. AND MRS. HENRY M. TOCH, 1928
(CEE 29–11)

## 106/107

# Filigree Spice Goblets

### 106
**Spice Container (*B'samim* Box)**
MASTER: AC
Moscow, 1865
Silver, filigree; cutout work
Height 4⅞ in. (12.4 cm), diameter of upper rim 1½ in. (3.8 cm)
MARKS: Master; place and date (Tardy, p. 354); *88*

Footed filigree base and banded stem support covered goblet surmounted with filigree globe topped with cutout fishlike flag.

### 107
**Spice Container (*B'samim* Box)**
MASTER: VP
Moscow, 1850 (?)
Silver, filigree; cutout work
Height 4 in. (10.2 cm), diameter of upper rim 1⁵⁄₁₆ in. (3.3 cm)
MARKS: Master (in Cyrillic); place and date (Tardy, p. 353)

Footed filigree base supports covered goblet surmounted with filigree globe topped with cutout flag. The container has been repaired and was originally supported by a stem.

These fanciful spice containers display a playful inter-mixture of tower, pear shape, and goblet form.

Reference
For a piece similar to cat. no. 106, see *Towers of Spice*, 1982, no. 7, p. 15, where the cup is within an elaborate fruit and flower cluster.

BEQUEST OF JUDGE IRVING LEHMAN, 1945
(CEE 45–47) (CEE 45–46)

## 108/109

# Footed Filigree Towers

### 108

**Spice Container (*B'samim* Box)**
Poland, 1859
Silver, filigree; embossed, chased, cutout
Height 6½ in. (16.5 cm), base 2¼ in. square (5.7 cm)
MARK: Place and date (Rosenberg, no. 7861)

Cylindrical filigree box with dome-shaped scalloped cover and round scalloped bottom set on four long wires flaring out to round feet separated by filigree armatures. Petal-shaped finial supports flagpole and notched flag.

### 109

**Spice Container (*B'samim* Box)**
Poland, about 1866
Silver, filigree; embossed and chased
Height 7¼ in. (18.4 cm), base 2 in. square (5.1 cm)
MARKS: Place and date (Rosenberg, nos. 7864, 7865)

Four wire legs held by scalloped flower flare out to round feet separated by filigree armatures. Above, rectangular filigree box supports pyramidal filigree tower with small door.

The small filigree tower-shaped spice container with wide base and long flaring wire legs is a Polish preference. The wide base steadies the small, tall spice container and lends it the special kind of dislocation often experienced in even the humblest Polish ritual objects. Hallmarks of Austria-Hungary appear on these two spice containers because the section of Poland in which these were made was under Austro-Hungarian rule.

BEQUEST OF JUDGE IRVING LEHMAN, 1945
(CEE 45–54)

GIFT OF MR. AND MRS. HENRY M. TOCH, 1928
(CEE 29–7)

105

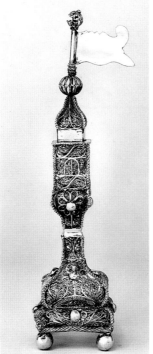

106 / 107

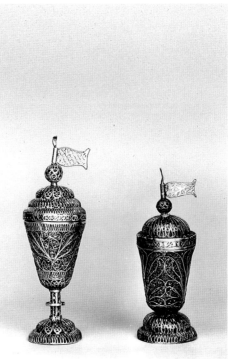

108 / 109

## 110

# Temple Spice Tower

### Spice Container (*B'samim* Box)

MASTER: W
Warsaw, 1881
Silver, partial gilt; embossed, engraved, cutout
Height 10¾ in. (27.3 cm), diameter of base 2⁵⁄₁₆ in. (5.9 cm)
MARKS: Master; place and date (Lileyko, p. 100)

High stepped, round base and knopped stem support rectangular, engraved box edged at the sides with twisted wire; gilded flags in the upper corners. All four sides engraved with representations of the façade of the Temple. Birds perch on top of columns joined by a foliate arch that spans a pierced, appliquéd niche in the center, one of which opens as a door. Below the niche, an engraved fence. Double spire with foliate demarcation topped with globe and gilded flag.

The representation of the Temple makes clear the relationship between the sacred duties in the home and the cultic practices in the ancient Temple. The priests burned incense in the Temple; now, the scent of spices is inhaled at the close of the Sabbath. This charming folk engraving is individualized by the little love birds, the center niche for the Torah scrolls, and the fence, which observes the admonition to "make a fence around the Law" (Pirke Avot 1:1). At one time bells hung from the wires at the corners, a reference to the bells that hung from the hems of the robes of the priests.

BEQUEST OF JUDGE IRVING LEHMAN, 1945
(CEE 45–48)

## 111

# Pear-Shaped Spice Container (*B'samim* Box)

MASTER: ADB
Poland, mid 19th century
Silver, embossed and engraved; castings
Height 5 in. (12.7 cm), width of base 2⅜ in. (6 cm)
MARKS: Master; place and date (Tardy, p. 328)

Engraved leaf-form base and petaled stem support two-part, pear-shaped container. Lower part pierced with three rows of holes and engraved with petals and triangles; smooth upper part with tooled bands. Small bird on globe finial screws on to stem, which holds all the parts together. Originally there was another leaf (now broken off) which held the pear.

The pear form of spice container was an East European preference, perhaps relating to the Garden of Eden whence Adam and Eve were banished, but permitted to take spices with them. In order to fill the container with spices the finial is unscrewed, which allows the container to be opened. The small holes made possible the inhalation of the fragrance of the spice during the recital of the Havdalah blessings on Saturday night.

Judge Lehman noted, "Haphdalah from Warsaw belonged to Grand Rabbi."

Reference

L. Ginzberg, *Legends of the Jews,* 1909, vol. 1, pp. 81–82.

Literature

I. Lehman, List of one hundred and eleven objects, circa 1928, no. 53.

BEQUEST OF JUDGE IRVING LEHMAN, 1945
(CEE 45–53)

110                                        111

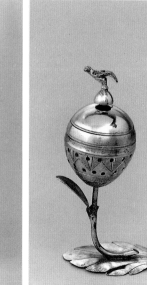

112

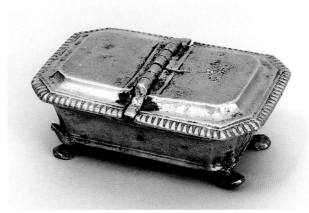

## 112

# Pewter Spice Box (*B'samim* Box)

Germany (Alsace?), end of 18th century
Pewter, cast and soldered  ·
2 x 4¾ x 3¼ in. (5.1 x 12.1 x 8.3 cm)

Four attached claw feet support rectangular box. Center-hinged cover with beveled top and cast fluted edge. Inside, two compartments on each side.

Although pewter has a lower melting point and is not as hard as silver, pewter objects were prized in well-to-do European households. The horizontal pewter spice box with four compartments for the spices is a known type, which is often embellished with cast masks and engraved monograms.

The donor included this note with his gift, "About 200 yrs old used as spice box for Saturday evening services (prayers) J. Abraham."

Reference

For a similar box, see G. Wigoder, *Jewish Art and Civilization*, 1972, p. 72.

GIFT OF J. ABRAHAM
(CEE 72–6)

113

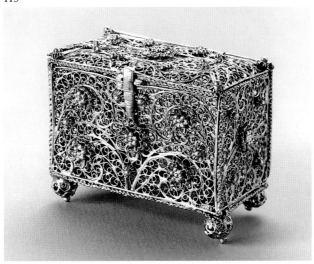

## 113

# Miniature Spice Chest (*B'samim* Box)

Italy, late 17th century
Silver, filigree; hammered latch
1¾ x 2³⁄₁₆ x 1⅜ in. (4.4 x 5.6 x 3.5 cm)

Filigree box with hinged top set on four filigree ball feet. Surfaces ornamented with filigree rosettes with silver granulation and smaller flowers with granule centers. Fine silver braid decorates all edges.

This lacelike box was used to hold the spices for the Havdalah ceremony. The exquisite workmanship is similar to the filigree and ornament on Italian wedding rings. The little ball feet of the box are seen as central ornaments on rings, and similar braid trims the rings as well. There are some breaks and some old repairs on the box, but considering its fragility and age, it is in fine condition.

Judge Lehman noted, "Filigree scent box bought by J. D. C. worker from Grand Rabbi of Warsaw in his family for 250 years."

References

For examples of rings, see cat. no. 133, and V. Klagsbald, *Catalogue raisonné de la collection juive du Musée de Cluny*, 1981, pp. 46 and 47.

Literature

I. Lehman, List of one hundred and eleven objects, circa 1928, no. 55.

BEQUEST OF JUDGE IRVING LEHMAN, 1945
(CEE 45–55)

**114**

# Holy Land Spice Goblet (*B'samim* Box)

Bezalel School of Arts and Crafts
Jerusalem, about 1920
Olive wood; turned, carved, painted
Height 5¼ in. (13.3 cm), diameter of base 2 in. (5.1 cm)

INSCRIBED
Painted on body
על בשמים / ירושלם
For spices / Jerusalem

Turned wooden goblet on turned footed base. Screw-on domed cover with incised holes and engraved circles.

The warm, polished surface of olive wood was a prized medium for small objects that could be brought back from a pilgrimage to Palestine. Wood from ancient olive trees, the ritual object, and even the Hebrew designation as coming from Jerusalem make these humble objects precious. The circlets scored around the holes are an ancient symbol seen on Jewish antiquities from the Holy Land.

References

P. Figueras, *Decorated Jewish Ossuaries*, 1983, p. 63, pl. 23; *"Bezalel" of Schatz*, 1983, p. 46, no. 506.

(CEE 72–7)

**115/116/117/118**

# Mezuzot

**115**

**Mezuzah Case and Parchment Blessing**
Bezalel School of Arts and Crafts
Jerusalem, late 1920s
Silver, embossed; filigree, granulation, appliqué
2½ x ⁹⁄₁₆ in. (6.4 x 1.4 cm)

Half-cylinder with window; top and bottom with circlets for affixing to door. Yemenite-style filigree ornament with lozenge ornament and granulation. Cutout oval in back for insertion of parchment.

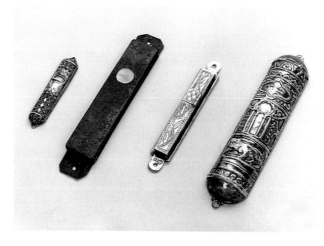

115 / 116 / 117 / 118

114

**116**

**Mezuzah Case and Parchment Blessings**
United States, 19th century (?)
Tin, cut and folded; glass window
5 x ¹⁵⁄₁₆ in. (12.7 x 2.4 cm)

Flat, folded box slides onto back. Round opening in front set with glass. "Shaddai" ("Almighty" in Hebrew) appears on the parchment in the window. Cutout holes at top and bottom for attaching to doorway.

**117**

**Mezuzah Case and Parchment Blessing**
Warsaw, 2d half of 19th century
Silver, cutout; engraved
3⅞ x ⅝ in. (9.8 x 1.6 cm)
MARKS: Place and date (Lileyko, p. 100); *STERLING IMP*

Flat back folds over raised front containing hinged door. Decoration of tooled geometrics and leaves on a vine. Round tabs at top and bottom have cutouts for attaching to door.

**118**

**Mezuzah Case**
Bezalel School of Arts and Crafts
Palestine, about 1913
Silver, embossed
5½ x 1⅜ in. (14 x 3.5 cm)

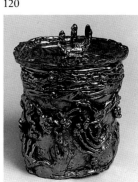

Half-cylindrical container with relief embossing in registers. Center register with Islamic style doorway; above, cartouche with "Shaddai" ("Almighty" in Hebrew); below, a lion. Domes on top and bottom with rings for attaching to doorway. The upper dome is hinged for the insertion of parchment blessings and can be opened only when not affixed to the doorway.

All these cases are made so that they can be opened or have back openings so that the parchment, inscribed by hand with verses from Deuteronomy (6:4–9 and 11:13–21), can be inserted. These verses begin with the Shema, "Hear, O Israel! The Lord our God, the Lord is one" and include "Inscribe them on the doorposts of your house and on your gates." The prayer represents the basic monotheism of the Jewish faith, and the mezuzah itself is a visible sign of a Jewish household. The mystical name of God, "Shaddai," also suggests a protective or amuletic function for the mezuzah.

BEQUEST OF JUDGE IRVING LEHMAN, 1945
(CEE 45–120) (CEE 45–249)

GIFT OF MR. AND MRS. HENRY M. TOCH, 1928
(CEE 29–31)

BEQUEST OF JUDGE IRVING LEHMAN, 1945
(CEE 45–250)

## 119

# Fabric Mezuzah Cover

Persia, 19th century
Cotton; gold-washed silver sequins
11¾ x 8¾ in. (29.8 x 22.2 cm)

Tan cotton rectangle (faded from pale green) lined with red and dark-blue hand-printed coarse cotton. Stitches through both fabrics hold sequins of slightly different sizes, some with impressed designs.

In the Middle East such a colorful mezuzah cover would have hung in the doorway of a house made of stone or clay. The fabric cover is both practical and extremely decorative. The format of the design is related to Islamic rugs woven with hanging lamp motifs. The cover was purchased in Meah Shearim in Jerusalem from an Iranian Jew.

GIFT OF PHYLLIS AND SAM ROSEN, 1982
(CEE 82–8)

## 120

# Geber Charity Box (Tzedakah)

Hana Geber
New York, 1985
Bronze, cast; with patina
Height 6 in. (15.2 cm), diameter of lid 3⅜ in. (8.6 cm)

Cast in two parts; oval cup with raised elements, uneven lid with three-pronged raised element and opening to accept contributions.

The sculptor Hana Geber (born 1910) has formed a small but very heavy object as if it were a maquette for a monumental work. She has used as motifs hands raised in priestly benediction, a Hanukkah menorah, and the *shin* atop the lid signifying one of the names of God. There are also forms in high relief, such as the basketry surface, and others which might be grape clusters or granulations or human bodies rising to heaven. The sense of passion the artist bestows on the humble object not only raises it artistically but also recalls the high spiritual content in the mitzvah of charity.

Literature

C. Grossman, *Hana Geber*, 1986.

GIFT OF RUTH A. MILLER IN LOVING MEMORY OF HER HUSBAND, LOUIS MILLER, 1987
(CEE 87–7)

## 121

# Phylactery Cases (Tefillin Boxes)

MASTER: MP
Warsaw, 2d half of 19th century
Silver, embossed and engraved
Cube 1⅞ in. (4.8 cm), width of base 1⅞ in. (4.8 cm), depth of base 2⅜ in. (6 cm)
MARKS: Master; place and date (Lileyko, p. 99)

INSCRIBED
On the top of one
של ראש
For the head

On the top of the second
של יד
For the hand

Cube decorated with a border of engraved leaf design; back hinged section ornamented with diapered pattern; base engraved with checkerboard and scrolling leaf design.

Such silver cases house leather boxes that hold the prayers and straps that are tied to the head and left arm during prayers. The silver cases are a mark of affluence and may be kept on a desk when the contents are not in use.

Judge Lehman wrote in Rabbi Meyer's catalog,

"These two covers I am told belonged to my father but I am not sure...."

Literature

I. S. Meyer, "Catalogue of the Jewish Art Objects in the Collection of Judge Irving Lehman," 1932, nos. 8 and 9.

BEQUEST OF JUDGE IRVING LEHMAN, 1945
(CEE 45–5A/B)

## 122

# Phylactery Cases (Tefillin Boxes)

MASTER: L. Sheinker
Novgorod (?), 1882
Silver, embossed and engraved
Cube 1¼ in. (3.2 cm), width of base 1¾ in. (4.4 cm), depth of base 2⅜ in. (6 cm)
MARKS: Master (in Cyrillic); place and date (Tardy, p. 360); *84*

INSCRIBED
On the top of one
ש"ר
F[or the] h[ead]

121

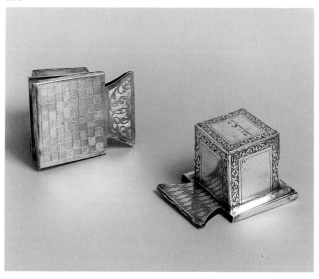

122

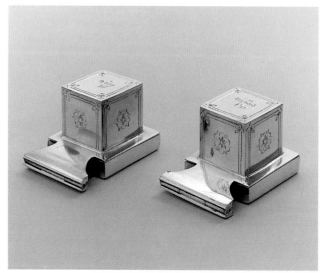

123

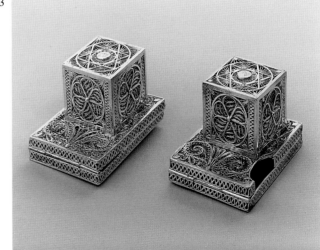

On the top of the second

שׁ״י

F[or the] h[and]

Small cube bordered with tooled engraving and engraved rosette in center of each side.

These cases enclosed small leather boxes and straps that are tied to the head and left arm during prayer service.

Literature

I. S. Meyer, "Catalogue of the Jewish Art Objects in the Collection of Judge Irving Lehman," 1932, nos. 6 and 7.

BEQUEST OF JUDGE IRVING LEHMAN, 1945
(CEE 45–6A/B)

Reference

*Bezalel 1906–1929*, 1983, pp. 161–65.

BEQUEST OF JUDGE IRVING LEHMAN, 1945
(CEE 45–19A/B)

## 123

# Phylactery Cases (Tefillin Boxes)

Bezalel School of Arts and Crafts
Ben Shemen, circa 1911–14
Silver filigree; engraved
Cube 1⅜ in. (3.5 cm), width of base 2 in. (5.1 cm), depth of base 2⅝ in. (6.7 cm)
MARK: Jerusalem (in Hebrew)

INSCRIBED
On the top of one

שׁ״ר

F[or the] h[ead]

On the top of the second

שׁ״י

F[or the] h[and]

Sides and bases decorated with filigree flowers within circles, flowers in oval, and leaf-and-petal design. Tops have six-pointed stars within circles. One of the boxes has a side opening.

Filigree work was a native craft of the Yemenite Jews and was a popular technique in the Bezalel School of Arts and Crafts. It was favored for small ritual objects as well as decorative objects for sale to tourists. A variety of filigree objects were produced at the moshavah (craft cooperative) at Ben Shemen during the three years of its existence.

## 124/125/126/127

# Phylactery Bags (Tefillin Bags)

### 124
**Embroidered Tefillin Bag**
Germany, 20th century
Silk, applied silk embroidery; rayon lining
6 x 8½ in. (15.2 x 21.6 cm)

Handsewn dark-blue silk drawstring bag with dark-blue ribbon ties. Appliquéd varicolored silk embroidery over tan silk; large flower on front in shades of dark red, pink, greens, and yellow; on the back, bud and leaf in greens and pink. Red rayon lining. The embroidery has been reused from a much earlier piece; the rayon lining is of a later period.

### 125
**Brocade Tefillin Bag**
Poland, 18th century
Silk and silver weave-patterned fabric, silver and silver-wrapped lace, silk ribbons; printed undyed linen lining
7 x 6¼ in. (17.8 x 15.9 cm)

Front of patterned fabric of pink and red roses with green leaves, silver flowers, and vines woven on a silver and undyed silk ground. Back a pieced lattice floral design (at one time silver, now undyed silk with silver remnants). Silver lace sewn to three sides. The interior is lined with pieced undyed linen hand printed with a red floral motif. Tie of undyed silk ribbon, two bows at the sides.

124 / 125 / 126 / 127

### 126
**Tapestry Tefillin Bag and Tefillin**
New York, 19th century
Wool on canvas, silk; cotton plaid lining; leather and parchment (tefillin)
6 x 4¾ in. (15.2 x 12.1 cm)

INSCRIBED
Woven on front
ר י
H[ead] H[and]

Woven on back
N I

Lower part of bag of purple, rust, red, green, and white wool tapestry, lined in cotton. Upper part of bright-blue double silk with silk ribbon drawstrings. The bag is in poor condition.

### 127
**Striped Tefillin Bag**
New York, 19th century
Silk, cotton, cording
9 x 7¼ in. (22.9 x 18.4 cm)

Undyed silk ornamented in center with hand-stitched red cotton insert. Red cording sewn into seams. Unlined, with slender double cord ties.

Inventive imagination and local crafts combine to create these small gifts for men, usually made by women in the family. The bit of embroidered silk salvaged and appliquéd to a bag, the wool tapestry made by a shaky but loving amateur attest to a thoughtful maker. The beribboned brocade bag made of scraps of rare fabrics usually seen on Torah curtains is lined with a hand-printed fabric, which was a market-day craft of European Jewish fabric sellers. The delicacy of these bags is surprising considering that they were used by men.

GIFT OF FLORENCE KORN LEHMAN
(CEE 50–5)

CONGREGATION EMANU-EL MUSEUM PURCHASE FUND, 1982
(CEE 82–6)

UNKNOWN DONOR
(CEE 85–20) (CEE 85–27)

**128**

# Collar for a Prayer Shawl (*Attarah*)

Poland, mid 19th century
Silver on cotton core, linen ribbon; cotton lining
Width 4¾ in. (12.1 cm), length 38¾ in. (98.4 cm)

Long rectangular band with five large rosette forms within squares interspersed with four smaller circles; the whole within border of circlets in a fishscale pattern formed by looped silver-wrapped cotton core. Silver surface is smooth except within the outer petals of the large rosettes in which there are also pressed silver surfaces. Piece is lined along edges with linen ribbon to which a cotton lining is tacked.

The *attarah* ("crown" in Hebrew) is sewn to a prayer shawl and marks the side of the prayer shawl that is pulled up on the head of the worshiper. The unique Jewish craft of looping silver-wrapped thread into designs that were then fashioned into such shawl ornaments, or used to make caps and vests, was called "Shpanyer arbeit" ("Spanish work") in Yiddish.

The late Giza Frankel, formerly of the Ethnological Museum and Folklore Archives in Haifa, noted that "the name itself—*spanier*—is of importance. It is not known whether the origin is the word *spinnen*—to weave, or whether the handcraft originated with Jews from Spain, who arrived in Poland as early as the sixteenth century" (p. 44).

Visually this work recalls the rich Spanish silver embroidery seen on the costumes of Spanish bullfighters. In the looping technique it appears as a form of fabric filigree work or silver lacemaking. Polish Jews in the Galician town of Sasów designed a special loom and by some imaginative transformation produced this fabric-making technique, which appears as a coalescence of artistic elements from their historical past.

References

G. Frankel, "Little Known Handicrafts of Polish Jews in the Nineteenth and Twentieth Centuries," 1975, pp. 42–49; B. Kirshenblatt-Gimblett and C. Grossman, *Fabric of Jewish Life*, 1977, no. 86.

CONGREGATION EMANU-EL MUSEUM PURCHASE FUND, 1982
(CEE 82–4)

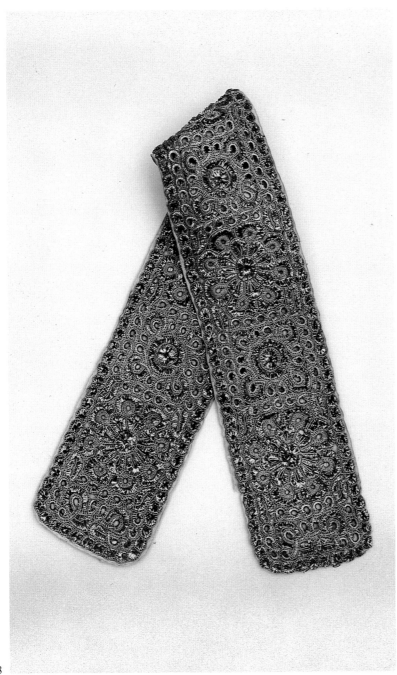

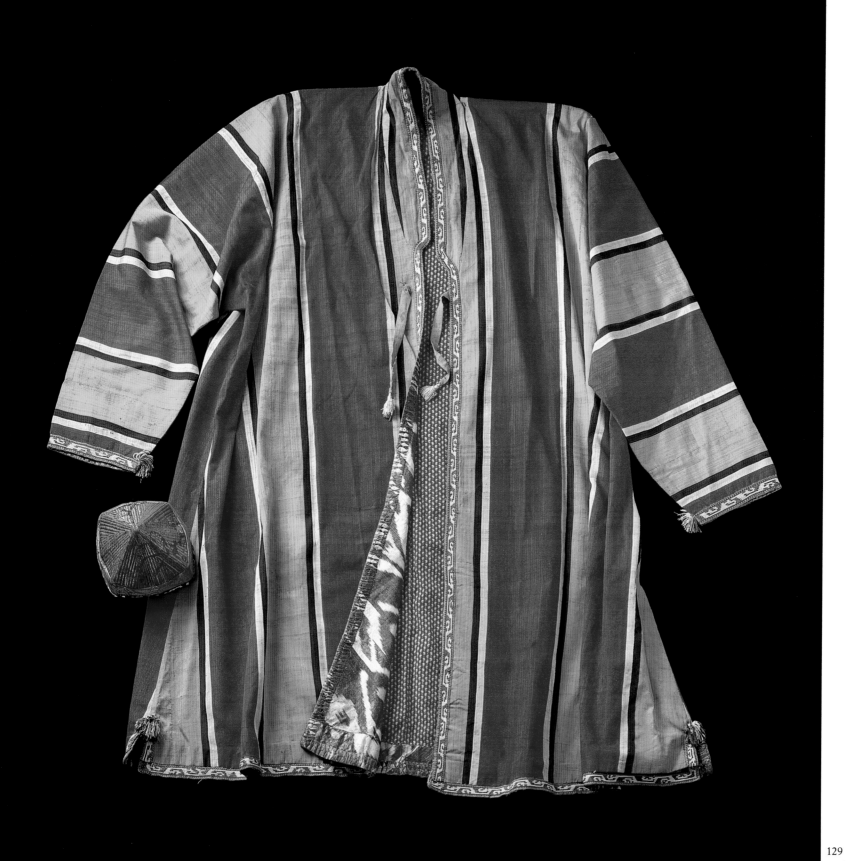

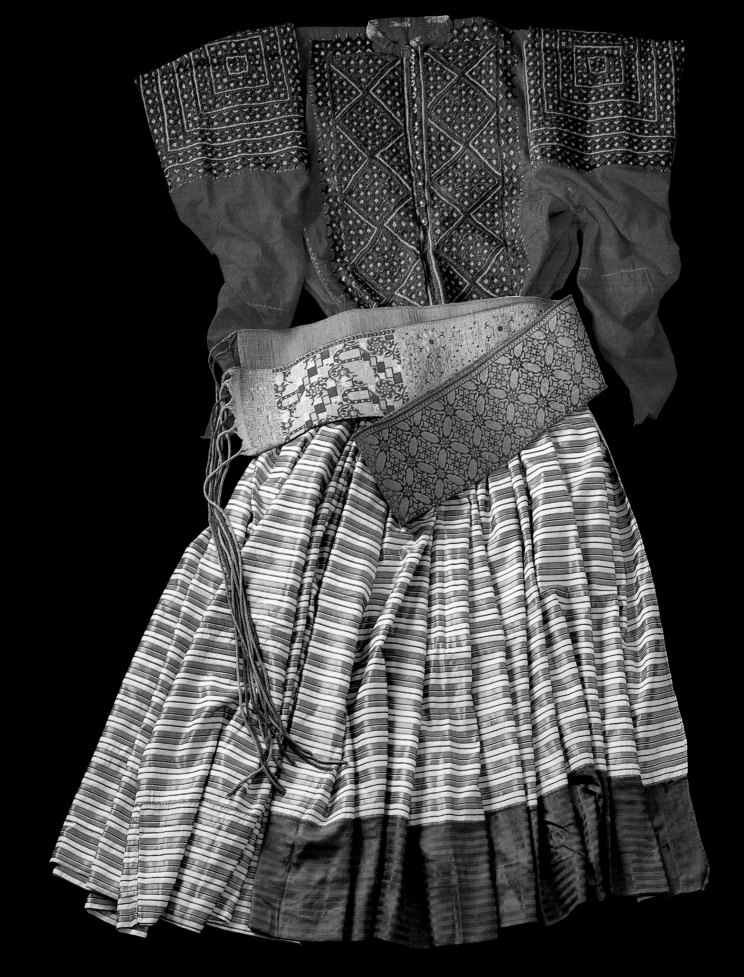

## 129

# Jewish Bokharan Robe and Cap (*Djomah* and *Kalpoche*)

**Robe**
Bokhara, 19th century
Striped silk, printed cotton, tie-dyed glazed cotton, silk-and-cotton braid
Length 51 in. (129.5 cm)

**Cap**
Bokhara, 1980s
Silk and cotton, cotton braid

Lengths of striped gold, purple, natural, and magenta silk woven on a thirteen-inch loom, trimmed with green, natural, red, and blue silk and cotton braid. Silk tassels at bottom of sleeves and at side slits; woven ties at front. Lined with printed red cotton with inner front band of tie-dyed magenta, natural, light blue, and yellow glazed cotton attached at the edges with green silk thread. Cap machine stitched gold and orange silk, trimmed in cotton braid, lined in brown-and-tan printed cotton. The robe has been shortened by two and one-half inches.

According to Mark Ribacoff of the Bokharan Jewish Aid Society of New York, the Bokharan men in New York still wear this traditional loose outer robe and headdress on festive occasions.

Purchased from Mark Ribacoff, New York.

Reference
A. Rubens, *A History of Jewish Costume*, 1981, fig. 67, p. 51.

CONGREGATION EMANU-EL MUSEUM PURCHASE FUND, 1987
(CEE 87–2A/B)

## 130

# Jewish Moroccan Wedding Dress and Belt

**Blouse**
Erfoud, early 20th century
Cotton, cotton embroidery; metal buttons
Length 32¾ in. (83.2 cm)

Red cotton blouse with green, yellow, red embroidery in diagonals on the front, in squares on the sleeves, which fold back. Small collar of brocaded cotton; metallic buttons on front.

**Wrap (Izar)**
Erfoud, early 20th century
Woven silk and cotton
Length 168½ in. (428 cm)

White cotton with green silk float thread; large rectangular inset of green silk. The wrap is double thickness, folded in on itself.

**Belt**
Fez, early 20th century
Woven silk and cotton; metallic thread; braided tassels
Length 85½ in. (217.2 cm)

Woven of red, orange, blue, and undyed cotton thread and metallic wrapped thread, with changes of pattern at irregular intervals. Twisted fringe. The belt was originally twice its present width.

The embroidered blouse would be tucked inside the gathered, double wrap (izar) and held at the waist with the wide, tightly woven belt, which would be wrapped and tied. The end of the wrap was brought up over the back to serve as a shawl. The costume would be completed by an elaborate headdress and many necklaces and ear ornaments.

Purchased from Jaimé Cohen, New York.

Literature
*La Vie juive au Maroc*, 1973, cat. no. 385, p. 196.

CONGREGATION EMANU-EL MUSEUM PURCHASE FUND, 1986
(CEE 86–5A/B) (CEE 86–6)

## 131

# Henna Pot

Fez, 19th century
Ceramic, painted, glazed
Height 5¾ in. (14.6 cm), diameter of rim 7 in. (17.8 cm)

Round glazed bowl with pale-green background set on slender, hollow base; rim painted with bright-green stripe, narrow blue stripe, and two black lines. Outer body divided into four sections by a black lattice design bordered with green stripes; each section filled with a roundel containing blue and yellow blossoms in the center. On the roundels and at intersections of the lattice design and rim, remains of globules of orange paint

131

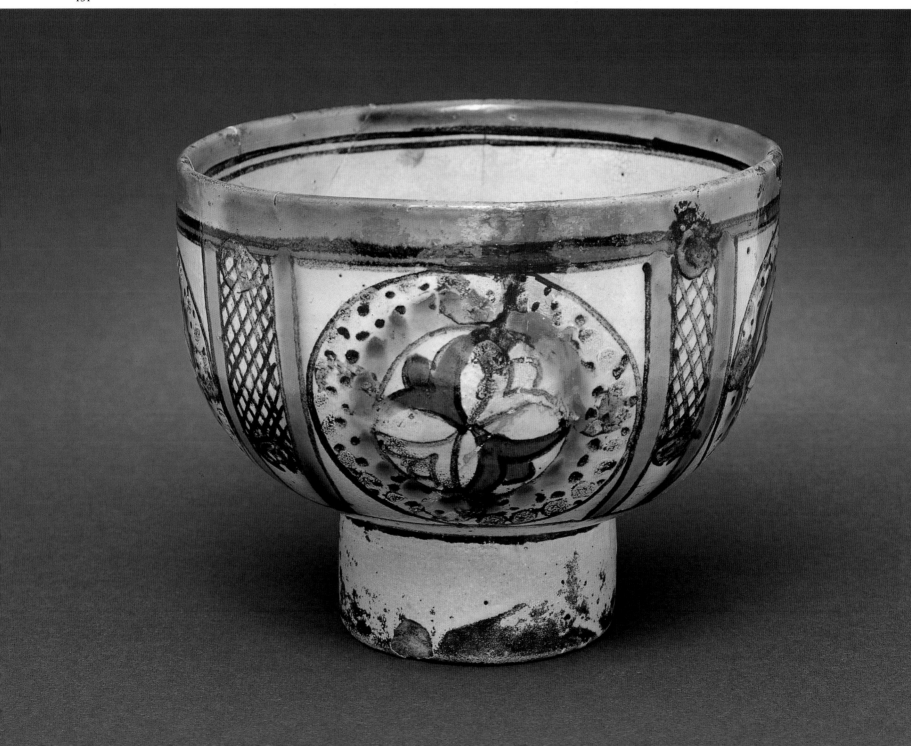

133

which may have held jewels. Interior painted with a six-pointed flower within a circle formed by a doubled black line. There are some losses and old repairs.

Special pots were made to contain the henna used by North African Jews for application to the face and hands of a bride and other female members of the bridal party. (Occasionally henna might also be applied to the groom.) Henna was thought to protect the bride from evil. The designs on the pot were probably also deemed protective and served as hex signs.

Purchased from Jaimé Cohen, New York.

References

On the use of henna among North African Jews, see I. Ben-Ami, *Le Judaisme marocain: Etudes ethnoculturelles*, 1975, passim. For a discussion of the tradition of the week-long wedding celebration, see C. Grossman, "The Real Meaning of Eugène Delacroix's *Noce juive au Maroc*," 1988, pp. 64–73.

Literature

*La Vie juive au Maroc*, 1973, cat. no. 189, p. 108.

CONGREGATION EMANU-EL MUSEUM PURCHASE FUND, 1986
(CEE 86–7)

## 132

# Jewish Moroccan Wedding Crowns (*Sfifot*)

Tétouan or Tangier, end 19th century
Seed pearls, gold beads, semiprecious stones in gold settings; sewn on cotton, silk lined

**Green Crown**
Length 16⅛ in. (41 cm), height at center 4⅜ in. (11.1 cm)

**Black Crown**
Length 16¼ in. (41.3 cm), height at center 4⅛ in. (10.5 cm)

Exterior bands of green cotton twill and black cotton twill sewn with small gold flower forms set with semiprecious stones, semiprecious beads, gold beads, and pearls of graduated sizes. Lined with natural cotton canvas; paper layers between outer and inner fabrics.

Although closely following a specific model, each of these headdresses is an individual work of art. The centers are highlighted by the size of the jeweled setting, the use of the largest of the seed pearls around the setting, and the gradually diminishing height of the band from the center toward the ends. The tiny seed pearls form a lozenge design around each group of jewels. The crown is held to the head with a scarf that covers the hair. According to Aviva Müller-Lancet, a woman would wear such a headdress first when she was a bride and subsequently on ceremonial occasions. The idea of the Jewish bride as a "queen" on her wedding day is pervasive in Jewish cultures.

References

For similar pieces, see A. Müller-Lancet in *La Vie juive au Maroc*, 1973, p. 224, no. 422, and pp. 116, 204, 205, 250. For crowns, see N. Feuchtwanger, "The Coronation of the Virgin and of the Bride," 1986/87, pp. 213–24.

BEQUEST OF JUDGE IRVING LEHMAN, 1945
(CEE 45–62) (CEE–63)

## 133

# Italian Wedding Ring

Venice, 17th century
Gold, embossed; filigree, engraved
Height ⁹⁄₁₆ in. (1.5 cm), inside diameter ¾ in. (1.9 cm)

INSCRIBED
מזל / טוב
Mazal / tov

Two registers of alternating red-gold filigree bosses and granulation framed by three rows of twisted and braided gold wire joined in a seam behind an appliquéd yellow-gold plaque on which the words "mazal tov" are engraved, cutting through the yellow gold, revealing the redder gold beneath.

The fine gold filigree and granulation is typical of Venetian goldsmithing. Such a ring probably belonged to the Jewish community and was lent to the bride for the wedding ceremony and the seven days of blessing that

132

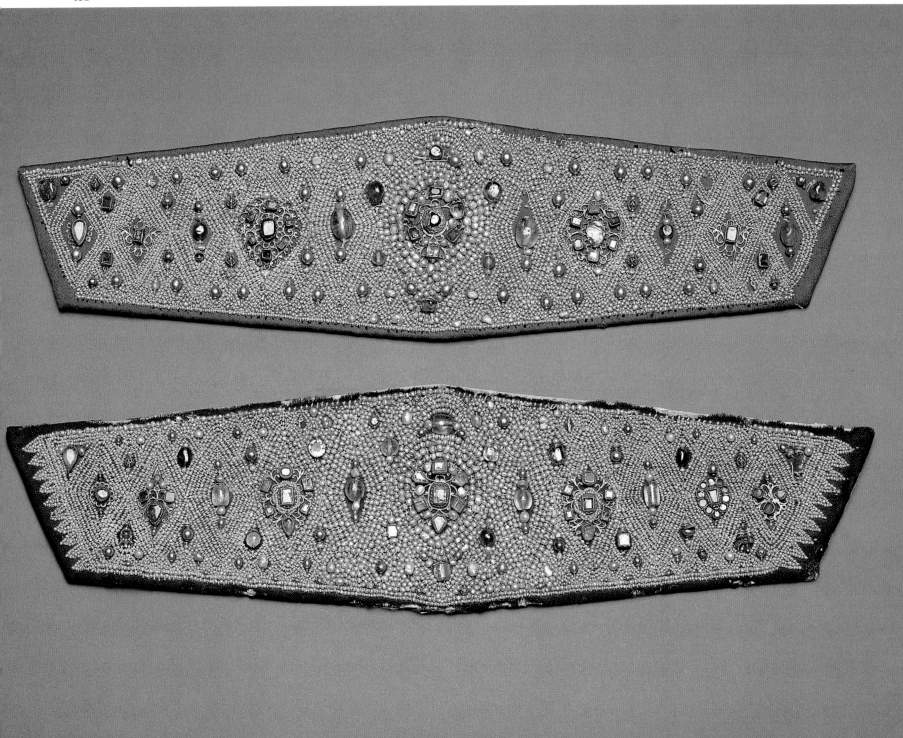

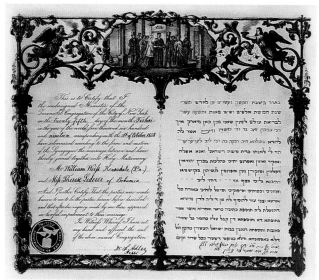

134

followed. The ring is a large size and was probably made to accommodate the fingers of many brides, whatever their sizes. From Italian manuscripts one may conjecture an elegant life style in which such a ring could be held in place by the train of a gown.

### References

For other Italian wedding rings, see V. Klagsbald, *Catalogue raisonné de la collection juive de Musée de Cluny*, 1981, pp. 14, 43–48, nos. 35–53; Y. Hackenbroch, *Renaissance Jewellery*, 1979, p. 50, no. 105.

BEQUEST OF JUDGE IRVING LEHMAN, 1945
(CEE 45–104)

## 134/134A

# Temple Emanu-El Marriage Contracts (Ketubot)

### 134

**Marriage Contract (Ketubah)**
of
William Weiss of Honesdale, Pennsylvania, and
Therese Lederer of Bohemia
New York City, October 3, 1858
Printed on paper, ink and gilt; blue-and-white
Congregation seal
14¼ x 16³⁄₁₆ in. (36.2 x 41.1 cm)

TRANSLATION OF HEBREW TEXT
Words in italics indicate handwritten insertions

*On Sunday, the twenty-fifth of Tishri 5619,* according to the creation of the world as we count it, in New York, *Reb Benyamin Ze'ev son of Reb Moses Weiss* spoke to the maiden *Hayyah Rivkah daughter of Reb Leib Lederer*, "Be my wife according to the law of Moses and Israel, and I will work for you, honor you, and maintain you according to the manner of Jewish men who work for their wives, honor them, nourish them, and provide for them in truth. And I will give you... *zuzim*, which belong to you, as well as your food, your clothing, and all your needs, and will live with you in conjugal relations." And he agrees to add unto her property an additional sum as an obligation. And he accepts the responsibility for this in accordance with the regulations of the ketubah and the supplementary documents, as they are customary with the

daughters of Israel, and in accordance with the ordinances of our sages, and not as an illusory obligation or formula in a document. All is valid and established.

Printed form with foliate border in ink and gilt. Incense-bearing angels in upper corners flank engraved center cartouche depicting a wedding ceremony.

The presence of incense-bearing angels gives rise to the speculation that this printed document was a composite of a standard form available to the printer plus engraving plates of the synagogue interior and the plant that separates the space into distinct halves. On the basis of a contemporary print, the wedding scene would appear to depict the interior of Temple Emanu-El in its location at the time on East Twelfth Street in lower Manhattan, where the marriage recorded in this document was performed by Rabbi Samuel Adler. The dress of the rabbi and the clothing of the wedding party reflect the fashionable dress of mid-nineteenth-century Emanu-El congregants at a wedding.

The Hebrew text is an abbreviation of the traditional ketubah; for an extended version, see catalog number 136.

GIFT OF THE WEISS FAMILY
(CEE 29–57)

### 134A

**Marriage Contract (Ketubah)**
of
Joseph Stern and Augusta Ochs
New York City, March 12, 1854 (12 Adar 5614)

Another marriage contract in the collection which utilizes the same printed form. In this case, the officiating rabbi was Dr. Leo Merzbacher.

GIFT OF THE STERN FAMILY
(CEE 29–58)

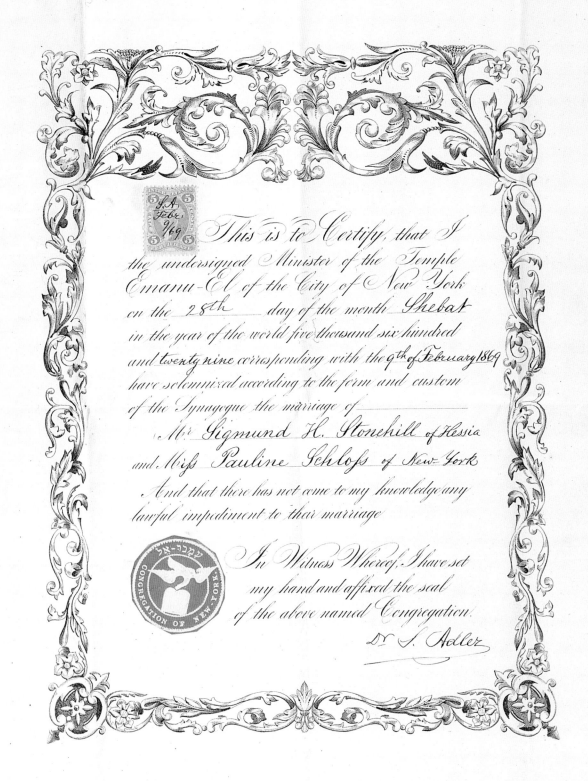

This is to Certify, that I the undersigned Minister of the Temple Emanu-El of the City of New York on the 28th day of the month Shebat in the year of the world five thousand six hundred and twenty nine corresponding with the 9th of February 1869 have solemnized according to the form and custom of the Synagogue the marriage of —————

Mr. Sigmund H. Stonehill of Hessia and Miss Pauline Schloss of New York

And that there has not come to my knowledge any lawful impediment to their marriage

In Witness Whereof, I have set my hand and affixed the seal of the above named Congregation.

Dr. S. Adler

CONGREGATION OF NEW YORK.

## 135/135A/135B/135C

# Temple Emanu-El Marriage Certificates

### 135

**Marriage Certificate**
of
Sigmund H. Stonehill of Hessia (Hesse?) and
Pauline Schloss of New York
New York City, February 9, 1869 (28 Shevat 5629)
Printed on paper, ink; red-and-white Congregation seal,
revenue stamp
14 x 11 in. (35.6 x 27.9 cm)

Printed border of scrolling leaf design surrounds printed document on which is applied seal of Emanu-El congregation and revenue stamp. Dates, names of the bride and groom and of Dr. Samuel Adler, rabbi of the congregation, inserted by hand.

This marriage contract marks the first wedding in the new, "uptown" synagogue building on Fifth Avenue and Forty-third Street. The press took special note of the festive occasion, since Pauline Schloss was the daughter of the well-to-do New Yorker Moses Schloss, who was also vice president of Temple Emanu-El. The ceremony was followed by a dinner at Trenor's Lyric Hall on Sixth Avenue near Forty-second Street for one hundred fifty family members and guests. Dinner was followed by "a ball in the large hall, at which nearly a thousand invited guests participated."

The revenue stamp attests to the legality of the document. Revenue stamps were customarily affixed to documents that had to be registered, such as mortgages and deeds, and a mark through them canceled them, thus indicating that they had been paid for. This marriage certificate was probably registered at City Hall, when the stamp would have been affixed.

Literature

*New York Herald*, February 10, 1869.

GIFT OF MRS. KATHERINE W. AIBEL AND PROFESSOR RICHARD A. WEBSTER, GREAT-GRANDCHILDREN OF PAULINE AND SIGMUND STONEHILL, 1984
(CEE 84–11)

Additional marriage certificates in the collection, all issued at the Forty-third Street Temple and all signed by Dr. Samuel Adler:

### 135A

**Marriage Certificate**
of
Gustave Ranger of Prussia and
Flora Mandelbaum of Bavaria
New York City, October 8, 1872 (6 Tishri 5633)

GIFT OF WALTER S. MACK, 1986
(CEE 86-4)

### 135B

**Marriage Certificate**
of
Herman I. Weil of Bavaria and
Carrie Gutman of New York
New York City, April 27, 1873 (13 Nisan 5633)

GIFT OF THE WEIL FAMILY
(CEE 85–29)

### 135C

**Marriage Certificate**
of
Albert August Levi of Worms and
Henrietta M. Meyer of New York
New York City, February 25, 1874 (8 Adar 5634)

GIFT OF THE LEVI FAMILY
(CEE 85–30)

## 136

# Marriage Contract (Ketubah)

Yitzhak Davidson and Gittel Silka Negbauer
New York City, August 10, 1860 (12 Av 5620)
Printed on paper, ink; revenue stamp
13 ½ x 9 ¼ in. (34.2 x 23.4 cm)

Printed Hebrew marriage contract set between garlanded pilasters with recessed urns in niches at the bottom and garland-draped urns above. On the connecting crossbar, in front of a

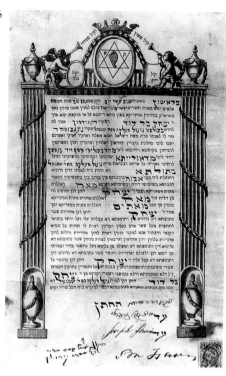

balustrade, a crowned and garlanded central oval with a six-pointed star embellished with inscription and lyre. Words on each side emerging from the trumpets of two winged putti begin a verse from the book of Jeremiah (33:11), which is continued on the flanking shields supported by the putti.

INSCRIBED
In star of center shield
ק א
C[ongregation] of A[merica] (?)

On either side of center shield
קול ששון / וקול שמחה
The voice of joy, / and the voice of gladness,

In shield at right
קול חתן
the voice / of the bridegroom,

In shield at left
וקול כלה
and the voice / of the bride

TRANSLATION OF HEBREW TEXT
Words in italics indicate handwritten insertions

*On Sunday, the twelfth day* of the month *of Av,* in the year five thousand six hundred *and twenty* since the creation of the world, the era according to which we are accustomed to reckon here in the City of New York in North America, which is an island surrounded by the ocean, how Reb *Yitzhak son of David,* called *Davidson,* said to this maiden *Gittel Silka daughter of Shmuel,* known as *Negbauer,* "Be thou my wife according to the law of Moses and Israel, and I will work for thee, honor, support, and maintain thee in accordance with the custom of Jewish husbands, who work for their wives, honor, support, and maintain them in truth. And I will set aside for thee *two hundred silver zuzim,* the price of your virginity, which belong to thee according to the Torah, and thy food, clothes, and necessities, and live with thee in conjugal relations according to universal custom." And this *maiden Gittel Silka, daughter of Reb Shmuel,* consented and became his wife. The dowry that she brought from *her father's house,* in silver and gold, valuables, clothing, and bedclothes, amounts to *one hundred* dollars American money, and the bridegroom Reb *Yitzhak* agreed to increase this amount from his own property with the sum of *one hundred* dollars American money, making in all *two hundred* dollars American money. And thus said Reb *Yitzhak* the bridegroom, "I take upon myself and my heirs after me the responsibility of this marriage contract, of the dowry, and the additional sum, so that all this shall be paid from the best part of my property, shall be mortgaged for the security of this contract and of the dowry and of the addition made thereto." Reb *Yitzhak* the bridegroom has taken upon himself the responsibility for all the obligations of this marriage contract, as is customary with other marriage contracts made for the daughters of Israel in accordance with the institutions of our sages, may their memory be for a blessing, it is not to be regarded as an illusory obligation or as a mere form of document. We have followed the legal formality of symbolic delivery between Reb *Yitzhak son of David,* the bridegroom, and *Gittel Silka, daughter of Reb Shmuel,* and have employed an instrument legally fit for the purpose to strengthen all that is stated above, and everything is valid and established. [Signed] Yitzhak ben David Davidson, bridegroom; witness Abraham, son of Naftali; witness Joseph Davis; officiant Shmuel, son of Meir, Sam Isacson.

Augusta Davidson was the great-grandmother of the donor, Reva Godlove Kirschberg, who was reared in Houston, Texas. According to family history, Samuel Davidson, the son of Isadore (Yitzhak) and Augusta (Gittel) Davidson whose marriage contract is reproduced here, was sent by his mother to marry Etta Finkelstein of Luling, Texas, which began a Texas branch of the family. The text of the marriage contract is traditional, as is the verse from Jeremiah, which is used in the wedding liturgy.

Reference

"Ketubah," *Jewish Encyclopedia,* vol. 7, 1904, pp. 472–78.

GIFT OF REVA GODLOVE KIRSCHBERG, 1982
(CEE 82–12)

## 137

# Louis Marshall's Deeds to Pews

Temple Emanu-El, Fifth Avenue at Forty-third Street
New York, 1897; 1906
LITHOGRAPHER: Ferd. Mayer & Sons, New York
Printed on parchment paper, ink; revenue stamp, red
Congregation seal
Each 19¼ x 15⅝ in. (49 x 39.7 cm)

Lithograph, with a view of the synagogue in the upper left
corner of the deed and on front of enclosing envelope.

Pew number 112 was originally purchased by Charles
G. Thurnauer for the sum of $2,450, and the deed was
signed on June 1, 1869, by Lewis May, president of the
Congregation. On September 22, 1870, the south half
of the pew was assigned to Augustus B. Elfelt; on
November 16, 1874, the northerly half was assigned to
Adolph Mack, who deeded it back on January 26, 1880,
to Charles G. Thurnauer, whose executors assigned it
to Louis Marshall on March 11, 1897.

One half of pew number 113 was originally pur-
chased by Jacob Neuberger for the sum of $2,100, the
deed signed on February 1, 1869, by Lewis May, presi-
dent of the Congregation. On November 1, 1870, it was
assigned to Charles G. Thurnauer, whose executors
assigned it to Louis Marshall on March 11, 1897. The
other half of the pew was originally purchased by
Charles Zinn for the sum of $2,100, with the deed
signed on February 1, 1869, by Louis May, president of
the Congregation. On January 29, 1880, it was assigned
to Adolph Mack, who assigned it to Louis Marshall on
October 8, 1906.

The affixed revenue stamp and Congregation seal
were proof of the recording of the deed. The receipt
issued to Louis Marshall for payment of the $10 fee for
the transfer and recording of pews 112 and 113, dated
March 17, 1897, is also extant.

The donor, a son of Louis Marshall, was himself
a lawyer and also an active participant in many Jewish
communal organizations.

BEQUEST OF JAMES MARSHALL, 1987
(CEE 87–23)

137

## 138

# Moses Ehrlich's Deed to His Cemetery Plot

Emanuel [sic] Congregation of the City of New York
June 15, 1857
Printed on blue paper; blue-and-white Congregation seal
12½ x 7¾ in. (31.8 x 19.8 cm)

A meeting place for worship, religious instruction for
the young, and a burial ground are the first require-
ments for the establishment of a Jewish congregation.
In May 1845, a month after members of a cultural soci-
ety on New York's Lower East Side decided to estab-
lish a Reform congregation, four lots in Williamsburg
were purchased to serve as a burial ground. In 1851, six
years after its founding, the Congregation purchased
land for its Salem Fields Cemetery in Brooklyn, situ-
ated on the northerly side of the Brooklyn and Jamaica

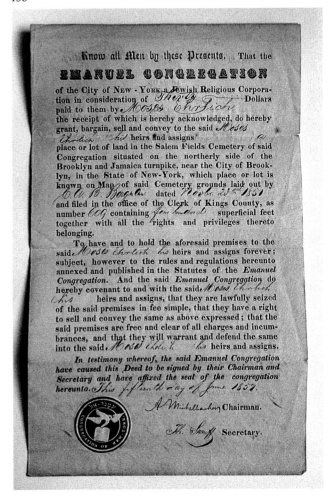

Turnpike. In 1857, Moses Ehrlich purchased plot number 609 for the sum of thirty dollars.

Reference

M. Stern, *The Rise and Progress of Reform Judaism*, 1895, pp. 20, 21.

GIFT OF MOSES EHRLICH FAMILY
(CEE 88–11)

## 139

# Richard Memorial Lamp (Yahrzeit Lamp)

DESIGNER: Chava Wolpert Richard
New York, 1972
Painted glass
Height 3½ in. (8.9 cm), diameter 3 in. (7.6 cm)
MARK: *DESIGN BY CHAVA WOLPERT RICHARD;
TOBE PASCHER WORKSHOP, THE JEWISH MUSEUM*

INSCRIBED
נר ה' נשמת אדם
The spirit of man is the lamp of the Lord (Prov. 20:27)

Mass-produced amber glass on short base; frosted letters of the Hebrew words against painted, dark-red band.

An inscription expressing the abiding belief in the eternity of the Jewish spirit (*neshamah*) is projected in elegant calligraphy in simple modern design. Chava Richard (born 1933) reveals her debt to the teaching of her father, the silversmith Ludwig Yehuda Wolpert (see cat. no. 169), in her use of calligraphy as a forceful motif that carries both the design and the meaning. The humble character of the object, which is simply a glass in which one places the candle to be lit on the anniversary of the death of a family member, is probably one of Chava Richard's outstanding designs. The use of a mass-produced glass as a Yahrzeit lamp is common and emphasizes the reality and starkness of death.

CONGREGATION EMANU-EL PURCHASE FUND, 1987
(CEE 87–9)

139

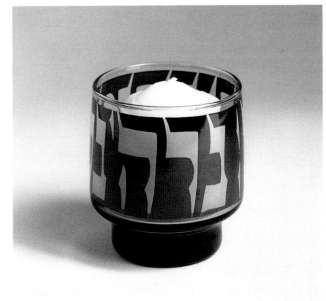

## 140

# Double Cup for Circumcision

MASTER: VS
Augsburg, 1650–60
Silver, gilt; embossed and engraved; gilt interior
Cup on left, height 3¼ in. (8.3 cm), diameter of rim
2⅝ in. (6.7 cm)
Cup on right, height 3⅛ in. (7.9 cm), diameter of rim
2¾ in. (7 cm)
MARKS: Master (Rosenberg, no. 556); place and date
(Rosenberg, no. 154)

INSCRIBED
Rim of left cup

כוס של מציצה הר״ר דניאל ב׳ הרב מר״ר שלמה הלוי נרו
סג״ל

Cup for *metsitsah*. The Rabbi R[eb] Daniel, s[on of] Rabbi Solo-
mon Halevi our t[eacher] and r[abbi], may his light sh[ine].
Dep[uty] to [the Levites]

Rim of right cup

כוס של ברכה הר״ר דניאל ב״הרב מו״ר שלמה הלוי נרו
מק״ק גאלינגען

Cup for blessing. The Rabbi R[eb] Daniel, s[on of] Rabbi Solo-
mon Halevi our t[eacher] and r[abbi], may his light sh[ine]. From
the H[oly] C[ongregation] of Gallingen

Two cups fit together to form shape of a wooden barrel with
planks suggested by engraved lines bound by embossed staves.
When so fitted together, only the engraved inscription for the
kiddush is visible.

140

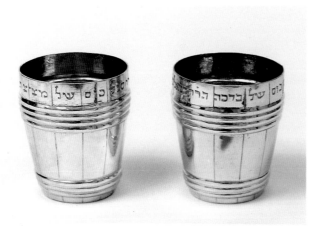

This two-part cup was made in Augsburg, as attested
by its hallmarks, and taken to the small town of Gal-
lingen (Prussia), southeast of Danzig. Apparently in
addition to his other duties, Rabbi Daniel Halevi was
a circumciser. The *metsitsah* cup was used to catch the
blood; during the rite of circumcision the mohel would
have used the kiddush cup to recite the blessing over
the wine. The double, barrel-shaped cup was also a
favorite form for a wedding cup, in which case both
parts would be used for the Kiddush.

Literature

I. Winter, *Ingathering*, 1968, no. 72, incorrectly described as a wed-
ding cup.

BEQUEST OF JUDGE IRVING LEHMAN, 1945
(CEE 45–83A/B)

## 141

# The Order of Circumcision
# (Prayerbook for the Mohel)

SCRIBE: Judah Leib ben Samson Segal
Düsseldorf, 1744
Ink, colors, gold, on vellum; tooled leather binding
13 folded leaves yield 26 pages
6 x 4 in. (15.2 x 10.2 cm)

TEXT
Contains order of the service for the ceremony of circumcision,
including laws and instructions for the mohel. Also includes
Grace after Meals, the laws and blessings for the Redemption
of the Firstborn, plus prayers for travelers on roads, on the sea,
and in the forest.

PAINTED MINIATURES
Title page. Figures of Aaron and Moses.
Folio 2v. Initial word in cartouche flanked by winged angels.
Folio 7r. The act of circumcision with seated godfather, mohel,
and five men, all in flattened hats and ruffled collars, most clad
in knickers.
Folio 9v. The blessings over the child with two men in prayer
shawls, one holding the infant, three women in long gowns,
and four additional men. All the men clad in short knickers, long

בָּרוּךְ

אתה י"י אֱלֹהֵינוּ מֶלֶךְ הָעוֹלָם אֲשֶׁר
קִדְּשָׁנוּ בְּמִצְוֹתָיו וְצִוָּנוּ עַל
הַמִּילָה ׃

ברוך

---

אבי הבן מברך

בָּרוּךְ

אַתָּה י"י אֱלֹהֵינוּ מֶלֶךְ הָעוֹלָם אֲשֶׁר קִדְּשָׁנוּ
בְּמִצְוֹתָיו וְצִוָּנוּ לְהַכְנִיסוֹ בִּבְרִיתוֹ שֶׁל
אַבְרָהָם אָבִינוּ ׃

יהקהל עונין

כְּשֵׁם

שֶׁנִּכְנַס לַבְּרִית כֵּן יִכָּנֵס לַתּוֹרָה וְלַחֻפָּה
וּלְמַעֲשִׂים טוֹבִים ׃

ובמעשׁתו

buttoned jackets, flattened, brimmed hats and ruffled collars.
Folio 13r. Celebratory feast with four women, four men, and a child, all seated.
Folio 22r. The Redemption of the Firstborn; figures around a table, one man seated with a plate of coins before him, another standing next to the swaddled infant on the table. Three women and two men stand behind the table.
Folio 23r. Landscape of a road by the sea with a man on a horse and several small figures.
Folio 24r. Sea scene with two sailing ships and two men paddling a canoe.
Folio 25r. Italianate landscape with a family and dog, resting backpacker, and others.

This handwritten book is based on a work by Rabbi David Lida (Rabbi David ben Aryeh Leib of Lida) printed in Amsterdam in the seventeenth century. Beautiful handwritten books with hand-painted illustrations continued to be made even though printed versions were available. Actually, the mohel was familiar with the prayers, but there is a requirement that they be read. All these prayers relate to the duties of the circumciser. The Grace after Meals appears because there is always a festive meal (seudah) after the rite. And since the circumciser might be obliged to travel to the family of the newborn male child, there are the Prayers for Travelers.

Literature
I. Winter, *Ingathering*, 1968, no. 208.

BEQUEST OF JUDGE IRVING LEHMAN, 1945
(CEE 45–95)

## 142

# Circumcision Knife and Sheath

Italy, early 18th century
Agate, silver, coral; steel blade; paper and leather case
Length of knife 7½ in. (19 cm), sheath 4 in. (10.2 cm)

Faceted purple and gray agate handle set in silver blade holder and scalloped silver cuff with engraved design; coral bead finial set between silver filigree petals, two below, one above. Knife is well-worn steel; sheath is paper painted orange and embossed in gold, lined in green suede leather.

The elegant proportions and the use of fine silver filigree, as well as the coral bead as finial, suggest an Italian origin for this knife. The coral bead was believed to hold amuletic power and is often seen at the top of Italian megillah cases. In the *Ingathering* exhibition held in New York at the Jewish Museum in 1968, the knife was listed as Italian, which was undoubtedly the judgment of Dr. Guido Schoenberger, at the time Research Fellow at the museum.

Judge Lehman noted, "Mohel knife 18th century bought by Goldschmidt from descendants of the Mohel who also used the Mohel book" (cat. no. 141).

Reference
For a similar knife attributed to Germany, see *Synagoga*, 1960, no. C254.

Literature
I. Winter, *Ingathering*, 1968, no. 75; I. Lehman, List of one hundred eleven objects, circa 1928, no. 107.

BEQUEST OF JUDGE IRVING LEHMAN, 1945
(CEE 45–107A/B)

## 143/144

# Heart-Shaped Amulet Cases (*Shaddai*)

## 143
**Amulet Case with Family Crest (*Shaddai*)**
Italy, early 18th century
Silver, embossed, chased, cutout
4¼ x 3¼ in. (10.8 x 8.3 cm)

INSCRIBED
On back
שדי
Almighty

Three-dimensional case with fullness in center (now greatly flattened), scrolling edges, and key in form of grape cluster at center bottom (now pressed inward). On small door in center (now soldered closed), a horizontal bar of stars and moon (other marks obliterated); crown above. Top in form of a baldachin with fringed curtains on both sides. On reverse, center cartouche bears embossed Hebrew inscription.

143

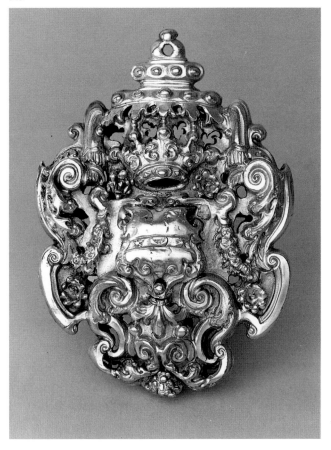

144

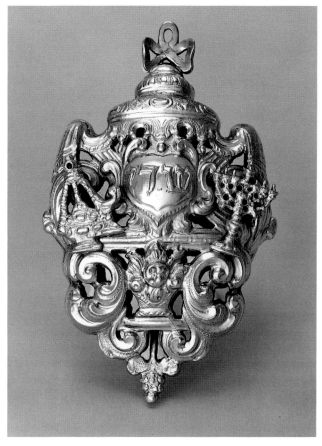

**144**

**Amulet Case with Temple Implements (*Shaddai*)**
Italy, 19th century
Silver, partial gilt; embossed, chased, castings
5½ x 4½ in. (14 x 11.4 cm)

INSCRIBED
On front and back
שדי
Almighty

Three-dimensional case with fullness in center. Open scrolling edges; gilded, cast grape-cluster key at center bottom. Lower register with flower-filled basket; upper register, heart-shaped cartouche carries Hebrew inscription. Applied gilded, cast elements: on one side, a seven-branched lampstand and hanging Temple lamp; on other side, Aaron's mitered hat and Tablets of the Law. Baldachin top with fringed curtains on both sides crowned with gilded ribbon loop finial for hanging.

Such amulet cases were often hung around the bed of a woman in childbirth or around an infant's crib. The case held prayers written on parchment which could be changed according to need. Such prayers were written by rabbis experienced in finding suitable biblical verses. Thus were human fears and concerns brought into rabbinic tradition.

Judge Lehman noted in his listing, "Amulet (17th century) from the Benguiat sale." The Benguiats were a famous Jewish family of international antique dealers who collected Judaica.

Reference

C. Adler and I. M. Casanowicz, "Descriptive Catalogue of [Benguiat Collection]," 1901.

Literature

I. Lehman, List of one hundred eleven objects, circa 1928, no. 25; I. Winter, *Ingathering*, 1968, nos. 136, 135.

BEQUEST OF JUDGE IRVING LEHMAN, 1945
(CEE 45–1) (CEE 45–22)

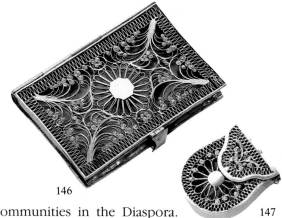

146

147

# 145

# Amulet Case in Book Form (*Shaddai*)

Italy, 17th century (?)
Silver, embossed and engraved; castings
3 x 2⅟₁₆ in. (7.6 x 5.2 cm)

INSCRIBED
Front and back
שדי
Almighty

Embossed container in book form with etched border and crown containing Hebrew inscription as book title. Cast columns with shrubs in baskets as capitals at each side. Affixed to center top, an openwork, cast arch with small globe and ring above for hanging. The hinged bottom is missing.

The flanking columns and center arch with its suggestion of angel wings present the book as if it were the sacred space of the Temple ark that contained the Ten Commandments. The Holy Writ as a symbol for the Temple in Jerusalem developed after the destruction of the Temple and the dispersion of the Jews, when in fact Jewish law became central to the spiritual and social cohesion of Jewish communities in the Diaspora.

The amuletic prayers were inserted into the book through the hinged bottom. The ring at the top of the arch reveals that the case was hung, probably on the wall of a sickroom.

Reference

For a similar case, see R. D. Barnett, *Catalogue of the Jewish Museum, London*, 1974, no. 596, p. 113, pl. CLXIV.

BEQUEST OF JUDGE IRVING LEHMAN, 1945
(CEE 45–15)

# 146/147

# Filigree Amulet Cases (*Shaddai*)

## 146

**Book-shaped Amulet Case (*Shaddai*)**
Italy, 18th century
Silver, filigree, embossing
2⅝ x 2 in. (6.7 x 5.1 cm)

Filigree work with central flower design, leaves, and border looping. One side round, the other indented to define the book shape. Cover with hinged clasp.

## 147

**Purse-shaped Amulet Case (*Shaddai*)**
Italy, 18th century (?)
Silver, filigree, embossing
1¼ x 1⅛ in. (3.2 x 2.9 cm)

Filigree work with central flower design, leaves, and border scrolling. Solid silver sides and top. Hinged flap with tiny rings at sides, one of which still has one link, revealing that it once hung by a fine silver chain.

The elegant filigree work on these cases with the effect of granulation within the scrollwork points to their Italian origin.

BEQUEST OF JUDGE IRVING LEHMAN, 1945
(CEE 45–51) (CEE 45–57)

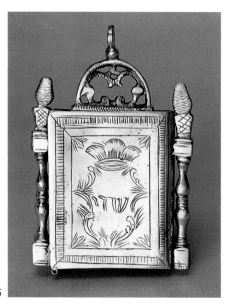

145

## 148

# Pitcher with Amuletic Phrase

Middle East, 19th century
Brass, hammered, chased, engraved; cast handle
Height 5½ in. (14 cm), diameter of base 4⅝ in. (11.7 cm)

INSCRIBED
On lower register
בן פורת יוסף בן פור...נ
Joseph is a fruitful vine, even a fruitful v[ine] (Gen. 49:22)

Slender round neck on rounded body with flat bottom. Raised Hebrew inscription provides decorative lower border; above, double ogee arches filled with birds and flowers. Cast round handle riveted to body.

Middle Eastern Jews favor the biblical phrase inscribed on this pitcher, which represents the wish for many children. One finds the quotation on household utensils and other secular and religious objects.

BEQUEST OF JUDGE IRVING LEHMAN, 1945
(CEE 45–210)

149

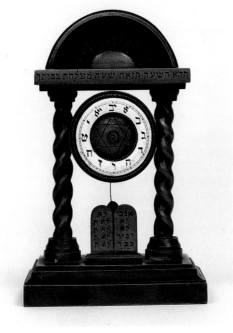

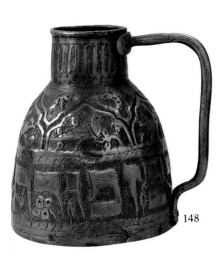

148

## 149

# Temple Clock

CLOCKMAKER: Joseph Buchegger
Wels, Austria, 19th century
Bronze, cast, engraved; enamel, paint
7⅛ x 4⁹⁄₁₆ x 2⅝ in. (18.1 x 10.6 x 6.7 cm), diameter of clock
2¼ in. (5.7 cm)
MARKS: Clockmaker; *in Wels. no. 264*

INSCRIBED
On lintel
תהא השעה הזאת שעה מצלחת בביתך
May this hour be a fortunate one in your house

On Tablets of the Law
אנכי / לא / לא / זכור / כבד
לא / לא ת / לא ת / לא ת / לא ת
I am (the Lord your God) / (You shall have) no (other gods beside Me) / (You shall) not (swear falsely) / Remember (the Sabbath) / Honor (your father and your mother)
(You shall) not (murder) / You shall not (commit adultery) / You shall not (steal) / You shall not (bear false witness) / You shall not (covet) (Exod. 20:2–14)

Rectangular stepped base supports two twisted columns to which round clock is attached. On base, between the columns, engraved Tablets of the Law. Lintel resting on columns bears inscription; arch above filled with half orb and rays. Face on raised enamel rim, painted Hebrew characters mark the hours. The clock hands are missing.

The presence of a modern clock set into a temple façade referring to biblical times strikes the modern eye as an amusing anachronism. However, this utilitarian object manages to embody many Jewish concepts. One is reminded of the centrality of Jerusalem in Judaic thought by the twisted columns that recall the Temple. The Ten Commandments remind one of the Law. The Hebrew inscription wishes one good fortune (mazal tov). These concepts are in view on an object that one looks at many times in the day.

Most significant, perhaps, is the Jewish concept of time—the Jewish calendar, the holidays of the year, and those religious occasions in the life of the individual that mark the rites of passage from birth to death.

BEQUEST OF JUDGE IRVING LEHMAN, 1945
(CEE 45–128)

# 150

## Toch Family Etrog Container

MASTER: PD
Vienna, 1861
Silver, traces of gilt; embossed and chased; gilt interior
5½ x 7½ x 4⅝ in. (14 x 19 x 11.7 cm)
MARKS: Master; place and date (Rosenberg, no. 7861)

Citron-shaped container in two parts with spring hinge and catch. Spreading base embossed to resemble roots, supports embossed tree-trunklike stem. Branch attached to lower container encircles lower part of fruit with embossed and chased leaves. The container has traces of gilt, all other parts are silver; the interior is gilded.

The etrog, which is carried in procession in the synagogue during Sukkot, is valued for its physical perfection, which includes the intact blossom end of the fruit. To keep the citron in its pristine condition, a special container is often used to hold it; sometimes silver sugar boxes are put into service. In this case, a handsome gilded fruit-shaped holder was made especially for the Jewish patron. According to the notes of Mr. Toch, "Used in the parental home of Henry M. Toch, 232 East 10 Street, New York City, where there was a synagogue from 1860 to 1887."

Literature

H. M. Toch, "Jewish Ceremonial Objects Presented by Mr. and Mrs. Henry M. Toch to Temple Emanu-el, 1929," p. 2.

GIFT OF MR. AND MRS. HENRY M. TOCH, 1928
(CEE 29–2)

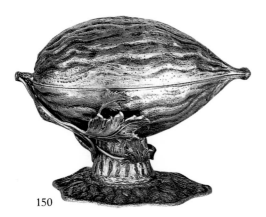

150

# 151

## Reuben Leaf Etrog Container

MASTER: Reuben Leaf
New York, 1922
Silver, embossed and chased; carved ebony; velvet lining
Height 6 in. (15.2 cm), diameter 7½ in. (19 cm)
MARK: *STERLING*

INSCRIBED
On lower band

שלש פעמים בשנה יראה כל זכורך את פני ד' אלהיך במקום
אשר יבחר בחג המצות ובחג השבועות ובחג הסכות ולא יראה
את פני ד' ריקם

Three times in the year shall all the males appear before the Lord your God in the place which He shall choose: on the feast of Pesach, and on the feast of Shavuot, and on the feast of Sukkot; and they shall not appear before the Lord empty[-handed] (Deut. 16:16)

On bottom of container

אברהם בן משה / מיכלה בת צבי-דוב / בוירד / פלדלפיה /
תרפ"ב

Avraham ben Moshe / Michla bat Tzvi-Dov / Burd / Philadelphia / 5682 (1922)

Round flaring flat-bottomed bowl on five legs with carved ebony feet. Decoration in two registers: lower register with embossed bands between which is engraved and chased Hebrew inscription; upper register an embossed and chased parade of people and animals before a walled city. On cover, embossed band of grapevine with grape clusters surrounds embossed petal design at center of which is carved ebony handle with star top. Both cover and interior of bowl are lined with purple velvet.

The three festivals mentioned in the inscription include Sukkot, when this container would be used to hold the etrog, a citrus fruit, carried in the synagogue service together with the lulav, composed of branches of palm, myrtle, and willow. On the pilgrimage festivals, Jews journeyed to Jerusalem, and the artist depicts such a parade of the old and the young—a person on horseback (cat. no. 151–A), another leading a camel (cat. no. 151), a mother and children riding on a donkey (cat. no. 151–B), a person leading a bull laden with fruit (cat. no. 151–D), some running (cat. no. 151–A), some trudging (cat. no. 151–C), one playing a flute (cat. no. 151–D). All

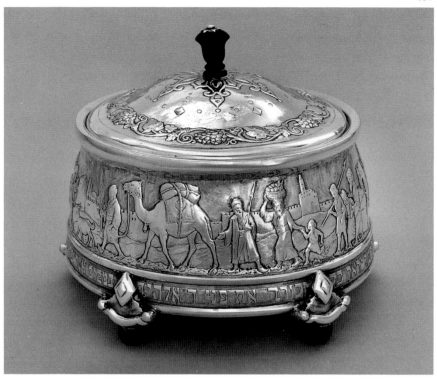

151

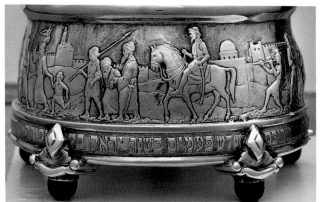

151–A

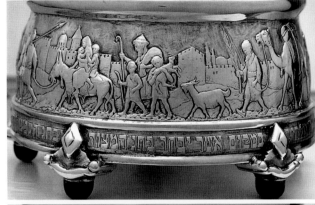

151–B

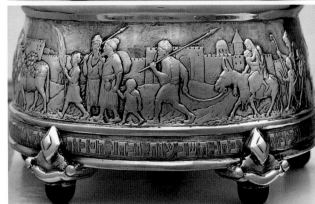

151–C

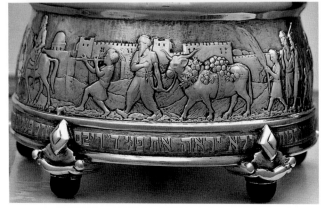

151–D

are set against the crenellated walls and towers characteristic of the landscape of the Holy City.

Reuben Leaf (born Lifshitz) was an artist in the Bezalel School of Arts and Crafts in Jerusalem, where from 1912 to 1916 he headed the department of metal and wood work. He came to New York in the twenties and established his own studio on Sixth Avenue. His work bears a strong affinity to the Bezalel School, but it is simpler and more integrated. In 1922 he made a group of objects for the Burd family in Philadelphia. They included, among others, this etrog container, as well as a Hanukkah lamp, a Passover plate, and an Elijah cup for Passover.

Reference

For other works by Reuben Leaf, see A. Z. Idelsohn, *The Ceremonies of Judaism*, 1929, pp. 20, 26, 27.

Literature

*Bezalel 1906–1929*, 1983, p. 372.

Congregation Emanu-El Museum Purchase Fund, 1986 (CEE 86–1)

152

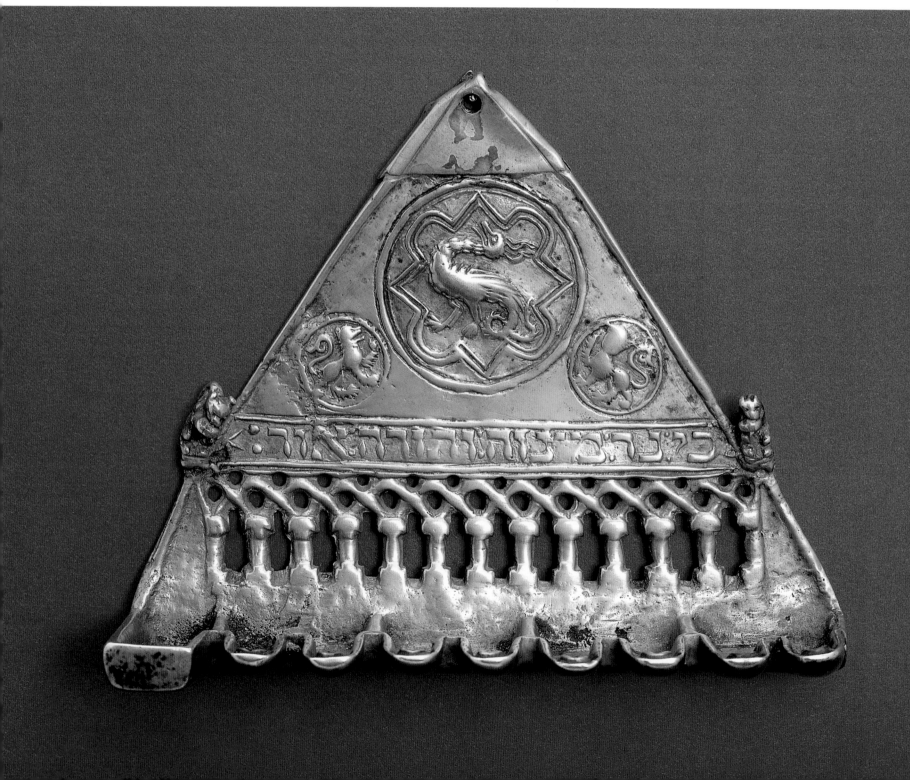

**152**

# Lehman/Figdor Hanukkah Lamp

Italy (?), 14th century
Bronze
5⅜ x 6¹¹⁄₁₆ x 2 in. (13.7 x 17 x 5.1 cm)

INSCRIBED
Front
Above intersecting arcades

כי : נר : מצוה : ותורה : אור : >

For the commandment is a lamp, and Torah is light (Prov. 6:23)

Cast in one piece with triangular backplate and tray of oil fonts at bottom at right angle to backplate. Upper backplate decorated with large central roundel containing phoenix in relief. Two lower roundels contain on left, relief of rampant lion in profile; on right, rampant lion with frontal (?) head. In wide band beneath roundels, Hebrew inscription in Ashkenazic style script. At either end of band, a three-dimensional squirrel perched on its haunches holding a nut in its paws. Lower section of backplate swells outward and contains rank of twelve freestanding columns supporting intersecting arches. Below, eight rounded, projecting oil fonts with small tongues to hold wicks; large rectangular oil font at left is shammash (servitor). The apex of the lamp is covered front and back with a nineteenth-century brass restoration.

Medieval bronzes were produced in Europe by means of an early form of mass production; the molten metal was poured into a mold and more than one object was made from the same mold. These were small, functional, long-lasting objects; however, they were often melted down later and the metal reused, so that remaining medieval bronzes are rare.

A lamp similar to the Lehman/Figdor lamp, in the Klagsbald Collection (cat. no. 152–A), appears to be from the same mold, although it has sustained many losses. Its relief medallions have been flattened, the squirrels at each side are fragmentary, and the arcade is narrow and has no relief elements. It would seem that the lamp was subjected to the great heat of a fire, which resulted in these losses. Subsequently, the central medallion was gouged out in order to create a mythological beast, but one that no longer corresponded to the original. Both lamps were cast in one piece (cat. no.

152–A

Above. Klagsbald Hanukkah Lamp. French or Italian, 14th century. Bronze, 5⅛ x 6¹¹⁄₁₆ in. (13 x 17 cm). Klagsbald Collection.

152–B

152–B) and both have the same measurements across the bottom of the backplate, with similar correspondences in the sizes of the medallions. The apex of each lamp is now lost, probably broken off at a fragile point. The Klagsbald lamp has two holes remaining at the top. Beneath the restoration of the Lehman/Figdor lamp two holes can also be discerned, which are probably vestiges of rivet holes that originally held an elaborate attached hanger by which the lamp was suspended.

Franz Landsberger (p. 197) has called the grotesque animal in the central medallion of the Lehman/Figdor lamp a salamander, the symbol of fire, and Mordechai Narkiss (pp. d–e) has identified it as a phoenix, the bird that is reborn from its own ashes. Both interpretations provide appropriate metaphors for the lighting of a Hanukkah lamp—the lighting of fires and the resurrection of the Temple in Jerusalem from the defilement of the Greek oppressors. The animal relief has also been

152–C

described as a dragon. However, the mythical phoenix would seem to be the correct reading, since the animal has flames coming from its head. The lions, representing the lions of Judah, as well as the phoenix, recall beasts within roundels seen in Ashkenazic medieval Hebrew illuminated manuscripts written in the early fourteenth century, such as the *Double Mahzor* dated about 1340 (now in Dresden and Wrocław), in which animals of the zodiac are depicted within roundels.

The squirrels perched on each side of the inscription refer to the inscription itself (cat. no. 152–C). The inscription, used over many centuries on Hanukkah lamps, includes the word "lamp," by which the object names itself. The verse "For the commandment is a lamp, and Torah is light" has many levels of meaning. The squirrels on either side of the lamp holding nuts at their mouths ready to break through to the kernel probably refer to the levels of meaning in the Torah itself. Gershom Scholem, in referring to *Midrash ha-Ne'elam*, an early work of the Zohar, quotes the author, "The words of the Torah are likened to a nut . . . [which] . . . has an outer shell and a kernel." Further, Scholem states: "The comparison of the Torah with a nut is not new in Jewish literature. It was already employed by the German and French Hasidim of the early thirteenth century. . . . The metaphor was particularly apt, because the nut was said to possess not only a hard outward shell, but also two finer inward coverings which protected the kernel" (Scholem, p. 54). One wonders whether the reference to nuts is also a playful reference to the dreidel game played with nuts during Hanukkah.

Hanukkah is called the Feast of Rededication, and in lighting the lights of the lamp one is re-enacting the relighting of the light in the Temple, which the architec-

tural references embody. The triangular backplate and row of columns serve as a metaphor for the Temple façade. The use of Hebrew calligraphy as a decorative element above an arcade is known in Spanish synagogue architecture.

Bezalel Narkiss, director of the Centre for Jewish Art at Hebrew University of Jerusalem, has discussed the origin of these and other related triangular-backed bronze lamps of the period as the products of the profound cultural interchange that occurred during the twelfth to fourteenth centuries among the Jewish communities of northern Spain, southern and eastern France, and southern Germany ("Objet," p. 202). Narkiss believes the Lehman/Figdor lamp to be the oldest-known Ashkenazic bronze Hanukkah lamp ("Feast," p. 112). In 1930, when the lamp was still in the collection of Dr. Albert Figdor of Vienna, it was cataloged as fourteenth century by Dr. Otto von Falke, the outstanding bronze expert of the time.

The exact origin of the lamp is difficult to establish. Within the small group of known lamps of this type, a critical indication of their specific geographic origin lies in the style of the arcade. Intersecting arcades occur in Sicily at the end of the twelfth century, where they appear as a design element on the cathedral at Monreale (Clapham, fig. 15b), and the motif is found later in Venice. Mordechai Narkiss (pl. IV, no. 14) has traced the large projecting oil font on the left side of the lamp (the servitor) to left-sided servitors of lamps of Italian origin. An Italian origin was also the opinion of Dr. Guido Schoenberger, late Research Fellow at the Jewish Museum, New York, who examined the lamp in 1952. Certainly in fourteenth-century Venice all these elements could coalesce—wealthy Ashkenazic patronage; possession of Ashkenazic illuminated manuscripts; remembrance of Spanish synagogue architecture and medieval cathedrals; and an appreciation of the mystical writings of the Zohar.

References

For the lamp in the Klagsbald Collection, see *Art religieux juif*, 1956, no. 2. For roundels, see B. Narkiss, *Hebrew Illuminated Manuscripts*, 1969, p. 11, and T. and M. Metzger, *Jewish Life in the Middle Ages*, 1982,

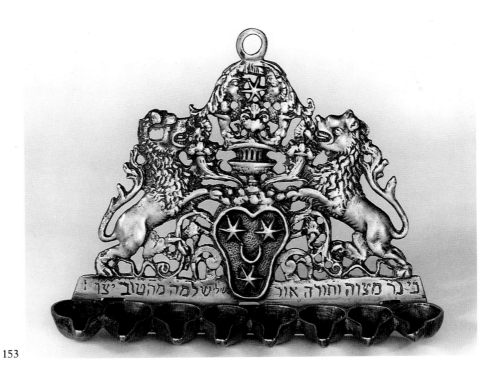

153

p. 15. For the *Double Mahzor*, see C. Grossman, *Fragments of Greatness*, 1981, cat. no. 7. For discussion of the "nut," see G. Scholem, *On the Kabbalah and Its Symbolism*, 1965, pp. 54–60, B. Kirshenblatt-Gimblett, "The Cut that Binds," 1982, p. 143. On intersecting arcades, see A. W. Clapham, *Romanesque Architecture*, 1936, pp. 56–57, pl. 15b.

Literature

O. v. Falke, *Die Sammlung Dr. Albert Figdor*, 1930, vol. 5, no. 463; M. Narkiss, *The Hanukkah Lamp*, 1939, pl. V, no. 17, pp. d–e; B. Narkiss, "Un Objet de culte," 1980, pp. 187–206; idem, "The Feast of Lights," 1986, pp. 103–12; S. Kayser and G. Schoenberger, *Jewish Ceremonial Art*, 1955, pl. LXI, no. 124, pp. 121, 125; F. Landsberger, *A History of Jewish Art*, 1946, pp. 196, 197, fig. 118; "Hanukkah," *Jewish Encyclopedia*, vol. 6, 1904, pl. opp. p. 226, no. 3, identified as "Silver (?), medieval (in the possession of Dr. Albert Figdor, Vienna)."

BEQUEST OF JUDGE IRVING LEHMAN, 1945
(CEE 45–112)

## 153

# Shlomo del Bene Lamp

Italy, 16th century
Bronze, cast and engraved
6¼ x 8½ x 2½ in. (15.7 x 21.6 x 6.4 cm)

INSCRIBED

כי נר מצוה ותורה אור שלי שלמה מהטוב יצו:

For the commandment is a lamp, and Torah is light (Prov. 6:23). This belongs to me, Shlomo Mah-Tov (del Bene). M[ay his) R[ock protect him] and [preserve him].

Cast openwork backplate with separate oil tray attached at three points. Rampant lions flank central flower-filled urn, surrounded by cornucopias, mermaids, and central six-pointed star above which is a simple flat ring hanger. Beneath the urn, a modified heart-shaped insignia with three six-pointed stars and a crescent in high relief on a stippled field. Inscription is etched into flat band at bottom. Both the hanger and head of the lion at the left have old repairs.

This Renaissance lamp suggests the life style of certain Italian Jews of the period. The rampant lions flank the Tree of Life, here represented by a classical urn overflowing with images of opulence. This particular lamp is a rare example in that it employs not only a family crest, which some Italian families were permitted to use, but also the family name. According to Shalom Sabar of Hebrew University, the name *Mah Tov* ("How good [it is]") translates into Italian as del Bene, a well-known family of rabbis and scribes (Mortara, p. 7).

The oil fonts are round with long troughs to hold the wicks. The servant light (shammash), now missing, was placed into the opening in the head of the left lion. Cast bronze plaquettes similar to this backplate are known from private collections. These are thought to have been furniture ornamentation (Ricci, no. 13).

References

M. Mortara, *Maskeret Hakhmei Halyah*, 1886, p. 7. S. de Ricci, *The Gustave Dreyfus Collection*, 1931, no. 13, pl. VIII, pp. 16–17.

Literature

I. Winter, *Ingathering*, 1968, no. 191, described as nineteenth century.

BEQUEST OF JUDGE IRVING LEHMAN, 1945
(CEE 45–231)

## 154

# Renaissance Hanukkah Lamp

Italy, late 16th century
Bronze, natural dark patina
10 x 10¼ x 1¾ in. (25.4 x 26 x 4.4 cm)

Cast in four parts, a topmost shield with attached ring on back riveted to a triangular backplate, a tray of eight oil fonts, and a three-sided base. In lower center of backplate, a rectangular plaquette in high relief of Judith, sword in hand, holding the head of Holofernes over a bag held by her kneeling maidservant. Above Judith, swags of fabric suggest a tent. Framing the relief, scrolling wavelike forms support three-dimensional putti. Above the Judith scene, three-dimensional mask with hollowed head surrounded by scroll frame in high relief (cat. no. 154–A) acts as oil font for servant light (shammash). Above the mask on each side, three-dimensional reclining figures. Below, eight narrow wick projections with tiny masks at their tips, above and between them seven relief masks with alternating faces of putti and bearded men. Torsos of winged angels with long hair in topknots poised at the corners join oil tray with plain high base with double scroll corners at front.

The story of Judith who saved her people by decapitating the enemy general Holofernes came to be associated with Judah Maccabeus, the hero of the victory celebrated at Hanukkah. In Florence, Donatello's statue of Judith and Holofernes became a symbol of the defense of that city against its enemies. No doubt Italian Jews wished to reclaim Judith as a Jewish heroine, thus she appears on sixteenth-century Italian bronze Hanukkah lamps (M. Narkiss, no. 28; Kayser and Schoenberger, cat. no. 125, p. 122). There are cast bronze plaques of Judith with the head of Holofernes dating from fifteenth-century Italy, made by such known masters as Andrea Riccio. These may have been secular or Jewish images of heroism or Christian metaphors (Ricci, no. 125, pl. 38).

This lamp is replete with Renaissance motifs: not only the incorporation of the rectangular relief plaquette at the center back but also the reclining figures that echo Michelangelo's river god sculptures and the figures of the Medici Chapel, as well as the masks, putti, angels, and scrolls that appear on secular bronze objects. The scrolling base and the elaborate sculpted details may be compared with an elaborate bronze ink-

154–A

stand set on scrolling base in the Correr Museum in Venice made by a sixteenth-century Paduan master (*Venetian Bronzes*, no. 243). Indeed, the introduction of the base, as well as the three-dimensional figures, mark this Hanukkah lamp as deeply indebted to secular objects. Basically a hanging lamp (indicated by its hanger, which falls to the rear), it is able, because of its base, to stand on a table, which would facilitate its use as a decorative object during the rest of the year.

A similar lamp now in the Sir Isaac and Lady Edith Wolfson Museum in Jerusalem, which appears to be from the same casting, has a statuette at the top which Mira Friedman has called a Hasmonean priest (Friedman, p. 230, fig. 8). An examination of the back of the Wolfson lamp reveals that the Emanu-El bronze has retained the original form. The Wolfson hanger, which had been attached by rivets, was removed and a bronze statuette was mounted in its place. However, the small shield with attached loop that was removed was then soldered to the back to permit continued use as a hanger. Moreover, all the perimeter figures are completely three dimensional, whereas the figure of the priest is hollow at the back, which is inconsistent with the rest of the lamp. The scrollwork at the corners of the base on the Wolfson lamp appears to be simplified, perhaps it was altered to make the lamp more stable when standing.

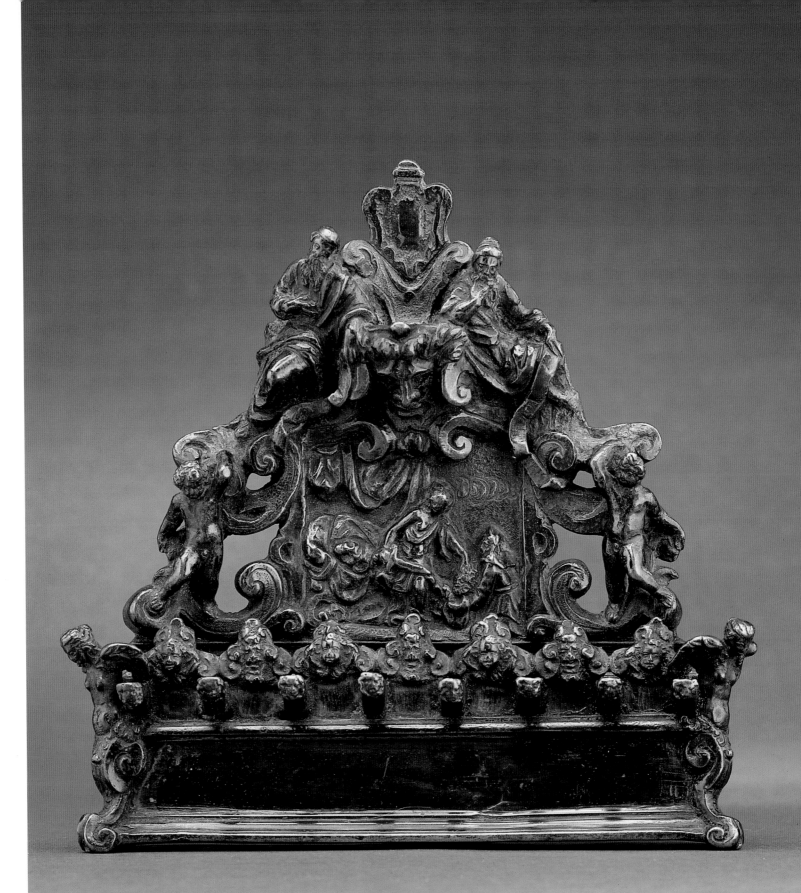

The Emanu-El lamp, a richly detailed, darkly patinated bronze, is an example of a transitional form. Earlier hanging Italian lamps of triangular shape with rounded oil fonts and motifs of Judith, lions, putti, masks, and scrolls were in low relief and made of two cast parts: backplate and oil tray. The integration of secular and religious motifs, the fine artistic quality of the sculpted figures, the interest in developing the simple hanging lamp into a fine object of display bespeaks cultivated, well-to-do patronage. This lamp is evidence that in sixteenth-century Italy there were city-states in which Jews could provide such patronage.

References

M. Friedman, "The Metamorphosis of Judith," 1987, p. 230, fig. 8; M. Narkiss, *The Hanukkah Lamp*, 1939, no. 28; S. Kayser and G. Schoenberger, *Jewish Ceremonial Art*, 1955, no. 125, p. 122. For bronze inkwell, see G. Mariacher, *Venetian Bronzes*, 1968, no. 243; for a Judith bronze relief, see S. de Ricci, *The Gustave Dreyfus Collection*, 1931, no. 125, pl. 38.

Literature

I. Winter, *Ingathering*, 1969, no. 66.

BEQUEST OF JUDGE IRVING LEHMAN, 1945
(CEE 45–203)

# 155

# "Lemberg" Hanukkah Lamp (Fragment)

MASTER: BT (?)
Lemberg (?), 2d half of 18th century (?)
11⅜ x 8⅝ in. (28.9 x 21.9 cm)
MARKS: Master; restamped *1824; 12*

Architectural design resembles Polish carved synagogue ark, with columns below and curved gable bordered with fluted scrolling forms above. In lower portion, four relief columns on decorated pedestals divide area into three parts: in the center, relief of steps leads to doors of ark, above which are draped tasseled curtains; in the side panels, urns, foxes perched amid vines and flowers, and paired lovebirds. Lintel and center arch decorated with foliate frieze. Above arch, rampant lions with

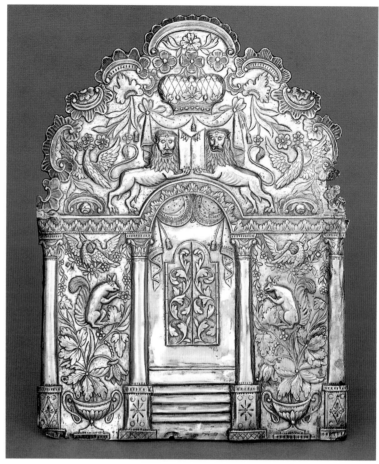

155

frontal heads hold Tablets of the Law; above the lions, swags and a large, puffed crown. At the sides, birds with spread wings amid foliage and flowers. This is a fragment of the lamp, which has sustained losses on the sides and at the bottom.

The freshness of the design, the fine quality of embossing and chasing, and the similarity of motifs relate this piece to a Torah shield in the collection of the Jewish Museum, which was described by Dr. Guido Schoenberger, late Research Fellow at the museum, as probably made in Lemberg in the second half of the eighteenth century (Kayser and Schoenberger, no. 55). Both pieces may indeed have been made by the same master. This lamp, which has lost its sides and bottom, was probably similar in form to a Hanukkah lamp in the same collection (Kleebatt and Mann, pp. 110–11) and to a silver wall lamp formerly in the Solomon Collection, London (M. Narkiss, no. 118).

In this style of lamp the backplate is made in two sections, a large upper section with an oil lamp tray beneath and a smaller back section that hangs below the oil tray. The lintel must have continued outward with additional sections on the sides (cat. no. 155–A), probably bordered with a curved edge similar to the one at the top. The attached bottom section, which may

155–A

156

have included a central cartouche, would have completed the design.

The reference of this design to the elaborately carved Polish synagogue arks and the inventive richness of motifs are in keeping with the best work of Jewish silversmiths of Poland. Denied access to silversmith guilds—and perhaps because of this—the work was free of cliché and embodied the exuberant religiosity of Polish Jews in cities and towns of the era.

References

S. Kayser and G. Schoenberger, *Jewish Ceremonial Art*, 1955, no. 55, pl. XXX; N. Kleeblatt and V. B. Mann, *Treasures of the Jewish Museum*, 1986, pp. 110–11; M. Narkiss, *The Hanukkah Lamp*, 1939, no. 118.

BEQUEST OF JUDGE IRVING LEHMAN, 1945

(CEE 45–28)

## 156

# Sailboat Hanukkah Lamp

MASTER: HI (?)
Frankfurt, end of 18th century
Silver, embossed and engraved; cutout, casting
12½ x 5½ x 2⅞ in. (31.8 x 14 x 7.3 cm)
MARKS: Master; place and date (Rosenberg, no. 2016)

Small rectangular oil container with eight compartments and bar for wicks set as lintel across two columns supported by spool-like pedestals. Flat engraved archway with cast flower at keystone attached by screws to back. Narrow projecting bar at rear of container supports vertical staff on which oil vessel (shammash) in shape of sailboat with pennant rests.

The gateway motif of this type of lamp may be related to the visionary monuments of the German Neoclassical architects. Similar lamps have different ornaments at the keystone, perhaps referring to the name of the patron—here perhaps Blumen, Blumenthal, or Rosen. The fanciful sailboat as the oil container (shammash) is an indication of the playfulness of this motif. It is also entirely possible that when the shammash was detached and the columns inverted, the column pedestals were used to hold Sabbath candles. The lamp originally was placed on a rounded dark wooden base.

References

For similar lamps, see C. Benjamin, *The Stieglitz Collection*, 1987, no. 139; M. Narkiss, *The Hanukkah Lamp*, 1939, no. 151; R. D. Barnett, *Catalogue of the Jewish Museum, London*, 1974, no. 269.

BEQUEST OF JUDGE IRVING LEHMAN, 1945

(CEE 45–111)

157

## Courtyard Hanukkah Lamp

Poland, 17th century (?)
Bronze, cast
10½ x 12 x 4¼ in. (26.7 x 30.5 x 10.8 cm)

Backplate and sides of T-shaped verticals support twelve gables. Upper back embellished with linked C-scrolls surmounted by candleholder; two cast birds screwed onto the corners. Two candleholders affixed to side brackets. Row of oil fonts held at the sides by large wing-nut screws. Row of eight rounded oil fonts stretch across front, attached with screws to the sides. The bird on the left is a replacement.

This early Polish cast brass Hanukkah lamp reveals its debt to the bronze lamps of the Mediterranean world in its open scrolling forms that are seen in Italian, Greek, and North African lamps (M. Narkiss, no. 27, pl. 9). The gables and columns probably allude to the twelve entrances to the ancient Temple. They may also refer to the colonnaded courtyards where scholars walked and studied, which were a feature of early synagogues.

    The incongruous candleholder atop the back scroll is a replacement for a finial that was most likely in the form of a palmette or fleur-de-lis. The birds on the back corners are not merely ornamental, their bases are screws that hold the sides to the back. The oil tray has two small holes at each side, which indicate that an additional ornamental section once rested on the front, no doubt in the usual fence form.

    Although these Polish lamps are related to their cast brass Mediterranean cousins, they have distinctive additions, evidence of their vigorous originality. No longer are they made to be hung in the doorway; they have become standing rather than hanging lamps. They sit on the bureau or the table, the sides and four legs providing stability. The candleholders at the top front, creating a double shammash, are the outstanding characteristic of Polish lamps. These brass lamps were cast and recast in multiples, so we know that thousands were once in use. The diversity of the lamps that remain continues to amaze connoisseurs.

Reference

M. Narkiss, *The Hanukkah Lamp*, 1939, no. 27, pl. 9 (Israel Museum), cited as Italian, sixteenth century.

BEQUEST OF JUDGE IRVING LEHMAN, 1945
(CEE 45–204)

158

## Doll-House Hanukkah Lamp

**House**
Eastern Europe, early 19th century
Silver, embossed; pressed and appliquéd
16½ x 12½ x 6¼ in. (41.9 x 31.8 x 15.8 cm)
MARKS: *KYY; 12*

**Oil Tray**
Silver, embossed
3½ x 11⅝ in. (8.9 x 29.5 cm)

**Clock**
MAKER: Bovet (?)
Switzerland, mid 19th century
White enameled face with painted Roman numerals
Diameter 2⁵⁄₁₆ in. (5.9 cm)

Two-story silver building with large open-fronted first floor. Appliquéd pressed pilasters on back wall alternate with three ornate, operative French windows. Fixed window in each side wall, ornate molding on corner posts. Bracketed lamps on each side, with small opening in their tops, swing forward and serve as double servitor (shammash). Removable oil tray formed of eight embossed lions on a platform, hinged heads of the animals open so that the hollow bodies may be filled with oil; long wick holders rise up as the lions' tongues. Two semicircular screens with pressed openwork design of crests, birds, and flowers enclose the area. Second story with tripartite roof with stepped barrel-shaped central section between lower pitched sides contains hinged clock encircled by pressed floral wreath. Rear wall etched with allover flower-and-leaf design and pressed floral bands; upper floor has operative French window, openwork decorative panels on slanted sides of roof. Clock a Swiss pocket watch (manufactured for Chinese export), goldplated works decorated with etched clouds, dragon, snake, lotus, and fire; Chinese signature.

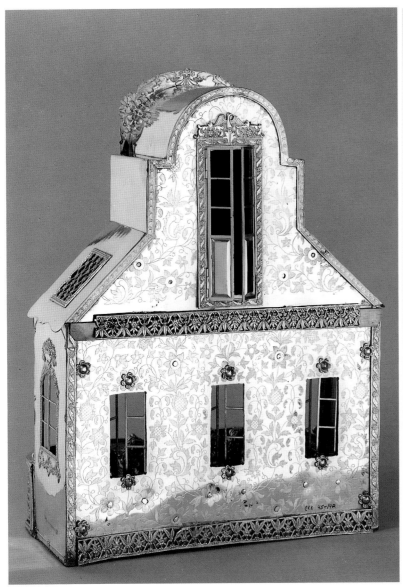
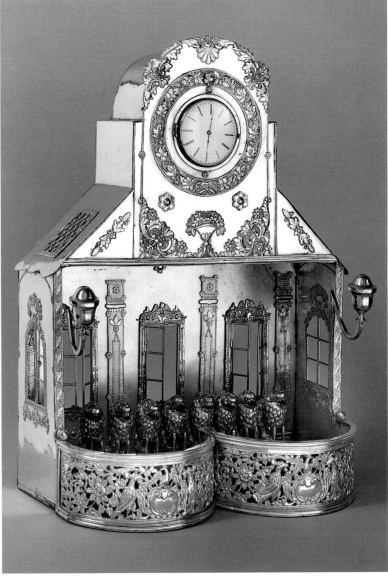

158

This miniature building could serve as a Hanukkah lamp with the insertion of the oil reservoirs and as a child's dollhouse on other occasions. The large room resembles a ballroom and more activities could be played out in the upper story through its functioning French window. The wallpaper-like rear wall adds an additional dimension of make-believe to the structure. The lamps resemble those found in nineteenth-century Prague, but the pressed silver work is characteristic of Warsaw silversmiths. Although the maker is unidentified, the double shammash indicates the lamp's Polish origin. The Swiss export watch is a replacement and the small flower-headed screws that penetrate the wall

do not support the present clock. The original clock must have had larger works; the French window in the rear provides access for winding the clock.

References

C. Clutton, *Britten's Old Clocks and Watches and Their Makers*, 1973, pp. 166 and 353; M. Narkiss, *The Hanukkah Lamp*, 1939, no. 98, for an elaborate silver Hanukkah lamp with carriage-lamp servitors and lion oil tray.

Literature

I. Winter, *Ingathering*, 1968, no. 67, identified as Prague, 17th century.

BEQUEST OF JUDGE IRVING LEHMAN, 1945
(CEE 45–142)

## 159

# Synagogue-Ark Hanukkah Lamp

MAKER: IGP
Eastern Europe, 19th century
Silver, pressed, embossed, cast
15½ x 10¾ x 4½ in. (39.4 x 27.3 x 11.4 cm)
MARKS: Master; unidentified mark (Rosenberg, no. 9502)

Carved baroque synagogue ark set on five cast claw feet assembled of pressed and cast silver parts. Backplate and sides impressed with motifs of flowers, lions, and birds. In center, doors of Torah ark between rampant lions with heads turned back; above the doors, a shield between confronting birds with heads turned back. Above the shield, a crown. At sides, vine-entwined columns in relief; in front of these, freestanding columns support engraved canopy hung with bells. Three-dimensional birds with outstretched wings perch on either side

of canopy, coiling flowering branches held in their mouths. Flower-filled urn at apex of arched top. At bottom, platform bordered by openwork fence set with eight oil pitchers.

This ornamental silver lamp emulates the richly carved wooden synagogue arks that were a feature of eighteenth-century Poland. The exuberant design elements mirror the religious fervor of the Hasidic movement that flourished in Eastern Europe in the eighteenth century. It is interesting to note that the silversmith distinguished in his choice of mediums the different materials of the synagogue ark. The wood carving is rendered as embossed silver in relief much like the carved wood; the canopy that was the fabric valance that hung in front of the ark is rendered flat with decorative chasing to emulate the woven textile.

References

For a similar lamp with canopy, birds, and urn, see *Architecture in the Hanukkah Lamp*, 1978, no. 40, listed as Ukraine, 1857; another in *Synagoga*, 1960, no. C 230.

BEQUEST OF JUDGE IRVING LEHMAN, 1945
(CEE 45–121)

## 160

# Sofa Hanukkah Lamp

MAKER: RA (?)
Vienna, 1856
Silver, embossed and chased
6⅞ x 10¼ x 2⅜ in. (17.4 x 26 x 6 cm)
MARKS: Master; place and date (Rosenberg, no. 7861)

Lamp in form of a sofa with baroque outline; back, arms, and legs with chased flower and scroll designs and cutout work. Blank tablets in center flanked by applied lions, applied crown above. On seat of sofa, bar with legs supports spoonlike oil reservoirs with narrow bands to hold wicks. Spoon-shaped servitor (shammash) fits on rear holder at right. A light ring is attached to the back for hanging.

The love of the baroque is evident in this fanciful lamp in the shape of a sofa. Medieval Hanukkah lamps were hung in doorways; only later, with Italian lamps and the

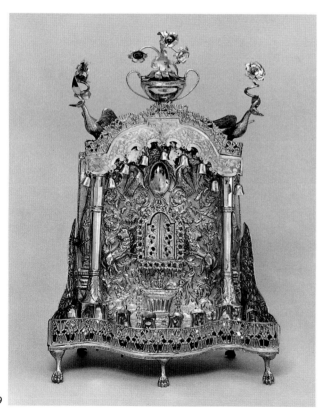

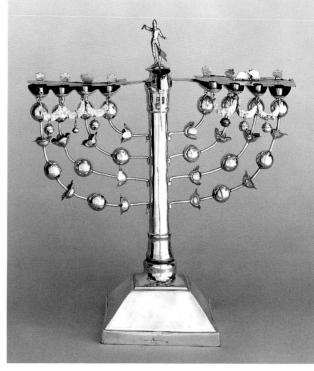

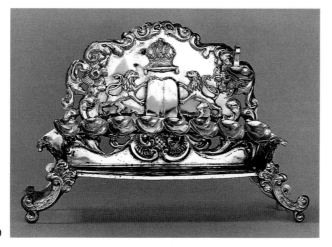

160

many popular versions of Polish bronze and brass lamps made in the sixteenth to twentieth centuries, did they become standing or "bench-type" lamps. In this voluptuous little silver lamp, the simple bench has become a luxuriant sofa.

In his notebook listing his Judaica holdings, Judge Lehman wrote, "Chanukah lights given me by Grandma (family piece)."

Reference

For a similar lamp in shape of a sofa, see R. D. Barnett, *Catalogue of the Jewish Museum, London*, 1974, no. 271, pl. LXXXVIII and p. 53.

Literature

I. Lehman, List of one hundred eleven objects, circa 1928, no. 88.

Bequest of Judge Irving Lehman, 1945

(CEE 45–88)

## 161

# Judah Maccabeus Hanukkah Menorah

MASTER: Justus Christian Bolster (?)
Nuremberg, 1786–87
Silver, embossed, cutout; casting
15 x 13¼ x 5⅝ in. (38.1 x 33.6 x 14.3 cm)
MARKS: Master (Rosenberg, no. 4300); place and date (Rosenberg, nos. 3765, 3777)

Sloping rectangular base supports smooth columnar shaft that carries branches threaded with alternating flower cups and globes. Spoon-shaped oil cups with sheet-silver covers and flat palmette handles rest on top of branches on each side; three hammered crescents and three covered bells hang from the cups. Servant light (shammash) attached at front, notched flag above. On top of shaft, a cast figure dressed in knickers and pointed cap, right arm raised and left arm lowered. The implements held in the hands are now broken off.

Among German Hanukkah lamps of the late eighteenth century there is a bench-type that contains a small figurine with a spear in the right hand and a shield in the left, which was identified as Judah Maccabeus by Guido Schoenberger (Kayser and Schoenberger, no. 129). However, in that type of lamp, the Judah figure is not a major feature.

The general form of the lamp shown here is a simplified version of earlier Frankfurt Hanukkah menorahs (Benjamin, no. 134), which usually have Judith as a finial with a sword in the right hand and the head of Holofernes in the left. The use of Judah Maccabeus as the finial, although he was directly connected to the Hanukkah story, is highly unusual.

The form, as well as the flowers and globes on the branches, are based on the Temple menorah described in the Bible (Exod. 25:31–32).

References

S. Kayser and G. Schoenberger, *Jewish Ceremonial Art*, 1955, no. 129, pl. LXIII, pp. 123, 126; C. Benjamin, *The Stieglitz Collection*, 1987, no. 134, pp. 178, 179.

Bequest of Judge Irving Lehman, 1945

(CEE 45–228)

## 162

# Peacock Hanukkah Lamp

MAKER: FT
Vienna, 1862
Silver, pressed, embossed, cast
9 x 13⅜ x 4¼ in. (22.9 x 34 x 10.8 cm)
MARKS: Master; place and date (Rosenberg, no. 7861)

Platform with six embossed feet carries narrow removable tray with eight embossed urns serving as oil containers. Mounted behind, a hollow-cast peacock with attached pressed wings and pressed fan-shaped tail made of seventeen vertical sections. In the bird's mouth, a removable pipe functions as servitor (shammash). A ring is attached to the back for hanging.

The peacock is mentioned in the Bible as part of the riches of Solomon imported to the Holy Land by the navy of Tarshish, "Gold, and silver, ivory, and apes, and peacocks" (1 Kings 10:22). Here, the peacock tail with its open fan of feathers radiating outward probably symbolizes God's light. However, instead of emphasizing religious references, this lamp with its pipe-smoking peacock stresses the playful aspects of the holiday.

According to the donor, the lamp was used every year in the East Tenth Street home of his parents, Mr. and Mrs. Moses Toch, from the 1860s until 1887 when it became his property.

Reference

For a peacock lamp from the same master, see *A Budapesti Zsidó Múzeum*, 1987, no. 111 and p. 124.

Literature

H. M. Toch, "Jewish Ceremonial Objects Presented by Mr. and Mrs. Henry M. Toch to Temple Emanu-el, 1929," no. 1; C. Grossman, ". . . kindle the Chanukah lights," 1986.

GIFT OF MRS. AND MRS. HENRY M. TOCH, 1928

(CEE 29–1)

## 163

# Traveling Hanukkah Lamp

MASTER: [?]G
Germany, late 19th century
Silver, embossed; cast
¾ x 4⅜ x 2⅛ in. (1.9 x 11.2 x 5.4 cm)
Width when open 7⅞ in. (20 cm)
MARKS: Master (a rose); place and date (Rosenberg, no. 3); *G*

INSCRIBED
On cover
לְהַדְלִיק נֵר שֶׁלַחֲנֻכָּה
To kindle the lamp of Hanukkah

Embossed inscription within foliate frame on hinged cover. Inside, center section of four compartments, smaller sections of two compartments hinged at sides swing out to form a continuous line or swing back to become part of the covered box. Each compartment with wick holder and pricket for candle. All exterior sides cast in scroll design of flowers and leaves. Underside of cover has applied round holder for candle.

The compartments of this little Hanukkah box lamp can hold either wicks and oil or small candles. Its compact size would have made it possible for a traveler to light the Hanukkah lamp wherever he or she might be during the eight-day holiday. The inscription is part of the Hanukkah lamplighting service. The vocalization marks on the Hebrew letters are somewhat unusual for such an inscription.

BEQUEST OF JUDGE IRVING LEHMAN, 1945

(CEE 45–240)

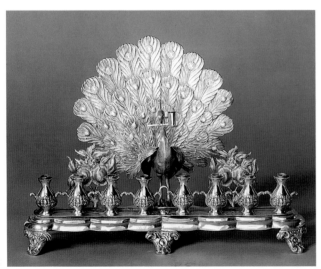

## 164

# Anshe Chesed Hanukkah Menorah

New York, 1863
Brass, cast and turned
Height 26 in. (66 cm), width at top 21 in. (53.3 cm),
diameter of base 7 in. (17.8 cm)

INSCRIBED
On upper base
*Presented / by / H. Stern and his / wife C. Stern to / Congregation Anshi* [sic] *Chesed / Dec. 6th 1863*

Stepped round base supports two-part fluted shaft. Uppermost center staff and branches of brass tubing accented at joints with graduated cubes. Petal-shaped drip pans. Servant branch (shammash) attached at cube of lowest branch.

Indications of repairs suggest that this lamp originally may have been a gas fixture and was later converted to candles by the addition of brass tubing candleholders. In 1874 Congregation Anshe Chesed and Congregation Adas Jeshurun were merged to form Temple Beth-El, which in turn merged with Temple Emanu-El in 1927.

GIFT OF H. AND C. STERN, 1863
(CEE 29–39)

## 165/166/167/168

# Bezalel Hanukkah Lamps

### 165

**Lamp of the Levites**
DESIGNER: Ze'ev Raban
Bezalel School of Arts and Crafts
Sharar Art Workshop
Jerusalem, early 1920s
Brass, pressed and rolled
10⅞ x 8⅝ x 2¾ in. (27.6 x 21.9 x 7 cm)

INSCRIBED
Above menorah
הנרות הללו קדש הם
These lights are sacred

On base
בצלאל ירושלם
Bezalel Jerusalem

On plaques on back
*MADE IN / PALESTINE / AT THE ART WORKSHOP / SHARAR / BEZALEL / JERUSALEM / P.O.B. 729 FROM BEZALEL TO ITS / MEMBERS*

Backplate with framed niche; in relief on the right, Aaron, as High Priest, first of the Levites, lights a seven-branched menorah; on the left, a young boy holds tray with pitcher and cup. Vertical compartments on either side with palm trees and deer on right, trees and lion on left. Above the niche, five stylized linear leaf forms enclose flowers, all framed by beaded edge. At apex, "ancient coin" with urn and archaic Hebrew letters. On top surface of footed base, eight candleholders; on front of base, relief cartouche with name of workshop; in attached roundels, symbols of the Holy Land. The servant light (shammash) is missing.

### 166

**Raban Lion Lamp**
DESIGNER: Ze'ev Raban
Bezalel School of Arts and Crafts
Jerusalem, early 1920s
Silver, embossed, cutout; semiprecious stone
5 x 10⅛ x 1 in. (12.7 x 25.7 x 2.5 cm)

INSCRIBED
On arch
אם אין אני לי מי לי
If I am not for myself, who will be for me (Pirke Avot 1:14)

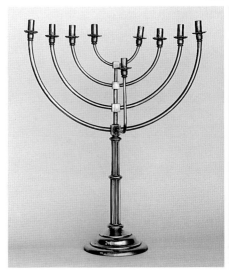

164

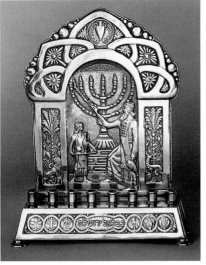

165

On Tablets of the Law

אנכי ה' / לא י' / לא ת' / זכור / כבד
לא ת' / לא ת' / לא ת' / לא ת' / לא ת'

I am the Lord (your God) / You shall have no (other gods beside Me) / You shall not (swear falsely) / Remember (the Sabbath) / Honor (your father and your mother)
You shall not (murder) / You shall not (commit adultery) / You shall not (steal) / You shall not (bear false witness) / You shall not (covet) (Exod. 20:2–14)

On back

בצלאל ירושלם

Bezalel Jerusalem

Semicircular backplate of two sheets of silver, front embossed with realistic crouching lions flanking Tablets of the Law. Rim of cutout motif of intersecting arches with stylized Hebrew inscription in center. Tray on four balled feet soldered to back; front panel decorated with cutout crouching leopards, intersecting arches, and dark-yellow center stone. Within tray, eight candleholders; servant light (shammash) raised on stem in center. There is a small hanger on the back.

## 167

### Filigree Temple Lamp

Bezalel School of Arts and Crafts
Jerusalem, mid 1910s
Silver, etched; filigree appliqué, turquoise stones, garnets
5 x 9 x 1¾ in. (12.7 x 22.9 x 4.4 cm)

INSCRIBED
On base of menorah

חנוכה

Hanukkah

On base

הנרות הללו קדש הם

These lights are holy

On right leg

בצלאל

Bezalel

On left leg

ירושלם

Jerusalem

Backplate in form of Temple façade with freestanding columns, lintel, and crenellations. Temple menorah flanked by guardian lions with garnet eyes, two priests stand behind. Within footed base, eight hinged oil compartments with protruding necks for

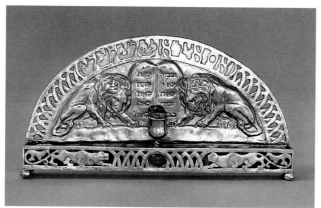

166

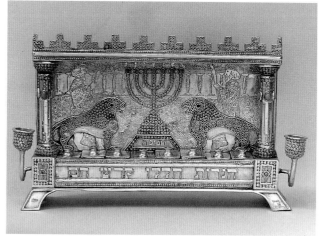

167

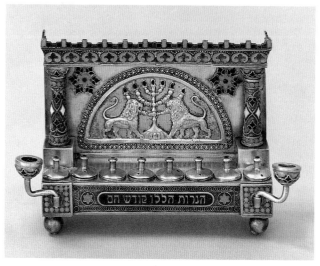

168

wicks. Candleholders attached at each side act as double servant light (shammash). Filigree circlets and granulation applied to crenellations, columns, menorah, lions, candleholders, and base. Turquoise stones decorate base, columns, and menorah. There is a small hanger on the back.

## 168

**Enamel Temple Lamp**
Bezalel School of Arts and Crafts
Silver and Enamel Workshop
Jerusalem, mid 1910s
Silver, embossed, chased; enamel work, appliquéd filigree
4 x 4¾ x 1⅜ in. (10.2 x 12.1 x 3.5 cm)

INSCRIBED
On front
הנרות הללו קודש הם
These lights are holy

Backplate in form of Temple façade with freestanding enameled columns and enameled lintel with crenellated top. Between columns, appliquéd enameled florets and appliquéd semicircle with seven-branched lampstand with enameled flames, flanked by standing lions in relief. Base on four balled feet carries eight covered candleholders for oil. Two enameled candleholders attached to front decorated with filigree work and enameling. Enamel colors are predominantly turquoise blue-green, dark blue, dark green with some white, red, and red-brown.

Lighting the Hanukkah lights is a reenactment of relighting the Temple light which, according to tradition, miraculously burned for eight days when there was only enough purified oil for one day. Thus these modern decorated lamps incorporate traditional references to the Temple (the façade, the menorah, the guardian lions of Judah).

The great contribution of the Bezalel School is in the blending of revived Middle Eastern crafts with modern design in a Zionist transformation that emphasizes the land of Israel. In these lamps, native semiprecious stones embody in metaphor and reality the concept of *eretz Yisrael*, "the land of Israel." Raban's realistic lions (cat. no. 166) bring the ancient symbol of the Lion of Judah into contemporary form.

References
For lamp similar to cat. no. 167, see *"Bezalel" of Schatz*, 1983, no. 665, p. 57; for lamp related to cat. no. 168, see *Bezalel 1906–1929*, 1983, p. 224, fig. 19.

Literature
*Raban Remembered*, 1982, no. 87, pp. 100–101.

UNKNOWN DONOR
(CEE 29–33)
BEQUEST OF JUDGE IRVING LEHMAN, 1945
(CEE 45–92) (CEE 45–94) (CEE 45–93)

## 169

# Wolpert Hanukkah Lamp

MASTER: Ludwig Yehuda Wolpert
Designed Palestine, 1939; made New York City, 1970s
Silver, cutout, embossed, engraved; partial patina
13 x 11 x 6 in. (33 x 27.9 x 15.2 cm)
MARKS: Master; *TOBE PASCHER WORKSHOP THE JEWISH MUSEUM; STERLING; 925*

INSCRIBED
At top
לך / נאה / לשבח
It is fitting to praise you ("Rock of Ages")

Eight cutout and engraved lions spring forward in semicircle from half-round base; on their paws, oil cups with wick holders. From back, six flat staves fan upward, a cup with candleholder attached to midsection. At the top, stylized Hebrew letters form triangle with ascender of *lamed* as highest central point. Dark patina applied to inside of cups and inner surfaces of staves. A hole in the curved bar behind the lowest line of lettering may be used to attach the lamp to the wall.

The use of stylized calligraphy as a central motif is a characteristic in the work of Ludwig Yehuda Wolpert (1900–1981). The elegance, symmetry, and high polish of his silver work carries over from Bauhaus-influenced training in Germany. After arriving in the United States in 1956, Wolpert worked for many years in the Tobe Pascher Workshop in the Jewish Museum in New York, where he devoted himself to the creation of Jewish

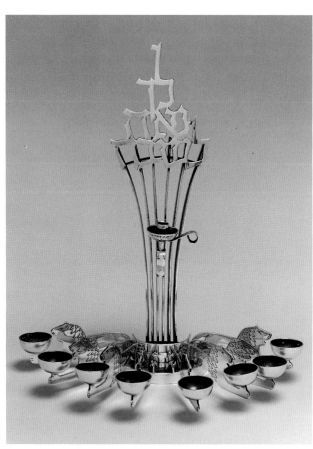

169

ritual objects and synagogue furnishings. The Hebrew inscriptions he chose to integrate into his pieces are unusual and meaningful. Examples of more traditional inscriptions for a Hanukkah lamp are "These lights are holy" and "For the commandment is a lamp and Torah is light," but Wolpert took a phrase from the song "Rock of Ages," which is sung on Hanukkah, and fitted the calligraphy to his design.

Literature

*Ludwig Yehuda Wolpert. A Retrospective*, 1976, no. 10.

CONGREGATION EMANU-EL MUSEUM PURCHASE FUND, 1987
(CEE 87–8)

## 170/171

# Dreidels (*Dreydlach*)

### 170

**Bone Dreidel (*Dreydl*)**
Eastern Europe, 19/20th century
Bone, carved, painted
Height 2 in. (5.1 cm)

INSCRIBED
On sides, in Yiddish

נ ג ה ש

N[isht] G[ants] H[alb] SH[tel]
Nothing All Half Put

Beveled cube with disks above and below. Narrow spindle, tip broken off. Painted letters.

### 171

**Bezalel Dreidel (*Dreydl*)**
Bezalel School of Arts and Crafts
Sharar Workshop
Jerusalem, 1923–29
Brass, cast, soldered; patina
Height 1¾ in. (4.4 cm)

INSCRIBED
On top

שראר ירושלם תד 729

Sharar Jerusalem P.O. Box 729

On sides

נ ג ה ש

N[es] g[adol] h[aya] sh[am]
A great miracle happened there

Cast sections soldered together; raised disks on each side with each letter in circle in six-pointed star. Fluted disk at bottom with protruding button for spinning.

Actually the four letters on each top can be translated in the two forms indicated here. The Hebrew "A great miracle happened there" also represents letters which, when translated into Yiddish, apply to the game of chance. The spinning of the dreidel is a children's game played during Hanukkah, usually for walnuts.

Carved bone or wooden tops are European folk art objects made by local craftspeople or family members who made toys for the children. Imitating the small carved top but cast in brass, the Bezalel School dreidel

170 / 171

attempts to reconcile the idiom of handcraft with a mass-produced object.

## 172

# Purim Plate
# (Shalach Monos Plate)

MASTER: [?]SRF ZINN
Central Europe, 1813
Pewter, cast and rolled; engraved
Diameter 8⅜ in. (21.3 cm), width of rim 1⅜ in. (3.5 cm)
MARK: Master

INSCRIBED
On rim
ומשלח מנות איש לרעהו ומתנות לאפינים שנת תקע״ג לפ״ק
Sending portions to one another and gifts to the poor (Esther 9:22). In the year [5]573, according to the sh[ort] c[ounting] (1813)

Six-pointed star inscribed with circle containing overlapping circles, petals, and three interlocking fish. Between outer corners of star, birds and lilies.

The Hebrew word for "to the poor" has a playful misspelling based on a change in the Hebrew grammatical root to one that means "to bake," probably meant to stress baked goods, since that is the usual gift (shalach monos) brought on Purim on such a plate.

    The crosshatched engraving was done by a local engraver who had purchased the plate as a blank made by a Christian pewter artisan. Since Jews were not allowed in the pewter guild, their artistry was limited to decoration. The designs usually came from books, but in this case the tooled lettering and design imitate another folk craft—embroidery. The use of the intertwined fish in the center may indicate that the owner's name was Karp.

172

## 173

# Esther Scroll in Leather Case
# (*Megillat Ester*)

Germany, early 1830s

**Scroll**
Vellum
Height 4⅜ in. (11.2 cm)
Text columns 3⁷⁄₁₆ x 2 ⅝ in. (8.7 x 6.7 cm), 27 lines each

**Case**
Leather-covered cardboard, tooled
Length 4½ in. (11.5 cm), diameter 1¼ in. (3.2 cm)

INSCRIBED
*Zum Geburtstage meines lieben Gatten / Franz Korit-schoner 1832*
On the birthday of my beloved husband / Franz Koritschoner 1832

Round gold-tooled red leather case contains finely written *Ha-Melekh* scroll.

The *Ha-Melekh* scroll is an Esther scroll carefully copied to insure that the word "the king" opens almost every column of text. The scroll of Esther does not contain the name of God. Although the king in the story refers to the Persian king Ahasuerus, the emphasis on "the king" in each column suggests an oblique refer-

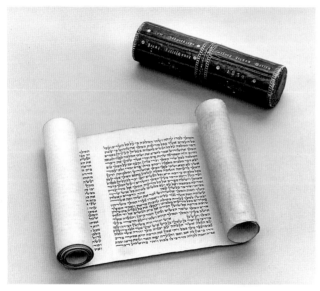

174–A

173

174

ence to the King of Kings, as a way of instilling God's name in the text.

GIFT OF MRS. LOUISE BRANDEIS POPPER, MATERNAL GREAT-GRANDDAUGHTER OF THE ORIGINAL OWNER, 1982
(CEE 82–11)

## 174

# Peacock Esther Scroll (*Megillat Ester*)

Poland, 19th century
Vellum, handwritten
Height 20½ in. (52.1 cm)
Text columns 15⅜ x 5 in. (39.1 x 12.7 cm), 42 lines each

Large *Ha-Melekh* scroll of Esther decorated with peacock-like ink decorations at the top of each column and on names of Haman's sons (cat. no. 174–A).

This scroll was commissioned in Poland by Leopold Natowitz, grandfather of the donor. Natowitz, a dia-

mond dealer in Antwerp who died in 1936, was a much-loved figure in his community. The marks at the beginning and end of the scroll show that it was at one time sewn into a case, probably made of silver.

GIFT OF CHARLES M. NEWTON IN HONOR OF HIS WIFE, ANN JOY NEWTON, 1986
(CEE 86–2)

## 175

# Holy Land Purim Case and Esther Scroll (*Megillat Ester*)

Palestine, about 1900

**Case**
Silver gilt, filigree; appliqué
Height 10½ in. (26.7 cm)

**Scroll**
Vellum; handwritten
Height 3⅛ in. (7.9 cm)
Text columns 2½ x 2¾ in. (6.4 x 7 cm), 14 lines each

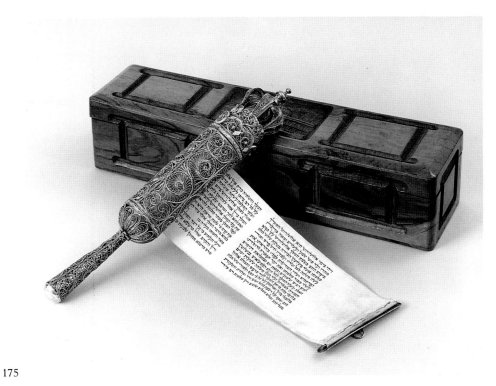

175

### Box
Olivewood, carved; velvet lined
2¹⁵⁄₁₆ x 12¾ x 3¼ in. (7.5 x 32.4 x 8.2 cm)

INSCRIBED
ירושלם / מקום מקדש
Jerusalem / Place of the Holy Temple

Fine *Ha-Melekh* Esther scroll sewn to flat gilded scroll handle; in Yemenite Jewish cylinder case formed of filigree scrollwork, rounded closure below with rounded case handle, scalloped upper rim with appliquéd lozenge shapes and gilding. Above, open crown with gilded knobbed finial encloses gilded dome. Turn-of-the-century olivewood box, carved dome-shaped building in center rectangle of top.

The use of native materials (olivewood) and Jewish crafts (Yemenite jewelry work) were the cornerstones of the Bezalel School of Arts and Crafts, of which this boxed scroll is a forerunner. The Moslem Dome of the Rock, which stands on the site of the ancient Temple of Jerusalem, became a symbol of the Temple for visitors to Jerusalem. The Hebrew inscription makes the reference clear: the *place* of the Holy Temple.

Reference

For discussion and photographs of the Dome of the Rock as the Temple of Jerusalem, see I. Fishof, " 'Jerusalem above my chief joy': Depictions of Jerusalem in Italian Ketubot," 1982, pp. 61–75.

GIFT OF MRS. EDWARD B. MARKS, 1960
(CEE 60–1A/B)

### 176/177

# Bezalel Purim Cases and Esther Scrolls (*Megillot Ester*)

Bezalel School of Arts and Crafts
Jerusalem, about 1920

### 176
**Irving Lehman Case and Scroll**
CASE
Silver, partial gilt; filigree
Height 7¼ in. (18.4 cm)
SCROLL
Vellum; handwritten
Height 2⅛ in. (5.4 cm)
Text columns 2 x 3⅝ in. (5.1 x 9.2 cm), 20 lines each

INSCRIBED
בצלאל ירושלם
Bezalel Jerusalem

Silver filigree cylinder bordered at top and bottom with bands of gilded beads; body made of filigree sections of alternating scrollwork creating a heart pattern; flat pull with ring. Rounded filigree case handle with bead at bottom; at top, crown ornamented with silver beads and globular finial encloses gilt dome. The fine vellum scroll is water damaged.

176 / 177

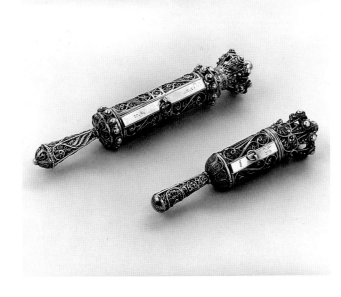

**177**

**Herbert Lehman Case and Scroll**
CASE
Silver, partial gilt; filigree
Height 5¼ in. (13.3 cm)
SCROLL
Vellum; handwritten
Height 1⅛ in. (2.8 cm)
Text columns ¹⁵⁄₁₆ x 2⁷⁄₁₆ in. (2.4 x 6.2 cm), 11 lines each

INSCRIBED
ח.ל. / בצלאל
H.L. / Bezalel

Silver filigree cylinder with rounded filigree case handle below and filigree crown above ornamented with silver beads and small ball finial. Center section banded with filigree work below and gilded scrolling above; body ornamented with alternating bands of filigree scrollwork of double heart-shaped and heart-and-fan-shaped patterns. Flat scroll pull with ring. The fine vellum scroll has some red (henna?) markings.

The initials *H.L.* (khet lamed) are probably those of Herbert Lehman, who must have given this lovely scroll to his Judaica-collecting brother Irving.

Literature
For cat. no. 176, see *"Bezalel" of Schatz*, 1983, no. 720, p. 63.

BEQUEST OF JUDGE IRVING LEHMAN, 1945
(CEE 45–14) (CEE 45–116)

**178**

# Flowered Purim Case and Esther Scroll (*Megillat Ester*)

**Case**
Eastern Europe, 1840
Silver, embossed, chased; cast
Height 13⅛ in. (33.3 cm)
MARKS: Date (Rosenberg, no. 7861); place (double-headed eagle in circle)

178

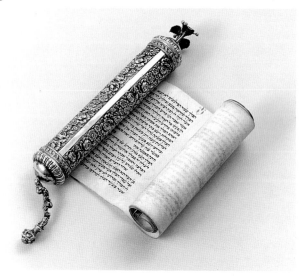

**Scroll**
Vellum; handwritten
Height 6¾ in. (17.1 cm)
Text columns 5¼ x 4½ in. (13.3 x 11.4 cm), 22 lines each

Rounded beaded bands at top and bottom border cylindrical container on which embossed and chased panels of roses and petaled flowers in high relief alternate with unadorned flat bands. Cast flower-shaped case handle at bottom; at top, open flower finial.

While the silver case bears a Vienna 1840 hallmark, the additional mark of the double-headed eagle in a circle indicates an origin somewhere within the political sphere of Austria, perhaps Poland. The fine Ashkenazic scroll is in the *Ha-Melekh* style, in which almost all of the written columns begin with the word "the King," which refers to King Ahasuerus. While the name of God does not appear in the text, an elegant feathery letter shin is attached to the letter hay at the top of the columns. This is probably an effort to suggest *ha Shem*, one of the names of God absent from the scroll but always remembered.

GIFT OF MR. AND MRS. HENRY M. TOCH, 1928
(CEE 29–25)

## 179

## Scenic Purim Case and Esther Scroll (*Megillat Ester*)

**Case**
MASTER: JT
Vienna, 1920s
Silver, partial gilt; embossed, chased, cast
Height 22 in. (55.9 cm)
MARKS: Master; place and date (Rosenberg, no. 7903)

**Scroll**
Parchment; handwritten
Height 14¼ in. (36.2 cm)
Text columns 12 x 4⅜ in. (30.5 x 11.2 cm), 42 lines each

INSCRIBED

וישם כתר מלכות בראשה / וימליכה תחת ושתי

So that he set the royal crown upon her head / and made her
queen instead of Vashti (Esther 2:17)

Cylinder in three registers: upper and lower ornamented with
embossed leaves and embossed, gilded inscription; center with
scene in high relief depicting King Ahasuerus placing crown
on Esther's head, Vashti at extreme left, Haman and Mordecai
at extreme right, and kneeling page in lower right foreground.
Scroll pull cast in form of two interlocking snakes; case handle
cast in form of leafy stem with flower-bud tip. Above, an open,
belled crown with bird finial. The scroll is a fine Ashkenazic
*Ha-Melekh* type.

The Esther story is found often as the subject in Jewish
and non-Jewish tapestries, embroideries, and paintings.

The translation of an epic scene onto a relatively narrow
cylinder cannot be completely successful since it
cannot be viewed all at once, but silversmiths were
undaunted and many such scenes appear on megillah
cases. Large scrolls in elaborate cases are often used in
the synagogue, where the story of the heroic Esther is
read to the congregation on Purim. The scroll may pre-
date the case.

Reference

For a similar case, see F. Landsberger, *A History of Jewish Art*, 1946,
p. 55, no. 35.

BEQUEST OF JUDGE IRVING LEHMAN, 1945
(CEE 45–29)

## 180

## Constantinople Purim Case and Esther Scroll (*Megillat Ester*)

Turkey, 20th century

**Case**
Silver, embossed, cast
Height 6¼ in. (15.8 cm)

**Scroll**
Parchment, handwritten
Height 2½ in. (6.4 cm)
Text columns 2⅜ x 2⅜ in. (6.1 x 6.1 cm), 34 lines each

Silver cylinder with three vertical panels embossed with scrolls
and flowers. Rounded top and bottom with bands embossed
with lozenge and bead design. Scroll pull with ring and
embossed flowers. Cast case handle. The finial, probably in the
form of a globe and crescent, is missing. The scroll is in a fine
Sephardic hand.

Middle Eastern megillah cases often have common ele-
ments, such as lozenge-shaped decorations and beaded
edges. One sees at times such a crank-shaped case
handle, in this instance quite small.

According to Irving Lehman's notes, this megillah

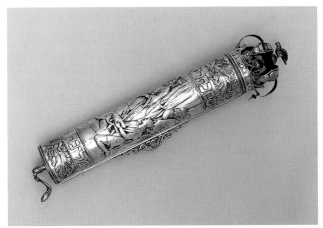

179

180

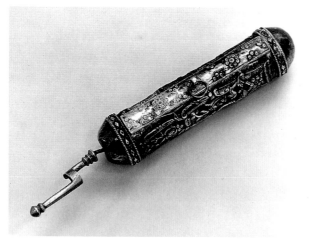

181

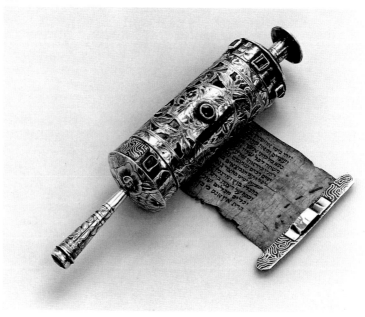

was "brought from Constantinople by Oscar S. Straus." Oscar Straus was an uncle of Mrs. Irving (Sissie Straus) Lehman. President Grover Cleveland appointed Straus as Envoy Extraordinary and Minister Plenipotentiary to Turkey in 1887. In 1909, after serving as Secretary of Commerce and Labor and as a member of the Permanent Court of Arbitration at The Hague, he returned to Turkey, having been appointed ambassador by President William Howard Taft.

Reference

"Straus, Oscar Solomon," *Universal Jewish Encyclopedia*, vol. 10, pp. 77–79.

Literature

Rabbi I. S. Meyer, "Catalogue of the Jewish Art Objects in the Collection of Judge Irving Lehman," 1932, cat. no. 24.

BEQUEST OF JUDGE IRVING LEHMAN, 1945
(CEE 45–24)

## 181

# Smilovici Purim Case and Esther Scroll (*Megillat Ester*)

**Case**
MASTER: Moshe Smilovici
Tel Aviv, 1950s
Silver, niello, appliqué, engraving; semiprecious stones
Height 7¾ in. (19.7 cm)

**Scroll**
Parchment; handwritten
Height 2¾ in. (7 cm)
Text columns 2⅛ x 3⅛ in. (5.4 x 7.9 cm), 12 lines each

Cylinder of cutout reused niello work pieced together and applied to a silver base. Upper and lower bands set with round and rectangular stones in red, yellows, greens, lavender; round red stone in center of cylinder. Case handle of unrelated niello work with blue stone at bottom. Round finial capped with engraved silver button. Scroll written in Sephardic hand.

This scroll case was identified by Lucica Koffler Smilovici as being the work of her husband, Moshe Smilovici (1912–1962). However, the work clearly identifies itself by its exuberant style. Smilovici worked with old silver pieces that he cut out and used as collage elements, usually adding set colored stones to enrich the surface. His juxtaposition of unrelated materials, his use of color with silver, and his slightly askew dimensions endow his best works, of which this is one, with a sophisticated folkish charm. The scroll was written in 1938 according to a note on its back.

For other work by Smilovici, see catalog numbers 25 and 26.

GIFT OF ARTHUR DIAMOND IN MEMORY OF HIS WIFE, ESTELLE, 1978
(CEE 78–3)

## 182

# Embroidery-Style Passover Platter (Seder Platter)

Prague, 18th century (?)
Pewter, cast, rolled; engraved
Diameter 15½ in. (39.4 cm), rim 2 in. (5.1 cm)
MARK: Indecipherable

INSCRIBED
On rim

קדש ורחץ כרפס יחץ מגיד רחצה מוציא מצה מרור כורך
שולחן עורך

Bless and Rinse, Celery, Split, Recitation, Wash, Blessing for Bread, Matzah, Bitter Herbs, Sandwich, Serving the Meal

Within scallops

א״כ צפון ברך הלל נרצה פסח מצה מרור

A[fter]w[ard], Hidden, Benediction, Psalms of Thanksgiving, Accepted, Pesach, Matzah, Bitter Herbs

In center

ה / שמעיה / ל / מ

Shemayah / the / L[evite] / M.

On back
– M – C –

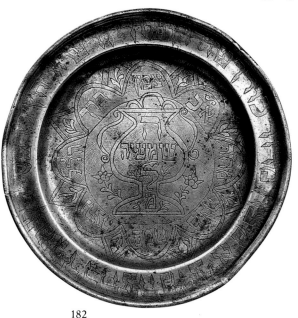

182

Large round platter with curved rim (now distorted). Engraved Hebrew words on rim, letters of each word filled with different patterns. Center design a twin-handled urn with inscription on body enclosed in circle surrounded by scalloped and pointed edging, words in scallops, fleur-de-lis in points.

This large platter with inscriptions giving the ritual order of the Seder from the Passover Haggadah would have been used to hold the ritual foods of Passover, or perhaps the wine decanter. The central design imitates an embroidered doily made of net (crosshatching) with embroidery (thick bands) to form the urn, flowers, scallops, and points. The form of the urn is sufficiently similar to a pitcher, the symbol of the tribe of the Levites, to suggest that the owner was a Levite. The pewter mark is obscured; the *MC* on the reverse is probably the initials of an owner.

According to a note made by Judge Irving Lehman, this "pewter Passover dish from Prague (bought by H. J. B.). Very old but date uncertain."

Literature

I. Lehman, List of one hundred eleven objects, circa 1928, no. 108.

BEQUEST OF JUDGE IRVING LEHMAN, 1945
(CEE 45–108)

## 183

# Haggadah-Style Passover Plate

MASTER: Slaken[ ] (?)
Central Europe, late 18th century
Pewter, cast, rolled; engraved
Diameter 12 in. (30.5 cm), rim 1⅝ in. (4.1 cm)
MARKS: Master; partial rose

INSCRIBED
On rim

זור קדש ורחץ כרפס יחץ מגיד רחצה מוציא מצה מרור כורך
שלחן עורך צפון ברך הלל נרצה

ZVR, Bless and Rinse, Celery, Split, Recitation, Wash, Blessing for Bread, Matzah, Bitter Herbs, Sandwich, Serving the Meal, Hidden, Benediction, Psalms of Thanksgiving, Accepted

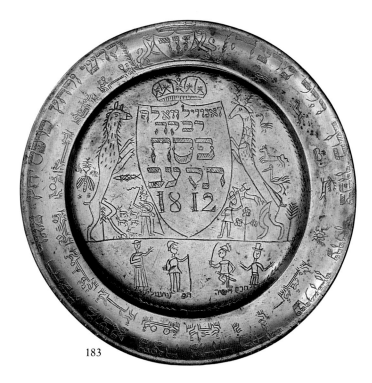

183

In shield

זאנוויל וואלף / רבקה / פסח / תקע"ב 1812

Zanvil Wolf / Rivkah / Pesach / [5]572 / 1812

Under figures

חכם רשה תם שענו לשעול

Wise, Wicked, Simple, Who does not [know] to ask

On upper center of rim, shield with initials of owners, held by rampant lions and surmounted by crown. Around rim, inscriptions of the order of the service illustrated with stick figures beneath each word. In center, shield with names of owners and date, crown above, rampant lion on left between bees and a fish, rampant deer on right between deer, birds, and flowers. On horizontal line, a hunter on left and woodsman on right. Below the line, the Four Sons.

The vigorous folk style of the engraving, based on pictures in a Haggadah, is inspired by the desire to explain and teach the meaning of the Passover Seder. Each of the key words is illustrated on the rim: under the first word, "Bless," immediately to the left of the shield, two stick figures at a table each holding an outsized wine goblet; under the next word, "and Rinse," a servant with pitchers and a large basin and two figures who rinse their hands. Each word in turn is so illustrated.

On the center ground line the two trees signify the Holy Land. The primitive rampant lion on the left represents the Lion of Judah, the rampant deer on the right represents the Land of Israel. The figures, birds, and animals represent the bounty of the land. Below the line are the Four Sons from the Haggadah: the Wise Son appears to be dressed as a Hasid with high hat; the Wicked Son is, as usual, the soldier; the Simple Son is the wanderer with staff; the One Who Does not Know to Ask is dressed as an assimilated or city Jew.

In the center shield, the name of Rivkah is larger than that of her husband, Zanvil Wolf, which suggests that the plate was a possession of the wife, part of her household furnishings.

Although pewter-making was in the hands of Christian guild members, Jews purchased undecorated objects and engraved them. They used their own designs modeled on embroidery or book illustrations to make them meaningful and to personalize them.

Reference

For a similar pewter plate, perhaps by the same engraver or from the same town, see A. Kanof, *Ceremonial Art in the Judaic Tradition*, 1975, p. 85, no. 171.

Literature

I. Winter, *Ingathering*, 1968, no. 187.

BEQUEST OF JUDGE IRVING LEHMAN, 1945
(CEE 45–115)

**184**

# Bezalel Passover Plate (Seder Plate)

Jerusalem, 1920s
Bezalel School of Arts and Crafts
Silver, embossed, chased, engraved
Diameter 11 in. (27.9 cm)
MARK: Bezalel (in Hebrew)

INSCRIBED
On rim

קדש ורחץ / כרפס יחץ / מגיד
רחצה מוציא / מצה מרור / כורך
שלחן עורך / צפון ברך / הלל נרצה

Bless and Rinse / Celery, Split / Recitation,
Wash, Blessing for Bread / Matzah, Bitter Herbs / Sandwich,
Serving the Meal / Hidden, Benediction / Psalms of Thanksgiving, Accepted

At inner rim of ovals

זרוע מרור חרוסת כרפס חזרת ביצה

Shankbone  Bitter Herbs  Haroset  Parsley  Horseradish  Egg

In center

השתא הכא / לשנה הבאה / בארעא דישראל / השתא
עבדי / לשנה הבאה / בני חורין

This year here / next year / in the Land of Israel / this year slaves / next year / free people

Wide rimmed plate, edge of sheet silver rolled over to form rounded rim with labeled oval indentations. Beading, hammering, alternating inscriptions, and urns fill background of rim. Raised roundel in center surrounded by deeply swirled leaf forms carries inscription.

This plate specifically states its function in both its form and in its quotations from the Passover Haggadah. Each of the labeled oval indentations is meant to hold one of the ritual foods of Passover; the raised center can hold a cup of wine. The quotations on the rim give the order of the Seder, the center contains a concluding verse. What better verse from a workshop in Jerusalem than, "Next year in the Land of Israel!"

BEQUEST OF JUDGE IRVING LEHMAN, 1945
(CEE 45–32)

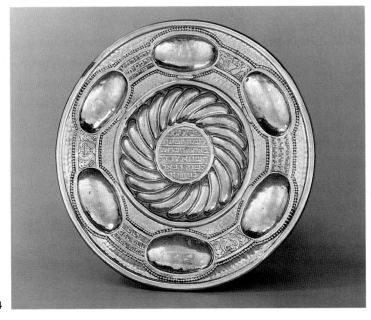

184

## 185/186/187/188/189

# Lehman Passover Wine Cups

### 185

**Footed Wine Cup (Kiddush *Becher*)**
MASTER: FIB (?)
Augsburg, 1695–1705
Silver, partial gilt; embossed and chased
Height 3½ in. (8.9 cm), diameter of rim 3 in. (7.6 cm)
MARKS: Master (Rosenberg, no. 828); place and date
(Rosenberg, no. 196)

Cup on three splayed ball feet, lower portion embossed with
diagonal spray-and-acanthus-leaf motif, scored band at upper
rim. Lower section and inside of cup have traces of gilt.

### 186

**Footed Wine Cup (Kiddush *Becher*)**
MASTER: M[?]GI
Dresden, 17th century
Silver gilt; embossed and engraved
Height 3¼ in. (8.2 cm), diameter of rim 2⅝ in. (6.7 cm)
MARKS: Master; place and date (Rosenberg, no. 1659)

Round-bottomed cup on three splayed ball feet. Delicately
engraved with three bouquets of flowers and fruits hanging
from scalloped ribbon ties. Scored band at rim.

### 187

**Elijah Goblet**
MASTER: IK
Magdeburg, 17th century
Silver, embossed and chased
Height 8⅛ in. (20.6 cm), diameter of base 4⅜ in. (11.2 cm)
MARKS: Master (Rosenberg, no. 3313); place and date
(Rosenberg, no. 3298)

INSCRIBED
On upper portion of cup
*IL*

Round base with baluster top ornamented with six highly
embossed shells; small pineapple-shaped shaft supports round
cup divided into six vertical sections. Lower portions decorated
with embossed leaves; upper plain sections bordered with
indented joinings. On one upper section, the elegant engraved
inscription.

### 188

**Wine Cup (Kiddush *Becher*)**
MASTER: Lorenz Biller (?)
Augsburg, 1695–1700
Silver, traces of gilt; embossed and chased
Height 3⅞ in. (9.8 cm), diameter at rim 3 in. (7.6 cm)
MARKS: Master (Rosenberg, no. 577); place and date
(Rosenberg, no. 192)

185 / 186 / 187 / 188 / 189

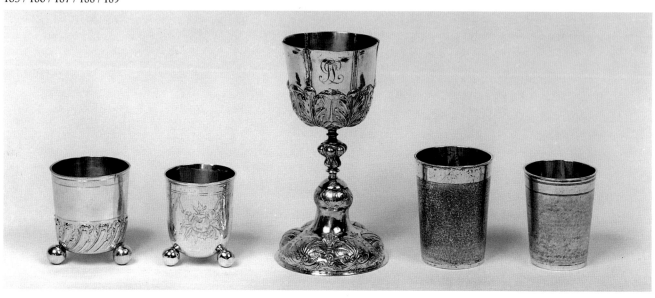

Heavy straight-sided tumbler slightly tapered to bottom. Surface between wide smooth band at top and narrow band at bottom chased in "sharkskin" pattern. Bottom has shallow inner rim.

### 189

**Wine Cup (Kiddush *Becher*)**
MASTER: Johann Höffler
Nuremberg, 1650–1700
Silver, traces of gilt; embossed and chased
Height 3¼ in. (8.2 cm), diameter at rim 2¾ in. (7 cm)
MARKS: Master (Rosenberg, no. 4238); place and date (Rosenberg, no. 3765)

Straight-sided tumbler, slightly tapered to bottom. Scored banded top and bottom with surface between chased in "sharkskin" pattern. Bottom has shallow inner rim.

These fine cups, and two more tumblers by Johann Höffler, were used by Judge and Mrs. Irving Lehman at their Passover Seders. They had been owned by Irving Lehman's family and were given to him by his parents. In the listing Judge Lehman himself drew up, he documents two of the "sharkskin" tumblers as having belonged to his mother's great-grandfather, which places the family ownership well into the seventeenth century. The footed goblet, used by the family as the cup for Elijah, bears Judge Lehman's initials. Ball-footed cups and tumblers decorated with a sharkskin pattern were much favored for kiddush cups by well-to-do German-Jewish families.

These four silver-and-gilt cups symbolically represent the four servings of wine over which blessings are recited during the Seder. A special cup of wine is set on the table in the hope that the prophet Elijah will arrive to announce the coming of the Messiah. This group is shown each spring in a small exhibit in the Sixty-fifth Street lobby of Temple Emanu-El.

Literature

I. Lehman, List of one hundred eleven objects, circa 1928, nos. 66, 73, 74, 75, 76; I. S. Meyer, "Catalogue of the Jewish Art Objects in the Collection of Judge Irving Lehman," 1932, nos. 64, 85, 92, 95.

BEQUEST OF JUDGE IRVING LEHMAN, 1945
(CEE 45–67) (CEE 45–68) (CEE 45–66) (CEE 45–76) (CEE 45–74)

190

## 190

# Lehman Passover Egg Dish

MASTER: Bartholomäus Pfister (?)
Nuremberg, 1650–1700
Silver, embossed
Height 1½ in. (3.8 cm), width at top 2⁷⁄₁₆ in. (6.2 cm)
MARKS: Master (Rosenberg, no. 4226); place and date (Rosenberg, no. 3765)

Spoon-shaped egg holder supported by upside-down miniature cup from which double-knobbed stem rises.

The roasted egg is displayed on the Passover table as a symbol of the offering in the Temple. This special dish to hold the egg may originally have been part of a set of dishes: one for the egg, one for the haroset, one for the bitter herbs, one for the salt water. All could have been placed on a large three-tiered round platter that held the three ceremonial matzot.

BEQUEST OF JUDGE IRVING LEHMAN, 1945
(CEE 45–80)

## 191

# De Jeshurun Festival Laver

MASTER: Hendrik Nieuwenhuys
Amsterdam, 1776
Silver, embossed, appliquéd, engraved
Length 20⅝ in. (52.4 cm), width 14½ in. (36.9 cm), depth 2 in. (5.1 cm)
MARKS: Master (Citroen, no. 346); place and date; year mark *R*

191–A

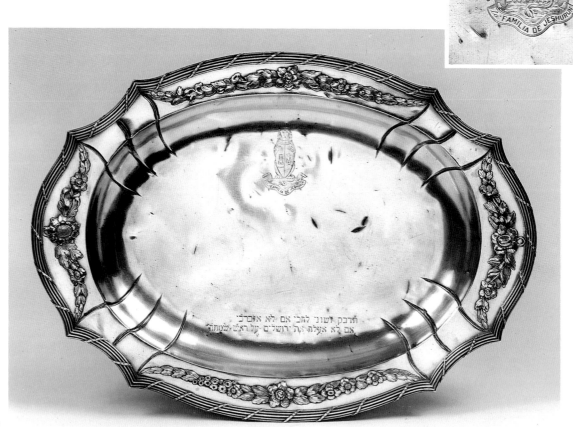

191

תדבק לשוני לחכי אם לא אזכרכי / אם לא אעלה את
ירושלים על ראש שמחתי

Let my tongue cleave to the roof of my mouth, If I remember thee not; / If I set not Jerusalem above my chiefest joy (Psalms 137:6)

Deep oval basin, fluted rim with applied ribbon-wrapped striations. Within bowl, engraved coat of arms of the Jeshurun family. Hebrew inscription below.

Such a laver originally had a matching pitcher, which was placed in the basin. We can deduce from the inscription, in which the last word is "joy," that it was used for ritual handwashing on the festivals. It is a tradition to recall the destruction of Jerusalem on all joyous occasions, thus the inscription.

The Jeshurun family of Amsterdam was originally from Spain, which is proudly declared in the family's coat of arms (cat. no. 191–A). In Spain the family had been "Conversos," but after fleeing the Inquisition in Spain the Jeshuruns returned to Judaism in the free milieu of Amsterdam.

Reference

"Jesurun [sic]," *Encyclopaedia Judaica*, vol. 10, 1971, col. 9.

BEQUEST OF JUDGE IRVING LEHMAN, 1945
(CEE 45–125)

**192**

# Lion Festival Tray and Vases

MASTER: GP (?)
Modena (?), Italy, 1810–72
Silver, embossed, chased; riveted
MARKS: Master; place and date (Rosenberg, no. 7327;
similar to Tardy, p. 289)

**Tray**
Diameter 17½ in. (44.5 cm)

<div align="right">INSCRIBED<br>On border of central medallion</div>

אלה מועדי י"י מקראי קדש אשר תקראו אתם במועדם

These are the set times of the Lord, the sacred occasions, which
you shall celebrate each at its appointed time (Lev. 23:4)

Round tray with central medallion in high relief of rampant lions
with outstretched tongues flanking a seven-branched lamp-
stand. Border of medallions, a separate band attached by
prongs. Surrounding field decorated with running lions, scrolls,
and waves, all in relief. Raised rim of chased scrolls and flowers.
The back of the narrow embossed edge is filled with a silver
band riveted to the tray.

**Vases**
Height 10½ in. (26.7 cm), diameter of rim 5¾ in. (14.6 cm)

Matching urn-shaped vases; bases with bands of acanthus-leaf
relief support fluted stems. On body, pairs of confronting lions
in relief. Above, wide necks of vases repeat chased acanthus-
leaf relief of bases and stems. The necks of the vases are attached
to the bodies by rivets.

The tray and matching vases were apparently table
appointments for the feast days of the Jewish year. The
vases probably held flowers, and perhaps appropriate
fruits graced the tray. While the embossing and chas-
ing are of a high order of workmanship, the use of
prongs and rivets to attach the pieces seems provincial.
The exuberance of the decoration relates the tray to a
ceremonial plate owned by the Jewish Community of
Venice dated to the seventeenth century which has a
Venice hallmark (*Arte nella tradizione Ebraica*, p. 100).
The lavish use of lions suggests the set was made for
a family named Leone.

Reference

S. Cusin, *Arte nella tradizione Ebraica*, 1963, pp. 100–101.

Bequest of Judge Irving Lehman, 1945
(CEE 45–230, 229 A/B)

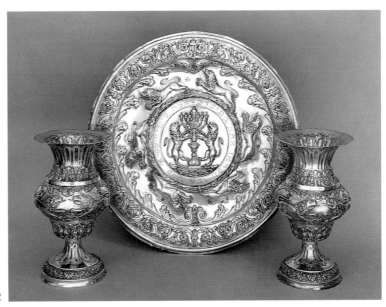

192

## 193/194/195

# Bezalel Plaques

### 193

**Herzl Memorial Plaque**
MASTER: Boris Schatz
Bezalel School of Arts and Crafts
Jerusalem, about 1907/8
Ivory, carved; silver frame
3 ¾ x 7⅜ in. (9.5 x 18.8 cm)
SIGNED: B Schatz / Jerusalem (in Hebrew)

INSCRIBED
At bottom

אל מלא רחמים שוכן במרומים המצא מנוחה נכונה על כנפי
השכינה במעלות קדושים וטהורים כזהר הרקיע מזהירים את
נשמה / השר וגדול בישראל בנימין זאב בן יעקב המכונה
תיאודור הרצל זכרונו לברכה / בגן עדן תהא מנוחתו וינוח
בשלום על משכבו ונאמר אמן / נולד בבודפסט בעשרה לירח
אייר תר״ך — נפטר בעדלך בעשרים לירח תמוז תרס״ד

God, full of compassion, who dwells on High, grant perfect rest on the wings of the Shekinah in the ascending heights of the holy and pure One whose radiance is like that of the Firmament to the soul of / the prince and great one of Israel Binyamin Ze'ev ben Yakov who was known as Theodor Herzl, may his memory be a blessing. / May his repose be in the garden of Eden and may he rest in peace, and let us say Amen! / Born in Budapest on the tenth of the month of Iyyar [5]630 (1860); died in Edlach on the twentieth of the month of Tammuz [5]664 (1904).

Scene of mourning carved within niche framed at top with small roundels enclosing on right, portrait of Theodor Herzl, six-pointed star on left. Eleven men, two women, and a child pray for the soul of the departed.

The text records the traditional text of El Male Rahamin, the prayer for the dead, with minor modifications. The figure in the left foreground is perhaps that of a poet or scholar, the one on the right is possibly the artist observing the scene.

193

**194**
**Jeremiah Plaque**
MASTER: Boris Schatz
Bezalel School of Arts and Crafts
Jerusalem, about 1907/8
Brass, cast; patinated
2⅛ x 2¾ in. (5.4 x 7 cm)
SIGNED: B Schatz / Jerusalem (in Hebrew)

INSCRIBED
Center of lower frame
ירמיה
Jeremiah

Lower right-hand corner
מי יתן ראשי מים / ועיני מקור דמעה / ואבכה יומם ולילה
/את חללי בת עמי

Oh, that my head were water, / my eyes a fount of tears! / Then would I weep day and night / for the slain of my poor people (Jer. 8:23)

Prophet sits within niche writing on a scroll outside walled city of Jerusalem seen in the background.

**195**
**Lamentations Plaque**
Bezalel School of Arts and Crafts
Jerusalem, about 1907/8
Brass, cast; patinated
2¾ x 2¾ in. (7 x 7 cm)
MARK: Jerusalem (in Hebrew)

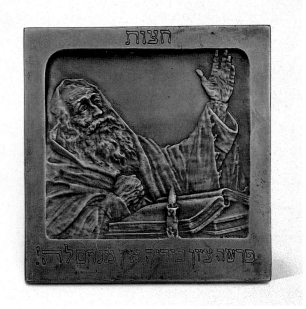

INSCRIBED
Top of frame
חצות
Midnight

Bottom of frame
פרשה ציון בידיה אין מנחם לה!

Zion spreads out her hands, she has no one to comfort her (Lam. 1:17)

Within a niche, rabbi with tallit covering his head, books and burning candle before him, recites Lamentations, his hand raised in a sign of speech.

The reading of Lamentations all night long is a traditional way of observing Tishah b'Av, which commemorates the destruction of the Temple.

This plaque is apparently based on an earlier work of 1903 signed by Boris Schatz. A paper label on the back of the piece identifies it as a product of Bezalel, Jerusalem. According to Gideon Ofrat (oral communication), the label was designed in 1905 by Ephraim M. Lilien, an Austrian illustrator and printmaker, who was a member of the committee formed to establish the Bezalel School of Art and Crafts.

References

On Boris Schatz plaques, see *Bezalel 1906–1929*, 1983, pp. 129 and 141, figs. 24 and 25. "Lilien, Ephraim Moses," *Encyclopaedia Judaica*, vol. 11, 1971, cols. 239–40.

BEQUEST OF JUDGE IRVING LEHMAN, 1945
(CEE 45–30) (CEE 45–253) (CEE 45–254)

## 196

# Souvenir Printed Torah and Set of Ornaments

Austro-Hungary, possibly Klagenfurt, early 20th century

**Torah Scroll and Mantle**
Printed on paper, rolled on wooden staves; silk mantle, machine embroidered
Height 7 in. (17.8 cm), height of scroll 4 in. (10.2 cm)

**Torah Ornaments**
MASTER: K G
Pressed gilded silver and silver
Height: shield 1⅞ in. (4.7 cm), finials 1¾ in. (4.4 cm), pointer 1⅝ in. (4.1 cm)
MARKS: Master; place and date (Tardy, pp. 75, 64 [?])

INSCRIBED
On shield
First ten letters of the Hebrew alphabet, representing the Ten Commandments

This type of Torah scroll is not suitable for synagogue reading, since the Torah read in the synagogue must be handwritten by a scribe on the skin of a kosher animal. This small printed version would be a charming and appropriate gift to a boy or girl on becoming a Bar or Bat Mitzvah. The design of the shield and finials correctly mimics contemporary Viennese designs for Judaica, which were in a flamboyant style.

GIFT OF MR. AND MRS. HENRY M. TOCH, 1928
(CEE 29–24)

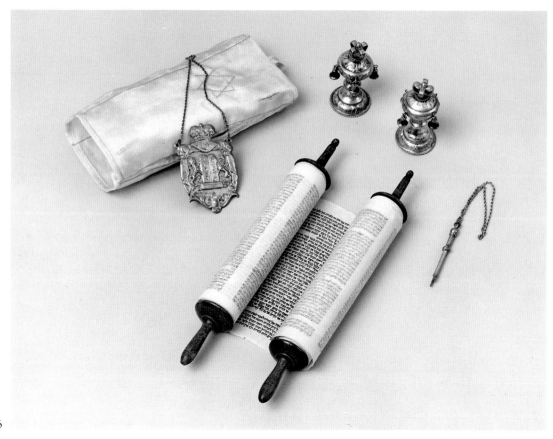

## 197/198/199/200

# Souvenir Printed Scrolls

### 197

**Torah Scroll**
New York City, 20th century
Printed on paper; black painted wooden handles and finials
Green silk mantle, imprinted in gold
Overall height 8 in. (20.3 cm)

INSCRIBED
Inside crown
כ ת
C[rown of] T[orah]

On Tablets of the Law

אנכי יי / לא יהיה / לא תשא / זכור את / כבד את
לא תרצח / לא תנאף / לא תגנב / לא תענה / לא תחמד

I am the Lord (your God) / You shall have no (other gods beside
Me) / You shall not swear (falsely) / Remember (the Sabbath) /
Honor (your father and your mother)
You shall not murder / You shall not commit adultery / You shall
not steal / You shall not bear (false witness) / You shall not covet
(Exod. 20:2–14)

### 198

**Torah Scroll**
New York City, 20th century
Printed on paper; black painted wooden handles and finials
Black silk mantle, imprinted in gold
Overall height 5¾ in. (14.6 cm)

INSCRIBED
Inside crown
כ ת
C[rown of] T[orah]

On Tablets of the Law

אנכי יי / לא יהיה / לא תשא / זכור את / כבד את
לא תרצח / לא תנאף / לא תגנב / לא תענה / לא תחמד

I am the Lord (your God) / You shall have no (other gods beside
Me) / You shall not swear (falsely) / Remember (the Sabbath) /
Honor (your father and your mother)
You shall not murder / You shall not commit adultery / You shall
not steal / You shall not bear (false witness) / You shall not covet
(Exod. 20:2–14)

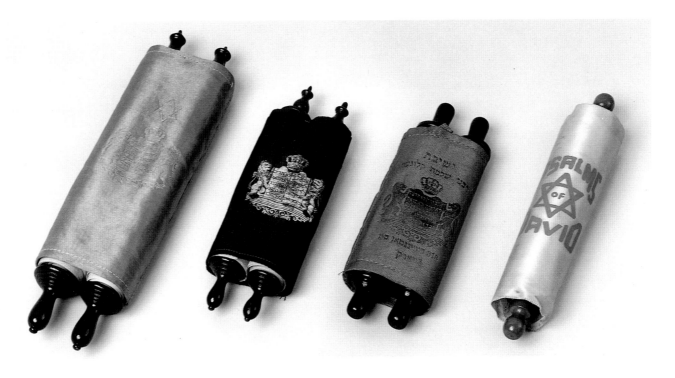

197 / 198 / 199 / 200

## 199

**Torah Scroll**
New York, 20th century
Printed on paper; black painted wooden handles and finials
Red cotton mantle, imprinted in gold
Overall height 5⅝ in. (14.3 cm)

INSCRIBED
Above crown

ישיבת רבנו שלמה קלוגער

The Yeshiva / of our Rabbi Solomon Kluger

Inside crown

כ ת

C[rown of] T[orah]

On Tablets of the Law

אנכי יי / לא יהיה / לא תשא / זכור את / כבד את
לא תרצח / לא תנאף / לא תגנב / לא תענה / לא תחמד

I am the Lord (your God) / You shall have no (other gods beside
Me) / You shall not swear (falsely) / Remember (the Sabbath) /
Honor (your father and your mother)
You shall not murder / You shall not commit adultery / You shall
not steal / You shall not bear (false witness) / You shall not covet
(Exod. 20:2–14)

Below Tablets of the Law

318 ריוונגטאן סט / נויארק

318 Rivington St. / New York

## 200

**Psalms of David Scroll**
New York City, 20th century
Printed in English, on paper, illustrated
Blue and red painted wood handles and finials
Ivory rayon ribbon mantle
Overall height 6⅜ in. (16.2 cm)

INSCRIBED
*PSALMS / OF / DAVID*

Scroll with six illustrations after engravings in Gustave Dore's
Bible folio of 1866 and one illustration after the painting *By the
Waters of Babylon* (1832) by Eduard J. F. Bendemann (Wallraf-
Richartz Museum, Cologne). Mantle embellished with six-
pointed star.

These small scrolls were mass-produced on the Lower
East Side and were used as gifts and souvenirs. They
highlight the piety that was brought to these shores
with the waves of East European immigration in the late
nineteenth and early twentieth centuries. It is interest-
ing that both Henry Toch and Irving Lehman owned
examples of such humble objects and included them
in their collections of rare and luxurious Judaica.

GIFT OF MR. AND MRS. HENRY M. TOCH, 1928
(CEE 29–13)
BEQUEST OF JUDGE IRVING LEHMAN, 1945
(CEE 45-241)
ANONYMOUS GIFTS
(CEE 85–23) (CEE 87–12)

# Glossary

**Afikomen**   The piece of matzah hidden at the beginning of the Passover meal (Seder) and shared by all at its conclusion.

**aron kodesh**   The holy ark, or cabinet, on the wall of the synagogue in which the Torah scrolls are kept.

**Ashkenazi**   A member of the culture of Central and East European Jewry with common traditions and a common language (Yiddish, a development of Hebrew and medieval German) and their descendants.

**attarah**   An open crown that ornaments the Torah scroll. Also the section of the prayer shawl that rests on the shoulders, which in some traditions is also pulled onto the head.

**atzei hayyim**   The two shafts on which the Torah scroll is rolled.

**bar mitzvah, bat mitzvah**   A young Jewish man who has completed his thirteenth year or a young Jewish woman at the age of twelve or thirteen who assumes his or her own religious obligations and is counted in the adult community.

**bimah**   The raised platform in the front, center, or rear of the synagogue from which the Torah scroll is read.

**brit milah**   The rite of circumcision of the male infant on his eighth day according to the injunction in the Bible (Gen. 17:10–12).

**b'samim box**   A container for the spices (b'samim) that are inhaled during the Havdalah service at the close of the Sabbath on Saturday evening.

**dreidel**   A four-sided top used by children in a game of chance traditionally played during Hanukkah.

**etrog**   The large lemonlike citrus fruit that is carried with the lulav through the synagogue on the holiday of Sukkot. (The etrog and lulav are ancient Jewish symbols associated with Temple rituals.)

**Haggadah**   The book read at the Seder, which gives the order of the service and contains the narrative concerning the Exodus from Egypt. Early Haggadot begin with illustrations from the Torah, but more usual representations are of the elders at B'nai Brak and the Four Sons. The book concludes with psalms and songs, including the well-known *Had Gadya*, "Only one kid."

**Ha-Melekh scroll**   An Esther scroll on which the scribe has written the text so that the words "the King" appear at the top of most of the columns.

**Hanukkah**   The eight-day winter holiday commemorating the victory in 165 B.C.E. of the small Jewish nation over their Syrian-Greek oppressors. Traditionally a lamp is kindled on the eve of each day beginning with one light and ending with eight.

**haroset**   A mixture of chopped fruits and nuts that is one of the ritual foods of the Seder, which represents the mortar used by the Jewish slaves in Egypt.

**Hasidim**   Members of a pious sect founded in Poland in the eighteenth century characterized by strictness of religious practice and a lyrical mysticism.

**Havdalah**   The Saturday evening service in the home which includes blessings over lights, wine, and spices. It concludes the Sabbath and separates it from the ordinary days of the week.

**huppah**   A canopy, usually of fabric supported by four posts, held over the bridal party during the wedding ceremony, which creates a sense of sacred space.

**Judenstern**   A hanging lamp with star-shaped basin developed in medieval Germany and associated with the Jewish Sabbath.

**kehillah**   A Jewish community.

**keter**   A crown, usually made of silver, that adorns the top of the dressed Torah scroll. In the Italian tradition, it is used together with finials; in the Ashkenazic tradition, it is sometimes used instead of finials.

**ketubah**   The marriage contract, a legal document of ancient Jewish origin, that defines the moral responsibilities of the bridegroom and protects the Jewish bride from financial exploitation in case of divorce.

**kiddush**   The blessing recited over a cup of wine as part of the Sabbath and festival rituals.

**Kohen**   A Jew descended from the line of priests, with ritual responsibilities passed from father to son.

**kosher**   Anything that adheres to Jewish law, as in the preparation of food, or in the condition of a Torah scroll in which any error or loss in the text would result in the scroll being considered ritually impure, or "unkosher."

**Ladino**   SEE Sephardi.

**Levite**   A descendant of the tribe of Levi designated with ritual responsibility, who therefore commands respect from members of the community.

**lulav**   A sheaf of myrtle, willow, and palm branches carried with the etrog through the synagogue on Sukkot.

**mahzor**   A prayerbook containing the liturgy for the festivals of the Jewish year.

***mappah***   An Italian Torah binder. Although the word means "table cloth," in Italian synagogue furnishings the term refers to the binder for the Torah scroll. It is also applied to the long cloth laid beneath and over the rolled-up sections of the Torah while the open central section is being read.

**matzah**   The unleavened bread eaten during the week-long holiday of Passover to commemorate the Exodus from Egypt. It recalls the flat bread eaten in such haste during the flight that the bread had no time to rise.

**mazal tov**   Literally, "good luck." "Mazal" is a zodiac sign, and when one wishes someone "mazal tov," one is expressing hope for a propitious zodiac sign.

**megillah**   A parchment scroll rolled on a single stave which contains the text of the Book of Esther, or the Book of Ruth, or Prophets, or Lamentations, or Ecclesiastes.

***me'il***   The Hebrew name for the Torah mantle, the fabric covering of the Torah scroll.

**menorah**   The seven-branched lampstand of hammered gold mentioned in the Bible as part of the furnishings of the Temple. (Exod. 25:31–36). With the exception of some Italian and French traditions and modern Reform synagogues, it is generally not replicated, in the belief that the seven-branched lampstand will reappear only in a messianic time, when the Temple will be rebuilt. The menorah appears on textiles, coins, and decorative objects as a symbol of Judaism.

***metsitsah***   The stanching of blood during a circumcision.

**mezuzah**   A parchment scroll containing two passages from the Bible (Deut. 6:4–9, 11:13–21) handwritten by a scribe and placed in a receptacle usually affixed to the doorway of a Jewish home.

**mitzvah**   A holy commandment; popularly, a good deed.

***mizrakh***   Literally, "east." A pictograph or amuletic inscription hung on the eastern wall of a synagogue or home indicating the direction of prayer, which is oriented to Jerusalem.

**mohel**   A ritual circumciser. SEE *brit milah*.

**moshavah**   A settlement in Israel in which the participants, usually farmers, are independent owners but share in the community production.

**ner tamid**   Literally, "eternal light." The lamp that is suspended before the ark in the synagogue which is always kept lit.

***neshamah***   "Soul" or "spirit" in Hebrew.

*parokhet*   The curtain that hangs before or inside the cabinet (*aron kodesh*) in which the Torah scrolls are kept. When hung in front of the cabinet, there is usually a valance that stays in place when the curtain is pulled aside to reveal the *aron kodesh*.

**Pesach**   Passover, the Feast of Unleavened Bread, a week-long springtime commemoration of the exodus of the children of Israel from Egypt as commanded in the Bible (Exod. 13:6–10), during which only unleavened bread is eaten and some foods are eschewed according to particular traditions. A celebratory Seder is held at the beginning of the holiday.

**Phylacteries**   SEE tefillin.

**Purim**   A jubilant holiday that celebrates the defeat of Haman's plan to destroy the Jews in the kingdom of Ahasuerus. The story is told in the Book of Esther, which is read on Purim. Gifts of food to friends, gifts of charity, and special Purim plays are also traditions of the holiday.

*rimmonim*   Literally "pomegranates"; the Torah finials that rest on the tops of the two wooden shafts (*atzei hayyim*) on which the Torah scroll is rolled. In some traditions in Italy, Holland, and England the *rimmonim* are called "bells."

**Rosh Hashanah**   The Jewish New Year, which occurs in the fall at the beginning of Tishri, the first month of the Hebrew calendar. Also called "The Birthday of the World," because it is traditionally thought to be the time of the Creation.

**Seder**   The festive meal on the first two nights of Pesach, during which the story of the Exodus from Egypt is told. Blessings are recited, songs and psalms are sung, and a meal usually based on the ethnic traditions of the hosts is served.

**Sephardi**   A member of the Spanish culture with common traditions and a common language (Ladino, a development of Hebrew and medieval Spanish) and their descendants.

**seudah**   A holiday feast.

**Shabbat**   The day of rest, the seventh day of the week. It begins on Friday evening with the welcome service, which includes a blessing over candles, over wine, and over bread, and concludes on Saturday evening.

*Shaddai*   One of the names of the Almighty, preferred on amulets for its mystical power.

**shalach monos**   The Yiddish term for gifts of food given to friends in celebration of Purim.

**shammash**   The "servant" light, the ninth light of a Hanukkah lamp, which is used to light the others. It also "serves" to make the light of the lamp usable for family activities, since the Hanukkah lights are designated as holy.

**Shavuot**   Feast of Weeks, or Pentecost, one of the ancient pilgrimage festivals. Celebrated fifty days after Passover, it commemorates the giving of the Law at Mount Sinai.

**Shekinah**   The mystical presence of the Almighty.

**shofar**   An instrument made from a ram's horn used to sound the notes of jubilation on Rosh Hashanah and at the end of the Yom Kippur service.

**shul**   Yiddish for "synagogue"; also for "school."

**siddur**   Book of daily prayers.

**Sukkah**   The temporary booth or open shed used for meals during the holiday of Sukkot, a reminder of the temporary shelters used by the children of Israel during their wandering in the desert.

**Sukkot**   The Feast of Booths, the week-long fall holiday for which open booths are decorated with leaves and fruits to commemorate the wandering in the desert after the flight from Egypt and to rejoice in the fertility of the earth.

**tallit**   The rectangular shawl with fringes that covers the shoulders, and sometimes the head, traditionally worn during daily prayers.

*tas*   A decorative metal shield usually hung from the staves of a Torah scroll, and often provided with a holder for small interchangeable plaques inscribed with names of holy days, which indicate the reading to which the scroll is rolled.

**tefillin**   Phylacteries—cubes of leather holding four verses from the Torah (Exod. 13:1–10, 11–16 and Deut. 6:4–9, 11:13–21)—tied on the head and left arm by means of attached leather straps, worn during daily morning prayers.

*tik*   A wooden case, often covered with silver, used in some Middle Eastern traditions to house the Torah scroll.

**Torah**   The moral, ethical, and religious law of the Jewish people. SEE Torah scroll.

**Torah binder**   SEE *mappah, wimpel*.

**Torah curtain**   SEE *parokhet*.

**Torah pointer**   SEE yad.

**Torah scroll**   The Pentateuch, the first five books of the Bible, handwritten by a scribe on a long parchment and rolled on staves, in which form it is read to the congregation in the synagogue.

**Torah shield**   SEE *tas*.

**tzedakah**   Charity, a religious responsibility.

*wimpel*   In the German Ashkenazic tradition, a long binder used to tie the Torah scroll when not in use, made from the cloth that bound the male infant during circumcision.

**yad**   A pointer used to follow the text while reading the Torah scroll, enabling the reader to avoid touching the sacred scroll.

**yahrzeit**   The yearly anniversary of the death of a loved one, frequently observed by the lighting of a memorial candle.

**Yiddish**   SEE Ashkenazi.

**Yom Kippur**   The Day of Atonement observed with fasting and repentance that concludes the High Holy Days in the fall, which begin with Rosh Hashanah, the Jewish New Year.

# Biblical and Talmudic Passages Cited in the Text

## BIBLICAL QUOTATIONS

*Genesis 1:28*
God blessed them and God said to them, "Be fertile and increase, fill the earth and master it."
(cat. no. 41)

*Genesis 19:27*
And Abraham arose early in the morning . . .
(cat. no. 12)

*Genesis 24:1*
. . . and the Lord had blessed Abraham in all things.
(cat. no. 61)

*Genesis 24:63*
And Isaac went out . . .
(cat. no. 12)

*Genesis 28:11, 17*
He [Jacob] came upon a certain place and stopped there for the night. . . . "How full of awe is this place! This is none other than the house of God, and this is the gate . . ."
(cat. no. 12)

*Genesis 49:22*
Joseph is a fruitful vine [even] a fruitful vine . . .
(cat. no. 148)

*Exodus 19:4*
. . . I bore you on eagles' wings . . .
(cat. no. 15)

*Exodus 20:2–14*
I am the Lord your God. . . . You shall have no other gods beside Me. . . . You shall not swear falsely. . . . Remember the Sabbath. . . . Honor your father and your mother. . . . You shall not murder. You shall not commit adultery. You shall not steal. You shall not bear false witness. . . . You shall not covet. . . .
(cat. nos. 4, 8, 9, 10, 11, 16, 17, 18, 38, 77, 149, 166, 197, 198, 199)

*Leviticus 19:18*
Love your neighbor as yourself.
(cat. no. 41)

*Leviticus 23:4*
These are the set times of the Lord, the sacred occasions, which you shall celebrate each at its appointed time.
(cat. no. 192)

*Numbers 8:24*
This is what pertains to the Levites.
(cat. nos. 12, 40)

*Deuteronomy 4:44*
And this is the Torah that Moses set before the children of Israel.
(cat. nos. 9, 15, 41, 42, 45, 47, 48, 49, 50)

*Deuteronomy 6:4, 9*
Hear, O Israel! The Lord our God, the Lord is One.
. . . Inscribe them on the doorposts of your house and on your gates.
(cat. no. 118)

*Deuteronomy 8:8*
. . . a land of wheat and barley, of vines, figs, and pomegranates, a land of olive trees and honey.
(cat. no. 64)

*Deuteronomy 16:16*
Three times in the year shall all the males appear before the Lord your God in the place which He shall choose: on the feast of Pesach, and on the feast of Shavuot, and on the feast of Sukkot; and they shall not appear before the Lord empty-handed.
(cat. no. 151)

*Deuteronomy 28:6*
Blessed shall you be in your comings and blessed shall you be in your goings.
(cat. no. 96)

*Joshua 1:8*
. . . but recite it day and night.
(cat. no. 76)

*1 Samuel 20:42*
Go in peace! Forasmuch as we have sworn both of us in the name of the Lord saying: "The Lord shall be between you and me, and between your offspring and mine, forever!"
(cat. no. 59)

*1 Kings 10:22*
Once every three years came the navy of Tarshish, bringing gold, and silver, ivory, and apes, and peacocks.
(cat. no. 162)

*Jeremiah 8:23*
Oh, that my head were water, my eyes a fount of tears! Then would I weep day and night for the slain of my poor people.
(cat. no. 194)

*Jeremiah 33:11*
. . . the voice of joy and the voice of gladness, the voice of the bridegroom and the voice of the bride. . . .
(cat. nos. 41, 42, 46, 47, 136)

*Ezekiel 43:7*
. . . I will dwell among the people of Israel forever.
(cat. no. 41)

*Psalms 19:1*
The commandment of the Lord is pure, enlightening the eyes.
(cat. no. 95)

*Psalms 19:8*
The Torah of the Lord is perfect, restoring the soul.
(cat. no. 47)

*Psalms 23:1*
The Lord is my shepherd; I shall not want.
(cat. no. 82)

*Psalms 23:5*
My cup runneth over.
(cat. no. 82)

*Psalms 34:15*
Shun evil and do good. . . .
(cat. no. 41)

*Psalms 119:72*
The Torah of Thy mouth is better unto me than thousands of gold and silver.
(cat. no. 47)

*Psalms 137:6*
Let my tongue cleave to the roof of my mouth, if I remember thee not; if I set not Jerusalem above my chiefest joy.
(cat. no. 191)

*Psalms 150:1*
Hallelujah. Praise God in His sanctuary.
(cat. no. 44)

*Proverbs 3:18, 17*
Its ways are ways of pleasantness and all its paths are peace. It is a tree of life to those that hold it fast; and the supporters thereof are happy.
(cat. nos. 39, 41, 47, 49)

*Proverbs 6:23*
For the commandment is a lamp, and Torah is light.
(cat. no. 152)

*Proverbs 20:27*
The spirit of man is the lamp of the Lord.
(cat. no. 139)

*Lamentations 1:17*
Zion spreads out her hands, she has no one to comfort her.
(cat. no. 195)

*Esther 2:5*
A Jewish man . . . and his name was Mordecai.
(cat. no. 84)

*Esther 2:17*
. . . so he set the royal crown upon her head, and made her queen instead of Vashti.
(cat. no. 179)

*Esther 9:22*
. . . sending portions to one another, and gifts to the poor.
(cat. no. 172)

*2 Chronicles 31:21*
And in every work that he began in the service of the house of God . . . he did it with all his heart, and prospered.
(cat. no. 64)

## TALMUDIC QUOTATIONS

*Pirke Avot 1:1*
. . . make a fence around the Law.
(cat. nos. 20, 110)

*Pirke Avot 1:14*
If I am not for myself, who will be for me?
(cat. no. 166)

*Pirke Avot 2:1*
Know what is above thee—a seeing eye, and a hearing ear, and all thy deeds recorded in a book.
(cat. no. 41)

*Pirke Avot 2:15*
The day is short, and the task is great, and the laborers are sluggish, and the recompense is ample, and the Master of the house urgent.
(cat. no. 41)

*Pirke Avot 4:13*
"There are three crowns: the crown of Torah, the crown of priesthood, and the crown of royalty; but the crown of a good name is the greatest of all."
(cat. nos. 2, 17, 37)

*Pirke Avot 5:20*
Be strong as the leopard, light as the eagle, fleet as a hart, and mighty as the lion, to do the will of thy Father, Who is in Heaven.
(cat. no. 41)

# Bibliography

**ADLER AND CASANOWICZ**
Adler, Cyrus, and I. M. Casanowicz. "Descriptive Catalogue of a Collection of Objects of Jewish Ceremonial Deposited in the United States National Museum by Hadji Ephraim Benguiat." In *Annual Report of the Board of Regents of the Smithsonian Institution . . . for the Year Ending June 30, 1899*, pp. 539–61. Washington, D.C.: Government Printing Office, 1901.

**ANSHE CHESED TRUSTEES MINUTES**
New York, N.Y., Congregation Anshe Chesed. Board of Trustees Minute Book. 1834–74. Manuscript.

*Architecture in the Hanukkah Lamp*
*Architecture in the Hanukkah Lamp.* Exhibition catalog. Jerusalem: Israel Museum, 1978.

*Art religieux juif*
*Art religieux juif.* Exhibition catalog. Paris: Musée d'Art Juif, 1956.

**BARNETT**
Barnett, R. D., ed. *Catalogue of the Permanent and Loan Collections of the Jewish Museum, London.* London: Published for the Jewish Museum by Harvey Miller; Greenwich, Conn.: New York Graphic Society, 1974.

**BEN-AMI**
Ben-Ami, Issachar. *Le Judaisme marocain: Etudes ethnoculturelles.* Jerusalem: Rubin Maas, 1975.

**BENJAMIN 1982**
Benjamin, Chaya. See *Towers of Spice*.

1987
Benjamin, Chaya. *The Stieglitz Collection: Masterpieces of Jewish Art.* Jerusalem: Israel Museum, 1987.

*Bezalel 1906–1929*
*Bezalel 1906–1929.* Jerusalem: Israel Museum, 1983.

*"Bezalel" of Schatz*
*"Bezalel" of Schatz, 1906–1929* (text in Hebrew). Exhibition catalog. Jerusalem: Israel Museum, 1983.

**BONDONI AND BUSI**
Bondoni, Simonetta M., and Giulio Busi. *Cultura ebraica in Emilia-Romagna.* Rimini: Luisè Editore, 1987.

**BREUER**
Breuer, M. "Frankfort on the Main: Music." *Encyclopaedia Judaica*, vol. 7 (1971), col. 92.

*Budapesti Zsidó*
*A Budapesti Zsidó Múseum* (The Jewish Museum in Budapest). Edited by Ilona Benoschofsky and Sándor Scheiber. Budapest: Corvina, 1987.

**BUTLER**
Butler, Charles. "The Temple Emanu-El, New York." *Architectural Forum*, vol. 52, no. 2 (February 1930), pp. 150–54.

**CARPENTER**
Carpenter, Charles H., Jr. *Gorham Silver 1831–1981.* New York: Dodd, Mead, 1982.

**CARPENTER AND CARPENTER**
Carpenter, Charles H., Jr., with Mary Grace Carpenter. *Tiffany Silver.* New York: Dodd, Mead, 1978. Reprint, 1984.

**CITROEN**
Citroen, K. A. *Amsterdamse silversmeden en hun merken.* North-Holland Studies in Silver, vol. 1 (text in Dutch, title and preliminary material in English). Amsterdam: Noord-Hollandsche, 1975.

**CLAPHAM**
Clapham, A. W. *Romanesque Architecture in Western Europe.* Oxford: Clarendon Press, 1936.

**CLUTTON**
Clutton, C. *Britten's Old Clocks and Watches and Their Makers.* 8th ed. London: Eyre and Methuen in Association with E. & F. N. Spon, 1973.

**COHEN**
Cohen, Yerachmiel (Richard). "Torah Breastplates from Augsburg in the Israel Museum." *Israel Museum News* (Jerusalem), vol. 14 (1978), pp. 74–85.

**CUSIN**
Cusin, Silvio. *Arte nella tradizione ebraica.* Introduction by Umberto Nahon. Milan: Edizione dell'ADEI–WIZO, 1963.

*Danzig 1939*　　　*Danzig 1939: Treasures of a Destroyed Community.* Essays by Günter Grass, Gerson C. Bacon, Joseph Gutmann, Elizabeth Cats. Catalog by Vivian B. Mann and Joseph Gutmann. Exhibition catalog. New York: Jewish Museum, 1980.

*Ebrei a Torino*　　　*Ebrei a Torino: Ricerche per il centenario della sinagoga, 1884–1984.* Archivi di arte e cultura Piemontesi, vol. 1. Preface by Primo Levi. Silver catalog by Perluigi Gaglia. Turin, 1984.

EMANU-EL TRUSTEES MINUTES　　　New York, N.Y. Congregation Temple Emanu-El. Board of Trustees Minute Book, 1845–1926; 1927–. Manuscript and typescript.

*Encyclopaedia Judaica*　　　*Encylopaedia Judaica.* 16 vols. Jerusalem: Keter Publishing House; New York: Macmillan, 1971–72.

*Encyclopedia of Jewish Religion*　　　*Encyclopedia of the Jewish Religion.* Edited by R. J. Zwi Werblowsky and Geoffrey Wigoder. New York: Holt, Rinehart and Winston, 1965.

ENSKO　　　Ensko, Stephen G. C. *American Silversmiths and Their Marks III.* New York: Robert Ensko, 1948. Reprint. *American Silversmiths and Their Marks. The Definitive (1948) Edition.* New York: Dover Publications, 1983.

FALKE　　　Falke, Otto von. *Die Sammlung Dr. Albert Figdor.* Edited by Otto von Falke. Entries by Max J. Friedländer, Leo Planiscig, and August Schestag. Part 1, 5 vols. Sales catalog. Vienna: Artaria, 1930.

FEUCHTWANGER　　　Feuchtwanger, Naomi. "The Coronation of the Virgin and of the Bride." *Jewish Art* (Jerusalem), vol. 12/13 (1986/87), pp. 213–24.

FIGUERAS　　　Figueras, Pau. *Decorated Jewish Ossuaries.* Leiden: E. J. Brill, 1983.

FISHOF　　　Fishof, Iris. " 'Jerusalem above my chief joy': Depictions of Jerusalem in Italian Ketubot." *Journal of Jewish Art* (Jerusalem), vol. 9 (1982), pp. 61–75.

FRANKEL　　　Frankel, Giza. "Little Known Handicrafts of Polish Jews in the Nineteenth and Twentieth Centuries." *Journal of Jewish Art* (Jerusalem), vol. 2 (1975), pp. 42–49.

FRANZHEIM　　　Franzheim, Liesel. *Judaica. Kölnisches Stadtmuseum.* Cologne: Museen der Stadt Köln, 1980.

FRIEDMAN　　　Friedman, Mira. "The Metamorphosis of Judith." *Jewish Art* (Jerusalem), vol. 12/13 (1986/87), pp. 225–46.

*Gates of Prayer*　　　*Gates of Prayer.* The New Union Prayerbook. Weekdays, Sabbaths, and Festivals. Services and Prayers for Synagogue and Home. New York: Central Conference of American Rabbis, 1975.

GINZBERG　　　Ginzberg, Louis. *The Legends of the Jews.* 7 vols. Philadelphia: Jewish Publication Society of America, 1909–38.

GOLDMAN　　　Goldman, Batsheva. "Raban—A Traditional Jewish Artist." In *Raban Remembered: Jerusalem's Forgotten Master,* pp. 57–69. Exhibition catalog. New York: Yeshiva University Museum, 1982.

GORHAM COMPANY RECORDS　　　Gorham Company Records. John Hay Library, Brown University, Providence, Rhode Island.

GRIMWADE 1950　　　Grimwade, A. G. "The Ritual Silver of Bevis Marks Synagogue." *Apollo,* vol. 51, no. 302 (April 1950), pp. 103–5; no. 303 (May 1950), pp. 130–32.

1958　　　Grimwade, A. G. "Anglo-Jewish Silver." *Transactions of the Jewish Historical Society of England.* Sessions 1953–55, vol. 18 (1958), pp. 113–25.

GROSSMAN 1980    Grossman, Cissy. "Womanly Arts: Italian Torah Binders in the New York Jewish Museum Collection." *Journal of Jewish Art* (Jerusalem), vol. 7 (1980), pp. 35–43.

1981a    Grossman, Cissy. *Fragments of Greatness Rediscovered: A Loan Exhibition from Poland.* Catalog of a traveling exhibition shown at the Jewish Museum, New York; Skirball Museum, Los Angeles; Walters Art Gallery, Baltimore. New York: Union of American Hebrew Congregations, 1981.

1981b    Grossman, Cissy. *A Philadelphia Sampler: Art and Artifacts from Jewish Collections.* Exhibition catalog. Philadelphia: Museum of American Jewish History, 1981.

1985    Grossman, Cissy. *To Bind the Torah Scroll.* Brochure. New York: Congregation Emanu-El, 1985.

1986a    Grossman, Cissy. *Days of Awe.* Brochure. New York: Congregation Emanu-El, 1986.

1986b    Grossman, Cissy. *Hana Geber: Sculptures of a Religious Passion.* Exhibition catalog. New York: Hebrew Union College–Jewish Institute of Religion, 1986.

1986c    Grossman, Cissy. *"...kindle the Chanukah lights."* Brochure. New York: Congregation Emanu-El, 1986.

1986d    Grossman, Cissy. *Remembrance of Times Past.* Exhibition brochure. New York: Congregation Emanu-El, 1986.

1986e    Grossman, Cissy. *Shavuos...the Giving of the Law.* Brochure. New York: Congregation Emanu-El, 1986.

1988    Grossman, Cissy. "The Real Meaning of Eugène Delacroix's *Noce juive au Maroc."* *Jewish Art* (Jerusalem), vol. 14 (1988), pp. 64–73.

GUTMANN    Gutmann, Joseph. *The Jewish Sanctuary.* Leiden: E. J. Brill, 1983.

HACKENBROCH    Hackenbroch, Yvonne. *Renaissance Jewellery.* London: Sotheby Parke Bernet in Association with the Metropolitan Museum of Art, New York, 1979.

*Haggadah*    *The Union Hagaddah. Home Service for the Passover.* Cincinnati: Central Conference of American Rabbis, 1923.

HINTZE    Hintze, Erwin. *Die deutschen Zinngiesser und ihre Marken.* 7 vols. Leipzig: K. W. Hiersemann, 1921–31. Reprint (6 vols.). Aalen: Otto Zeller, 1964–65.

HOFFMAN    Hoffman, Lawrence A. *Beyond the Text: A Holistic Approach to Liturgy.* Bloomington : Indiana University Press, 1987.

HOLY SCRIPTURES    The Holy Scriptures, According to the Masoretic Text. Philadelphia: Jewish Publication Society of America, 1917.

IDELSOHN, 1929    Idelsohn, A. Z. *The Ceremonies of Judaism.* Cincinnati: National Federation of Temple Brotherhoods, 1929.

1932    Idelsohn, A. Z. *Jewish Liturgy and Its Development.* New York: Henry Holt, 1932.

*Jewish Encyclopedia*    *The Jewish Encyclopedia. A Descriptive Record of the History, Religion, Literature, and Customs of the Jewish People from the Earliest Times to the Present Day.* 12 vols. New York: Funk and Wagnalls, 1901–6.

KANOF    Kanof, Abram. *Ceremonial Art in the Judaic Tradition.* Exhibition catalog. Raleigh: North Carolina Museum of Art, 1975.

KAYSER AND SCHOENBERGER

Kayser, Stephen S., and Guido Schoenberger, eds. *Jewish Ceremonial Art.* Catalog of an exhibition held at the Metropolitan Museum of Art, New York, commemorating the American Jewish Tercentary. [Also published as *Art of the Hebrew Tradition.*] Philadelphia: Jewish Publication Society of America, 1955.

KIRSHENBLATT-GIMBLETT

Kirshenblatt-Gimblett, Barbara. "The Cut that Binds: The Western Ashkenazic Torah Binder as Nexus between Circumcision and Torah." In *Celebration: Studies in Festivity and Ritual,* edited by Victor Turner, pp. 136–46. Washington, D.C.: Smithsonian Institution Press, 1982.

KIRSHENBLATT-GIMBLETT AND GROSSMAN

Kirshenblatt-Gimblett, Barbara, and Cissy Grossman. *Fabric of Jewish Life.* Vol. 1, *Textiles from the Jewish Museum Collection.* Exhibition catalog. New York: Jewish Museum, 1977.

KLAGSBALD

Klagsbald, Victor. *Catalogue raisonné de la collection juive du Musée de Cluny.* Paris: Editions de la Réunion des Musées Nationaux, 1981.

KLEEBLATT AND MANN

Kleeblatt, Norman, and Vivian B. Mann. *Treasures of the Jewish Museum.* With an essay by Colin Eisler. Exhibition catalog. New York: Universe Books, 1986.

KOOLIK

Koolik, Marilyn Gold. See *Towers of Spice.*

KRINSKY

Krinsky, Carol Herselle. *Synagogues of Europe: Architecture, History, Meaning.* An Architectural History Book. Cambridge: MIT Press, 1985.

LANDSBERGER

Landsberger, Franz. *A History of Jewish Art.* Cincinnati: Union of American Hebrew Congregations, 1946.

LEHMAN

Lehman, Irving. List of one hundred eleven objects. Circa 1928. Collection Congregation Emanu-El, New York. Manuscript.

LEVY

Levy, Beryl H. *Reform Judaism in America: A Study in Religious Adaptation.* New York: Bloch, 1933.

LILEYKO

Lileyko, Halina. *Srebra warszawskie w zbiorach Muzeum Historycznego m.st.Warszawy* (Warsaw Silver in the Collection of the Warsaw Museum of History and Painting). Warsaw: Państwowe Wydawnictwo Naukowe, 1979.

MANN

Mann, Vivian B. "The Golden Age of Jewish Ceremonial Art in Frankfurt—Metalwork of the Eighteenth Century." In *Leo Baeck Institute Year Book XXI,* pp. 389–403. London: Secker and Warburg, 1986.

MARIACHER

Mariacher, Giovanni. *Venetian Bronzes from the Collection of the Correr Museum, Venice.* Catalog of an exhibition shown at the University of Texas, Austin; Dayton Art Institute; William Rockhill Nelson Gallery of Art, Kansas City; Toledo Museum of Art; Santa Barbara Museum of Art; Dallas Museum of Fine Arts. Washington, D.C.: Smithsonian Institution, 1968.

*Marks of Achievement*

*See* Warren, David G.

*Menaḥoth*

*Menaḥoth.* Vol. 2 of *The Babylonian Talmud: "Seder Ḳodashim."* Edited by Rabbi Dr. I. Epstein, and translated into English by Eli Cashdan. London: Soncino Press, 1948.

METZGER AND METZGER

Metzger, Thérèse, and Mendel Metzger. *Jewish Life in the Middle Ages: Illuminated Manuscripts of the Thirteenth to the Sixteenth Centuries.* Secaucus, N.J.: Chartwell Books, 1982.

MEYER — Meyer, Rabbi I. S. "Catalogue of the Jewish Art Objects in the Collection of Judge Irving Lehman. April 18, 1932." Collection Congregation Emanu-El, New York. Manuscript.

MORTARA — Mortara, Marco. *Maskeret Hakhmei Italyah. Indice alfabetico dei rabbini e scrittori israeliti di cose giudaiche in Italia, con richiami bibliografici e note illustrative.* Padua: F. Sacchetto, 1886.

NARKISS, B. 1969 — Narkiss, Bezalel. *Hebrew Illuminated Manuscripts.* Jerusalem: Keter Publishing House. 1969.

1980 — Narkiss, Bezalel. "Un Objet de culte: La Lampe de Hanuka." In *Art et archéologie des juifs en France médiévale,* edited by Bernhard Blumenkranz, pp. 187–206. Preface by Salo Wittmayer Baron. Paris: Les Belles Lettres, 1980.

1983 — Narkiss, Bezalel. "On the Zoocephalic Phenomenon in Mediaeval Ashkenazi Manuscripts." In *Norms and Variations in Art: Essays in Honour of Moshe Barasch,* edited by Lola Sleptzoff, pp. 49–62. Jerusalem: Magnes Press, Hebrew University, 1983.

1986 — Narkiss, Bezalel. "The Feast of Lights." *FMR* (English ed.), vol. 5, no. 23 (December 1986), pp. 103–12.

NARKISS, M. — Narkiss, M. [Mordechai]. *The Hanukkah Lamp.* Jerusalem: Bney Bezalel, 1939.

NEVINS — Nevins, Allan. *Herbert H. Lehman and His Era.* New York: Scribner's, 1963.

OFRAT — Ofrat, Gideon. "The Art of Zeev Raban." In *Raban Remembered: Jerusalem's Forgotten Master,* pp. 19–38. Exhibition catalog. New York: Yeshiva University Museum, 1982.

PHILIPSON — Philipson, David. *The Reform Movement in Judaism.* Rev. ed. New York: Macmillan, 1931.

Raban Remembered — *Raban Remembered: Jerusalem's Forgotten Master.* Exhibition catalog. New York: Yeshiva University Museum, 1982.

RAINWATER — Rainwater, Dorothy T. *Encyclopedia of American Silver Manufacturers: Their Marks, Trademarks and History.* New York: Crown, 1975.

RICCI — Ricci, Seymour de. *The Gustave Dreyfus Collection: Reliefs and Plaquettes.* Oxford: University Press, 1931.

RIETSTAP — Rietstap, Johannes Baptist. *General Illustrated Armorial.* By V[ictor] and H[enri] Rolland. 3d ed. 6 vols. Lyons: Sauvegarde Historique, 1950.

RIVKIN — Rivkin, Ellis. *The Shaping of Jewish History: A Radical New Interpretation.* New York: Scribner's, 1971.

RORIMER — Rorimer, James J. *The Cloisters. The Building and the Collection of Mediaeval Art in Fort Tryon Park.* 2d ed. New York: Metropolitan Museum of Art, 1951.

ROSENAN — Rosenan, Naftali. *L'Année juive.* Exhibition catalog. Basel: Musée Juif de Suisse, 1976.

ROSENBERG — Rosenberg, Marc. *Der Goldschmiede Merkzeichen.* 3d ed., enl. and ill. 4 vols. Frankfurt: Frankfurter Verlags-Anstalt, 1922–28.

ROTH — Roth, Cecil, ed. *Jewish Art: An Illustrated History.* New York: McGraw-Hill, 1961.

RUBENS — Rubens, Alfred. *A History of Jewish Costume.* London: Peter Owen, 1967; 1973; 1981.

SCHEFFLER 1968    Scheffler, Wolfgang. *Berliner Gold-schmiede: Daten, Werken, Zeichen.* Berlin: Verlag Bruno Hessling, 1968.

1976    Scheffler, Wolfgang. *Goldschmiede Hessens: Daten, Werke, Zeichen.* Berlin/New York: De Gruyter, 1976.

SCHOENBERGER    Schoenberger, Guido. "A Sabbath Lamp from Frankfort-on-the-Main." In *Essays in Honor of Georg Swarzenski,* edited by Chaim Stern, pp. 189–97. Chicago: Henry Regnery, 1951.

SCHOLEM    Scholem, Gershom G. *On the Kabbalah and Its Symbolism.* Translated by Ralph Manheim. New York: Schocken Books, 1965.

SHACHAR 1971    Shachar, Isaiah. *Jewish Tradition in Art: The Feuchtwanger Collection of Judaica.* Translated by R. Grafman. Jerusalem: Israel Museum, 1971; 1981.

1975    Shachar, Isaiah. *The Jewish Year.* Leiden: E. J. Brill, 1975.

SHILO-COHEN    Shilo-Cohen, Nurit. See *Bezalel 1906–1929.*

SOBEL    Sobel, Ronald B. "A History of New York's Temple Emanu-El: The Second Half Century." Ph.D. diss., New York University, 1980.

STERN    Stern, Myer. *The Rise and Progress of Reform Judaism, Embracing a History Made from the Official Records of Temple Emanu-El of New York, with A Description of Salem Field* [sic] *Cemetery, Its City of the Dead, with Illustrations of Its Vaults, Monuments, and Landscape Effects.* New York: Myer Stern, Publisher, 1895.

*Synagoga*    *Synagoga: Kultgeräte und Kunstwerke von der Zeit der Patriarchen bis zur Gegenwart.* Exhibition catalog. Recklinghausen: Städtische Kunsthalle, 1960.

TANAKH    Tanakh. A New Translation of the Holy Scriptures, According to the Traditional Hebrew Text. Philadelphia: Jewish Publication Society of America, 1985.

TARDY    *Tardy International Hallmarks on Silver.* Paris: Tardy, 1981.

TOCH    Toch, H. M. "Jewish Ceremonial Objects Presented by Mr. and Mrs. Henry M. Toch to Temple Emanu-el, 1929. Description of the Contents of the Cabinets." Typescript.

*Torah*    *The Torah. A Modern Commentary.* Commentaries by W. Gunther Plaut, Bernard J. Bamberger, and William Hallo. New York: Union of American Hebrew Congregations, 1981.

*Towers of Spice*    *Towers of Spice: The Tower-Shape Tradition in Havdalah Spiceboxes.* Introduction by Chaya Benjamin. Text by Marilyn Gold Koolik. Exhibition catalog. Jerusalem: Israel Museum, 1982.

*Treasures of a London Temple*    *Treasures of a London Temple.* Compiled by A. G. Grimwade, R. S. Barnett, Temple Williams, and E. Croft-Murray. Foreword by L. D. Barnett, C.B. Introduction by The Very Reverend D. S. Gaon, Haham of the Spanish and Portuguese Jews of Great Britain. London: Taylor's Foreign Press, 1951.

*Treasures of the Holy Land*    *Treasures of the Holy Land. Ancient Art from the Israel Museum.* Foreword by Martin Weyl. Archaeologist's Introduction by William G. Dever. Introduction by Yael Israeli and Miriam Tadmor. Exhibition catalog. New York: Metropolitan Museum of Art, 1986.

*Union Prayerbook*    *The Union Prayerbook for Jewish Worship.* Newly Revised Edition. Edited by the Central Conference of

American Rabbis. 2 vols. Cincinnati: Central Conference of American Rabbis, 1940, 1945.

*Universal Jewish Encyclopedia*  *Universal Jewish Encyclopedia. An Authoritative and Popular Presentation of Jews and Judaism since the Earliest Times.* Accomplished with the cooperation of the United States Work Projects Administration for the City of New York. 10 vols. New York: Universal Jewish Encyclopedia, 1939–43.

*La Vie juive*  *La Vie juive au Maroc* (Hebrew text). Edited by Aviva Müller-Lancet. Exhibition catalog. Jerusalem: Israel Museum, 1973.

VOET  Voet, Elias, Jr. *Merken van Amsterdamsche Goud- en Zilversmeden.* The Hague: M. Nijhoff, 1912.

*Walk through the Cloisters*  *A Walk through the Cloisters.* Text by Bonnie Young. Photographs by Malcolm Varon, New York: Metropolitan Museum of Art, 1979.

WARREN, HOWE, AND BROWN  Warren, David G., Katherine S. Howe, and Michael K. Brown. *Marks of Achievement: Four Centuries of*

*American Presentation Silver.* Exhibition catalog. Houston: Museum of Fine Arts in Association with Harry N. Abrams, 1987.

WIGODER  Wigoder, Geoffrey, ed. *Jewish Art and Civilization.* Secausus, N.J.: Chartwell Books, 1972.

WINTER  Winter, Irene. *Ingathering: Ceremony and Tradition in New York Public Collections.* Introduction by Karl Katz. Exhibition catalog. New York: Jewish Museum, 1968.

WISCHNITZER 1955  Wischnitzer, Rachel. *Synagogue Architecture in the United States: History and Interpretation.* Philadelphia: Jewish Publication Society of America, 1955.

1964  Wischnitzer, Rachel. *The Architecture of the European Synagogue.* Philadelphia: Jewish Publication Society of America, 1964.

*Wolpert*  *Ludwig Yehuda Wolpert: A Retrospective.* Exhibition catalog. New York: Jewish Museum, 1976.

# Index

## GENERAL INDEX

Except where indicated otherwise, numbers refer to pages. Page numbers in *italics* designate illustrations.

Listing of
Geographical Origins of Cataloged Works
appears on page 198

## GEOGRAPHICAL ORIGINS OF CATALOGED WORKS

## PHOTOGRAPH CREDITS

All color photography is by Malcolm Varon, New York City.
All black-and-white photography is by Will Brown, Philadelphia,
except for the following:
pages 2, 4–6, 14: Congregation Emanu-El Archives
pages 43, 64, 88 center, 134, 135 top: Cissy Grossman, New York City
page 10: Kasia Grudia, New York City
pages 65–69, 72, 84 top: Malcolm Varon